THE *Afterlife* OF *Images*

BODY, COMMODITY, TEXT

Studies of Objectifying Practice

A series edited by
Arjun Appadurai,
Jean Comaroff, and
Judith Farquhar

THE *Afterlife* OF *Images*

Translating the

Pathological Body

between China

and the West

Larissa N. Heinrich

Duke University Press Durham and London 2008

Designed by
Heather Hensley

Typeset in Monotype
Fournier by Tseng
Information Systems, Inc.

Library of Congress
Cataloging-in-Publication
Data appear on the last
printed page of this book.

An earlier version of chapter 1 was published as "How China Became the 'Cradle of Smallpox': Transformations in Discourse, 1726–2002," in *positions: east asia cultures critique* 15, no. 1 (2007).

An earlier version of sections of chapter 2 was published as "Handmaids to the Gospel: Lam Qua's Medical Portraiture," in *Tokens of Exchange: The Problem of Translation in Global Circulations*, ed. Lydia Liu (Durham, N.C.: Duke University Press, 1999).

An earlier version of sections of chapter 3 was published as "The Pathological Empire," in *History of Photography* 30, no. 1 (2006).

Duke University Press gratefully acknowledges the support of three organizations that provided funds toward the production of this book: the Association for Asian Studies, the Australian Academy of the Humanities, and the Chiang Ching-Kuo Foundation for International Scholarly Exchange.

For my grandmothers Rebecca and Rose

TABLE OF CONTENTS

LIST OF ILLUSTRATIONS

ACKNOWLEDGMENTS

This book began as an attempt to provide a concrete answer to the abstract question of how the stereotype of China as the "Sick Man of Asia" reached maturity over the course of the nineteenth and twentieth centuries. Over the years, however, it also evolved into a more general philosophical attempt to redeem beauty from its unlikely refuge in representations of disease, trauma, prejudice, and imperialistic impulse. Such a process inevitably represents not only an intellectual endeavor but a personal one, and in both respects I have been supported by many people. I am deeply grateful to Lydia Liu, Andrew Jones, and Patricia Berger for their superb mentorship. Meiyuan Zwia Lipkin, Fran Martin, and Rachel Sturman provided excellent scholarly advice and friendship throughout the preparation of this manuscript. Bridie Andrews, Chia-feng Chang, Stephen Rachman, and Hugh Shapiro shared early drafts of their work with me. Yi-Li Wu read drafts of chapter 4 while generously sharing sources, materials, and her own research. Yuezhi Xiong at the Academy of Social Sciences in Shanghai not only made me feel welcome during my year there but lent me a number of hard-to-find documents from his personal collection. Daw-hwan Wang hosted me during a semester at Academia Sinica in Taiwan, where he and P'ing-yi Chu of the medical history studies group provided both scholarly assistance and congenial counsel. A number of scholars read or commented on drafts of the manuscript over the years, including Maram Epstein, Douglas Fix, Bryna Goodman, David S.G. Goodman, Wendy Larson, Michael Nylan, Jonathan Zwicker, and Duke University Press's anony-

mous reviewers, and for their comments I am extremely grateful. For their help in tracking down obscure sources and in answering specialized questions I thank Lisa Claypool, Nixi Cura, Amy Garlin, Suzanne Jablonski, Dongyu "Jeremy" He, Charlene Makley, Lauren Nemroff, Steve West, Ping Wang, and Andrea Zemgulys. Wu Hung, Wen-hsin Yeh, and Christian Henriot gave me the opportunity to present earlier drafts of chapters 2, 3, and 4 at conferences in Chicago, Berkeley, and Tokyo, and I benefited greatly from their insights and those of the other conference participants. Many thanks also to Monique Cohen and Nathalie Monnet of the Oriental manuscripts division of the Bibliothèque Nationale de France, Thierry Klaerr of the Bibliothèque de l'Institut de France, and Toby Appel at the Harvey Cushing/John Hay Whitney Medical Library at Yale, all of whom provided invaluable assistance in navigating critical eighteenth- and nineteenth-century archival materials. Many engaging conversations with my colleagues Hui-hsien Lin, Isaac Shou-chih Yan, and Yunyun Chang in the exhibitions department of the National Palace Museum in Taipei contributed directly to the genesis of this book. Mary-Jo Arn read through numerous drafts and offered valuable comments from start to finish. Clara Iwasaki's fine research assistance, and Laura Iwasaki's fine-tuning, greatly improved the manuscript; Jon Kowallis's support was critical to its completion.

Research for this book was completed with the generous support of the Fulbright-Hays Doctoral Dissertation Research Abroad grant, the Chiang Ching-kuo Foundation for International Scholarly Exchange (both through a Doctoral Dissertation Write-Up Fellowship and through Project RG005-P-03), the Australian Academy of the Humanities, and a teaching relief grant from the University of New South Wales in Sydney. All translations are mine unless otherwise indicated.

Finally, for their love and support I also thank Joseph Chang, Kari Hong, Lucy Macnaught, and my family: Michael Heinrich and Sandy Legler; Susan, Stewart, and Aaron Dean; Ken Heinrich and Mary-Jo Arn; and the Pecoraro clan.

THE *Afterlife* OF *Images*

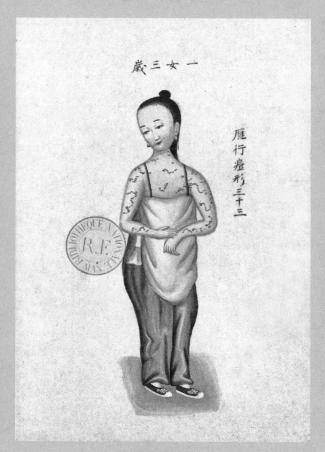

歲三女一

雁行痘形三十三

FIGURE 1: "Girl, age three, goose chevron pox, form thirty-three." COURTESY
OF THE BIBLIOTHÈQUE NATIONALE DE FRANCE, MANUSCRITS CHINOIS 5224 FOL. 32.

INTRODUCTION

> That the formal qualities of images themselves may be in large
> part irrelevant is suggested by their historical trajectories and
> the radical revaluations that they undergo. If an image that
> appears to do a particular kind of work in one episteme is
> able to perform radically different work in another, it [would
> appear] inappropriate to propose inflexible links between
> formal qualities and effect.
>
> — *Christopher Pinney*, Photography's Other Histories

Some years ago, when I was working at the National Palace Museum in Taipei and also researching representations of pathology in Chinese art, a colleague pointed out a small picture in one of the museum's permanent exhibits that I had never noticed. I had probably passed it a hundred times. It was a tiny photographic reproduction of what appeared to be an eighteenth- or early nineteenth-century gouache of a child with smallpox, and it was part of the museum's ongoing "Comparison of Chinese and World Cultures" (華夏文化與世界文化之關係) timeline exhibit mounted on a wall not far from the building's entryway. In the exhibit, both a Chinese timeline and a separate "Western" timeline ran contiguously to form an imposing visual comparison of the various advancements in technology and science through the course of human history. On the Chinese timeline were familiar references to early Chinese inventions like bronze casting, printmaking, and gunpowder, while the Western timeline included references to industrial technology, optical engi-

neering, anaesthetics, and the like. In this context, the little child with smallpox was clearly intended to signify China's invention of the practice of inoculation as a technological achievement in advance of the West. Exhibit designers had borrowed the little image from a Taiwanese historical encyclopedia of science and technology in China, where it had been reproduced without attribution.[1] A small red seal on the image itself, however, identified it as belonging originally to the archives of the Bibliothèque Nationale de Paris.

The image, I eventually discovered, had a rich and complex history. It had crossed the Pacific back and forth several times over more than two centuries; it had been reproduced in a number of different linguistic and cultural contexts; and it had evolved from earlier forms to the one found in the National Palace Museum along a fascinating and often paradoxical trajectory. A curator at the Bibliothèque Nationale confirmed that the painting belonged to a set of sixty-one small paintings of children with different manifestations of smallpox that had been sent to the library in 1772, when it was still the Bibliothèque Royale, by the French Jesuit Martial Cibot, along with an essay on smallpox in China.[2] While the images were never published as such — the essay was published separately, its own story the subject of chapter 1 of this book — selections from among them had found their way into a number of French bibliographic contexts in the intervening years, one of which was probably the source for the Taiwanese encyclopedia. In one book an image from the collection was used to signify "pediatric cutaneous illnesses" in a kind of superficial survey of Chinese medical practices in the premodern period.[3] In another — a copiously illustrated three-volume encyclopedia of "world" medicine first published in the 1930s — an image of a Chinese child with smallpox was included in the company of Egyptian hieroglyphs and Japanese medical prints as representative iconography in a brief chapter on "the medicine of China."[4] More tellingly, when the French minister Henri Bertin first viewed the images on receiving them in 1772, he wrote in a draft of a letter, "It seems to me, according to the symptoms described in the treatise and depicted in the hideous figures accompanying it, that smallpox in China is infinitely more malignant than in Europe."[5] Far from symbolizing technological prowess, in other words, in the context of their representation in France these images in fact stood for a kind of backwardness, a kind of vulnerability to disease coded implicitly as Chinese.

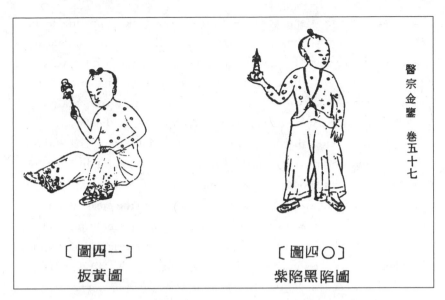

醫宗金鑒 卷五十七

〔圖四一〕
板黃圖

〔圖四〇〕
紫陷黑陷圖

FIGURE 2: Configurations of smallpox. Reproduced from a reprint of 醫宗金鑒 *Yizong jinjian* [*The Golden Mirror of Medical Orthodoxy*], edited by Wu Qian (1742; Taipei: Xin Wen Feng Chu Ban Gongsi, 1985).

The Chinese sources on which these images were based meanwhile presented a different picture, literally: they were woodblock prints from an important Qing medical anthology called the 醫宗金鑒 *Yizong jinjian*, or *The Golden Mirror of Medical Orthodoxy*, that had been commissioned by the Qianlong emperor in 1739 and that contained a comprehensive illustrated section on smallpox intended both as a guide for diagnosis and for the management or containment of the disease through inoculation and other means.⁶ Atypical of medical texts of this period, the relatively numerous illustrations of pathological manifestations in this text compositionally and thematically drew from an entrenched iconography of Chinese children known as the *Baizi tu* (百子圖, or "Hundred children pictures"), which—in regular contexts—symbolized health, longevity, fertility, good fortune, and even sovereignty.⁷ In short, the image had gone from representing health and fecundity in its earliest incarnations to representing disease and even death; it had been "translated" and augmented across time and space, from representing proactive treatments for smallpox in the context of the Qianlong imperial project to representing the perceived severity of Chinese smallpox, or of Chinese disease generally, in the French examples. The supreme irony, of course, was that the image eventu-

ally found its way home: it was reunited with the Qianlong imperial archive, known now as the National Palace Museum in Taiwan. In this context the image's value as a sign of Chinese technological expertise had been restored, albeit in the service of a historically nationalist agenda, so that instead of representing Chinese backwardness vis-à-vis the rest of the world, it now represented the opposite: Chinese advancement as compared to the West.

This book explores that protean yet circuitous journey: it traces the development and origins of the medical rhetoric and iconography that linked Chinese identity with bodily pathology at the onset of modernity. In so doing, it sketches the contours of the varied contexts in which the meanings of medical representations were crafted and transformed in the nineteenth and early twentieth centuries. Thus it reads the early medical rhetoric and iconography of medical missionaries in China which transmitted to the West an image of China as sick or diseased — the "Sick Man of Asia" (*dongya bingfu* 東亞病夫). At the same time it describes through various case studies the process by which these ideas were absorbed back into China (and indeed disseminated throughout the world) through missionary activity, through the earliest translations of Western medical texts into Chinese, and ultimately through the literature of Chinese nationalism itself. Like the little image of the child with smallpox, this study therefore not only suggests the importance of looking at context and images alongside text but also exposes the extrascientific means by which some powerful stereotypes and ideas came to fuse Chinese identity with the deceptively empirical notion of pathology in the construction of modernity.

A leitmotif in medical missionary writings of the nineteenth century is the recurring reference to the need for visual materials — what the writings often refer to as "ocular" evidence or proof — for persuading potential patients, medical students, converts, and others in China of the superiority of Western medical techniques. On the one hand, this had to do with the same eminently practical problem of communicating across culture and language that had preoccupied missionaries in China from the start: missionary doctors believed, like many before them, that illustrations, models, demonstrations, and the like would prove more effective in communicating the strengths of Western science to dubious Chinese audiences than words or intellectual explanations alone could. Indeed, a primary factor in determining which illnesses

the missionary hospitals would treat—*waike* (external) ailments such as easily removed tumors and cataract surgeries that would restore sight to the blind— was, at least initially, precisely the question of which surgeries would yield cures that Chinese could observe with, or cause to be enacted on, their own eyes.[8] But this missionary fixation on the ocular also had to do with deeply rooted convictions about *how* the Chinese saw, what it was they saw when they looked, and how it was they made sense of that information on seeing it. In an 1885 address commemorating the fiftieth anniversary of the Canton hospital, for example, the Reverend T. W. Pearce remarked:

> In China more than elsewhere we must, in dealing with the people, put plain facts and deeds before them if we are to make an impression on the mind at all striking and durable. The institution is a plain fact likely to have more effect than the best kinds of argument. The Chinese write and speak pictures. This hospital is a picture on which they must constantly look. It supplies ocular evidence of some things which foreigners believe; [and] of some motives which influence them in their relations with the Chinese.[9]

Some missionaries believed, in other words, that the Chinese had an almost natively hieroglyphic way of seeing or "reading" the world and processing its visual information—a belief not at all inconsistent, incidentally, with proto-linguistic theories advanced first by the Jesuits that linked Chinese writing to hieroglyphics and the history and culture of ancient Egypt, whereby pictures *were* words, and words pictures. The Chinese did not read and write in the conventional sense, it was reasoned, so much as "look at" and "depict."[10] Thus to communicate through the ocular was to communicate in the Chinese own vernacular. When working with a people who "write and speak pictures," using images of pathology and the body as a means of proselytizing about Western medical prowess was therefore only natural: images of illness and cure represented a potent kind of conceptual currency that could be exchanged for "striking and durable" impressions on the minds of Chinese viewers.

A central premise of this book is therefore that the impressions these images actually generated, far from being durable, not only diverged from their original models but (like the little image of the child with smallpox) accumulated a host of powerful secondary meanings, meanings that took on a dynamic and ideologically complex afterlife. This afterlife had lasting consequences for

how ideas about Chinese race, pathology, culture, and identity were formed and conceived on the eve of modernity and subsequently communicated not only in literature and visual culture but also in culture at large. As a foundational example of such an argument, consider the problem of how to interpret representations of illness in early modern Chinese literature, a problem that fascinated me as a graduate student in modern Chinese literature some years ago and one that forms part of the genesis of this book. I could not help but notice that literature of the Republican period and beyond is conspicuously overpopulated with disease: what seem like legions of characters spit blood, develop sores, hallucinate, hobble, go mad, and succumb to general weakness and malaise. Described in graphic detail, these literary illnesses of the early modern period often take on more-than-subtle allegoric functions as representations of the larger metaphorical ills of China and Chinese nationhood in a tumultuous time. Some of the best-known examples, for instance, appear in the fiction of the great early modern writer and "father of modern Chinese literature" Lu Xun (1881–1936). In his stories "My Father's Illness" and "Medicine," for example, Lu Xun levels an infamous critique against "backward" Chinese cultural practice generally by depicting the ineffectuality of Chinese medical practice in the face of grave illness, and in other essays and stories the author regularly turns to the conceptual vocabulary of illness, medicine, and anatomy to describe a Chinese cultural body nearly beyond repair.[11] Other important writers of Lu Xun's generation such as Ding Ling, Yu Dafu, Mao Dun, and Shi Zhecun likewise created a host of pathological main characters whose illnesses are described in such excruciating detail that they may actually be identified (or, more properly, diagnosed) by the interested reader as tuberculosis, catatonia, neurasthenia (weak nerves, neurosis), or even syphilis.[12] Where did these ideas come from, these descriptions of very specific symptoms? Beyond appropriating literary and cinematic models from the West—characters from the work of Charles Dickens, Nikolai Gogol, or Gaston Leroux's *Phantom of the Opera*—what sources informed the characterization of symptom and etiology? Did they derive from Western medical literature, traditional Chinese medical knowledge, or both? And which cultural resonances were these depictions, now seasoned by the agendas of a new era, intended to invoke in readers?

In attempting to make a responsible interpretation of the intended and re-

ceived meanings of representations of disease in works like these—or indeed of representations of illness in any national literature—it is no longer enough to refer only to "borrowing" from other literatures as has been the habit of literary studies of a more hermetically removed era, nor only to the more metaphoric aspects of representations of the body politic. Literary studies have grown more sophisticated and, by necessity, more inclusive, so that we must give weight not only to the allegorical aspects of an incidence of illness in literature but also to its etiology and origins; we must untangle its expression and its specific cultural value (borrowed and original alike), as well as its associated meanings in the precise moment of its occurrence, like a kind of cultural radiocarbon dating. By the early Republican period, in other words, the metaphorical or culturally inflected meanings of various Western-named diseases like tuberculosis, neurasthenia, or syphilis had had some time to evolve. The appearance of these illnesses in Chinese literature therefore was not simply coincidental to the writers' craft, nor did it represent purely creative appropriations of some distant Western source. What popular knowledge was circulating about these diseases at this time that would have lent them literary nuance? What resonances were contributed by ideas about disease and etiology from traditional Chinese medical knowledge? Springing from somewhere beyond (or at least, not limited to) the traditional Chinese medical canon, in other words—planted in such thin soil—how did these diseases and syndromes acquire meaning in China?

To complicate matters still more, one must accept that in taking on questions of the etiology and development not only of disease but of ideas about disease in literature and culture at large, one must also address the problem of ideas about the body as well. The body is, after all, the physical and conceptual field on which illnesses play out and onto which they project their allegorical impact. And as such it would be a fallacy to assume that this "body"—especially after the eighteenth century—remained stable as a concept even as other myths of science and medicine underwent dramatic and elemental transitions. If we recognize, for instance, that the body cosmogenies of traditional Chinese medicine differed dramatically from their postanatomical counterparts as introduced in the mid-nineteenth century, then how are we to interpret representations of the newly pathological body that emerged in the literature of the modern era—a body that was not just *any* body, but (at least in part) an *ana-*

tomical one? Grappling with the specific cosmological significances and associations of representations of the body in premodern Chinese culture/s (both literary and medical alike) is challenge enough for the literary scholar. But how then are we to cope with this body in transition as it suffers the assorted ideological indignities of enlightenment, imperialism, missionary imperative, and, of course, science? What do we make of the fact that, like any imported ideological construct, the anatomical body and its associated diseases and conditions in China would have brought with it its own set of values and messages to be accepted, rejected, transformed, misinterpreted, selectively appropriated, or ignored?

Clearly the work of analyzing representations of illness in literature lies in the footnotes to that analysis: it is what happens before the literary analysis can even begin. In the context of Chinese studies it thus makes sense for the first ports of call to be medical history and the history of science, as they provide the most immediate and thorough information about specific diseases, general theoretical structures, traditional and transitional classification schemes, therapeutic practice and technology, and pharmacology. In terms of the social and cultural aspects of medical history as well, one can now find excellent studies of the early modern period in China that range in their treatments from the micro (individual diseases and their historical translation) to the macro (entire historical transitions and the transitions in meaning of broader concepts like hygiene and health generally).[13] To gain an understanding not necessarily of how illnesses are transmitted so much as how *ideas* about illness are transmitted (the trade in ideas being a central feature of literary representations of illness), one might also consult a variety of post-Foucauldian scholarship that addresses cultural and theoretical problems concerning the "objective, scientific" historicity of medicine and science—scholarship that is finding increasingly strong purchase in Chinese academic contexts as well.[14] Regarding the thorny question of what constitutes the "Chinese" versus "Western" body in its vulnerability to disease, meanwhile, there are now several options. One might look to comparative cultural studies, where the illustration of one cultural corporeal configuration can serve to highlight, through contrast, the fine points of another; or to studies that take into account the cultural and historical contingencies of the lived or constructed body through Chinese history and across such subdisciplines as cinema studies, sexuality, performance studies, political science, and even the history of costume and clothing.[15]

Missing from this list—and thus constituting the gap that this book attempts to fill—is the rather newer field of visual culture studies. With its attention not only to the techniques of the artist or artisan but also to the cultural and historical conditioning of vision itself, visual cultural studies fills an important gap in the analysis of transmission of ideas about illness across cultures and across history. In the history of medicine as a general discipline, for instance, Sander Gilman has noted the conspicuous absence of studies of medical illustration, which, he laments, remains but a "stepchild" of the field.[16] Likewise the history of Chinese medicine in particular is also marked by the absence of dedicated studies of images and illustration, an absence that has not gone unnoticed.[17] In both cases, the absence of studies of medical illustration is especially glaring when one allows that medical literature, in a variety of cultural contexts, is so often defined by its dependence on a dynamic conversation between medical texts (expository, explaining a disease, condition, or corporeal state in words) and the images that illuminate them (diagrams, charts, or descriptive illustrations intended to complement the text, and vice versa). Literature studies suffer from a parallel problem: while the discussion of illness as an allegory or even as a marker of realism in literature has been well developed, visual cultural sources and the intertextual aspects of visual culture and literature have only recently entered scholarly conversation as aspects of culture available to—or indeed the responsibility of—literary scholars in analyzing fiction in China. Meanwhile, the intrepid literary scholar might turn to critical theory and philosophy for the analytical tools to unpack the layered meanings of illness in cultural contexts of various kinds, but he or she may find it challenging to superimpose these concepts onto the unfamiliar terrain of art-history subjects. While learning valuable analytical, structural, and theoretical techniques from art history, the literary scholar may nonetheless be frustrated in attempts to find comprehensive and specific applications of the tenets of art history to medicine and medical historical materials. When, in addition to all of this, one considers the centrality of culturally specific notions of the ocular to late nineteenth- and early twentieth-century medical missionary discourse, visual cultural studies become not just important but *crucial* to understanding medical-related literary and cultural phenomena in China in the early modern period.

This book therefore departs considerably from its intellectual roots in literary studies. Drawing not only on literature studies but on medical history, art

history, critical theory, and the history of science, the book employs visual cultural materials to construct a narrative about the legacy of nineteenth-century medical language, concepts, and imagery for modern Chinese conceptions of self and national identity. Looking at how ideas about illness and Chinese identity were translated between China and the West, my argument culminates in a discussion of one means by which these ideas were ultimately absorbed into China's own vision of itself, into its own rhetoric: the vision of a weak and fundamentally diseased self we see so clearly and in such gory detail in literature of the Republican period. In this way the present book is both about and not about modern Chinese literature. On the one hand, I attempt to provide an important footnote to the medical education of, and cultural sources for, writers of the Republican period, and consequently try to illuminate how these writers arrived at their own influential visions of the (Chinese) world. But on the other hand, my goal is to provide a working model for future studies—of other literatures, perhaps, or other medical histories—of how to integrate the stepchild that is medical illustration into a more comprehensive understanding of the transmission of ideas about illness across and within cultures, and indeed of the relationship of medical ideology to aesthetics in general.

This book comprises both a series of case studies and a chronological narrative. As a collection of case studies, it provides detailed discussions of individual examples of the transmission of ideas about illness between China and the West. These examples are drawn from a variety of disciplines and methodologies, ranging from medical historiography to art history and from the history of photography to the history of the body. Since one goal of providing this diversity of examples is to outline different models for the inclusion of medical illustration in studies of China generally, these examples are intended to function somewhat independently of one another. As a narrative, however, the book moves along a decidedly historical axis, beginning with a discussion of the ways in which ideas about illness were transmitted between China and Europe in the eighteenth and nineteenth centuries and ending with a discussion of how such ideas, transformed as conceptions about pathologies specific to China, entered into the rhetoric and historical subconscious of Chinese literary modernity. Therefore, as diverse as the individual chapters may be, taken together their goal is essentially a historical one: to illustrate the various

stages of transmission, translation, dissemination, and absorption by which ideas about pathology in one cultural context might enter into the mainstream of cultural discourse in another.

I shall begin by revisiting the question with which I started: how did ideas linking China with the origins of smallpox come to circulate and be accepted in certain larger discourses about health and Chinese vulnerability to disease? In the first chapter I examine not the circulation of smallpox illustrations in China, however, but the textual transmission and escalation of certain ideas about Chinese attitudes toward smallpox that trace back to the essay originally accompanying the images back to Paris from Beijing, Father Cibot's "De la petite vérole" ("On Smallpox"). Reading this report against both earlier reports on smallpox in China and the Chinese medical materials that acted as source texts, I will consider conflicts among French, British, American, and Chinese ideological interests at different historical junctures and trace the ways in which these interests informed subsequent interpretations and narrative appropriations of the story of smallpox. Paralleling the story of the little images of children with smallpox, this chapter demonstrates how certain Chinese ideas about the managability of the disease were ultimately transformed into ideas about Chinese fatalism and a vulnerability to pathology. In its focus on the radical contingency of modes of transmission concerning ideas about pathology, this chapter is intended not only to show the "ascientific" aspects of the development of stereotypes about pathology but also to emphasize the role of transmission itself—historiography, essentially—in shaping these stereotypes.

The second chapter takes up the question of how ideas about pathology and Chinese identity were transmitted in the period surrounding the first Opium War (1839–42) and the subsequent establishment of treaty ports in China by looking at the collaboration between the celebrated painter Lam Qua, whose studio in the hongs of Canton was one of the most renowned sources for the hybrid export art of the China Trade, and the American medical missionary Peter Parker, who set up and ran one of the earliest and most successful missionary medical hospitals in Canton in the 1830s. Between approximately 1834 and 1850, Lam Qua (and members of his studio) painted more than a hundred full-color portraits in oil of various of the more dramatic or "interesting" cases of gross pathology that Parker met with during his time at the hospital—char-

ismatic and clear-eyed portraits of women and men with enlarged goiters, cancerous growths, congenital deformities, and gangrene. In the age before photography (or to be more precise, before it had become practical to use photography in the service of medicine), these paintings were used not only to promote Parker's missionary interests back home—he displayed them to an extraordinary array of dignitaries and officials in the United States and Europe when he returned briefly to gather support for his mission—but also, importantly, to illustrate to Chinese patients in the hospital and to potential medical and theological students in China the potential of Western medical techniques to enact both surgical and spiritual cures. In collaborating on these images, Parker and Lam Qua pioneered a mode of representing illness and Chinese identity that would directly inform subsequent efforts by medical missionaries to illustrate Chinese pathology even as the political landscape began to shift with the opening of the treaty ports, the relaxing of restrictions on missionary activity in China, and the concurrent emergence of discourses of race to explain what had formerly been the province of the concept of "cultural characteristics." Though it was visual in nature, their collaboration actually constituted an exercise in translation, a translation that resulted in the development of a powerful visual idiom for representing Chinese pathology on the eve of modernity.

Relatively little has been written about the history of medical photography in China. At the same time, the potential of both photography and medicine to act as vehicles for colonial ideology has been widely and independently recognized. In the third chapter I look at the little-known history of medical photography in China, focusing on its early stylistic roots in the work of Parker and Lam Qua and its subsequent development into an independent and influential genre. As in the case of the collaboration between Parker and Lam Qua, medical photography in China at the outset was intended to have a dual function: to communicate knowledge about Chinese pathology to Westerners and the West and to educate Chinese patients and medical students in the Western medical arts (and indeed, by the turn of the century Chinese graduates of medical missionary academies had begun to take medical photographs themselves). What makes this period unique, however, is that—on the wings of developments in medical and photographic technology, in medical missionary infrastructure, and in new "scientific" fields like ethnography and an-

thropometry—medical missionaries in China now had the capacity to generate and exchange images of Chinese pathology on a scale, and with a scope, that would have been inconceivable before. By turn of the century, medical photographs were not only displayed in hospitals but archived in hospital-affiliated medical museums; they were used for training purposes in medical classrooms; they circulated in private collections among doctors; they were sold as postcards in the China trade; and, most important, they were published widely in the new medical missionary journals that circulated among doctors even in the most remote medical outposts of China. In this third chapter, I therefore provide an overview of the history, stylistic development, and ideological concerns of medical photography in China from the earliest recorded example in 1861 to the publication of the heavily illustrated second edition of W. Hamilton Jefferys's and James L. Maxwell's medical anthology *The Diseases of China, including Formosa and Korea* in Shanghai in 1929. This chapter thus moves from an emphasis on *translating* ideologically charged pathological imagery in Lam Qua's day to a focus on the roles of technology and social networks in *disseminating* such images in the early modern period.

Chapter 4 constitutes the climax of this book's historical narrative: it bridges the formal divide between speculation about the effects of ideologically laden medical missionary illustrations on their Chinese target audiences and concrete examples of ways in which these illustrations were perceived and adapted in Chinese settings; it examines, in other words, examples of how these new ideas about pathology were *absorbed*. It begins by considering the case of the first Western-style illustrated anatomical textbook to be translated into Chinese: Benjamin Hobson's 1851 *Quanti xinlun*, or *A New Treatise on Anatomy*. Unlike Lam Qua's paintings or the photographs produced by later medical missionaries, Hobson's anatomy was, from the outset, not intended for Western readers; rather, it was written and designed explicitly for a Chinese readership. Here I examine the ways in which Hobson's anatomy therefore had to reconfigure or translate ideas of the body at the same time that it negotiated the complex terrain of new linguistic and conceptual vocabulary and competing notions of physiology and structure. Unlike other historical studies of this text, my examination focuses less on questions of the actual ideologies of the body that it communicated—its theological underpinnings, for example, or the superimposition of neologistic concepts such as *muscle* and *nerves*—than

on the problem of the new aesthetics and modes of seeing and representing the body that the anatomical text propounded both through its form and its content. With its formal dependence on dissection-based notions of interiority, surface, penetrating visuality, and discrete function, the aesthetics deployed by Hobson's anatomy represented a significant conceptual break from conventional Chinese modes of representing the body. Consequently, though we might characterize Hobson's book as the earliest and most systematic translation into Chinese of a Western-style anatomy, we might also remember it as one of the earliest and most systematic translations into Chinese of a Western-style practical philosophy of literary and artistic realism: Chinese readers were being asked to accept not only a new anatomical science but a new representational mode.

How then was this new representational mode—this "anatomical aesthetic"—received and absorbed by Chinese readers and culture/s at large? I return finally to an example from literature, to a set of poems by Lu Xun, whose greatness as a writer and a producer of culture has often eclipsed our appreciation of the effect of his training in Western-style medicine. Before Lu Xun was a writer, he was a doctor. The coincidence of his education in the new dissection-based anatomy, his intense interest in art, and his literacy in the modes and perceived inadequacies of conventional Chinese descriptions of the body contributed directly to his adoption of an unmistakably anatomical aesthetic in certain of his literary experiments. This anatomical aesthetic was deeply pathological, deeply visual, and also deeply modern; it was self-reflexive yet broadly allusive, polysemic yet profoundly local. Most of all, it was an aesthetic that resonated with, and radically transformed, the expectations and frames of reference of an entire generation.

1

How China Became the "Cradle of Smallpox"

Transformations in Discourse

> We often distinguish between the knowledge of the past and
> that of the modern world. . . . we could say that ancient false-
> hoods and modern truths relate to each other like the two
> revolutions of a single spiral. To be sure the former is smaller
> than the latter, but they both fall back on society.
> — *Bruno Latour,* The Pasteurization of France

From the perspective of the twenty-first century, the World Health Assem-
bly's 1980 declaration that smallpox had been completely eradicated looks
naive — even hopelessly so. Not only has the declaration been compromised by
the threat of bioterrorism, the narrative conceit of humanism it was grounded
on (the romance of man over nature, the desire for an unambiguous resolu-
tion) has been severely undermined. The declaration reveals a deep-seated
desire on the part of its authors to bring an end to a horrible disease, but it
also conceals an impulse to apply narrative closure on a grand scale, to make
of smallpox a story with a conclusion (or a conclusion with a story, as the case
may be). At least some of the unsettling power of the bioterrorism threat thus
goes beyond the material menace of the reeruption of the disease to the sub-
stantially troubling symbolic or ideological lack of narrative closure that such
a reemergence implies.

From the historiographical perspective, an interesting thing about this
anxiety concerning closure in the writing of historical narratives about small-

pox is what it suggests, almost incidentally, about the residual relationships between ideology and disease. We may declare smallpox a thing of the past and put that declaration in writing, but the mere threat of its reemergence—the anxiety sans disease—shows that its symbolic and ideological associations, like antibodies, are still present in the historical unconscious. As Bruno Latour notes, "Few diseases obey the fine ordering of irresistible progress that renders them definitively a thing of the 'past.'"[1]

Yet such narratives of anxiety and closure take on even more ideological freight when paired with understandings of premodern China and its historical relationship to disease in the context of global circulation. Here, narratives of disease could be said to exist in a coaxial relationship to narratives of national identity, complicated by both the colonial imperatives that shaped relations between China and the West at this time and the highly contextual scientific fictions that emerged to describe and to determine these relationships. It was in the nineteenth century, for instance, that China became in the popular imagination of the West not only the "Sick Man of Asia" but, more specifically, the "original home of the plague," as well as a perceived source of the cholera in Europe (also known as "the pestilence of the East") and for some—no coincidence—the "cradle of smallpox."[2] At the same time, medical-colonial ideologies of race and national character introduced to China first by medical missionaries in the early 1800s developed simultaneously with anesthetics, antisepsis, germ theory, and, later, concepts of hygiene, so that ideas associating China with various diseases were fused at the symbolic level with narratives of modernity and a sort of scientific neonationalism.[3] Regarding images of the plague, Carol Benedict has noted that "in the eyes of many nineteenth-century Europeans and Americans, plague marked China as a hygienically 'backward' country that continued to incubate a medieval disease in the modern era. For them, plague was yet another indication of the deterioration of the so-called Sick Man of Asia."[4] Conceptualizations of health and hygiene in this formative period thus became thoroughly imbricated with conceptualizations of modernity and vice versa, so that the presence of disease in China—cholera, plague, smallpox—was interpreted both as corresponding to and evidence of a *lack* of modernity. The legacy of this same discourse can be found in many narratives about SARS and its origins today.

Tracing the ways ideas about smallpox and Chinese identity circulated be-

tween China and the West will lay the groundwork for the larger question of what happens when ideas about illness and identity meet ideological imperatives. How were ideas about cultures, and more specifically ideas associating Chinese culture with illness, circulated between China and Europe in the eighteenth and nineteenth centuries? How were sources subsequently used or appropriated and why? And what was the product of this appropriation—what is its legacy for today? Martial Cibot's seminal late eighteenth-century essay "De la petite vérole" ("On Smallpox") provides a window through which we can glimpse some of the attitudes toward inoculation in both France and China at this time. Taking a genealogical approach, I begin this chapter with an investigation into the historical context of the essay's production, examining attitudes toward inoculation in both countries at this time. I then provide a close reading of some of Cibot's more central arguments, a discussion of the Chinese source texts from which they derived (or rather purported to derive), and a look at the initial reception of the manuscript back in France. Finally, I follow the evolution of Cibot's thesis from secondary to primary source for the belief in various nineteenth- and twentieth-century European and American contexts that China was the "cradle of smallpox," or what Latour might call (along with "modern truths") one of "the two revolutions of a single spiral" linking knowledge of the past with that of the modern world.

"Un Homicide de Volonté": The Inoculation Controversy in France and the Origins of "De la petite vérole"

> I stumbled across . . . a letter by Mr. de la Coste in which he speaks of the ingestion or inoculation of smallpox; and I recalled having read something similar in a Chinese book, which led me to transcribe the text of it. . . . A method closely resembling that which came from Constantinople to England was in use for a century in China.
>
> — *Correspondence of Father François Xavier D'Entrecolles, 1726*

Many nineteenth- and early twentieth-century medical and historical discourses of smallpox in China, far from crediting China with the earliest practice of inoculation, identify China as the original source of the disease itself. As James Carrick Moore wrote in 1815, "According to [Jesuit missionary] authorities, medicine appears to have been cultivated, and the Small Pox to have existed in China, from a very remote period. . . . Several missionaries [also]

inform us, that the Chinese worship a goddess, who has a super-intending power over the Small Pox: This is a strong confirmation of the antiquity of that malady in China, which the learned believe to have prevailed there for at least 3,000 years."[5]

Likewise in 1838, Charles Toogood Downing articulated his observation that "the history of the smallpox illustrates in a curious manner the reciprocal benefit which nations derive from each other," tracing a trajectory of the disease that placed its beginning in China. He wrote: "This dreadful malady is supposed to have originated among the Chinese, and to have spread westward in a gradual manner among the natives of Western Asia, until it became as prevalent with the people of Europe, as among those of the Centre Kingdom. The disease then ran its frightful course, unchecked by the ingenuity and resources of man; spreading dismay and horror wherever it appeared, and blighting the loveliness and beauty of the fairest works of the creation." About inoculation practice, Downing added: "As if in some measure to compensate the nations of the west for the dreadful gift which they had bestowed, the Chinese discovered, towards the close of the tenth century, the mitigating effects of inoculation. This practice, by which it was vainly hoped that the original disease might be entirely eradicated, followed the same course, and soon became common as far as the shores of the Atlantic."[6]

In Downing's narrative, the idea that China is the original home of smallpox is compounded by the idea that China is the original home of a failed therapeutic practice as well: inoculation here is characterized not as a successful prophylactic technique but as an unsuccessful attempt to "eradicate" smallpox in order to compensate "the west for the dreadful gift which [the Chinese] had bestowed." Following the invention of vaccination and attempts to promulgate it in China, furthermore, such critiques of the entrenched nature of smallpox in China and the failure of Chinese inoculation practice were increasingly linked to narratives about Chinese refusal to adopt Jennerian vaccination. As Henry Charles Sirr remarked succinctly in 1849, "Smallpox is a great scourge, the natives having a peculiar prejudice against vaccination."[7]

For historiographical purposes, what appears especially interesting about the idea that smallpox originated in China, and to a lesser degree its corollary about the failure of inoculation in spite of the endemic nature of the disease, is that it owed the force of its authority largely to a single document: Father

Martial Cibot's short essay "De la petite vérole," which I described briefly in the introduction to this book.[8] Composed in Beijing in the late 1760s, the essay (along with colorful illustrations of children with smallpox) reached Paris around 1772 and was published without illustration seven years later in the collection of proto-Sinological essays *Mémoires concernant l'histoire, les sciences, les arts, les moeurs, les usages, etc. des Chinois, par les missionnaires de Pékin* (*Memoirs on the History, Sciences, Arts, Manners, Customs, etc. of the Chinese, by the Missionaries of Beijing*, hereafter referred to as *Memoirs*). The essay opened with the proclamation that smallpox had existed in China for three thousand years, and it is by this signature that the essay is most often remembered: as the meticulous medical archivists K. Chimin Wong and Wu Lien-teh noted in the 1930s, the statement was "often repeated," as well as "ruminated in some quite modern compilations," such that "China was even considered as the cradle of smallpox."[9] A reference to this work even made it within two degrees of separation into the bibliography of Donald Hopkins's 2002 world history *The Greatest Killer: Smallpox in History*.[10]

Why did Cibot's text prove so enduring? Especially when read against the neutral tone of an essay on inoculation in China composed in 1726 by Father François Xavier D'Entrecolles (1664–1741) and later published in *Lettres édifiantes et curieuses écrits des missions étrangères par quelques missionaires de la Compagnie de Jesus* (*Edifying and Curious Letters of Some Missionaries of the Society of Jesus in Foreign Missions*), Father Cibot's more well known essay from nearly a half century later seems strikingly opinionated: not only does it espouse an unambiguously critical orientation toward Chinese medicine in general and inoculation in particular but it does so in remarkably vivid language. Where D'Entrecolles claims only to "transcribe the text" of a Chinese book about inoculation, for example, Cibot asserts that he compiled "On Smallpox" after having read "many very knowledgeable and very boring essays on the origin and the cause of smallpox," including numerous references to the "pathetic stupidity" of Chinese medicine, its "lunacy and inconsistency," and his belief that the history of Chinese medicine was obscured by "clouds of idiocy."[11] Where D'Entrecolles undertakes his report on the premise that knowledge about foreign practices of inoculation could prove useful in Europe, Cibot reserves his most profound critique for the practice, noting at one point the example of a Chinese novice under his supervision who would not practice

inoculation on his own patients "even if offered sums of a hundred or two hundred ounces of silver."[12] And even more striking, where D'Entrecolles's report is premised on the idea of commensurability between cultures—inoculation being something that, after all, "closely resembl[es] that which came from Constantinople to England"—Cibot repeatedly emphasizes the *impossibility* of successfully communicating or "translating" the practice: "Besides making much use of plants that are specific to China, which are rarely used in Europe, [Chinese medicine] reasons on their virtues and qualities according to ideas that pertain to its own systems, its own theory, and consequently in a manner quite different from [that of] European medicine. Given this, how to find a way to make sense of it? Of what use to [Europe] might its most esteemed recipes and remedies be?"[13] Or as Cibot points out elsewhere, "the general system upon which Chinese medicine is based may be ridiculous and absurd, if you will; yet so much is it incorporated into [both] the general and the particular theory of medicine, that all its reasonings are unintelligible if one does not have the key. Thus [as for] the means by which one would go to the trouble of advancing this system overseas, one risks, after having studied it thoroughly, having learned only fantasy."[14] The historian Han Qi has summed up the contrast between D'Entrecolles's and Cibot's texts as follows: "In D'Entrecolles's and Cibot's introductions to the arts of smallpox inoculation [one] can clearly see the differences in their views of Chinese medicine. D'Entrecolles sought to find something useful for Europe in China and introduced with objectivity the possibility of transmitting the Chinese art of inoculation to Europe. But Cibot clearly had biases about Chinese medicine and believed that European medicine was the more reliable." Thus the dramatic difference in tone between the two essays can be explained in part by the changed political and social climate in France at the times the two authors were writing; or as Han Qi remarks all too briefly, "The emergence of such differences in point of view had very much to do with the times."[15]

It is a point well worth elaborating. In the nearly five decades between the writing of the two essays, the debate about inoculation—whether or not the government should endorse it, whether or not it was moral to interfere with a disease that appeared to be the product of divine will—had in fact become a key platform in French Enlightenment discourse.[16] The terms of this debate broke down along lines consistent with Enlightenment concerns, so that while

the French royal family and members of the ecclesiastical establishment opposed inoculation on the grounds that interfering with the disease violated the will of God, Enlightenment thinkers for whom inoculation had strong symbolic resonance in a state that could increasingly be characterized not only by its delayed responses to disease and public health but by its sickness or disease at the metaphoric level actively supported it.[17] On the opposition side, smallpox was equated with Job's boils, and consequently the disease was seen "as a punishment of God . . . [that] could not be tampered with."[18] Opponents argued further that doctors who performed inoculation risked committing *un homicide de volonté* (deliberate homicide) as opposed to *un homicide de fait* (de facto homicide, or manslaughter) since inoculation made contracting smallpox a certainty when it could have remained only a possibility without the interference of the doctor. According to yet another argument, inoculation as a practice was suspect due to the morally dubious circumstances of its foreign origin. By contrast, arguments in favor of inoculation emphasized not only the potential prophylactic benefits of the practice but also Enlightenment concerns about individual choice versus state and religious intervention. Voltaire, for instance, argued that the question of whether or not to practice inoculation was a matter of individual choice and should not be subject to state or religious jurisdiction.[19] While freedom to practice inoculation therefore embodied Enlightenment ideals about free will, the French state's opposition to inoculation came to represent to Enlightenment thinkers a lapse back into darkness, a self-destructive impulse that both literally and figuratively worsened the "sickness" of France.

The debate came to a head in 1763, approximately five years before Cibot composed "De la petite vérole," when a French parliamentary decree forbade the practice of inoculation everywhere within its jurisdiction. The decree was issued, it was claimed, in order to allow the medical and theological university faculties time to determine whether, as the historian Arnold Rowbotham notes, inoculation "was harmful or useful to the human race, whether it was contrary to religion, whether it should be permitted, forbidden, or tolerated." Moreover, he adds, this decree "raised a storm of criticism in France. The incident was looked upon as something more than a mere matter of the social efficacy of inoculation. It involved a question of supreme importance in the movement of Progress, namely, whether the Church, represented by the

Faculté de Théologie, should have the right to legislate in a matter which was almost entirely scientific. The whole movement toward enlightenment was involved in this question."[20] Alarmed by the ban on inoculation, Enlightenment thinkers responded by pointing out that other countries in Europe had already begun to adopt the practice and that France's failure to follow suit indicated both a failure to deal appropriately with matters of public health and "the backwardness of their own country in matters of social progress."[21] Where anti-inoculation advocates emphasized the negative associations of inoculation with other countries, Enlightenment thinkers thus characterized France as desperately in need of outside models. Lamented Voltaire to a friend, "We have seen nothing like it since the ban on emetics," adding, "you have no idea of the extent to which they mock us in Europe."[22]

It was against the backdrop of this mounting controversy that Father Cibot departed France for China in 1758, arriving in Beijing in 1760, where he subsequently began to correspond with the minister Henri Bertin, the "driving force behind the production of the *Memoirs*," on the many matters of interest to the French back home. As Joseph Dehergne has written, these interests included, broadly speaking, the "three great problems that impassioned knowledgeable circles at the end of the Enlightenment, at the time of the first stammerings of European Sinology, to wit: the origin of the Chinese (Egypt and China); the Chinese chronology (Jesuits in China wound up acknowledging that, to square up with the Bible, it was necessary to adopt that of the *Septante* . . .); and then how to make sense of the Chinese characters and find theories to explain them."[23] But these interests were also articulated in highly specific terms as well: in 1765, for instance, Bertin and the great economist Anne-Robert-Jacques Turgot (whose research on distribution of wealth reportedly inspired Adam Smith's work) each prepared a series of questions to be sent to the missionaries in China aboard the vessel *Le Choiseul* in the care of two young French-educated Chinese Jesuit priests named Alois Gao and Étienne Yang.[24] Turgot's list of fifty-two detailed questions addressed, among other topics, wealth and land distribution, paper manufacture, printing, textiles, natural history, and the history of the Jews in China. Bertin, meanwhile, urged the young men to go even further, to spare no detail. "We beg you," he wrote, "to hold nothing back for fear of its seeming minute . . . or trivial. . . . You know in what spirit all your questions, all your details will be welcomed."[25] Indeed, by 1771–72, when "On Smallpox" was received back in France, Cibot had al-

ready contributed a number of essays solidly in the spirit of Bertin's project on subjects ranging from religious practice and kung fu to geology, sericulture, cinnabar, and glass-painting techniques.

When it came time to report back on smallpox and inoculation practice in China, however, Cibot would have been confronted with a serious ideological dilemma. He was, after all, a representative of the church and had left France for China just as the debate about inoculation had begun to gather momentum; his opinions on inoculation against smallpox could hardly have favored the Enlightenment agenda in view of the church's opposition to the practice on moral grounds. Yet knowing quite clearly "the spirit in which all his detailed reports would be welcomed" by Bertin, Turgot, and others—the avid interest, the tension within the church, and the fact that inoculation had become a flash point for political and religious conservatism—what kind of essay could he write? Could he report on Chinese inoculation practice indifferently, as D'Entrecolles had done? Or could he present it in some other way, perhaps trying to downplay the benefits of inoculation as it was practiced in China?

Further complicating matters was the fact that in Beijing at this time knowledge and prophylactic practice concerning smallpox differed significantly from those in Paris, both practically and institutionally. Starting as early as 1622, for example, smallpox reporting systems were established among Manchu bannermen whereby squad leaders were required to report anyone showing signs of smallpox so that this person and his or her family could be sent out of the city in order to contain the disease domestically. Similarly, Qing rulers also took deliberate measures for dealing with relations on the frontier and with visiting non-Chinese and Mongolian dignitaries from Lhasa, the north, and so on to prevent the spread of the disease among visiting diplomats and Manchu officials. Thus rules for dealing with smallpox were established for safely fielding offers of tribute, for attaining audience with the emperor, for the selection of military personnel (for example, in choosing officers who had already survived smallpox to be sent on campaigns in smallpox-ridden areas), for funeral rituals, and so on. The Manchus set up strictly maintained *bidousuo* 避痘所 (smallpox avoidance centers), quarantine centers to which the emperor, for instance, might retreat during particularly rampant smallpox seasons. Shrines for worship of the Smallpox Goddess were also maintained at strategic locations in and near the Forbidden City.[26]

More significantly, the imperial government took deliberate steps toward

endorsing the practice of inoculation within its own ranks, employing specialists to practice their art not only on the Kangxi and Qianlong emperors but on other members of the imperial retinue. Such specialists were "honoured as medical officials in the national medical academy (*tai yi yuan*) or were given official rank," and by the Yongzheng period (1723–35) even "held posts in the *tai yi yuan*," while "the emperor ordered the recruitment of new members from the south of China."[27] And in 1739, Qianlong demonstrated even further institutional support for the practice by sponsoring the compilation of an imperial medical anthology with a significant component devoted to smallpox diagnosis and inoculation, *The Golden Mirror of Medical Orthodoxy* (hereafter referred to as *The Golden Mirror*), the very text on which Cibot would later base much of his own discussion. Edited by Wu Qian, *The Golden Mirror* included not only the comprehensive woodblock illustrations intended to aid in the specific diagnoses of different cases but also a skillful compilation of existing treatises on smallpox such as the one referred to by D'Entrecolles; precise descriptions of how to prepare smallpox matter for inoculation; instructions for the optimal conditions under which to perform inoculation, both physical and environmental; descriptions of successful and adverse reactions to inoculation; and suggestions for postprocedural care. Especially in contrast to the French royalty's steadfast refusal to practice inoculation personally and the comprehensive ban on the practice in Paris in general, the implementation of quarantine rules among Manchu bannermen, the practice of inoculation within the Qing ranks, and the imperial subsidy of *The Golden Mirror* represented a significant official endorsement of inoculation practice in China.

Various comments and references throughout "On Smallpox," as well as the fact that Cibot acknowledged *The Golden Mirror* as a primary source text for his essay, leave no doubt that the father was well aware of the imperial endorsement of inoculation practice; his essay was, if nothing else, clear in its reference to and transliteration of the title and provenance of the text.[28] So when Bertin called on Cibot to present objective information about inoculation in China, we can easily imagine the important choice with which the father would have been faced: he could either report impartially on inoculation in China as D'Entrecolles had done and risk providing Enlightenment thinkers back home with ammunition against the church, or he could present the requested information in such a way as to communicate that it was not

advisable to emulate Chinese inoculation practice after all, in spite of its apparent acceptance by rulers in that land. Evident in the shift in tone between D'Entrecolles's piece and Cibot's later one, as well as in Cibot's free-form (or what Joseph Needham in *China and the Origins of Immunology* calls "précis") interpretations of the Chinese source texts that I shall describe below, the father clearly chose to represent Chinese inoculation practices as unworthy of emulation.

"They Could Hardly Be Understood Otherwise":
How Cibot Arrived at the Figure of Three Thousand Years

While the tensions around the question of inoculation in France and the apparent endorsement of the practice by the ruling elite in China may have contributed to Cibot's dismissal of the practice of inoculation in his report, the question why Cibot asserted that smallpox had existed in China for three thousand years still remains. For such is the powerful claim with which he opens his piece on smallpox in China, and, as I have remarked, the one by which his essay is now most commonly remembered. The first half of the opening paragraph reads:

> Smallpox is an epidemic illness in China, and has been known by Medicine for more than three thousand years. They tell of how it was not dangerous in high antiquity, and that it was very rare for it to be fatal. They hardly regarded it as an illness because some herbal infusions and a light diet regimen were sufficient to cure it. It was only, they say, after the decadence of the former government overturned everything in morals and manner of living, as well as in public administration, that this illness acquired a venom and force signaled by the grimmest of symptoms, extinguishing in a matter of days the hopes of families and depopulating whole provinces in a matter of weeks. Its ravages, so rapid, alarmed the Emperors, worried the people, and made them fall before the knees of Medicine.[29]

In this passage, Cibot neatly summarizes not only the evolution of the disease in China but also the evolution of medical responses to it, all in a few short sentences. Linking smallpox with the distant past, Cibot claims that the disease existed first in a harmless form, evolving into its present fatal form "only . . . after the decadence of the former government [had] overturned everything."

Returning to *The Golden Mirror*, however, we find a slightly different story. At the very beginning of the first chapter on smallpox, for example—a chapter entitled 幼科痘疹心法要訣 "Youke dozhen xinfa yaojue" ("Essential Methods of Variolation in Pediatrics"), under the subheading of 痘原 "Dou yuan" ("The Origins of Smallpox")—is the following terse overview of smallpox in Chinese history: "In the earliest times there was no pox, and [human] nature was pure and simple; in the middle period there was pox, and lust ran rampant. The pox scabs that originate in the fetus exit, never to return; and [one] can comprehend the depth and intensity of the toxin."[30] Economically, these lines simultaneously provide a rough outline of smallpox in China and associate it with morality: smallpox did not exist in ancient times when "[human] nature was pure and simple," but the disease later came to exist when "lust ran rampant." Such an explanation for smallpox etiology is consistent with certain themes in Chinese medicine in general, where the severity and manifestation of a disease are linked with morality and lifestyle.[31] Further, this brief passage also functions as a kind of rhetorical convention common to both medical and philosophical texts, whereby the problems of the present are blamed on the moralistic failures and increasing decadence of an idealized distant past.[32] Thus in these short lines from *The Golden Mirror* we see a fairly complex reference not only to a rhetorical tradition of looking to the past as a model for the future—not just for smallpox but for other diseases as well—but also to Chinese explanations of smallpox and other diseases as something closely related to the deterioration of moral behavior across generations.

In Cibot's interpretation, however, the economical juxtaposition of the severity of smallpox and the moral climate suggested by the Chinese source text is transformed into an expanded discussion of the process of the development and spread of the disease that emphasizes the timeline, or developmental stages, associated with the disease and people's responses to it. Cibot transforms the skeletal information provided in *The Golden Mirror* into an abbreviated creation myth of sorts, one with a beginning, a middle, and an end. "In the earliest times there was no pox" in Cibot becomes a "high antiquity" in which smallpox existed but was "not dangerous," while the "middle period" is then assigned the figure of "three thousand years." Writes Cibot later, "They only say a few words about the origin and cause of smallpox, but it is remarkable that they insist that it was unknown in high antiquity, and that it didn't

begin in China until the middle ages, in other words, under the Zhou dynasty which began 1122 years BC."[33]

Cibot's insistence on assigning precise values to the more generalized stations on the Chinese timeline had partly to do with the ideological priorities of the Jesuits: Jesuit missionaries in China at this time hoped to establish a comparative chronology with Europe and therefore often sought in the events of Chinese history a confirmation of the Bible. The existence of a plaguelike disease in China at this time would therefore contribute to orienting Chinese history in terms of Old Testament history. Danielle Elisseeff-Poisle writes, for example, that

> the majority of [French Jesuits in China in the first half of the eighteenth century] never strayed from their European concerns, seeking only in Chinese history a confirmation of the Bible. Such was the obsession, for instance, of Nicolas Fréret, who spent his life seeking correspondences between the Bible and Chinese history. He was aided by astronomers, such as his friend Joseph-Nicolas Delisle, in his attempt to identify the cosmic events mentioned in the Bible making use of the precise descriptions given by Chinese sources: comets, earthquakes and the Flood, trying to match the dates, for it would have been much too disquieting if the history of the Chinese people predated that of the Jews.[34]

Concerns about comparative timelines were even more pressing among a conservative minority of Jesuits known as the Figurists, of whom Cibot was reputed to be one.[35] Figurists, unlike other Jesuits, labored not only to match up timelines but also to identify signs, or archetypal "figures," in Chinese culture that corresponded to figures or events in biblical history—a Tower of Babel or diasporic model for the origins of mankind.[36] As Michael Lackner explains, "According to this esoteric conception, both Jews and pagans possessed a knowledge of the truth, but this knowledge was represented only in *figura*, in symbolical, allegorical and archetypal forms."[37] Further, some Figurists believed that "a certain period of Chinese antiquity did not belong to the Chinese exclusively but to early mankind as a whole"; thus the two timelines had to be reconciled. For both Figurists and other Jesuits, this concern about reconciling Chinese and Christian chronologies ultimately led to a special papal "permission to use the Septaguint chronology, greater by 1,500 years, for missionary

purposes," which was intended to allow greater flexibility in "squaring up" the two timelines.[38]

The clear signature of Cibot's Figurism on his interpretive methods in preparing "On Smallpox" can be seen throughout the text. In one case, for example, Cibot compares smallpox to the plague, another famous divine scourge, describing how early attempts at inoculation seemed promising at first, but later failed to stand up to the "decisive facts" of epidemics, the "evil" of which "was much like the plague in certain respects."[39] Even more obviously, in the second half of the opening paragraph, Cibot writes that Chinese medicine, "before the knees" of which both emperors and common people had eventually to fall,

> had lost nearly all the old books to civil wars; working [instead] with those which had escaped the general shipwreck, as well as with new observations that multiplied daily. Its initial work led it, *comme de raison*, to the complicated, obscure systems by which they [authors of Chinese medical texts] explain everything. The slight hitch [*petit embarras*] of having to reconcile these [systems] with everyday facts chilled the enthusiasm with which they had praised and defended them; and the good sense to which they had not had the leisure to listen gradually convinced them that smallpox stemmed from the first sources of life and derived from an innate "leavening," the effects of which it was necessary to study.[40]

What Cibot translates here as "innate 'leavening'" (*un levain inné*) corresponds to the Chinese concept of *taidu* 胎毒 (fetal toxin), a heat-related toxin that can be passed to the infant by either parent before it is born or activated through the mother's milk after it is born, and that could be affected by the "emotion, desire, habits of daily life, and the diet of the parents before conception."[41] In *The Golden Mirror* it is defined thus: "Smallpox is fetal toxin. It lurks in the formed fetus, flares up when stirred, and is an inevitable [part of] life."[42]

Especially because of its association with a moral economy, the Chinese concept of *taidu* bears a seductive resemblance to the concept of original sin, a resemblance Cibot does not fail to notice: "That which has most struck me in all these essays is that in speaking of the origins of smallpox . . . one sees . . . a tradition infused with Original Sin, and some texts in particular on 'Tou-tai' or 'poison from the maternal breast' that can hardly be understood otherwise. But this is not the place to press this observation; let's return to our book."[43]

This reference to original sin that "can hardly be understood otherwise" (qui ne peuvent guère s'entendre autrement) reveals Cibot's debt to Figurism in his interpretation (and interpretive philosophy) of *The Golden Mirror* because it reads Christian symbolism into an unrelated Chinese setting, a kind of false cognate at the cultural level.

Cibot's choice of the figure of three thousand years therefore confirms that he was working with this special expanded Jesuit calendar, and furthermore with a Figurist's agenda of looking for signs of Christianity in ancient China: His attribution of the concrete value of three thousand years to the Chinese term *zhonggu* 中古 (middle period) represents an effort to reconcile the Chinese and Christian calendars with respect to smallpox, so that 1122 "years BC" plus 1768 AD equaled 2890, or roughly three thousand years total. By choosing the number three thousand Cibot effectively suggested with respect to the adjusted calendar that smallpox had existed in China not just for three millennia but, conceptually, since the beginning of time. Meanwhile the fact that Cibot emphasizes in his translation the Chinese idea of a relationship between the worsening of smallpox over time and the "the decadence of the former government [that] overturned everything in morals and manner of living" only serves to reinforce the anticipated link between Chinese and Christian timelines since it conveniently places smallpox at the crossroads of morality and degeneration on a grand, biblical scale — a favorite theme, as it happens, of the French religious factions who sought to characterize smallpox as God's punishment for human sin.

How "On Smallpox" Was Received

When Cibot's manuscript reached Bertin in Paris in 1772, however, the political climate had begun to change, and many of the ideological concerns that informed Cibot's writing of the text were on the verge of becoming irrelevant. Perhaps the greatest change was that Louis XVI, having witnessed Louis XV's gruesome and untimely death from smallpox, at last had himself inoculated in 1774, bringing the debate on inoculation in France to an unmistakable conclusion. The religious faction had lost, and inoculation was officially in vogue.

Bertin only gave the manuscript a cursory reading, summarizing his conclusions in some notes that he would later turn into a formal letter to the missionaries in Beijing. He wrote:

I could only skim the manuscript, but I viewed with much astonishment (1) that inoculation was already known in China in the 10th century, but that it only lasted about 50 years; (2) that this illness seems to be much more cruel even than it is in Europe. The abandonment of inoculation was caused in part, according to the statements in the memoir, by a form of fatalism that disregards all remedy, all warning, [so that] persuaded that death is inevitable, precautions for preserving life [become] superfluous. . . . It seems to me according to all the symptoms described in the treatise and depicted in the hideous figures that accompany it, that smallpox in China is infinitely more malignant than in Europe.[44]

Instead of scouring Cibot's manuscript for clues about inoculation practice in China as he might have done only a few years earlier, Bertin only "skimmed" the document ("je n'ay pu que le parcourir"), arriving at two conclusions: first, that inoculation had been quickly abandoned due to a kind of fatalism on the part of the Chinese; and second, that smallpox was much more severe in China than it was in Europe. Unhappily for Cibot's original agenda, in his quick perusal of the piece Bertin never questioned the validity of inoculation itself. Instead, Bertin sent the illustrations and the text to the Bibliothèque Royale (now the Bibliothèque Nationale de Paris). It would be seven years before the text would be published in the second volume of the new *Memoirs* series.

Comparing once again the Chinese source material with the information communicated by Cibot in "On Smallpox," it is not hard to see how Bertin arrived at these conclusions. In *The Golden Mirror*, for instance, we remember the brief definition of smallpox as a toxin that "lurks in the formed fetus, flares up when stirred, and is [an] inevitable [part of] life." The same passage goes on to relate the skeletal version of the story of the discovery of inoculation on Mount Emei by a Buddhist immortal (*shenren* 神人) in the northern Song dynasty, recording also the gradual disappearance of knowledge about inoculation and following this with a comment on the production of the present edition:

But the specialty of inoculation was transmitted by word of mouth and was not recorded in the texts of the discipline [Needham translates 方書 as "texts of the adepts"], and [I] fear later generations dismissed it as mere bluster. It was passed down for a long time sans documentation, so that eventually

these reasonable, sound methods weren't used anywhere. What a great pity it would be if these divine skills were to be lost! Here methods of inoculation are thoroughly researched and carefully evaluated and [then] compiled as a book for all posterity so that inoculation may serve as a bridge upon which the people may advance to old age![45]

In the earlier example, the Chinese text refers to the fact that smallpox is "[an] inevitable [part of] life." But in this second fragment, a minimythology is provided to account for the loss of inoculation skills across generations that is augmented by typical rhetoric concerning the thoroughness and innovation of the present research.[46]

In Cibot's hands, this original Chinese is transformed into something uniquely literal, to be taken at face value and embellished to present inoculation as ineffective and based in fantasy. Earlier we saw how Cibot presented Chinese medical responses to smallpox historically in terms of the loss of "nearly all the old books to civil wars." In another example, however, it is not the lack of books but the ineffectuality of the medicine in question (inoculation) that presents the problem. He writes:

The fatal necessity of having smallpox, whether in childhood or at a more advanced age, makes the doctor imagine "going before the blow"—that is to say, by inoculation to vanquish its evil by preparing for it. The first successes of this unique trial astonished Medicine and enthused the people. At the end of the tenth century they believed here that inoculation . . . would close forever all the tombs that Smallpox had set out to open. The secret spread rapidly in all the provinces of the Empire, even reaching the villages. Everyone claimed that anyone who had been inoculated could no longer catch smallpox . . . but this opinion, such a consolation for fathers and mothers, would not last more than half a century. The smallpox epidemics had ruined to the core all the arguments and all the systems with so many and so decisive facts that in the end it was necessary to give up.[47]

Here the Chinese explanation of smallpox as an "inevitable [part of] life" in Cibot becomes "the fatal necessity of having smallpox." The legend that inoculation was brought down from Mount Emei in the tenth century becomes a belief that "inoculation . . . would close forever all the tombs that Smallpox had set out to open." "Mouths" multiply exponentially in Cibot's text, so that

the Chinese explanation that inoculation was lost initially due to transmission by word of mouth ("sans documentation") in Cibot becomes a story about how the secret of inoculation "spread rapidly in all the provinces of the Empire, even reaching the villages." Meanwhile the "reasonable, sound methods" of the Chinese text become in Cibot a mere "opinion" that was only "a consolation for fathers and mothers." Most important, Cibot provides an alternate mythology to account for the disappearance of inoculation: inoculation was ultimately lost *not* because of the failure to record it in writing as the Chinese suggests; rather, Cibot writes, the Chinese were forced to "give up" inoculation because "all the arguments and all the systems" of Chinese medicine were no match for the "decisive facts" of "smallpox epidemics." It was not that inoculation was lost; it was that it failed.

Returning to the quote by Bertin and his conclusions about the uniquely Chinese "fatalism" that he blames for the failure of inoculation practice there, we can follow the evolution of the concept of fatalism from the Chinese text to its French translation by Cibot and finally to its interpretation by Bertin. Gathering momentum through different ideological prerogatives, what began in *The Golden Mirror* with the idea that smallpox forms "an inevitable part of life" is translated in Cibot's essay as "the fatal necessity of having smallpox." This idea, plus Cibot's claim that inoculation was abandoned when it turned out to be no match for the epidemics finally becomes for Bertin the explanation that "the abandonment of inoculation was caused . . . by a form of fatalism, that disregards all remedy." Ironically, what began in China as the belief that *smallpox* was inevitable was ultimately transformed into the idea that *mortality* from the disease was inevitable, and by extension that "the precautions for preserving life [were] superfluous" to the Chinese.

A Case of Mistaken Identity:
How China Became the "Cradle of Smallpox"

Given this complicated bibliographic history, what makes the contribution of Cibot's essay to the global discourse of smallpox especially interesting is that the text is so often quoted yet so rarely read. While Cibot's essay has been cited frequently enough over the past two centuries to earn it acknowledgment as a primary source for the idea that China constituted the cradle of smallpox, in many cases bibliographic references to the text still remain obscure. Donald

Hopkins's *Princes and Peasants* (later called *The Greatest Killer*) is a case in point: in his discussion about the earliest known existence of smallpox in China, the author notes that "Jesuit missionaries in Peking quoted a Chinese treatise based on the oldest writings of Chinese physicians and edited by the Imperial College of Physicians," making no reference to *The Golden Mirror*, Cibot, or the provenance of this information.[48] A closer look, however, reveals that this reference comes from the 1936 *History of Chinese Medicine* by K. Chimin Wong and Wu Lien-teh, which refers to Cibot, but only to note that his text was based on "an old medical work in the College of Imperial Physicians in Peking."[49] Yet Wong and Wu make no mention of the essay's connection to *The Golden Mirror*, a work they subsequently discuss under an entirely different heading. John Dudgeon likewise fails to identify Cibot's source text, even as he criticizes the work:

> We know how books are sometimes made to speak with the authority of antiquity. It needs only a comparatively late writer to make the statement of its immemorial character, or still better, to mention some dynasty, emperor or celebrated personage who was in some way connected with it, and the thing is quoted and believed in ever afterwards. The whole question of the antiquity of smallpox is very suspicious; the passages are vague and would apply to many other skin afflictions.[50]

In all of these cases, the authors borrow authority about the antiquity of smallpox in China from Cibot's essay — even, as in Dudgeon's case, to discredit it — without ever interrogating the content of the text itself.

It is precisely this absence of "On Smallpox" from its own discourse — including the assumed transparency of its translation — that makes its contribution to the development of the "cradle of smallpox" stereotype so striking. How is it that the real identity of the essay (including historical circumstances of its production, the Chinese source text, the political concerns of its author, etc.) traveled for so long in disguise, its reputation increasingly independent from its source? How might one explain the shift in focus from interest in Chinese inoculation practice to the antiquity of smallpox in China? A broad answer of course has to do with the emergent tensions within European orientalism, on the cusp of a major transition when "On Smallpox" was composed.[51] European attention was about to shift from looking to China as a model for en-

lightened thinking (i.e., not only as a model of enlightened despotism but also as a source of knowledge about the natural world such as geology for the production of porcelain or medicine for the treatments for diseases like smallpox, syphilis, etc.) to seeing it as a source of corruption and barbarism.[52] In 1780, for example, the encyclopedist Denis Diderot (1713–84) — far from praising Bertin's pursuit of knowledge of China to benefit France — in fact wrote critically of the minister's desire to "completely recast the spirit of the nation . . . by . . . inoculating the French with the Chinese spirit."[53]

But on a narrower scale, with respect to the history of medicine in general and the history of smallpox in particular, the key ideological event that marks the disappearance of the Chinese source texts for "On Smallpox" (while at the same time allowing its claims on antiquity in China to linger) was the invention of Jennerian vaccination in 1798. Drawing conceptually on the practice of inoculation, vaccination called for a patient to be inoculated not with smallpox matter but with matter derived from cowpox, a disease that was not fatal for humans but that produced parallel immunity. Inoculation with cowpox, or "vaccination," therefore promised to generate immunity in humans without simultaneously endangering the life of the patient, thereby reducing the doctor's risk of committing *un homicide de volonté*. Further, vaccination did not require tampering with the disease itself, a key objection to inoculation practice among factions who viewed smallpox as a divine scourge. But even more important, the invention of vaccination also allowed for a kind of revisioning of history at the conceptual or symbolic level, one in which the threat of smallpox was finite, bounded by humankind's newfound ability to bring closure to the tale. As Thomas Jefferson wrote to Edward Jenner in 1809, "You have erased from the calendar of human afflictions one of its greatest. . . . Future nations will know *by history only* that the loathsome smallpox has existed."[54]

With respect to China in particular, however, vaccination had other advantages over inoculation. First, it seemed to provide a singular opportunity to advance the cause of Western medicine (and not incidentally, Christian faith) where it had been resoundingly rejected before. Wong and Wu believed, for instance, that because "the Chinese were already familiar with the feasibility of smallpox prevention," vaccination had the potential to "help gain a permanent foothold for western medical practice in China" where other medical practices had failed to penetrate.[55] But even more, after the humiliating

Macartney embassy of 1793, in which Qianlong famously rejected George III's commerce-minded overtures because "we do [not] have the slightest need of your country's manufactures," vaccination was also quickly recognized for its symbolic value as a type of commodity.[56] John Barrow, the former surgeon of the Macartney embassy, for instance declared in an 1806 letter to Jenner that the invention of vaccination meant nothing less than that "the English at length as well as the other Europeans have *established their claim (which though last is not least) on the gratitude of the Chinese.*"[57] For Barrow, vaccination technology represented the linchpin commodity that Europeans had been waiting for—the "manufacture" that would finally penetrate that most hermetic of symbolic markets, the Chinese. According to this logic, the discovery of what seemed to be a universal good in both senses of the word represented the perfect inroad into a formerly impenetrable market. Under the weight of such a conceptual economy, that the Chinese might reject the new technology in favor of native practice of inoculation was, collectively, inconceivable.

Thus it was with some surprise that Europeans started to notice the rejection of vaccination in China, as in India, and ultimately began to suspect that the native practice of inoculation was an obstacle to the realization of the "gratefulness" of the Chinese that John Barrow had anticipated in 1803. Despite the fact that it was not without its benefits, the continuing practice of this "old-style inoculation" came to be seen by Western doctors as a direct threat to the successful implementation of vaccination among the Chinese. In 1850, for example, one report mentions that "some vaccination was done but that the old-style method was still in greater vogue."[58] Likewise, in 1871 one R. A. Jamieson linked the failure of vaccination to take hold with the entrenched practice of inoculation, noting that "the Chinese do not show any active resistance to vaccination. But they are accustomed to inoculation, and so far as I can ascertain, confluent smallpox so seldom follows the usual operation that there is no very strong inducement to change the system. In other words they would as soon have their children vaccinated as not, but they do not much care."[59] Many Western doctors also expressed frustration with the "distrust and even contempt with which the people looked upon foreign science" or "the suspicion with which vaccination was . . . regarded as a subtle device of the wily foreigner."[60] It seemed to them that Chinese resistance to foreign medicine, the value of which in the case of vaccination seemed self-evident,

was as much of a problem as the disease itself. Chinese needed to be educated about the benefits of vaccination, and this meant finding a way to cut through the thicket of "superstitious ignorant notions" and folk beliefs that governed the Chinese practice of inoculation, even limiting the effectiveness of vaccination when it was finally adopted.[61] Donald Hopkins inherits the legacy of this line of thinking when he reduces Chinese resistance to vaccination to "the country's geographic isolation, its entrenched bureaucracy, and a traditional suspicion of all things foreign."[62]

Paradoxically, advocates of the vaccination practice thus quickly learned that in spite of its shared conceptual roots with inoculation, it would nonetheless be necessary to actively suppress inoculation for vaccination to flourish in China. When William Lockhart introduced vaccination into Shanghai in 1844, for example, he expressed his "hope . . . that the modern method [would] soon supersede old-style variolation administered to a majority of the Chinese children." Toward this end, "Pearson's pamphlet in Sir George Staunton's translation was [once again] republished with corrections and some slight additions and distributed all over the district."[63] Efforts were made to convince Chinese authorities of the need to eradicate traditional inoculation practice and to persuade local philanthropists to put their money and efforts into educating people about the "evils" of inoculation. In 1870, for example, "the foreign consuls brought pressure to bear upon the Magistrate [in Shanghai], and induced him to issue . . . a proclamation forbidding the old-style practice within the foreign settlements" (though this turned out to be what Jamieson called a "dead letter").[64] As late as 1916, Wong and Wu record, an attempt was made to promote vaccination over inoculation through government regulation by an "energetic and up-to-date official" in Zhejiang province who was "dissatisfied with the evils resulting from old-style inoculation."[65]

Inoculation in the nineteenth century thus became associated with "old-style" cultural practice or obsolete and superstitious Chinese "cultural characteristics"; it became, along with Chinese (and Indian) medicine in general in Western characterizations of the modern, something hopelessly enmired in irrational organic native systems, occasionally striking on a useful concept or effective technique or treatment, but then as if in spite of itself. Within this framework, the collapsing of inoculation practice with smallpox itself — one outdated, one soon to be eradicated, both in need of Western cures — was what

allowed vaccination in turn to make its debut as one of the standard-bearers of "modern" medicine in China, and Europe to create at last a theoretical justification for its medical-colonial enterprises. The story of smallpox was retold to include the failure of inoculation, or as Latour remarks in the European context, "We go from the absence of smallpox to the absence of vaccination."[66]

In a sense, then, when we note in Western historiography a certain blind spot about the original Chinese sources for Cibot's authoritative treatise on smallpox, we are also seeing a literal or performative absence, the suppression of a specific Chinese discourse on inoculation that otherwise might have threatened the foundations of vaccination practice on which the idea of the modern in colonial medical relations had so conveniently been built. The case of mistaken identity here concerns not only the ideologically charged assumption that something about the Chinese "character" made it especially vulnerable to disease but also the cumulative mistake about the identity of "On Smallpox" in the construction of modern smallpox narratives. Put another way, nineteenth- and twentieth-century historians of smallpox in China neglected to account for the ideological power of narrative in the construction of notions of disease and transmission, resulting in a complex legacy of stereotypes and misunderstandings about China in the present day. We need not make the same mistake.

The Pathological Body

Lam Qua's Medical Portraiture

> Ample evidence of the inefficacy of the ethical systems of
> the Chinese, is found in their national and domestic customs.
> Not only the minds of the people, but their bodies also, are
> distorted and deformed by unnatural usages: and those laws,
> physical as well as moral, which the Creator designed for the
> good of his creatures, are perverted, and, if possible, would
> be annihilated.
>
> — *Introduction to Article 1*, Chinese Repository 3 *(1834–1835)*

In the previous chapter I described how ideas associating disease and cultural identity could circulate and escalate in medical discourse, acquiring radically divergent meanings depending on the context of their reception and translation. In the case of ideas about smallpox and China, this circulation worked on two tracks: first, ideas associating pathology with Chinese identity were communicated through the circulation of images of smallpox; and second, ideas about smallpox in particular were communicated through textual transmission, as in the case of the differing trajectories of Martial Cibot's essay "De la petite vérole." In eighteenth- and early nineteenth-century exchanges between European Jesuits in Beijing, Chinese doctors, travelers to China, and European correspondents, both textual and visual sources contributed to the pathologization of Chinese identity, but they did so largely independent of each other, leaving room to view their subsequent reunions (when they happened) mainly as a matter of historical convenience or even coincidence.

By the time of the first Opium War (1839–42), however, the larger historical contexts that had enabled these early exchanges had shifted once again, giving way to a new set of conditions that would contribute in their turn to the formation and circulation of stereotypes associating Chinese identity with illness in discourses between China and the West. A key factor, for instance, was that beginning in 1757, the Qing court restricted all commercial activity by foreigners to the port of Canton.[1] From that time onward, all commercial transactions by foreigners were conducted exclusively through specially licensed Chinese hong (or *hang* 行) merchants in the tiny zone of thirteen "factories" in which foreigners were permitted to live during trading seasons. The goal of these restrictions was to "keep . . . Western traders under control and monopoliz[e] the profits of international commerce for the [Qing] government."[2] Such restrictive policies had enormous consequences in the years leading up to the Opium War, not least of which were the bankrupting of many of the hong merchants and the increasing frustration among foreign traders who resented what they felt to be unreasonable limitations on their trade. Yet these imperial restrictions also meant that this tiny district of warehouses and storefronts became, for the following eight decades, virtually the only window through which Westerners could learn about—and form stereotypes of—Chinese cultural practice.[3] In terms of what foreigners could learn in a time of intensifying "scientific" curiosity, life in the hongs represented a substantial de facto limit on the kinds and quality of data that could be gathered. As Fa-ti Fan has remarked of research by British naturalists at this time, "Until the nineteenth century, exotic animals brought to Europe had . . . not [been] procured through any arduous, heroic actions of European naturalists." Rather, he notes, "their fieldwork sites were the markets. The vendors in the few streets in the neighborhood of the Factories and the Fa-tee nurseries not far upstream supplied the bulk of the specimens the naturalists sent home."[4] Similarly, the exotic illnesses and the bulk of [human] specimens encountered by British and American Protestant missionary doctors when they first established hospitals in the hongs came largely from the limited field of the Canton delta region. Furthermore, the fact that these missionaries (unlike their Jesuit predecessors) deliberately aimed to use medicine as a vehicle for spreading the gospel also narrowed their target demographic: they took pains to treat mainly illnesses that could provide ocular evidence of their medical (and spiritual) superiority to a doubtful and

often illiterate Chinese clientele. Thus missionary hospitals, especially at first, treated a disproportionate number of eye diseases and external growths; accordingly, as patronage of the clinics gradually increased, so did the Western doctors' reputation among local people for relieving external, or *waike* 外科, ailments. To a certain degree, the "bulk of specimens" that came to the Canton hospitals in these early years must thus be understood as both self-selecting and as coming from a limited pool.[5]

Yet importantly, the fundamental relationship of these medical missionaries to their home institutions, nations, and sources of funding had also changed since Cibot's time. Unlike the Jesuits, the Protestant missionaries had to scrabble for their own funding, receiving support from privately sponsored philanthropic and religious organizations, from international networks of missionaries and doctors, and to an impressive (and largely unacknowledged) extent from the largesse of local Chinese philanthropists. The latter contributed reduced or free rent in the hongs; family-subsidized medical students and volunteers; and later funds to underwrite various missionary medical publications. More important, where French and Italian Jesuits had collected and exchanged data about Chinese and Western medical practice largely with an eye toward assimilating into local culture before advancing religious goals, American and British Protestant missionaries believed that Chinese needed to learn enlightened medical and scientific practice, as well as religion, from the West and that the West, by contrast, had very little to learn from China. Thus unlike Cibot, for whom religious values represented a conflict in terms of what he could report back to a governmental body eager for information about Chinese medical and scientific knowledge, Protestant missionaries like Peter Parker faced the dual pressures of having to prove the superiority of Western medicine and win trust in China, on the one hand, while simultaneously convincing medical and religious authorities back home of the merits of their undertakings, and therefore their worthiness of funding, on the other.[6]

The use of medical illustrations and expository text proved vital to meeting this double-sided challenge, both in conveying to European and American Christians a visceral sense of the presence of potential converts in China who could be "saved" through their generosity, and in communicating to Chinese patients an impression of the dramatic potential of Western surgical cures. In this chapter I describe the circumstances of production and content of a re-

markable set of medical illustrations that, unlike the smallpox images of more than half a century earlier, functioned explicitly to link notions of pathology with ideas about Chinese identity: the 114 surviving paintings in oil of approximately eighty-eight different patients of the medical missionary Peter Parker, painted by the Cantonese commercial artist Lam Qua between about 1836 and 1855 and displayed widely during this time in a fund-gathering tour of the West, in Western medical museums and archives, and in the lobby of the Canton hospital in which Parker ministered to patients both physically and spiritually.[7] Looking at the circumstances of production, technique, and content of these paintings, I provide first an example of how information about pathology and Chinese identity was circulated and adapted in the early nineteenth century through both text and visual culture. Equally important, however, I then also outline the early to mid-nineteenth-century roots of the connection between visual culture and the transmission of ideas about Chinese pathology that would become a lasting foundation for later representations, even as the cultural landscape shifted once again with the onset of the Opium Wars, the opening of the treaty ports, the development of photographic and medical technology, and the maturation of evolution-based concepts of race.

Why These Paintings?

Much has already been written about Peter Parker (1804–88), about his background and education, about his many accomplishments and setbacks as a missionary, a healer, and a statesman.[8] But relatively little has been written about Parker's ongoing collaboration with the painter Lam Qua (林華, or Guan Qiaochang, 關喬昌, ca. 1801–60), even though it lasted for more than fifteen years and even though the paintings it yielded remain a source of intense fascination to anyone who views them.[9] In many ways, this is not at all surprising. Recent scholarship has begun to address the formidable challenge of reintegrating "lost histories" of collaboration between Western missionaries and their Chinese informants into studies of China during this period, but the problems arising with regard to these efforts—particularly in tracking down Chinese sources less mediated by Western accounts—are manifold, and the Chinese voices remain notoriously difficult to reconstruct. The historian Xiong Yuezhi, for instance, has managed to supply the details of some of these individual histories, especially of early collaborative translations, in his com-

prehensive study of the dissemination of Western technology in China, and an awareness of the need to investigate similar collaborations, including those involving the intermediary body of Japan, has directly informed the research of Bridie Andrews, Chu P'ing-yi, Roger Hart, Lydia Liu, Ruth Rogaski, Wang Daw-hwan, Yi-Li Wu, and others.[10] Fa-ti Fan's study of the British naturalists in China moreover emphasizes the importance of visual culture elements in such collaborations, as when he observes that "the tradition of visual representation in natural history allowed British naturalists in China and in Europe to communicate scientific information, even when other means proved unsuccessful," adding that "it was the Chinese artisans who made the process possible."[11] In this sense the paintings Lam Qua created for Parker can be read as a kind of unmediated, or less mediated, translated text: they were the direct product of a cross-cultural conversation and as such represented a cooperative attempt to arrive at a new, hybrid visual idiom. As an examination of the product of a creative process, an analysis of these works therefore might well be considered an attempt at recovering one kind of "lost" history.

But two other reasons for analyzing representations of Chinese identity and pathology in Lam Qua's paintings stand out: First, both the paintings and the detailed case journals that Parker kept were, when circulated abroad, used explicitly for the purpose of describing not only pathology but Chinese "character" to curious Westerners. By 1851, Parker's hospital in Canton had provided medical attention to more than forty thousand patients; yet in his reports for the *Chinese Repository* between 1838 and 1848, as well as in sixteen separate medical reports published between 1836 and 1852, Parker could inevitably only describe a small fraction of these cases, and of these cases, the subjects of Lam Qua's extant medical paintings represented an even smaller select subset. Explaining how he chose cases for description in the reports, Parker wrote in 1839 that "some more particular notice is subjoined of a few cases, chosen, in general less from any interest attaching to them in a medical point of view, than from circumstances in them illustrative of Chinese character, customs, habits of thought and action." In 1848, nearly a decade later, Parker noted specifically about the paintings by Lam Qua that some subjects were chosen "for their interest in a surgical point of view, others illustrating different shades of the character of the Chinese."[12] Thus an analysis of the paintings and some of the journal entries describing them promises a unique window into ways in which

Westerners conceived of, and to a certain extent advanced, ideas associating Chinese character with pathology in the age before theories about race and culture were more fully formed.[13]

But more important—and perhaps directly related to their portrayal of Chinese character—Lam Qua's paintings were both intended for and reached an impressively diverse and often quite influential viewing audience. When Parker traveled in the United States and Europe between 1840 and 1841 to gather support for the newly established China Medical Missionary Society, for instance, he maintained a punishing schedule of engagements that brought him to, among other locales, Washington, DC, Princeton, Baltimore, London, Edinburgh, Glasgow, and Paris, where he pleaded his cause to a list of luminaries that strains credulity: besides speaking before both houses of Congress, Parker also met with John Quincy Adams, Henry Clay, Daniel Webster, the American presidents William Henry Harrison and Martin Van Buren, the dukes of Sussex and Wellington, the archbishop of Canterbury, and the king and queen of France. Along the way he exhibited paintings by Lam Qua in Boston, New Haven, New York, Philadelphia, and Salem (and presumably in other stops on his circuit where the exhibition of the paintings was not specifically documented), leaving a scattering of individual works behind him and donating a body of twenty-three paintings to Guy's Hospital in London.[14]

At the same time that Lam Qua's paintings reached an influential and wealthy Western audience, another factor makes them uniquely revealing: they were displayed strategically for Chinese audiences as well. Unlike in the Western contexts, however, the intended audience among Chinese viewers appears to have belonged to a very different demographic: the largely poor and unlettered classes of people who found their way to the Canton hospital for treatment. Although we have no records of exactly which paintings were used, several early eyewitness accounts make explicit reference to the use of the paintings in the lobby of the Canton hospital itself. One such account, written by a surgeon in the late 1830s, describes how "around the walls" of the hospital's first-floor receiving room "[were] arranged portraits in oil and water colors of some of the most remarkable patients who have been here treated, with their different appearance before and after the operation"; the writer adds dryly that "whether it is to be attributed to the skill of the native limners who execute these works of art, and who style themselves over the doors of their shops, 'handsome face

painters,' I will not pretend to decide; but certainly many of these men and women appear as good looking before as after the operation, notwithstanding the enormous tumors and awkward blemishes which have been removed."[15] In his 1861 memoir the medical missionary William Lockhart recalls how a

> Chinese artist, Lamqua, to show his appreciation of the value of the Canton hospital to his countrymen, took the portraits of many of Dr. Parker's more remarkable patients, first showing the malady from which they suffered, and then the appearance after the patient was cured. These paintings form an interesting series of characteristic maladies, and when Dr. Parker was in England, on one occasion, he presented a set of them to the Museum of Guy's Hospital, where they excite the surprise of students and visitors.[16]

And as late as 1848, only a few years after the Qing government had relaxed proscriptions against the practice of Christianity in China, Parker himself recorded that paintings of medical cases in the hospital's receiving room were now being used in sermons delivered to Chinese audiences by China's "first . . . Protestant convert" Liang Fa (梁發, or Liang A-fah): "With happy effect [Liang] dwelt upon the Savior's life and example, and pointing to the paintings and illustration of cures, suspended around the hall of the hospital, informed his auditors that these were performed by His blessing and in conformity to His precepts and example; at the same time declaring the great truths which concerned them still more, that their soul has maladies which none but Christ himself could cure."[17] Thus in addition to their function in the West as a means of illustrating "shades of the character of the Chinese" and matters of surgical interest with an eye toward soliciting funding from a powerful Western audience, Lam Qua's medical portraiture clearly also functioned as a means of communicating to Chinese patients at home that the foreign hospital could offer dramatic cures of both body and soul.[18]

While the success of these paintings in the West may be difficult to quantify in specific terms, in broader, more institutional terms it was unmistakable: not only did Parker get the funding he sought for the Medical Missionary Society and pledges of support for the education of Chinese medical students but his fund-gathering tour of the West also generated demand for more paintings in association with such support.[19] In a letter pledging financial aid for Parker's newly founded society, for instance, the fledgling China Medical Missionary

Society of Philadelphia stated explicitly that it would "provide . . . for annual meetings, when public addresses are to be made on behalf of the cause; and [offer] pecuniary support of its hospitals, and in educating Chinese youth of talent, in the healing art, in furnishing periodicals, and keeping [Parker's] Society informed of the progress of the medical and surgical sciences, the improvements in instruments and surgical apparatus, & c."; nonetheless "*it will expect in return* such contributions to materia medica, paintings of remarkable diseases, and specimens of morbid anatomy, as it may be practicable for [Parker's] Society to furnish."[20] As medical missionary activity in China flourished in the wake of the Opium Wars and expansion inland, the impact of Lam Qua's paintings may also be measured in the legacy of their innovative visual idiom for future medical illustrations—the seemingly endless depictions of tumors and surgeries, of "befores" and "afters" that began to fill not only the walls of newly established medical museums but the pages of the various widely circulating medical journals and customs reports that I describe at greater length in chapter 3 of the present volume. Thus Lam Qua's paintings constitute a valuable source of information not only about images of Chinese identity communicated to the West but also about images of health and spirituality as communicated to thousands of Chinese patients, as well as about iconography and modes of transmission that would later prove influential in missionary medical activity around the turn of the century.

"What No See No Can Do": Lam Qua and His Studio

Lam Qua was one of the most well-known and successful Cantonese commercial painters of his generation, or in the words of the art historian Carl Crossman, he was "the most celebrated Chinese painter in the English style in Canton."[21] Described as "a stout, thick-set man about the middle size, and bearing a considerable degree of intelligence and urbanity in his countenance,"[22] Lam Qua apparently also had a sense of humor. Once, when someone pointed out to him how a certain English painting had incorrectly depicted Chinese executioners wearing ridiculous "long silken robes, with satin boots, and . . . mandarin caps, with peacocks' feathers dangling from them," he is reported to have commented: "Suppose *Englis* man no plenty know why for talk lie pigeon all some dat; me *tink* he plenty *foolo*: Chinaman no all some foolo, what see can do, what no see no can do" (Perhaps the Englishman really didn't know a lie

about that in Pidgin [when he heard one]; [but] I think he's quite the fool: the Chinaman's no such fool, what he sees he can do, what he doesn't see he can't do).[23] If this anecdote is true, then it is unsurprising that Lam Qua was particularly renowned among export painters for his skill at rendering accurate likenesses of his subjects, or as yet another writer remarked sarcastically, "[Lam Qua's] facility in catching a likeness is unrivalled, but wo [sic] betide if you are ugly, for Lam Qua is no flatterer."[24] So fine were Lam Qua's likenesses that observers routinely compared him to major Western painters like William Hogarth and Thomas Sully, and indeed Lam Qua was one of the first Chinese painters to be exhibited in Western venues such as the École Turgot in France, the Royal Academy in London, the Apollo Club in New York, the Pennsylvania Academy of Fine Arts, and the Boston Athenaeum — "no mean feat," as Crossman points out, "for a Chinese who had learned to paint in a foreign style."[25]

The urbane and witty Lam Qua presided over a large studio — one of as many as thirty in the area — where he conducted a brisk trade with thousands of customers, foreign and Chinese alike, producing portraits, landscapes, miniatures, copies, and enlargements of existing works on ivory, glass, rice paper (flattened pith), or canvas; he also produced pictures of the emperor or the goddess Guanyin for Chinese clients "when the winter trading season was over, and the Westerners repaired to Macau or to their homelands."[26] Although it belonged to Lam Qua, the studio shared (to borrow Fa-ti Fan's words) a "workshop culture" not unlike that of a guild, in which painters sometimes employed an assembly-line style of working similar to that used by chinaware painters, and in which "[a] painting might pass through several hands before it was completed. One artisan traced the outline, another drew in the figures, a third man painted the background, and so on." Thus, as Fan notes generally, "the export painters used any techniques that fit their needs: copying, tracing, employing ready-made sketches of trees, houses, boats, or animals assembled in different ways to produce a different scene."[27] Lam Qua's studio was divided into three stories: the first floor functioned as a storefront full of finished paintings and curios; the second served as a workshop in which a dozen or more young men copied outlines and applied color; and the third housed a "smaller, skylit" room where Lam Qua himself worked at an easel, often surrounded by onlookers as he captured the likenesses of his sitters.[28] Such sitters included

not only "Western traders and Parsees" but dignitaries like Chi Ying (耆英, a signatory to the Treaty of Nanking); the commissioner Lin Chong (林則徐, or Lin Zexu, supposedly responsible for the onset of the first Opium War); Sir Henry Pottinger (the first governor of Hong Kong); and Peter Parker himself.

A commonly cited stylistic source for Lam Qua's Western-style painting is the celebrated English expatriate painter George Chinnery (1774–1852), from whom Lam Qua seems to have inherited his deftly applied "fresh fluid brush-strokes and use of . . . light."[29] As Patrick Conner describes it,

> Until 1825, Chinese export portraiture was typified by a certain directness and clarity which has led to the suggestion that its models were American portraits of the late eighteenth century, or perhaps English miniature portraits of the 1750s and 1760s. But the arrival of Chinnery brought about a radical change. For the first time a professional artist from the West (and moreover one who had been renowned as the principal artist of British India) was resident and active on the China coast. He brought with him a flamboyant mode of portraiture which the Cantonese artists would have known only from engravings — a manner which Chinnery had in turn learnt from Sir Thomas Lawrence and others in the last years of the eighteenth century: this involved dramatic chiaroscuro, studied poses (often with arms dangled casually over chair-backs), an emphasis on the bulk and texture of costume, and a range of stylized backgrounds which included scarlet drapery, massive columns, glimpses of distant landscape or seascape, and a hint of storm-cloud in the sky beyond.[30]

There has been considerable debate about whether or not Lam Qua directly studied with Chinnery, but either way it is clear that Chinnery's work was a direct source for Lam Qua's, a fact corroborated, as Conner points out, by the marked transitions in style between works attributed to the young Lam Qua before the arrival of Chinnery and those that came later. At the same time, however, it is important to emphasize that a gifted and stylistically "bilingual" artist like Lam Qua had at his disposal a number of other sources and inspirations as well. Writing of stylistic sources for the Cantonese artists who illustrated the early nineteenth-century works of the British naturalists, Fan reminds us that a diverse range of Western images were already available as models for Chinese export art in the context of porcelain manufacture by the late 1700s:

"These workshops often received specific designs—portraits, scenes, or coats of arms—from their Westerner clientele, a practice that can be traced back to the seventeenth-century Dutch traders in China. . . . The Declaration of Independence, portraits of George Washington, William Hogarth's drawings, and Christian art were among the subjects of porcelain painting done in Canton."[31] Thus we should bear in mind that in creating his famously accurate likenesses and catering to a demanding and diverse clientele, Lam Qua, in addition to more high-brow stylistic influences (both Western and Chinese), also took into consideration a multitude of other available sources—low-brow, whimsical, erotic, and otherwise—available to him in the stylistically cacophonous port of old Canton.

"Written with Indelible Characters upon His Body"

It was probably through Lam Qua's nephew Kwan A-to (關亞杜, or Guan Yadu), Parker's first Chinese medical pupil, that the introduction to Lam Qua was made. Although we have no record of who exactly asked whom for what, it is clear that after meeting with Parker, Lam Qua agreed to provide paintings of "the more interesting cases that [were] presented at the hospital," and this, at least initially, completely free of charge. As Parker noted in evaluating one of Lam Qua's earlier works, a painting of the patient Lew Akins, "I am indebted to Lam Qua, who has taken an admirable likeness of the little girl & a good representation of the tumor. The more interesting cases that have been presented at the hospital, he has painted with equal success, and uniformly says that as there is no charge for 'cutting,' he can make none for painting."[32]

There has been much speculation about Lam Qua's real motives for providing free of charge what eventually became the largest single body of his works in existence. It seems plausible, for instance, that the paintings constituted a sort of thank-you for Parker's training of the young Kwan, who went on to become an accomplished surgeon and to continue his practice at the Canton hospital well after Parker retired.[33] Likewise they could easily have been an expression of appreciation for Parker's "devotion . . . in the care of suffering Chinese," as Parker's anecdote implies. As one writer speculates in an 1889 memorial note about Kwan: "He was placed in the hospital class by his uncle, the late artist LAMQUA, a disciple of the renowned CHINNERY, who was himself so much impressed by the devotion of Dr. PARKER in the care of suffering

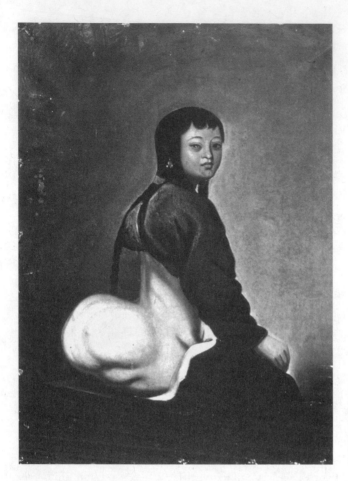

Chinese that he painted gratuitously the more remarkable cases, first showing the malady and then the appearance after the cure."[34] And as Parker himself once noted, "[Lam Qua] is a great lover of the medical profession, and regrets that he is too old to become a doctor himself."[35] Such romantic motives notwithstanding, Lam Qua's gesture must also be viewed against the backdrop of the philanthropic contributions to the hospital made by his contemporaries in the hongs, who regularly donated support in the form of free or subsidized rent (as supplied, for example, by the senior hong merchant Howqua, who also donated $300 in cash toward administrative expenses in 1837, and later was active in the board of the Medical Missionary Society); subsidized tuition (as when a "young man of good talent," not Kwan but another, enrolled as Parker's medical student "wholly supported by his father"); volunteer labor (as with the fas-

cinating cases of former patients who went on to become porters or members of staff at the hospital); and membership dues and subscription fees related to the Medical Missionary Society; after all, the Canton hospital provided all surgeries absolutely free of charge, at least in the early years.[36] Lam Qua's gift of donated paintings could thus be seen less as an isolated expression of gratitude than as a form of active participation in a philanthropic microculture of giving and mutual exchange. This might explain in part why, in 1851, Parker recorded in his ledgers that $25 had been paid to Lam Qua for "paintings of tumors": the hospital now had other sources of income.[37] Moreover, whereas Kwan A-to had drawn a yearly salary of only $60 when he first apprenticed at the hospital in the late 1830s, by 1847 he was "doing most of the minor operations and a good many of the important ones," and by 1861 his salary had more than doubled to $128.[38] Attracting many new patients, the young Kwan had matured from a resident intern (not "wholly supported" by his father like his classmate) to an active staff member who no longer represented a drain on hospital resources.

For Parker, meanwhile, there were a number of motives for commissioning Lam Qua's portraits of his more "interesting" patients. First, of course, he needed something that would serve as "both a medical record and as proof of his expertise" when attempting to justify his requests for funding back home.[39] In terms of using illustrations and specimens to provide such a record, furthermore, there was a precedent in the hongs of which Parker could not have been unaware: British naturalists like John Reeves, John Blake, and William Kerr had routinely coached and employed Cantonese export painters in making illustrations of botanical specimens for years, and actual medical specimens — a bound foot retrieved from "the dead body of a female found floating in the river at Canton," a live man with a strange tumor — had also already made the perilous journey from China to the West in similar contexts.[40] As in the case of botanical samples, it did not prove practical to transport actual specimens in quantity, so Parker needed illustrations that could function by proxy, conveying "real" and scientifically useful representations of what the Philadelphia chapter of the Medical Missionary Society would later refer to as the "peculiarities of diseases native to China." Toward this end, it is worth noting here that the written accounts of the surgeries that Parker kept follow the paintings closely in their attention to fine detail — they recorded faithfully the shape,

color, texture, and weight of the tumor or diseased part; the precise amount of time the surgery required; information about the circumstances of the presentation of the disease and about the time required to recover (when available); and biographical data about the patient in question. Almost formulaic, these descriptions — even in cases where it is difficult to confirm with certainty the link to a specific painting — should be considered a part of, or implicitly complementary to, the paintings themselves.

But contributing to motivations for producing illustrations of pathology was also a matter close to Parker's heart: the need to familiarize Chinese medical students and laypeople with the healing potential of Western medicine. From the earliest writings, medical missionary literature of this period is filled with references to the need for *visual proof* of the missionaries' goodwill and peculiar skills, as well as visually oriented teaching materials; in the words of one early author, "The Chinese need[ed] *ocular* demonstration of the intelligence, practical skill, and kind feelings of those who come to their shores from far."[41] For Parker, a practical means of providing this "ocular demonstration" was to enact surgical cures on the body that would be readily and enduringly visible to the patient's compatriots. In 1839, in a record of remarks made at the first annual meeting of the Medical Missionary Society, for instance, Parker explained:

> We find by experience, that [the Chinese] is not apt to forget either our good words or our good deeds, but if there were any oblivious tendency in this way, it would be corrected by the restoration of sight to the blind, the removal of excrescences that preyed upon the vitals of the sufferer, and so on; *for he bears a testimony which he will convey to his grave, written with indelible characters upon his body*, that China, with a swarming population, cannot produce a man, that can at once vie in skill and humanity with the stranger.[42]

In addition to restoring sight to the blind and inscribing surgical "testimony . . . with indelible characters upon [the] body," Parker clearly reasoned that Chinese might also learn about the dramatic healing potential of Western medical practice through illustrations of these same "testimonies." At the same annual meeting, the founders of the Medical Missionary Society drew up a charter outlining the society's goal not only of encouraging the education of more

Chinese students in the Western medical arts but also of building in China "an Anatomical Museum, containing specimens of natural and morbid anatomy and paintings of extraordinary diseases . . . to be under the control of the Committee," that would prove useful to Western medical missionaries and Chinese medical students alike.[43] Although Parker did not live to see the opening of the medical museum, his remarks and the society's statement of goals resonated with and set the tone for medical missionary objectives for years to come.

The Medical Portraits

Although Lam Qua's exceptional skill meant that he did not need to be coached in Western representational conventions the way the earlier botanical illustrators had had to be, the medical paintings demanded of him would still have represented serious practical and phenomenological challenges for the artist.[44] For one, the subjects of Lam Qua's medical portraiture, unlike those of the export and local paintings from which he made his living, came from diverse social backgrounds and both genders. Whereas Lam Qua's subjects typically included Western merchants, missionaries, and dignitaries, as well as local hong merchants and other Chinese subjects like the "private secretary to the governor of Canton," we know thanks to Parker's Journal that a majority of the uniformly Chinese subjects for this unusual series of paintings came from nonelite classes and social positions. While Parker's patients included the "son of a respectable tea broker in Canton," for instance, there was also "an artificial flower maker"; "a slave . . . sold by her mother"; "a stone cutter"; "a gardener . . . accused as a smuggler"; "a shoemaker of Pwanyu"; "a laborer of Tungkwan"; and so on. Of particular note, furthermore, is that many of the subjects of Lam Qua's medical portraiture were female, although women and girls otherwise appear less frequently in his works. The medical portraiture thus diverged from Lam Qua's typical commercial subject matter in its inclusion of a mostly poor and otherwise almost uniformly unrepresented class of people whose only point in common was their pathology (see plate 1).

The medical portraits would also have presented certain basic programmatic challenges to Lam Qua that would not have confronted him or his staff when making typical "handsome face" commercial portraits. The peculiar shapes, needs, and circumstances of the sitters for these paintings, not to mention the dual subjects of pathology and human host, meant that typical modes of com-

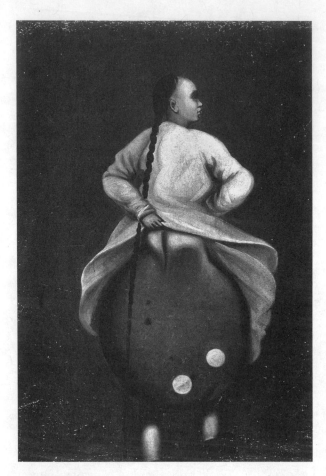

FIGURE 4: Lam Qua, *Wang Ke-king, the Son of a Respectable Tea Broker Resident in Canton*, ca. 1837, oil on canvas, 23 × 18 inches. COURTESY OF YALE UNIVERSITY, HARVEY CUSHING/JOHN HAY WHITNEY MEDICAL LIBRARY.

mercial portraiture—contrived to offer the subject the most "handsome" face possible in the quickest, most economical way and according to preset compositional conventions—could not, or would no longer, apply. Instead, Lam Qua had to pioneer other ways of dealing with presentation that took into consideration, for example, how long or in what positions a subject might sit for a likeness. Entries from Parker's hospital journal confirm that many patients had individual challenges that would have kept them from sitting for a portrait in the conventional way. He writes, for example, of Wang Ke-king that "when the man sits down, the tumor forms a circular cushion which elevates him six inches or more in his chair" (figure 4).[45] Of Yang She's tumor Parker notes that "it extended below the umbilicus, but not so far as to rest in the lap; consequently its weight was sustained by the attachment, and the patient had to

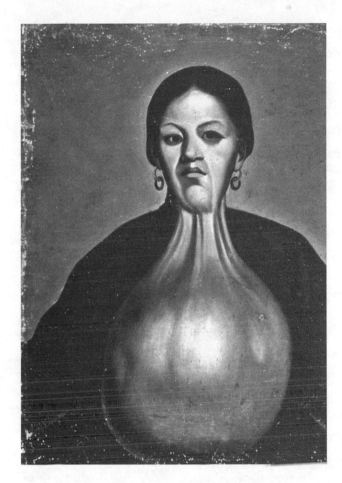

FIGURE 5: Lam Qua, *Yang She, Aged Twenty, of Hwayuen*, ca. 1838, oil on canvas, 23 × 18 inches. COURTESY OF YALE UNIVERSITY, HARVEY CUSHING/JOHN HAY WHITNEY MEDICAL LIBRARY.

sit constantly in a bracing posture, to prevent its drawing down her head. The natural features were distorted, the cheeks being drawn tense by the weight of the tumor" (figure 5).[46] Thus where a typical client might sit for several hours at a time in Lam Qua's studio, his or her facial features painted in to a preprepared body, these sitters required innovative, deliberate arrangements of lighting, position, clothing, and overall composition. Unlike conventional sitters, Wang Ke-king is painted from behind, in a standing position, to allow a clear view of the growth; Lew Akin's robes are parted strategically to reveal the pathology, which (even more than her face) is the touch point for the apparent primary light source (figure 3); Yang She's sloping shoulders and the tense geometric strokes delineating "the attachment" illustrate clearly her need to "sit constantly in a bracing posture" even as she is being painted.

It seems clear that in some cases Lam Qua turned to tropes of the erotic in coping with the problem of representing the unique bodies of his sitters — or even perhaps for variety. In one case, for example, we might recognize in the subject's posture, clothing, and gaze an almost ironic reconfiguration of certain late eighteenth- and early nineteenth-century European nudes, perhaps most notably Jean-Auguste-Dominique Ingres's infamous *La Grande Odalisque* with its provocative portrayal of a woman's sumptuous derrière (figure 3). As Conner usefully points out, Lam Qua had in fact made a painting based on an engraving of Ingres's notorious work for a commercial client, inventing a new color scheme in the absence of representation in the engraving, so we cannot doubt his familiarity with this model.[47] A similar point can be made regarding another of the medical portraits, an arguably less successful example in which a woman reclines horizontally on a traditional *kang* bed, framed by curtains, the bedding pulled back strategically to reveal a cancerous breast (plate 2).[48] Belonging to the same family as Éduard Manet's later *Olympia*, the layout and even the content of the painting represent the familiar pose of a courtesan modeling for a client (is the camellia blossom of Alexandre Dumas's play, memorialized by J. J. Grandville and possibly by Manet, here transformed into a pathology?).[49] Here again it should be pointed out that in addition to drawing from the circulation of European models of nudes and courtesans, the hybrid commercial art of Canton also included stylistic cognates in the form of paintings of Chinese courtesans for brothels: sometimes portraits of women in oil on glass, rather than the women themselves, were displayed for prospective clients to choose among.[50]

The "dramatic chiaroscuro, studied poses . . . and . . . range of stylized backgrounds" of the English "grand manner" further proved surprisingly well-suited to the task at hand: the style lent itself, as Sander Gilman has pointed out, to the externalizing of identity in the environment of the portrait and consequently to the collapsing of Chinese identity with pathology, a factor which I shall address shortly in greater detail.[51] At the same time, in searching for the roots of Lam Qua's medical iconography, we must of course also consider the possibility of non-Western sources for the representation of pathology. The search, while frustratingly circumstantial, is not without its promises: we might look once again, for example, to the widely circulated eighteenth-century imperial medical anthology known as *The Golden Mirror*

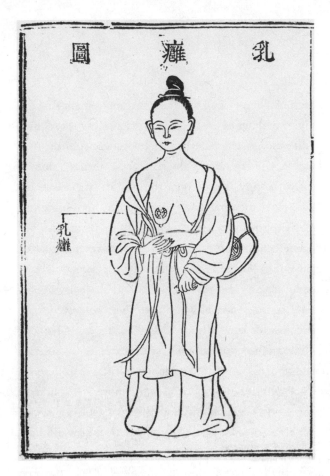

FIGURE 6: Depiction of an abscess on the female breast. From 御纂醫宗金鑑 *Yuzuan yizongjinjian* [*Imperially Decreed Golden Mirror of Medical Ancestors* (The Golden Mirror of Medicine)], 1742. Reproduced from Unschuld, *Medicine in China*, 127.

of Medical Orthodoxy. An anomaly among Chinese medical texts for its visual or diagnostic (as opposed to schematic) representation of external pathologies, *The Golden Mirror* contains, in addition to the numerous illustrations of children with smallpox on which the image accompanying Cibot's manuscript was based, a substantial number of illustrations of general external pathologies among adults, pathologies such as cancers of the breast, skin, arms, legs, and so on (figure 6). Whereas the smallpox images may be traced to the "Hundred children pictures," sources for this unique second set of illustrations remain something of a mystery.[52] Regardless, given *The Golden Mirror*'s imperial sponsorship and indeed the fact that images from its section on smallpox were reproduced earlier in a markedly export-style idiom, as well as Lam Qua's interest in medicine and his fluency in Chinese visual culture, the possibility

that these images constituted a source for Lam Qua's medical portraiture cannot be ruled out.

Character and Cure

Perhaps Lam Qua's greatest challenge of all was Parker's requirement that the paintings capture not only something of use to medical science but also something of what he referred to as the "character" of their Chinese subjects. For in paintings such as these, as Gilman notes, "the patient . . . bears a double stigma—first, the sign of pathology, and second, the sign of barbarism, his or her Chinese identity."[53] How then did Lam Qua nuance the representation of this double stigma? One must take care, first of all, to distinguish between the elusive early nineteenth-century concept of *character* and that of *race*; the former term was not in Parker's time defined by the same misleading corporeality associated with later ideas of "race." Rather, *character* encompassed more ineffable characteristics such as what Westerners perceived to be a uniquely Chinese "disregard for time, disregard for accuracy, a talent for misunderstanding, a talent for indirection . . . intellectual turbidity, an absence of nerves, contempt for foreigners, an absence of public spirit . . . indifference to comfort and convenience, physical vitality," and many more.[54] If character in the age before race was something sublime, something based not only in physical form but in more elusive ideas about cultural practice, how did Lam Qua account for it in his paintings? In the remainder of this chapter, I will argue that Lam Qua met this challenge in at least three different ways: through his handling of his subjects' facial expressions, through his use of landscape in various paintings, and through his portrayal and manipulation of the trappings of a Chinese cultural semiotics—all of which stand out especially clearly when analyzed in conjunction with passages from Parker's reports.

EXPRESSIONS

A striking feature of many of the subjects of Lam Qua's medical portraiture is the paradoxical nature of their calm, impassive, even sweet facial expressions, as if the human subjects were indifferent to, or unaware of, the pathology that vied so aggressively with them for the attention of the viewer. As Peter Josyph writes: "Their faces are quite serene, with rarely a hint of pain, shame, or discomfort of any kind"; if the portraits communicate a sense of human-scale

vulnerability, he continues, it is due to "the absence of any specific emotion by which the patient can truly be seen to own his disease."[55]

One explanation for this expressive opacity lies with the disposition of the grand manner toward portraying a subject's emotional state not through expression or gesture but by projecting the trappings of individual identity outward onto the subject's environment, clothing, or even animals: the face was no place for emotion here, and any reference to it would have fundamentally, even pathologically, altered the meaning and function of the painting. Stylistically speaking, the subjects' generic inscrutability therefore might be explained by the use of the same painting style that so informed Lam Qua's other, commercial works. Gilman further suggests that the concurrent development in the West of a certain genre of medical illustration in which individual subjects also displayed a curious indifference to their pathologies could have been a contributing factor. As he explains, "The image of the identifiable patient as the bearer of a specific pathology arose in European medical illustration as an outgrowth of the medical philosophy of the *Ideologues*, who believed that only single cases could be validly examined and could serve as the basis of any general medical nosology." Gilman singles out in particular the work of Jean-Louis Alibert (1766–1837), whose monumental manual on skin diseases in the early 1800s "began . . . a tradition of illustrating medical studies with images that were perceived as mimetic rather than schematic."[56] The subjects of the manual's illustrations, like Lam Qua's, look quite unconcerned about the frightening afflictions that share the frame with them, or as Barbara Stafford writes, Alibert's illustrations were simultaneously "dispassionate reproductions of fragmenting corporeal afflictions and moving images of individual Stoic heroism, transcending the tumor-burdened body," according to which "the disquieting and contradictory message of perfection overlaid with morbidity was that no one was secure."[57] Thus the English grand manner as well as innovations in Western medical illustration may have contributed to Lam Qua's creation of a new Chinese stoic.

But Lam Qua's portrayal of his subjects' emotional reserve also reflects an effort to satisfy Parker's requirement that the portraits express something of the "shades of Chinese character" to his Western audiences. Parker's journal entries corroborate this reading. For Parker, for example, it just so happened that insensibility to pain ("an absence of nerves") was a crucial part of the ro-

mance of Chinese heroism (his own and that of the Chinese) against which his own tenuous position as a Western medical missionary in China was defined. If one keeps in mind that the hospital performed most of the surgeries before the introduction of ether-based anesthesia to China (by Parker) in 1847, it becomes clear that Parker's journals again and again reveal his fixation with, and awe of, what he perceived as a peculiarly Chinese ability to cope with extreme pain.[58] For example, Parker writes of Woo She, who suffered from "scirrous breast," that "*her fortitude exceeded all that I have yet witnessed. She scarcely uttered a groan during the extirpation*, and before she was removed from the table, clasped her hands, and, *with an unaffected smile*, cordially thanked the gentleman who assisted on the occasion. . . . *The natural amiableness and cheerfulness of this woman* . . . attracted the attention of many who visited the hospital during her stay. Surely, *natural sweetness of the temper* exists in China."[59] In the journal entry regarding the case of Mo She, a woman suffering from the same condition as her friend Woo She, Parker explicitly links resistance to pain with the acceptance of foreign medicine: "This is the first instance of the extirpation of the female breast from a Chinese, and few operations could exhibit in a stronger light their *confidence in foreign surgery*, yet it was submitted to with the *utmost cheerfulness*."[60] In another entry Parker writes: "No. 2214. Nov. 21st. Sarcomatous tumor. Lo Wanshun, aged 41. This interesting [woman], of the first society of her native village, had been affected with a large tumor upon the left side of her face. . . . The patient endured the operation with fortitude, characteristic of the Chinese. The loss of blood was considerable; she vomited but did not faint."[61]

Over and over again in Parker's journal mythology insensibility to pain, along with a tendency toward conspicuous demonstrations of gratitude and a willingness to tell friends about the new foreign surgery, is portrayed as one of the more striking and peculiar aspects of Chinese identity, something comprising the elusive Chinese "temper" of Parker's world.[62] In making his case for the further funding of the medical mission, Parker uses this receptive temperament as evidence that Western medicine could succeed in converting the Chinese to Christianity, just as a "natural" insensibility to pain corresponded to an increasing "confidence in foreign surgery" among the Chinese heathen.

Lam Qua was also a master painter of landscapes. In his commercial works one notes again many of the signature flourishes of the grand manner: the "massive columns [and] glimpses of distant landscape or seascape," for example, with the suggestive "hint of storm-cloud in the sky beyond." This was not landscape in the romantic sense—it did not, as far as I understand, aim to establish an overarching dialectic of "man" and "nature"—but rather positioned nature as the external, as a reflection of inner life. Thus turmoil in that external world signals turmoil in the subject's inner life, without at the same time collapsing them. Similarly, when landscapes appear in Lam Qua's medical portraiture, they set up certain implicit symbolic relationships between the human subject and the landscape that it inhabits. The environment mirrors or echoes illness and health sympathetically, creating a pathological ecology wherein the invisible hand of the missionary doctor heals concentrically, removing first the outward manifestation of the patient's pathology and then in turn causing the more global cure of the natural world and, we may presume, the world's spirituality.

One example of this type of painting is that of Akae, a thirteen-year old girl (plate 3). Here we see a triple subject or triple focus: the girl, her facial tumor, and the narrativistic landscape against which she is painted. Akae stands slightly left of vertical center, holding what appears to be an empty sack in front of her. Her clothes are plain; she is barefoot; a pair of earrings marks her as female. The foreground of the painting remains mostly bare, in contrast to the large triangular outcropping of rock that diagonally bisects the space behind her. In the upper left corner, a tree extends out from behind the outcropping and geometrically frames the head of the girl. From beyond the foot of the rock a harbor scene unfolds; a male figure walks past a boat as clouds billow up on the horizon. The tumor on Akae's face—the focus of the viewer's attention as guided by the architectural lines of the rock, the tree, and the horizon—seems almost incidental to the composition as a whole. Parker's journal entry reads:

> No. 446 Dec 27th [1836] . . . Akae, a little girl aged 13. As I was closing the business of the day, I observed a Chinese advance timidly to the hospital leading his little daughter, who at first sight appeared to have two heads. A

sarcomatous tumor projecting from her right temple, and extending down to the cheek as low as her mouth, sadly disfigured her face. It overhung the right eye and so depressed the lid as to exclude the light. . . . The child complained of vertigo, and habitually inclined her head to the left side. . . . From the first it appeared possible to remove it.[63]

In typical Parker fashion, the doctor goes on to describe the patient's stoic resistance to pain and her subsequent complete recovery:

On the 19th January, with the signal blessing of God, the operation was performed. The serenity of the sky after several days of continued rain, the presence and assistance of several surgical gentlemen, and the fortitude of a heroine with which the child endured the operation, call for my most heartfelt gratitude to the giver of all mercies. . . . The patient cheerfully submitted to be blindfolded & to have her hands and feet confined. The tumor was extirpated in eight minutes. . . . In fourteen days the whole except the fourth of an inch was entirely healed.[64]

With the exception of the subject being a lower-class female and that this girl "at first sight appeared to have two heads," Lam Qua's painting of Akae looks typical of many portraits or landscapes by himself or other commercial artists of the period. Even the palette parallels that used in Lam Qua's commercial landscapes.[65]

Yet a closer look reveals it to be a more holistic environment, a painting of a whole interactive system rather than a set of accidental or conventional components. The outcropping of rock, for example, does not exist in a void but rather corresponds to, or echoes, the outcropping of flesh on the girl's face. Meanwhile the primary elements of the landscape taken as a whole, as if corresponding to Parker's notation that the patient "habitually inclined her head to the left side," concentrate like the tumor on one side of the composition. The rock slopes upward at about a forty-five-degree angle; the tree hangs in a kind of aesthetic sympathy from above; the cumulous clouds billow atop one another with patches of light that suggest the fullness of the tumor. The tree, rock, clouds, and tumor all work together to emphasize fullness, roundness, hanging, solidity, or what Parker might call "excrescence." The girl's body becomes a microcosm of this natural grouping, the host of an implied landscape, the upright figure in a picture alive with motion (up the grade of the rock, out

over the figure on the limb of the tree, and billowing upward and away with the clouds). In short, in Lam Qua's painting, the self is conceived as resonant with nature, so that pathologies in the human body are also visible in the natural world. The whole landscape, the painting seems to suggest, and not just the little girl, will respond favorably to Parker's treatment.

The deliberateness and consistent application of this type of landscape in Lam Qua's medical portraiture comes across most clearly in the unique "before and after" paintings of the patient known as Po Ashing (plates 4 and 5). As in the painting of Akae, natural landscape in these paintings functions as a sort of sympathetic projection of the human landscape of Po Ashing himself; the state of the landscape also gives us some clue as to the patient's internal (and by association spiritual) state. As the only examples of Lam Qua's paintings from the Yale collection that employ the before-and-after format (the remainder, one might say, being all "befores"), they provide an invaluable source of information about how such paintings were intended to function when they were displayed for Chinese audiences in the hospital receiving room and in concert with sermons by Liang Fa as described above.

Painted of someone whom Parker refers to as "the first Chinese, so far as I know, who has ever voluntarily submitted to the amputation of a limb," the before picture shows Po Ashing seated on a chair against a dark, backlit interior.[66] His figure takes up most of the frame. His good arm rests on one knee, while the other arm is balanced over the other knee. He wears no shirt, only a hat and three-quarter-length trousers. He looks at the viewer confrontationally. The after picture meanwhile shows Po Ashing in profile, his direct gaze replaced by a full-on view of the site of the amputation. This time his torso is draped with a jacket open to one side, his queue is partially visible beyond the empty arm socket, and under the same hat he wore in the earlier painting he manifests a mild, unconcerned expression. He shares the frame with a bright, uncluttered landscape background that juxtaposes a gently sloping hill and calm body of water in the left lower corner with a clump of bushes and a few scattered rocks in the lower right.

Compared to the painting of Akae, the after landscape of Po Ashing is much more open. The overpopulation of Akae's portrait, with its large rock outcropping and harbor scene, in Po Ashing's portrait becomes an expanse of open sky with a light blending of clouds; possibly how an after painting of

Akae might have looked. Meanwhile within the painting itself, the contrast of uncluttered light space (the sky and sea) with dark, defined solids (Po Ashing, the shrubbery) invoke the patient's own astonishing composure in the face of the loss of an arm: the serenity of his expression seems to be mirrored in the calm of the surrounding landscape. Since we also have the before painting for comparison, we know that not only the sea and sky but the entire natural environment has shifted to reflect Po Ashing's newfound freedom, his liberation from sickness. In the transformation of the claustrophobic darkness and literally confrontational attitude of the before picture into the lightness and calm of the after landscape we see the progression from sickness to a globalizable health.

Landscapes in both the portrait of Akae and the after portrait of Po Ashing thus mirror the physical condition of the human subject and function metaphorically to enhance the sense of a narrative-like progression from a dark, encumbered self and environment to a spacious, light, and calm one. The variously clear or turbulent sky that appears in other landscape portraits may thus be read either as a sign of what awaits the patient who submits him- or herself to Parker for treatment (the "after" that they can look forward to) or the externalized projection of the sickness in need of cure. In perhaps the most moving portrait of all, for example, a man's back faces us, its smooth perfection marred by a textured open spinal tumor near the base (plate 6). Instead of looking at the man's face, which is turned away from us, we join the subject in gazing from within a darkened room out through the window, where a hint of blue sky is visible beyond a wall of clouds: the man's future if he is treated by Parker. In another painting, Lo Wanshun, her tiny feet here as much a pathology as the growth on her face, looks calmly at the viewer from within a darkened room (plate 7). On the right side of the painting, directly across from the site of her disfigurement, blue skies beyond the clouds promise redemption and a reunion with the natural environment, or as Parker notes, "[Lo's] face [within ten days of surgery] had nearly its natural appearance."[67]

Against the backdrop of a culture whose "characteristics" included proscriptions against both amputation and autopsy, these landscapes suggest a novel reconception of Chinese identity whereby even an amputee may move from isolation and social ostracism to reintegration and harmony with nature, to a normal life. As Parker writes of Po Ashing, for example, "This patient

perfectly recovered. In about one year after, he married, and by selling fruit, with one hand, he is able to obtain a livelihood." Of Lo Wanshun he remarked, "Grateful and happy, she returned to her husband and family."[68] By opposing the tumor sufferer to the graphic sign of his or her cure, the paintings make explicit what is implicit in paintings without landscapes: the possibility of the socially and spiritually reintegrated life that surgery can bring, the possibility that surgery will compensate for the implicit isolation brought about by these patients' pathologies and thus allow them finally to emerge as social beings. Thus in these paintings we get a special glimpse into an ironic reconceptualization of Chinese identity for this period: surgery as a means of becoming whole.

CRITIQUES AND RESISTANCE:
"GOOD" CHINESE VERSUS "BAD" CHINESE

In the landscape paintings, we see how a cure becomes global and utopian: not just the individual patient's body, the compositions seem to say, but the whole environment (natural as a metaphor for social and even spiritual) may be healed by Parker's hand. Likewise, as in the case of Lo Wanshun, we can also see how Chinese cultural practices such as foot binding might be represented as pathological—the compositional equivalent of the pathology itself—in Lam Qua's paintings (see, for example, plate 8). By the same token, some of Lam Qua's paintings also construct Chinese identity specifically (through its trappings) as an inherent obstacle to the idealized surgical cure in a way that betrays the missionary frustration with Chinese resistance to evangelism as much as it conveys a critique of Chinese culture. In the journals, for example, Chinese reluctance to accept Christianity is expressed in other language as a resistance to the surgical knife: Parker's reports repeatedly relate stories of frustrated attempts to ply his trade on obstinate Chinese patients whom he believes are more handicapped by cultural prohibitions against Western surgical procedures than by the tumors, goiters, and fractures that afflict them. In Parker's time, this failure to accept Western medical treatment was literally a failure to open oneself up to the Christian god since medicine was intended to be the vehicle of the Word. But even later, once the influence of missionary organizations in establishing hospitals began to wane, the attitude that Chinese were culturally incapable of acting in their own best interest persisted.[69]

Evidence of this idea of a generic cultural obstinacy around surgeries can also be found in some of Lam Qua's portraits. In the portrait of Wang Ke-king, "the son of a respectable tea broker resident in Canton," for instance, the figure stands along the vertical axis with his back to the viewer and his head turned slightly so that we can make out his profile and his almost cheerfully oblivious expression (figure 4). He wears a long white gown, coarsely detailed, which he lifts with his left hand to expose for the viewer an enormous pendulous growth that appears to be even larger and even wider than the host torso itself (Parker records that the growth was "nearly one third of the weight of the man").[70] From beneath this growth project Wang's legs, his trousers lying in a heap around his ankles. Hanging the length of his body and tapering off toward the bottom edge of the frame is Wang's queue. The two white circular patches on the growth would no doubt have been explained by Parker to the viewing audience as examples of a form of Chinese medical treatment, about which the physician William Henry Cumming remarked, "Chinese plaisters applied to two craters that have opened upon this mountain [are] as effectual probably in preventing Eruptions as would be a wire gauze hood over the top of Vesuvius to check a discharge of his artillery."[71] The background, a simple interior, is of the same luminous brown as the before picture of Po Ashing.

From Parker's journals we know that for this case, unlike for the majority of those depicted in the medical series by Lam Qua, there is no implicit after — no utopia, no universal healing. This patient not only did not survive and go on to live a "normal" life but he never even accepted the treatment from which he might have had a chance to "perfectly recover." Parker writes: "Previous to the [bioptic] incision, the main objection to an operation . . . was the unwillingness of his wives; the removal now seems more formidable to the patient himself. Whether it shall be attempted or not depends upon his relations to determine . . . [the young man] is of a nervous temperament, all his motions quick, and very sensitive to the slightest touch."[72] Later Parker makes a lengthy entry, worth reproducing almost in its entirety:

On the 26th of March 1838 Wang Ke King was seized by a violent fever which terminated fatally in three days. I was not aware of his illness till his death was reported. Immediately repairing to his late residence, I was shown the way into his room, where his two youthful widows and a little daughter, clad in sack cloth, were upon their knees upon the floor by the

side of the corpse, with incense and wax candles burning before them. After retiring from the room, it was explained to the father and brothers how desirable it was that the tumor should be examined, the service it might be to the living, and the inconvenience of putting the body & tumor into one coffin; they affected assent, but must first consult the widows and mother. The father soon returned, saying it would be agreeable to him to have the examination, but the mother and wives of the deceased would not assent. "They feared the blood and that the operation might occasion pain to the deceased." After returning home, the kindness of a friend enabled me to offer a present of $50 to the family, provided they would permit the autopsy. A linguist was sent to negotiate with them, but in vain. Probably $500 would not have overcome their superstition.[73]

Unlike Po Ashing or Akae, whose cases are distinguished in Parker's writing by their voluntary nature and their uncomplaining and even cheerful submission to the surgical knife, Wang Ke-king, by contrast, is portrayed as a somewhat helpless pawn, "nervous" and "sensitive," caught in the middle of an elaborate net of Chinese customs and superstitions that prevent him from receiving treatment. These customs and superstitions interfere at every juncture with the "desirable" application of Western science. Where Po agreed to be "the first Chinese to willingly submit" to an amputation, for example, it is Wang's wives' objection to surgery that prevents his going beyond the biopsy. After his death, cultural proscriptions concerning autopsy, not legalized until 1913, filtered through the nexus of familial superstition concerning the afterlife and the proper treatment of the dead, further keep Wang's body from being usefully examined.[74] As the microcosm of culture, it is ultimately the family, in particular the women, that is held responsible for obstructing the advancement of Western "service . . . to the living": even a bribe of $50 is not sufficient to "overcome their superstition" (more likely than not, it was only sufficient to insult). Ultimately the combination of the journal and the painting presents Wang to be as much the victim of his upper-class family's backward cultural practice as of the tumor itself.

Thus in Lam Qua's portrait of Wang, the long, fine queue running the length of his body serves as the literal yardstick against which we measure not only the astounding dimensions of the tumor, but (we are meant to read) the extraordinary backwardness of a culture that would not allow Parker to

operate on it. As the most obvious outward marker of Chinese cultural difference, the queue, which actually was commonly used as a sort of measuring tape in everyday life, forms a blunt visual equation with the huge tumor. In other words, it is clear that this picture represents a very noticeable pathology in need of excision; but the question is, which one? Along with the plaisters, which underscore by their diminutive size the inadequacy of traditional Chinese medicine to address the problem of the tumor—as well as even the white robe that invokes the specter of death (it is the only portrait in the series to use white in this way)—the queue seems to symbolize the need for cultural reform, for the surgical removal of all that is "distorted and deformed" in Chinese resistance to Western technology and spirituality.

A final example of Lam Qua's medical portraiture further illustrates how the portraits, read in conjunction with Parker's journals, pathologize Chinese cultural practice and, by extension, Chinese identity. In the only picture to contain two human subjects, a painting that easily recalls the Madonna and child, an upper-class woman is portrayed holding her young daughter on her lap (plate 8). In this portrait the child occupies the center of the frame. Looking more like an adult in miniature, she sits somberly on her mother's lap, her left arm disproportionately foreshortened. Her well-dressed mother sits in a similar angle to the child, holding her somewhat stiffly, her arms posed geometrically around the child's body. The motion of the painting flows in a crescent, beginning with the mother's hairpin, curving inward along the angle of her body, and ending finally at the child's gangrenous feet, which, like Akae's facial tumor, seem almost an afterthought as they dangle in the lower left quadrant of the frame.

Like the portrait of Wang Ke-king, this painting also depicts a subject whose illness, we read, could have been cured or at least treated more effectively with the early intervention of Western medicine. We know from Parker's report that the family members concerned in the process of bringing in the patient for treatment showed some reluctance about accepting the principle of Parker's advice:

Loss of both feet at the ankle, from compression.—March 8, 1847. Lu Akwang, an interesting little girl of Honan, 7 years of age. February 9, agreeably to a custom that has prevailed in China for thousands of years, the bandages were applied "a la mode" to her feet, occasioned her excessive sufferings,

which *after the lapse of a fortnight* became insupportable, and *the parents were reluctantly compelled to remove the bandages*, when as the father represented, the toes were found discolored. Gangrene had commenced, and *when she was brought to the hospital, March 8*, it had extended to the whole foot. The line of demarcation formed at the ankles, and both feet were perfectly black, shriveled and dry, and nearly ready to drop off at the ankle joint. . . . The friends preferring it, *notwithstanding advice to the contrary*, they were furnished with the necessary dressings, and the child was treated at home, being brought occasionally to the hospital. The last time she was seen, the right stump had nearly healed over; the other was less advanced in the healing process.[75]

In this passage Parker's language clearly demonstrates a critical attitude toward the patient's family: not only does he write that they were only "reluctantly compelled" to confront the problem initially but Parker also takes special note of the timeline of events concerning this particular case. The girl's "excessive sufferings," he writes, continue for "a fortnight," by which time "the toes were found discolored." However it is another two weeks, the physician writes, before the parents bring the girl to the hospital, by which time the gangrene "had extended to the whole foot." He then further criticizes the parents by recording how, "notwithstanding advice to the contrary," the family insists on treating the girl at home.

As in the case of Wang Ke-king, the locus of this critique lies within the family unit. Where Parker opens the passage discussing the larger problem of foot binding as a cultural phenomenon ("a custom that has prevailed in China for thousands of years"), by the close of the narrative the problem has become localized: this particular family's stubbornness, their "reluctance" to accept Parker's "advice" regarding proper treatment. Where cooperative parents like Akae's father consistently earn Parker's effusive praise throughout his journals, the target of this critique of Chinese cultural practice, as in the case of Wang Ke-king, is located in the wealthy or upper-class Chinese family.

Lam Qua's portrait therefore, like that of Wang Ke-king, is a critical one: less a portrait of the adverse effects of Chinese cultural practice at large than of the interference of a class-marked Chinese culture with Western healing paradigms. Like the queue in the picture of Wang, in this painting the additional presence of the mother acts as a sort of symbol of the culture against which the

gravity of the child's pathology is measured; the presence of the mother evokes the sinister nurture of Chinese culture, to be read as "foot binding = Chinese = maternal = barbaric." The parents' significant role in Parker's journal narrative in obstructing his better judgment regarding the girl's treatment is echoed in the mother's protective embrace. Thus what fascinates about this painting is that what might otherwise seem like maternal nurture is in fact represented as its opposite. Whereas on the one hand the painting presents a girl who must be cured of her *pathological* condition, on the other it also portrays a mother who must be cured of her *cultural*, Chinese, condition.

In short, in Lam Qua's paintings we see both the creation and pathologization of an image of Chinese identity based on certain Chinese "characteristics": insensibility to pain, the inadequacy of native medicine, a cultural inability to perform either amputation or autopsy, a belief in the spirits of the dead, and superstition in general. As part of what was to become in the modern era the idea of the Sick Man of Asia, a persistent romantic and imperialist stereotype about Chinese nationhood in which national identity and race were always already pathological, these paintings not only fabricate a Chinese cultural identity that is fundamentally sick but they also describe a cure for it. For those "good" Chinese who accept the ministrations of the Western surgeon, the cure of a promised land, with its clear skies and a reunion with nature, awaits. However, for "bad" Chinese, who either reject the doctor-missionary's treatment or who fail to escape from the menacing web of Chinese tradition, the end appears grimmer. Either way, the paintings hint at a radical cure: the superimposition of a new and improved Chinese identity that can be had only through the ministrations of the medical missionary.

Laying the Foundations

Within an astonishingly short time after Parker returned from his fund-gathering mission in the West, not only was China "opened" to European incursion—Westerners could at last move relatively freely within the interior, plying their ideological and commercial interests—but developments in anesthetics, antisepsis, dissection, photography, x-ray (Röntgen) technology, and microbiology, and eventually the discourse of race itself, followed each other in quick succession and were soon adopted among medical missionaries in China. As one report notes upon the signing of the Treaty of Nanking, "[We]

need no longer be confined to a corner of the empire, nor its hospitals be limited to one spot where the jealousy of a weak and despotic government has surrounded us with a system of restriction and surveillance that has rendered intercourse with the people limited and uncertain."[76] At the same time, the idioms and collaborative methods that Parker and Lam Qua helped pioneer in the years before the Opium Wars bled naturally into the agendas of the new world order, as if ready-made: painting studios became photography studios; beliefs about Chinese "insensibility to pain" became debates about the appropriate use of ether and chloroform; "freaks" became "patients," and later, hospitals became museums; Chinese medicine came to be defined in opposition to Western medicine; and the less easily quantified categories of Chinese characteristics gave way to the more material hierarchies of race.[77] The following chapter examines this transition in greater detail through the lens of the development of medical photography in China.

The Pathological Empire

Early Medical Photography in China

> The patient is the rediscovered portrait of the disease; he
> is the disease itself, with shadow and relief, modulations,
> nuances, depth; and when describing the disease the doctor
> must strive to restore this living destiny.
> —*Michel Foucault,* The Birth of the Clinic: An Archeology
> of Medical Perception

Talking about early photographic representations of China, one thinks first of the documentary photography of John Thomson, whose portrayal of an essentially Chinese character across the body of his works has come to symbolize an age, a nineteenth-century ethnographic and touristic moment that managed to incorporate not only Cambodia, Malaysia, and Thailand but also all of China into the vast visual rhetoric of the global.[1] But there was another influential genre that worked in similar ways: early medical photography. By the late nineteenth century there existed in China a vibrant fraternity of medical practitioners that had concrete religious, political, commercial, and ideological ties not only within the country but all over the globe, and that had been there perhaps longer, and penetrated more deeply, than any other foreign group. Western doctors in China in the late nineteenth century often acted not only as medical providers but also as missionaries, diplomats, translators, military surgeons, or educators, and later as accomplished politicians with substantial material and cultural ties to the West. They hailed from the

United States, the United Kingdom, Canada, Sweden, Germany, the Netherlands, France, and beyond, and they often collaborated closely at a grassroots level where other representatives of their nations clashed. By the turn of the century, these doctors formed what I now think of as an extensive "circuit community," the web of whose influence regularly extended beyond the limits of national identity and whose members exchanged information about their "more fascinating cases" through letters, demonstrations, fund-gathering tours, lectures, and presentations, as well as through a profusion of new and dedicated disciplinary publications.

The introduction of photography in the mid-nineteenth century provided Western doctors in China with a powerful tool for illustrating these exchanges. Beginning in 1861 with the first recorded use of a photograph for medical purposes in China, photographic images began to be circulated in private exchanges among doctors; in medical and teaching museums both in China and abroad; and in serialized publications like the *China Medical Missionary Journal* and the *China Imperial Maritime Customs Medical Reports*, as well as in anthologies of the "freaks" and physical anomalies that were so much the object of Western fascination.[2] The earliest translations of Western photography manuals into Chinese in the 1870s were done by Western missionary doctors; and by the time the first so-called instant cameras were introduced in China around 1895, Western doctors regularly and enthusiastically exchanged, circulated, collected, annotated, archived, and published images of their patients, while developing techniques that would later become industry standards in medical and clinical photography worldwide.[3] In the tradition of Lam Qua's medical portraiture, moreover, a key target audience of these images—and even, by the beginning of the twentieth century, a key producer of the photographs themselves—was the Chinese, in the form of patients, medical students, and doctors.

Photography has been well discussed in academic contexts as a vehicle of colonial, scientific, and other ideologies, and, unsurprisingly, such discursive rubrics also prove germane here.[4] Anne Maxwell, for instance, makes the important point that "photographs of the colonized encompassed a wide range of forms and genres." She elaborates that these forms and genres included but were not limited to "*cartes-de-visite* (sometimes referred to as cabinets), daguerreotypes, collotypes, postcards and stereocards," and that they spanned

"a wide range . . . of registers, including ethnology, travel, and portraiture," a diversity of media which becomes relevant in this chapter's discussion of the forms in which medical photography circulated in China.[5] Likewise Roberta Wue draws connections between the thematic and conventional priorities of late nineteenth-century export photography in Hong Kong and those of earlier Cantonese export art, connections that bear directly on our understanding, in a parallel fashion, of the relationship between Lam Qua's work and the medical photographs that came later.[6] Nancy Armstrong's analysis of representations of class in late nineteenth-century documentary photographs of London street life meanwhile reflects usefully on a discussion of the spectrum of subject matter, as well as on the modes of representation, that characterized medical photography in China during the same period, while James Ryan's discussion of "photographic 'types'" and "the role of photography within a more systematic process of scientific observation, particularly of racial difference" in Victorian photographic practice, brings into play questions about the ways that scientific or medical looking overlapped with ideas about, and visualizations of, race.[7] With respect to the relationships among representations of race, type, and pathology in photography in particular, Ryan notes that

> the language and imagery of "race" occupied a central place within Victorian culture where it was used variously as a measure of bodily difference and as a description of national identity. While interest in "race" was increasingly focused around the sciences of ethnology and anthropology, it pervaded all manner of scientific concerns, particularly those of imperial import. . . . photographs of "types" were framed by a wider cultural discourse which marked and read human character through visible signs of the human body. Theories of physiognomy, the reading of "character" in physical features (particularly the face), and phrenology, the indication of character from the shape of the skull, were central to the making and reading of character in Victorian literary and visual culture. . . . claims that photography could "rigidly preserve the pathology of the human body" ensured that photography was taken up by those interested in the classification and identification of different physical and mental conditions.[8]

Here we are reminded that, like Lam Qua's paintings before it, medical photography in China also was inevitably "taken up by those interested in the clas-

sification and identification of different physical and mental conditions," but now, in addition to attempting to manifest the more diffuse notions of "character" that Lam Qua tried to portray, representations of Chinese pathology were even further complicated by the complexities of new ideas about race in the age of ethnography and phrenology.[9] (Or as Ryan helpfully concludes, "In the minds of many Victorians, 'Zulu Kaffirs' and 'the insane' . . . were equally 'other' to the white, male and middle-class norm of Victorian culture.")[10] In short, in early medical photography in China we see the convergence of those colonial, commercial, ethnographic, and scientific ideologies that marked the indisputable entrance of the "Chinese specimen" into global discourses of race and health: the racialized and pathologized Chinese identity that was the supposedly scientific counterpart to more heuristic stereotypes about China as the "Sick Man of Asia."

In this chapter I aim not only to sketch some of the basic history of medical photographic practice in China but also to outline an important transition in the representational priorities of medical photography that occurred between the time it was introduced, in the late nineteenth century, and the time it matured into its own genre, in the early twentieth century. In photography of this period, I will argue, we can see a clear transition from a more biographical or culturally descriptive mode of representing Chinese identity (a "culturally characteristic" and metaphoric pathology closer in spirit to that represented in Lam Qua's paintings) to a more thoroughly racialized mode indicating a primarily metonymic relationship of disease to host (the "Chinese specimen," now representing the Chinese empire as well). It was this pathological Other, as much as Thomson's formulation of a Chinese racial type, that ultimately was conveyed to Westerners as an essential image of China, and, importantly in the age of photography and medical expansion, to Chinese viewers as well.

Modes of Circulation

Early medical photography in China circulated in what can be reduced to three ways: through the establishment of medical archives and museums; through private collections in the form of scrapbooks, curios, and postcards; and more widely through inclusion in publications like the newly established *China Medical Missionary Journal*. All three of these modes overlapped and ultimately contributed to the development and reification of those ideas about

China and Chinese pathology that pervaded medical discourse in both China and abroad at the start of the modern era. Examples of all three groups survive not only in isolated vernacular cases and in archival forms (both public and private) but also in medical anthologies like *The Diseases of China, Including Formosa and Korea*, a heavily illustrated work published first in Philadelphia in 1910 and again, with certain modifications, in Shanghai in 1929.[11] In its goal of presenting "to medical men working in China, both Chinese and foreign, a concise account of the special diseases they will meet with . . . in this Empire," *The Diseases of China* drew directly on material collected over nearly five decades and thus remains one of the best (and least exploited) resources available on early medical photography in China.[12]

In the words of Georges Didi-Huberman, "The nineteenth century was the great era of the medical museum."[13] China was no exception. In 1838 the newly formed China Medical Missionary Society had declared its intention to establish a "museum of natural and morbid anatomy" containing "paintings of extraordinary diseases, & c.," and by 1895 dedicated medical museums or permanent exhibits in more varied collections had been established in Canton, Shanghai, Jinan, and beyond.[14] Concurrent (and occasionally coincident) with a proliferation of scientific and historical museums in China during the late nineteenth and early twentieth centuries, these medical museums were designed to function didactically, both as a repository for information about diseases in China for use by doctors and archives around the world and as an educational tool for local medical students and clinicians in the manner of a teaching hospital, with which the museums were often affiliated.[15]

Where live or preserved specimens of gross pathology were either difficult to come by or impossible to transport, medical museums were designed to provide students and clinicians with the next best thing: realistic representations of the pathologies in question, as well as ready access to samples. In the case of medical museums in China, moreover, such representations would provide the ocular demonstration that missionaries like Peter Parker believed was essential to successfully communicate the benefits of foreign surgical practice to the Chinese where other methods had failed; Lam Qua's paintings greeted

patients in the receiving room of the Canton hospital for the same reason. Further, this missionary conviction about the value of the ocular in conveying the values of the emerging medical institution had only grown since Parker's and Lam Qua's day. For example, as noted in the introduction, the Reverend T. W. Pearce remarked in an 1885 address commemorating the fiftieth anniversary of the Canton hospital on his belief that "the Chinese write and speak pictures," and that the hospital itself was therefore "a picture on which they must constantly look," supplying "ocular evidence" of the foreigners' good intentions.[16] Thus, even before the invention of photography, there was a precedent not just for the archival practice of collecting images of pathology but also for the expectation that such images could function positivistically as proxies for "real" Chinese pathologies at home and abroad.[17] As the century wore on there was also an increasing awareness of the potential of the medical institution itself to act as an "ocular" emissary of medical missionary values. The establishment of dedicated medical museums could not be far behind.

The first recorded use of photography for this type of medical archival purpose in an institutional context occurred in 1861, when John Kerr (1824–1901), Parker's successor at the Canton hospital, in residence from 1855 until 1899, commissioned a photograph of a man with "elephantiasis" (later identified as neurofibromatosis or Von Recklinghausen's disease). As K. Chimin Wong and Wu Lien-teh note, "apparently for the first time—*photographs* as well as paintings of interesting cases were made and paid for"; another writer even ventures—incorrectly—that this "was certainly the first instance of photography in China."[18] In the annual report for the Medical Missionary Society for 1861, Kerr wrote:

> Elephantiasis. This man, 65 years old, is a native of Shan-ping. His body and arms are covered with hundreds of tumors, varying from the size of a small pea to that of a walnut. A large flabby tumor hangs from the left side of his head and face. It extends beyond the median line behind and involves the cheek in front, forming a kind of semicircle around the ear, just above which the scalp is not involved. The attachment does not extend below the middle of the neck, but the tumor hangs down to the shoulder. On the back part of this tumor is a large cicatrix, the remains of old ulceration, probably caused by caustic applications. The thighs and legs have very few of these tumors. On the right elbow is a soft flabby tumor as large as a man's

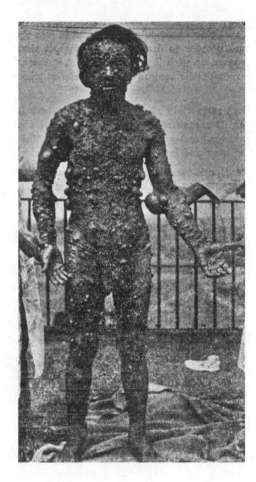

fist. His body and limbs were well developed. Digestion good and spirits lively. The disease first made its appearance on the right elbow at seven or eight years of age. The large tumor on the side of the head began when he was twenty years old and the smaller ones within the last fifteen years. The number of tumors increases every year. A photograph of this case was taken by Mr. Miller.[19]

In many ways this employment of photography by Kerr was, though it used a different medium, clearly the direct legacy of Parker's employment of Lam Qua to paint portraits of his more "interesting" cases. Like Parker before him, Kerr outsourced the task of representing the pathological patient to a professional artisan in Canton. Due not only to coincident dates but also suggestions about style, it is very likely that "Mr. Miller" refers to Milton M. Miller, a successful

American photographer working in Hong Kong and Canton whose focus on compelling portraits (rather than landscapes and "types," as practiced by many of his contemporaries) was a kind of signature.[20] Furthermore, like Parker's earlier case journals, the description in the text follows that of the image in close detail, although in Kerr's text the patient remains anonymous and no attempt is made to describe a cure or the outcome of treatment. Like Parker before him, Kerr also recorded in the hospital ledgers the precise amounts he spent for medical illustrations made on behalf of the hospital. In 1861, for example, Kerr noted spending $42.50 on "Paintings and Photographs," while in 1863, $10.95 were paid for "photographs and drawings of cases" (as a point of comparison, recall that Kwan A-to, Parker's former assistant and Lam Qua's nephew, now working for Kerr, was paid an annual salary of $128 and $120 in 1861 and 1863, respectively).[21] Finally, as portrait photography at this time employed wet collodion glass and albumen plates that required not only a long exposure time but preferably a well-lit studio equipped with "a glassed-in room that let in sunlight . . . and metal head braces (to hold the sitter steady and motionless through the long exposure time)," we must also consider that despite the change in medium the experience of sitting for a photographic portrait at this time would still have been extremely uncomfortable, even for those sitters who were not already compromised by some inconveniencing pathology.[22] (As Walter Benjamin remarked in his description of a photo of Franz Kafka in his youth: "It was probably made in one of those nineteenth-century studios whose draperies and palm trees, tapestries and easels placed them somewhere between a torture chamber and a throne room.")[23] Thus the sixty-five-year-old "native of Shan-ping" who was the subject of China's first known medical photograph would have had to stand uncomfortably still, naked and propped up by two pairs of supportive hands on an outdoor balcony—not much of an improvement over the situation of Lam Qua's sitters from only a decade earlier.[24]

After this incident, Kerr's commitment to the use of photography and other forms of medical illustration as a means of simultaneously communicating with Chinese viewers and advancing Western clinical knowledge continued to grow. In addition to keeping ledgers recording annual expenditures for photographs, woodcuts, paper, and printing supplies, for instance, Kerr almost immediately began to use the photographs in the hospital. One Robert E. Speer,

PLATE 1: Lam Qua, *Chow Keätseuen, Aged Thirty-one, a Florist of Shuntih*, ca. 1839, oil on canvas, 23 × 18 inches. COURTESY OF YALE UNIVERSITY, HARVEY CUSHING/JOHN HAY WHITNEY MEDICAL LIBRARY.

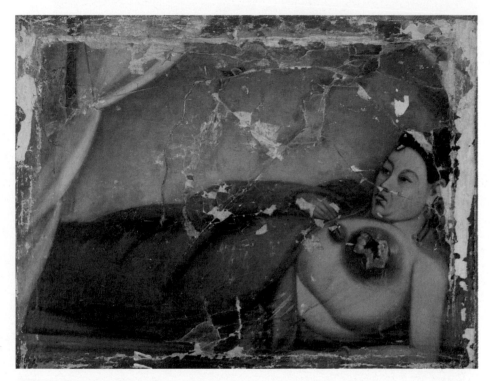

PLATE 2: Lam Qua, *Unidentified Patient*, ca. 1837–50, oil on canvas, 24 × 18 inches. COURTESY OF YALE UNIVERSITY, HARVEY CUSHING/JOHN HAY WHITNEY MEDICAL LIBRARY.

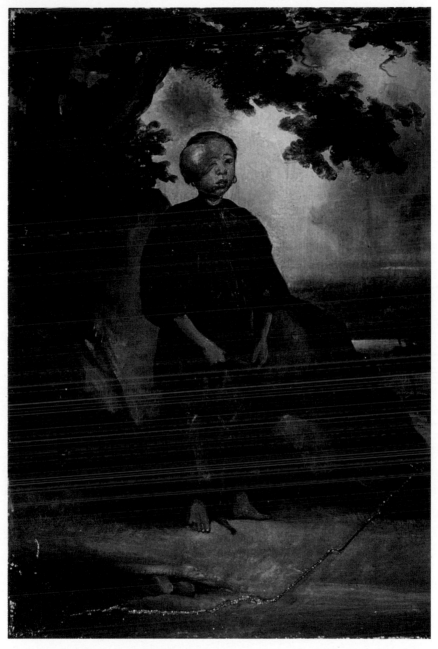

PLATE 3: Lam Qua, *Akae, a Little Girl Aged Thirteen*, ca. 1836, oil on canvas, 23 × 18 inches. COURTESY OF YALE UNIVERSITY, HARVEY CUSHING/JOHN HAY WHITNEY MEDICAL LIBRARY.

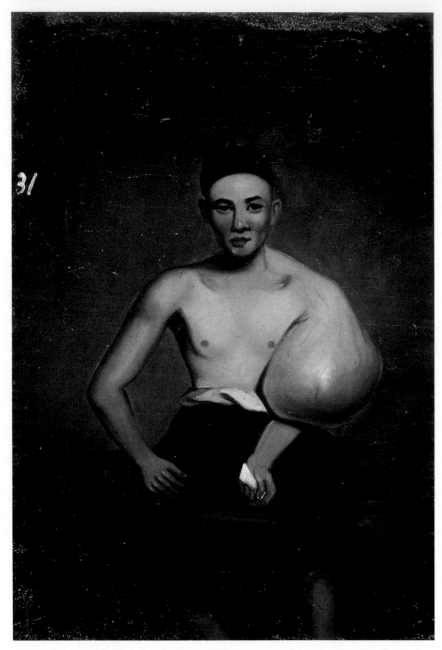

PLATES 4 AND 5: Lam Qua, *Po Ashing, Aged Twenty-three* (before and after surgery), ca. 1837, oil on canvas, 24 × 18 inches. COURTESY OF YALE UNIVERSITY, HARVEY CUSHING/JOHN HAY WHITNEY MEDICAL LIBRARY.

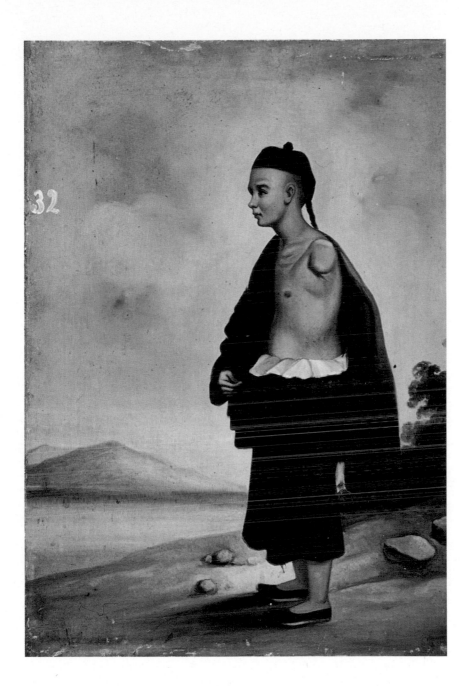

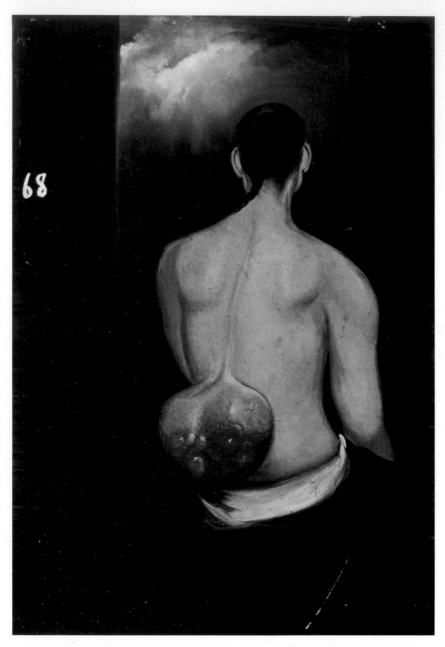

PLATE 6: Lam Qua, *Unidentified Patient*, ca. 1837–51, oil on canvas, 24 × 18 inches. COURTESY OF YALE UNIVERSITY, HARVEY CUSHING/JOHN HAY WHITNEY MEDICAL LIBRARY.

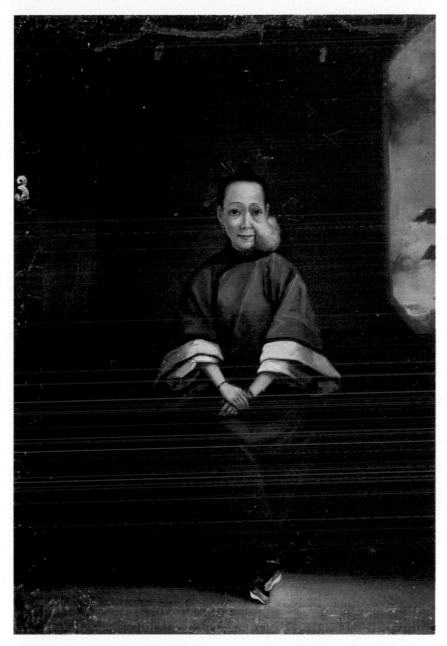

PLATE 7: Lam Qua, *Lo Wanshun, Aged Forty-one, [an] Interesting Woman of the First Society of Her Native Village* (?), ca. 1837, oil on canvas, 24 × 18 inches. COURTESY OF YALE UNIVERSITY, HARVEY CUSHING/JOHN HAY WHITNEY MEDICAL LIBRARY.

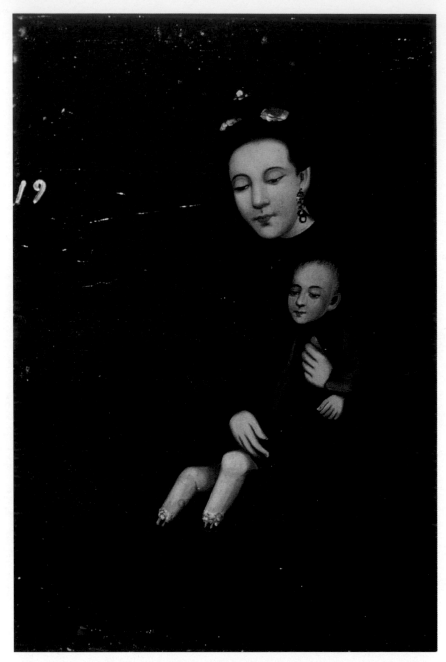

PLATE 8: Lam Qua, *Lu Akwang, an Interesting Little Girl of Honan, Seven Years of Age*, ca. 1847, oil on canvas, 24 × 18 inches. COURTESY OF YALE UNIVERSITY, HARVEY CUSHING/JOHN HAY WHITNEY MEDICAL LIBRARY.

in an article for the *Monthly Missionary Survey*, quotes a journalist's description of a visit to Kerr at the Canton hospital. Before visiting the clinic in person, the journalist reports, Charles Seymour, an American consul general in Canton, informed him that Kerr "'undertakes, almost daily, cases which our distinguished surgeons at home do not dare attempt, even in Philadelphia, the medical capital of our country.'" When the journalist subsequently "passed through the hospital" himself and "*inspected the photographs of operations already peformed, and viewed the array of deformities to be treated that afternoon,*" he wrote, "I could not doubt that what he said was literally true."[25] In January of 1866, furthermore, when the Medical Missionary Society published its amended charter, it once again stipulated that the establishment of a medical museum should constitute one of the organization's priorities. The "Regulations of the Medical Missionary Society" read: "Anatomical Museum. VI. That this Society form a museum of natural and morbid anatomy, paintings of extraordinary disease, &c., to be called 'the Anatomical Museum of the Medical Missionary Society in China,' and to be under the control of the committee of management." This time, however, the regulations even specified in article 10 that "all articles in the museum of the Medical Missionary Society, duly labelled, shall be placed in charge of a person, appointed by the committee for that purpose," and by 1876 — although it did not bear the name of the Medical Missionary Society — records show that "[a] museum had been started [at the Canton hospital] where specimens and collections 'as a result of operations' were kept."[26] The existence and didactic function of this museum is confirmed in the translated testimonial of a former pupil of Kerr's called Leung Kin Choh (梁乾初), who commented that "if one wishes to know the extent of the work done in the Hospital Clinic, [one] need only have a look at the collection of vesical calculi removed. Two large baskets, weighing about 130 pounds, were to be seen in the museum, and as many more had been taken away by the patients."[27]

Even as the educational facilities of the Canton hospital expanded to include a museum, however, Kerr never forgot the Medical Missionary Society's goal of establishing a dedicated, *national* China Medical Missionary Museum. In 1887, a newer, broader China Medical Missionary Association was formed. This time, designed specifically to bring together medical missionary workers from all over China, the new association would admit only medical practition-

ers into its membership (rather than lay members and purely philanthropic supporters), thus distinguishing itself from the earlier and more local Medical Missionary Society at Canton. With Kerr as the association's first president, the organization once again asserted its desire to establish an affiliated medical museum. In 1887, on behalf of the association, H. W. Boone issued a general plea in the pages of the new *China Medical Missionary Journal*:

> There are at present more than 80 medical missionaries scattered throughout the provinces of China. Nearly as many more medical men are engaged in the practice of their profession at the various ports of trade. All of these gentlemen have from time to time the opportunity of seeing rare or interesting cases of great medical or surgical interest. Some of these doctors have taken every opportunity to prepare and preserve specimens illustrative of the various diseases that have come under their observation. Many more would be willing to take the same trouble if the results of their labors could be made available for the benefit of others. . . . Every medical missionary is a member of our Association. Every respectable medical man can become an honorary member by applying or signifying his desire to join. We beg all medical men in China to remember the Medical Museum.[28]

By 1890, the minutes of the annual meeting of the new Medical Missionary Association included the stipulation that "if possible a Medical Museum be started in Shanghai, and that a sum not exceeding $50.00 per annum be allowed the Curator for expenses." It was also recorded that "the CHAIRMAN [Boone] stated that he was prepared to give a room, suitably fitted up with shelves, in S. Luke's Hospital, in the event of a Museum being established."[29] In the *China Medical Missionary Journal*, furthermore, a full-page notice appeared with the heading "Museum of the Medical Missionary Association of China, St. Luke's Hospital, Shanghai," acknowledging an inaugural contribution of "a Jar, containing specimen in spirit. From the Rev. S. R. Hodge, M.R.C.S., L.R.C.P., (*Lon.*)," and for the library a translation of *Gray's Anatomy* by a "Dr. H. T. Whitney," as well as a "complete set of copies of the *China Medical Missionary Journal*"; the signature under the notice read "Percy Mathews, M.D., *Curator*."[30] Though the development of the museum's collection started slowly, in 1895 "a valuable addition to it was made . . . when the specimens prepared by Dr. Jamieson were purchased," and in 1900 a new curator, a Dr. Lincoln, was named.[31]

FIGURE 8: Photographer unknown, "St. Luke's Hospital, Shanghai. Main building," ca. 1907. Reproduced from Jefferys and Maxwell, *The Diseases of China* (1910), 678. COURTESY OF HARLAN HATCHER GRADUATE LIBRARY, UNIVERSITY OF MICHIGAN, ANN ARBOR.

A note on popular Chinese awareness of the medical archival practices of St. Luke's: Various records from the late 1800s confirm not only that many Chinese knew about the medical archival activities taking place within hospital walls but also that this awareness contributed to popular attitudes among Chinese toward Western-style medical practices like autopsy and dissection.[32] One avenue by which ordinary denizens of Shanghai learned about such practices, of course, was through local connections to the hospital itself: besides nurses, coolies, clinicians, medical students, and patients, the hospital employed numerous laypeople to do everything from preparing meals to washing linens and conducting the hospital's horse-drawn ambulance through the streets of Shanghai.[33] But local people also learned about archival practices such as the removal and preservation of pathological specimens through publications like the 點石齋畫報 *Dianshizhai huabao* [*Dianshizhai Pictorial*], an illustrated journal published in Shanghai between 1884 and 1898.[34] In one vignette from 1895, for example, a woman with a large abdominal tumor goes to St. Luke's (known in Chinese as the *Tongren* 同仁 hospital) for treatment, where she dis-

covers that "according to the Western doctors, a tumor of this size [had] never been seen before, so they preserved it in medicinal water and sent it to a major hospital in the West as material for investigation." Another report from 1896 describes the delivery of an abnormal foetus. In the latter case, a baby is born with "four arms and four legs, like two people embracing," and two heads "but only one body." The report concludes, "We have heard that the dead child has been preserved in medicinal water, and kept inside the operation theatre. It will be placed in a museum for research."[35] Both reports specify that the surgeries were performed by a "woman doctor" (possibly a reference to Elizabeth Reifsnyder, a prominent female surgeon in Shanghai during these years), and both reports are accompanied by detailed and fanciful illustrations depicting the surgical proceedings, including the removal of the tumor and abnormal foetus by a conspicuously attired foreign woman surgeon—a "striking and durable impression" indeed.[36]

Though Parker did not live to see it, the museum first envisioned by the Medical Missionary Society was established at last not in Canton but at St. Luke's Hospital in Shanghai. Here it became known among foreigners and locals alike, and true to the charter of the original Medical Missionary Society, its archives became not only a valuable resource for Western doctors but an educational tool for the training of Chinese medical students. Moreover, with rapid-fire advancements in optics, light-sensitive emulsions, and other practical technologies toward the end of the century, would-be archivists no longer had to depend on professional photographers with well-equipped studios to produce their visual records, and photographs of unusual specimens began to pour in from all over the empire.

"PECULIAR TO CHINA": PRIVATE COLLECTIONS

The circulation of any specific type or genre of photography in private collections can be difficult to trace, and individual details of production often remain impossible to authenticate. Nonetheless it is certain that early medical photography in China circulated not only between doctors in remote outposts and the archives in Shanghai but also between individual doctors stationed around the country, as well as among tourists and the general population as souvenirs, curios, case studies, and collectors' items. As we have already seen in the case of "Mr. Miller," for example, medical and commercial photogra-

phy occasionally overlapped at the level of production; in photography's early years, the same photographer might be employed to shoot both medical and conventional portraiture.[37] At the same time, however, this overlap also occurred at the level of content, in the form of demand for "medical" photography in commercial contexts. One example concerns the parallel markets for images of bound feet: doctors and tourists alike collected them avidly.[38] Similarly, from Parker's day onward, both doctors and tourists were fascinated by images of wounds inflicted by war, torture, and punishment. As Roberta Wue remarks regarding early photography produced for export in Hong Kong, "At its ugliest, established preconceptions of Chinese culture created a voyeuristic and morbid fascination with specific Chinese cultural practices, particularly the custom of binding women's feet and Chinese torture and execution. . . . Such scenes inevitably made their way into photography, and could only reaffirm for Western viewers their worst assumptions about the barbaric and despotic Chinese character."[39] Such a fascination played easily into an escalating general demand for photographs of different Chinese "types."

In the era of the medical museum, not only bound feet and an array of wounds but medical anomalies and "freaks" thus performed double duty as subjects for both commercial and medical photography in China. "Diseases Peculiar to China," the twelfth chapter of the first edition of the medical anthology *The Diseases of China*, is subdivided into sections on "Freaks and deformities. Artificial deformities. Foot-binding. Scars" and contains numerous photographs and several x-rays. It opens with the comment that "China has long been known as **the world's largest storehouse of physical freaks,** and we are familiar with the expressions Chinese giant, Chinese dwarf, and so on, and remember a good proportion of Chinese freaks in our home dime museums and circuses."[40] Meanwhile an initial photograph, taken by the editor W. Hamilton Jefferys himself, makes equally explicit the chapter's conceptual links to various commercial and voyeuristic discourses of the supposedly freakish and physically anomalous: it is a picture not of any particular medical condition or disease in our contemporary sense of the term, but of the perfectly healthy "McGinty, a well known dwarf, at fifty years of age," whom the editors go on to describe as an example of a Chinese curio who had "travelled with various circuses throughout the world [and] is now a man well on in life and permanently resident in Shanghai, his occupation being the amusement of guests at

FIGURE 9: William Hamilton Jefferys, "McGinty, a well known Chinese dwarf, at fifty years of age," date unknown. Reproduced from Jefferys and Maxwell, *Diseases of China* (1910), 303. COURTESY OF HARLAN HATCHER GRADUATE LIBRARY, UNIVERSITY OF MICHIGAN, ANN ARBOR.

the Astor House, where he dresses as a porter and 'chin-chins' the globe trotters" (see figure 9).[41]

The idea of the Chinese "freak" as human curio, the function of whose corporeality is to provide amusement for well-heeled travelers passing through Shanghai, likewise translated into the market for postcards and photographs as souvenirs or "authentic" records of travelers' experiences in visiting China and seeing for themselves what kinds of monsters and anomalies were "peculiar to China." The postcard reproduced in figure 10, for instance, bears the label "Chinese Lady with a 'Double Chin.' Goytree [Goitre] caused from drinking water." (A subcaption informs us additionally that "80 per cent of the people are affected in this manner in certain parts of China.") Here what Wue might call a kind of "slippage" occurs: an image that may or may not have been pro-

Chinese Lady with a "Double Chin."
Goytree caused from drinking water.
80 per cent of the people are affected in this manner
in certain parts of China.

Burr Photo Co., Shanghai, China.

FIGURE 10: "Chinese Lady with a 'Double Chin,'" postcard. Burr Photo Co., Shanghai, ca. 1901–10. Private Collection.

duced for use in one context (the medical) has here "slipped" into use in another (the commercial, the souvenir), the value of the authenticity that it sells bolstered further by the "scientific" truth suggested in its subtitle. As Anne Maxwell reminds us, photographs produced for the mass market in the late nineteenth and early twentieth centuries portraying either "'native' peoples as capable of gratifying Europeans' erotic fantasies and hedonistic desires" or, crucially, "the tropes of physical decrepitude and sexual promiscuity," were often "wedded . . . firmly to stereotype."[42]

We must also remember that as members of expanding foreign communities, doctors were themselves—as much as traders, tourists, and other travelers in China—active consumers of photography and other items produced for the China trade. Journals, letters, and anthologies, for instance, contain many references to a culture of private collection and exchange among doctors of photographs of tumors and other "curious" cases, some of which reveal a hobbyist's enthusiasm for the sport (for example, when Jefferys and James L. Maxwell remark of large tumors in the first edition of *The Diseases of China* that "one never sees one large enough but that some one else has removed one larger"; or "one never has seen one of curious enough origin but what one's neighbor can go one better").[43] A rare example of this kind of private

FIGURE 11: Photographer unknown, "John Swan in sedan chair, Canton Hospital," ca. 1901. REPRODUCED WITH THE PERMISSION OF KAREN SWAN NAFTZGER.

collection survives in the form of a scrapbook kept by John Swan (1860–1919), the third superintendent of the Canton hospital after Parker and Kerr between 1899 and 1914.[44] Here Swan collected not only pictures of some of his more dramatically afflicted patients but also photographs of the hospital's buildings and grounds (he was known for his renovations and extensive additions to same), as well as pictures of himself in various medical (professional) contexts. Besides a photograph in the operating room in which he is accompanied by two assistants and a patient on a gurney, for instance, Swan kept another personal memento: a photograph of himself seated in a sedan chair, supported by two Chinese coolies, and posed on the hospital grounds (figure 11). In this image, oriented horizontally on the manicured lawn and bounded by the hospital walls, Swan sits stiffly, his head turned slightly and his gaze oblique. His white uniform, safari hat, and dark shoes contrast sharply with the dark clothing, bare heads (braids coiled on top of the head), and bare feet of the two Chinese men. Most starkly, the white medical kit with its contrasting cross identify with a simple sign the picture and the man in the chair as belonging to a Western medical infrastructure. The attitude of the picture (located as it

is still *within* the hospital, the passenger's gaze looking beyond the viewer) suggests departure, perhaps on one of Swan's "journeys of fifteen or twenty miles into the interior," where he regularly traveled to treat obstetrical cases for the "relief" of which the hospital became increasingly well known during his tenure.[45]

But the picture also suggests a certain imperializing attitude toward or orientation around the experience of being a Western medical doctor in China, according to which enlightened Western medical practice (the cross, the doctor in white, the journey into the interior) was built literally on the backs of the Chinese. Here it is important to consider that the mode of representing oneself in a sedan chair supported by coolies, like representations of foot binding or medical phenomena, was not an accidental configuration but rather constituted a sort of trope or recurring theme in export or souvenir photography that had been actively employed (and actively debated) among foreigners in China from as early as the 1850s.[46] Fa-ti Fan's description is worth quoting at length:

> Under [the] relentless Chinese gaze, the Western travelers strove to live up to the image by which they defined themselves vis-à-vis Orientals, and they acted out the ideology of imperialism in the play of symbols. The working of cultural performances of imperialism in everyday life is well illustrated by an instance highly relevant to travel in China. The sedan chair borne by bearers was a common transport in much of central and southern China, and Westerners traveling in these areas routinely used it. Although a white man, stiffly attired, sitting high on a chair carried by barefoot Chinese evokes for us everything appalling about Western imperialism, this particular mode of transport had existed in China long before Westerners came. It was widely used by Chinese travelers who could afford it and thus differed from the system of *silleros*, Indian carriers, in the Andes, which had been developed to take white people across the steep mountains. . . . Indeed Western customers were extreme rarities compared with the Chinese who daily patronized the chair as transportation. But Westerners in China imbued symbolic meaning into the image of "a white man riding the Orientals," hence the numerous stereotypical pictures of this motif produced in the era. . . . A transport representing the customers' social status in the Chinese context was translated into racial superiority and imperial domination.[47]

At the same time that some Westerners appropriated the sedan chair to "act out the ideology of imperialism in the play of symbols," others objected to this appropriation: "The contemporaries," Fan observes, "were highly conscious of the multiple meanings of taking the chair transport. For example, an American naval surgeon who visited China in 1856–1858 despised the 'English' practice of using the sedan chair in Chinese cities. 'On a slave plantation, or in any city of a southern State,' he said, 'the most delicate and fragile lady would be ashamed to make a beast of burden of the negro slave, whilst it is not at all improbable that the two heavy old or new Englishmen now promenading upon the backs of these sweating Chinamen, are denouncing the horrors of American slavery.'"[48] As such, then, this image may be read not only as a personal memento of the doctor's journeys into the Chinese interior (here both literal and figurative, naturally) but also as representative of a certain contemporary discourse asserting the superiority of Western medicine, and institutional practice generally, through the semiotics of the sedan chair.[49]

"AN ORGAN IN WHICH TO EXPRESS OURSELVES":
PUBLICATIONS

By far the broadest and most systematic circulation of medical photography in China in the late nineteenth and early twentieth centuries, however, occurred through publications related to medicine such as journals and anthologies. Some of the earliest such illustrations appeared in the 1890s in the *China Imperial Maritime Customs Medical Reports* in the form of woodcut and lithograph reproductions "traced" from photographs (see figure 12).[50] The customs reports also contained numerous charts, graphs, and foldout diagrams, sometimes colored, of microorganisms, and in 1901 a rather impressive full-page, color-tinted portrait of a patient with complications resulting from leprosy; by 1904 an actual photograph, of lepers, was reproduced.[51] Even more consistent, however, were the increasingly frequent illustrations in the new quarterly *China Medical Missionary Journal*, established by Kerr and the new Medical Missionary Association in 1887 precisely for the purpose, among others, of filling the gap left by the customs medical reports, which the founders felt "consisted of scientific articles only and were not available for discussions of ways and means."[52] As Boone stated in the *China Medical Missionary Journal*'s inaugural issue, "In the establishment of a Medical Journal we have taken a

No. 1.

No. 2.

FIGURE 12: Before and after of a facial tumor. Reproduced from Thomson, "Dr. John D. Thomson's Report on the Health of Hankow." COURTESY OF HARLAN HATCHER GRADUATE LIBRARY, UNIVERSITY OF MICHIGAN, ANN ARBOR.

great step forward. In our Quarterly Journal we have now, for the first time, an organ in which to express ourselves, to report upon our work, and to enable us to gather the constantly increasing mass of observations and experience for the good of our own body and the world in general."[53]

The periodical, known to its authors as "the first medical missionary jour nal in heathen lands," began circulating in March of 1887, and in 1890, in the same minutes that called for the establishment of a medical museum, Kerr, Boone, and their colleagues added a clause to the association's charter stipulating "that photographs of cases may be published in the Journal, at the discretion of the Editor."[54] Significantly, this journal was intended, like the museum, to be of use not only to a medical missionary readership but ultimately to a select Chinese readership as well: Chinese authors eventually contributed both essays and photographs to the *China Medical Missionary Journal*, and starting as early as 1888, members of the China Medical Missionary Association began toying with the idea of publishing a separate quarterly entirely in Chinese.[55]

A precedent for such a multifocal illustrated journal already existed in the form of the *Reports of the Medical Missionary Society*—the same reports in which Parker recorded detailed descriptions of those cases that he felt merited

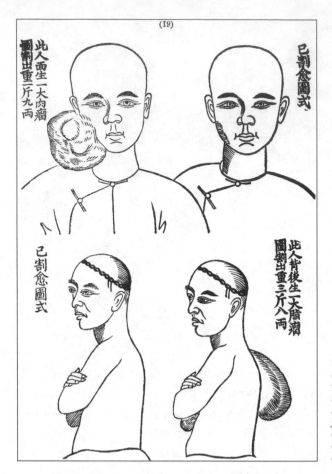

(19)

此人面生一大肉瘤　圖割出重二斤九両

已割愈圖式

已割愈圖式

此人背後生一大筋瘤　圖割出重三斤八両

FIGURE 13: Before and after of facial and back tumors. Reproduced from *Report of the Medical Missionary Society in China, for the Year 1868*, 19. COURTESY OF HARLAN HATCHER GRADUATE LIBRARY, UNIVERSITY OF MICHIGAN, ANN ARBOR.

attention for either their "surgical point of view" or their ability to illustrate "different shades of the character of the Chinese."[56] An example from 1848–49, for instance, was reportedly "the first to contain any cuts or drawings of interesting phenomena met with in the course of the year."[57] Under Kerr, not only were these reports sometimes republished in Chinese editions but illustrations appeared more and more often, usually in the form of woodcuts executed by artisans in Canton, but also as drawings and later lithographs, most labeled descriptively in Chinese, and frequently following the before-and-after format (see figure 13). Kerr made his objective in including such Chinese-captioned illustrations explicit. In the 1863 *Report*, the doctor noted that "a Report of the Hospital in Chinese has been published, at a cost of 84 cents per 100 copies. It is illustrated with several cuts two of which are contained in this Report. The

object is to communicate such information as will excite the interest of intelligent and wealthy Chinese in the operations of the Hospital, and induce them to contribute to its support."[58] At the back of each report also always appeared two separate lists: one of the names of Western donors and one, in Chinese, of the names of local benefactors. As with the photographs and specimens prepared for the museum several decades later, these journals were intended to serve the dual purpose of providing information to foreigners about medical practice in China while at the same time reaching a Chinese audience of potential donors, converts, and students.

Due to the limits of printing technology, the earliest issues of the *China Medical Missionary Journal*, like the *Reports of the Medical Missionary Society* before them, could only reproduce photographs in the form of woodcuts, lithographs, and engravings. Unlike before, however, advancements in photographic technology meant that photographic illustration itself was much more widely available and employable by doctors than it had been before. Whereas the 1861 medical photograph of the "native of Shan-ping" would have required an uncomfortably long exposure time and the absolute stillness of the sitter, by 1874 the invention of the more light-sensitive silver gelatin emulsion allowed for a more "instant" (and therefore much less physically taxing and labor-intensive) portraiture, and by 1895 the introduction of Kodak "pocket" cameras in China — as well as the invention of roll, celluloid, and paper film — further democratized the medium.[59] Consequently, although photographs published in the *China Medical Missionary Journal* at first might be reproduced as lithographs or engravings, their circulation, including their addition to the archives at St. Luke's and their exchange among doctors individually, flourished.[60] Thus a key contribution of the new journal was that it regularly began to include not only illustrations of microorganisms, graphs, and cases seen in major urban centers such as Canton, Shanghai (where it was published), or Beijing but also case studies sent in by individual doctors armed with cameras in remote provinces or battlefields. As Jefferys and Maxwell observed, "There are constantly being reported and shown in photographic form from various parts of the empire growths which, each and all, have their special interest or peculiarity, and many of which have been reproduced and accounted for in the *China Medical Journal*."[61]

Almost from the outset, then, the fact that the *China Medical Missionary*

Journal became a reader forum, a formal context for the types of exchange that had previously been exclusively private or limited to individual institutional collections, constituted an important development: readers could write in and contribute their own photographs or ask for advice about certain cases, and useful correspondence, "at the editor's discretion," might even be published. A typical example concerns the case of the doctor John Kuhne, who wrote in to the *China Medical Missionary Journal* in October of 1907 regarding a tumor removed from a small boy. "We have not examined the growth and would be very grateful to get your opinion about it," he wrote. "The specimen has been for a night in alcohol [*sic*] and has shrunk somewhat; afterwards it was put in formaldehyde. Hoping it will reach your hands undamaged, I make my best wishes for the success of your work and of the JOURNAL."[62] In this issue of the *China Medical Missionary Journal*, a dated report, complete with a laboratory report no. 5,297 from the Health Department of the Shanghai Municipal Council, is published alongside Kuhne's letter, followed by two photographs: one of the tumor in question, "showing the structure quite plainly," and another example from the St. Luke's archives "for comparison." As photographic technology developed and became available to more amateurs, the journal further turned out not only to be a forum for the discussion of medical cases but also (in the spirit of those earlier doctors who had first translated photographic manuals into Chinese) of photographic technique itself. Jefferys, for example, employed the vocabulary of the safari when he reported in a 1907 article entitled "Kodaking for Small Game" that "Dr. O. T. Logan, that chronic inspiration to good deeds, suggested to me, not long since, that something could be done by hitching a kodak to the proper extremity of a microscope, and I have gone 'luny' on the subject. It is great sport and beats bird nesting and tarpon snapping all hollow. I cannot claim any great results as yet, but find all the satisfaction in the world in recording what I do see in this very satisfactory form."[63] The article then goes on to describe in detail the mechanics of Jefferys' invention, followed by numerous examples. Several issues later, in 1908, Charles W. Young, a doctor working at the Peking Union Medical College, published a response in the "correspondence" section of the *China Medical Missionary Journal* under the heading "A Snapshot from Peking." Identifying first some of the organisms encountered by Jefferys, Young then suggests various methods for preparing slides, and finally makes some specific suggestions about photographic techniques.[64]

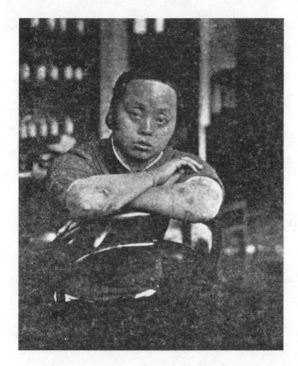

The *China Medical Missionary Journal* (and its later incarnations as the *China Medical Journal* and the *Chinese Medical Journal*) was, in short, the realization of the forum for which Boone had originally hoped; it was an open conversation among doctors, published and available to all, the successful realization of "an organ" for doctors to "express themselves." More important, this conversation could now include Chinese doctors like E. S. Tyau (刁信德), who took the photograph in figure 14. An ideal student and target of Western medical missionary ideals, the talented Tyau graduated from the class of 1903 at the newly established medical school at St. John's, where he subsequently became an "Instructor in Diseases of the Skin"; published scholarly articles in both Chinese and English; and assumed the post of the president of the National Medical Association of China between 1922 and 1924.[65]

Stylistics

[E]ven when the production of the picture is entirely delivered over to the automatism of the camera, the taking of the picture is still a choice involving aesthetic and ethical values: if, in the abstract, the nature and development of photographic tech-

nology tend to make everything objectively "photographable," it is still true that, from among the theoretically infinite number of photographs which are technically possible, each group chooses a finite and well-defined range of subjects, genres and compositions.

—*Pierre Bourdieu*, Photography: A Middle-Brow Art

Like Lam Qua's paintings before it, early medical photography in China did not belong to a fixed genre, but instead drew on a number of different styles to arrive at a hybrid functionality in each of the contexts I described above. This was consistent with trends in medical photography worldwide: "Many of the conventions employed in making early medical photographs," writes Daniel Fox, "were those which were used in paintings and drawings to produce portraits and domestic scenes. Photographers drew on these conventions, using them in all areas of medicine in order to represent, for instance, sick people, treatment, and doctors, individually or in groups."[66] Unlike in Lam Qua's day, however, by the late 1800s the medium had been somewhat democratized such that one need not be an artist or studio photographer to take a medical photograph; the field was now open to amateur "game hunters." More important, the burden of illustrating the "character" of the Chinese was no longer a priority in medical photography; now that the opening of the treaty ports and the relaxation of legal proscriptions against heterodox religions had broadened the missionaries' base of support, medical images were no longer required to function as aids in soliciting financial support or in justifying a medical missionary presence in China. Instead they had to satisfy a newfound taxonomic impulse to communicate details about the pathology, first, to the "interested fraternity" of doctors—both Western and Chinese—among whom they would circulate and be compared, and second, to those Chinese medical students, like E. S. Tyau, who would soon become active contributors to medical missionary activities themselves.

Yet in spite of these changes, early medical photography in China at first depended heavily on some of the same iconography and styles that had informed the production of medical illustration in Lam Qua's day. As one can see clearly in the woodcut images Kerr used in his bilingual medical reports of 1868 and the woodcut reproductions of photographs in the *China Imperial Maritime Customs Medical Reports*, for instance, an immediate source for some of these early photographs was the tradition, initiated by Parker and Lam Qua,

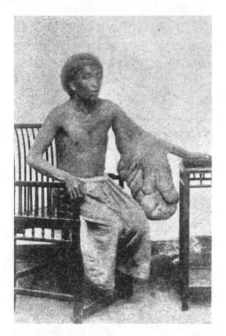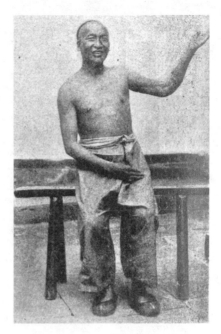

FIGURE 15: C. C. Elliott, "Molluscum fibrosum. Before operation and after operation," ca. 1908. Reproduced from Jefferys and Maxwell, *The Diseases of China* (1910), 438. COURTESY OF HARLAN HATCHER GRADUATE LIBRARY, UNIVERSITY OF MICHIGAN, ANN ARBOR.

of employing a before-and-after format to highlight the benefits of surgery (see figures 12 and 13). Now, however, photography allowed expression to play a more explicit role: in an 1890 issue of the *China Medical Missionary Journal*, for instance, the Reverend Dr. A. W. Douthwaite reported that

> Mr. Wang, whose portrait is given herewith had for several years been burdened with a large sub-axillary tumour . . . thus rendering the poor fellow a nuisance to himself . . . besides putting out of question his marriage, which had been arranged for before the tumour appeared. . . . The man made a rapid recovery after the operation, with the result of which he was highly delighted, as is evident from the happy expression of his face in the second photograph. He went home to be married four weeks after the operation.[67] (See figure 15.)

In this set, a man with a bewilderingly large growth on his arm and a perhaps equally bewildered expression on his face sits in a chair "before operation," his hand resting on a table the better to display the dimensions of the growth and support its weight of "thirty-five pounds," described in the reports as "a most

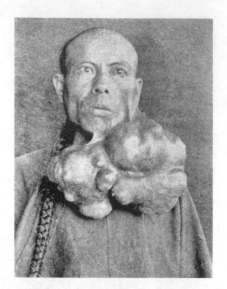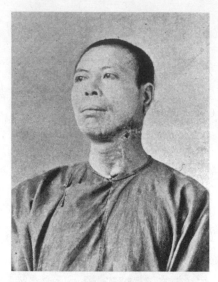

FIGURE 16: P. B. Cousland, "Chondroma" and "The same, removed," ca. 1883–88, Swatow. Reproduced from Jefferys and Maxwell, *The Diseases of China* (1910), 458. COURTESY OF HARLAN HATCHER GRADUATE LIBRARY, UNIVERSITY OF MICHIGAN, ANN ARBOR.

extensive case of *molluscum fibrosum*."[68] The "after operation" shot, however, reveals the same man, dressed the same way, with a bare torso and loose, light-colored pants, this time reclining against a high bench and smiling broadly, his left arm raised high with a demonstrative palm up, his head now uncovered. In another picture, meanwhile, unlike in the case of the recalcitrant Wang Ke-king painted by Lam Qua, one notes that the culturally pathological specimen of the man's queue (not just the tumor) appears to have been successfully excised (see figure 16).[69]

At the same time, lingering traces of the same portrait traditions that acted as sources for Lam Qua also remain in many of the photographic images produced for the *China Medical Missionary Journal* and the collections at St. Luke's. In the photograph reproduced in figure 17, for instance, one can see obvious parallels with portraiture traditions in painting: a three-quarters pose with the woman looking out obliquely, romantically; the focus on the upper torso; or even a sort of deliberate triangularity among the dangling growth, the dangling hairpiece, and the woman's jewelry. Though reproduced in *The Diseases of China, Including Formosa and Korea* with the caption "Pedunculated fibroma. Thirty years old," when it originally appeared in the *China Medical Missionary Journal*, this photograph was labeled as "A Remarkable Fibroma";

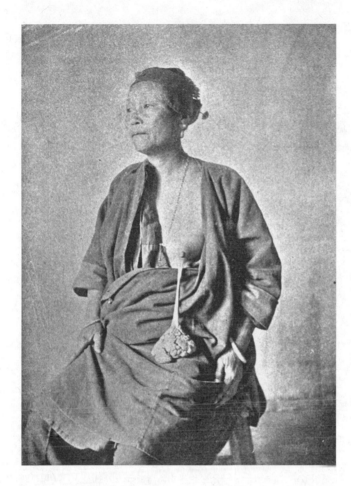

FIGURE 17: James L. Maxwell, "Pedunculated fibroma. Thirty years old," ca. 1906. Originally published as "A Remarkable Fibroma." Reproduced from Jefferys and Maxwell, *The Diseases of China* (1910), 495. COURTESY OF HARLAN HATCHER GRADUATE LIBRARY, UNIVERSITY OF MICHIGAN, ANN ARBOR.

what seems clear here, regardless, is that the image is fundamentally still also a portrait of a "remarkable woman." It insists on individual presence even as it demonstrates a pathological condition.

But portraiture and the before-and-after model were not the only stylistic sources for early medical photography in China. Some of the earliest photographs to be included in the *China Medical Missionary Journal* documented injuries encountered by doctors in the course of treating war wounds, and in so doing might be said to be participating in what was for photography a relatively developed practice of battlefield documentary, from Civil War photography to the posed dead in the 1860 Beijing postwar/invasion landscapes by Felix Beato and Japanese compendia of descriptions of war wounds.[70] In her study of medical photography from the Civil War, Kathy Newman notes that

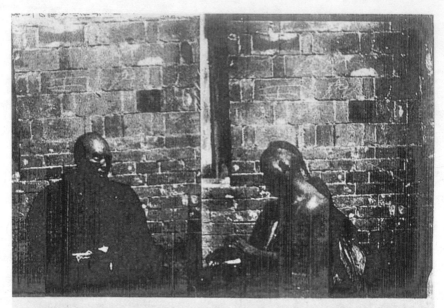

Fig. 1. Entrance Wound. Fig. 2. Exit Wounds.

FIGURE 18: Photographer unknown (Yasuzumi Saneyoshi et al.?), "Entrance Wound/Exit Wound," ca. 1894, Mukden. Reproduced from *China Medical Missionary Journal* 10, no. 3 (1896): 95. COURTESY OF AUBREY R. WATZEK LIBRARY, LEWIS AND CLARK COLLEGE, OREGON.

photographs taken in 1865 and collected for inclusion in an Army medical museum and in the subsequent six-volume *Medical and Surgical History of the War of Rebellion* performed a number of functions ranging from providing "on-the-job" training for doctors in field hospitals to documenting pension claims and, more broadly, marking "the point at which art, science, and national bureaucracies converge[d]."[71] Among other things, Newman analyzes the representation of gunshot wounds in both images and text, noting how not only the formal properties of such images but also the "mechanical tone" of accompanying textual descriptions (such as its use of statistics) contributed to the erasure of "all traces of the romance performed by the portraits."[72] Similarly in the following 1896 illustration from the *China Medical Missionary Journal*, contributed by a Scottish medical missionary called Dugald Christie who was working in Mukden (Shenyang) when the Sino-Japanese conflict of 1894–95 broke out and who operated on the subject, we see a descriptive or "documentary" set of photographs illustrating first the site of the "entry wound" and then the site of the "exit wound" of a bullet (figure 18). The victim is Chinese

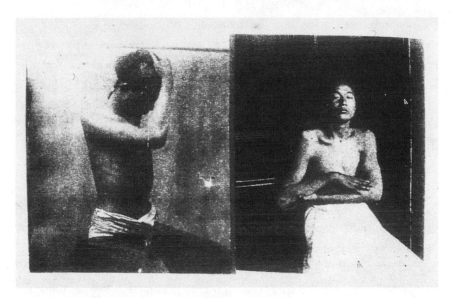

FIGURE 19: Photographer unknown, "Luxation of the Shoulder," date unknown. Reproduced from *China Medical Missionary Journal* 10, no. 3 (1896). COURTESY OF AUBREY R. WATZEK LIBRARY, LEWIS AND CLARK COLLEGE, OREGON.

but appears to have been "shot" (both figuratively and literally) by a Japanese, perhaps connected to a contemporaneous Japanese documentary project, as suggested by the fragment of Japanese script visible in the upper left-hand corner.[73] Thus the picture may have been taken in late 1894 at the Red Cross Hospital in Newchwang, where Christie wrote that he hoped "to relieve the inevitable sufferings of the Chinese wounded."[74] The accompanying text describes the wound as a common one on the battlefield and makes hypotheses about weapon type, angle of entry and exit, and success or failure of various modes of treatment in similar cases.[75] In this sense, the picture is largely documentary or didactic in function; its relation to the text is complementary, and like the Civil War photographs, it, too, in its international origins, illustrates if not art, at least a fascinating convergence of "science" and "national bureaucracies."

Likewise the image reproduced in figure 19, from an 1896 volume of the *Chinese Medical Missionary Journal*, is intended to corroborate statements in the text, or (as the text informs us directly), "The accompanying wood cuts, taken from the photographs of the case, will serve to illustrate the results of the operation."[76] Here the picture illustrates almost exactly what is described in the text: it is labeled "a luxation of the shoulder," in which "the elbow is directly backward and away from the side." The author writes that following

treatment the patient "now has free motion of the shoulder in every direction. Can put his hand on his head . . . now he earns his living, and he has no difficulty whatsoever with his arm."[77] What we can see from this textual relationship is that in this case, as in the former, the image functions in a secondary role to the text, illustrative but not essential, documenting a successful treatment in two views. Where the former pair of photographs allow the author to illustrate the topography of the bullet wound, however, in this set the photographs serve to illustrate the subject's restored flexibility in a kind of early or precinematic action shot of sorts.

Recalling Anne Maxwell's discussion of colonial photography's deployment not only of "tropes of physical decrepitude" but also images of "natives" "capable of gratifying Europeans' erotic fantasies and hedonistic desires," however, I would argue that inevitably still there was another protogenre at play by the time of early medical photography in China: the erotic. While the fact that so many of these photographers were not only amateurs but doctors in the missionary tradition complicates any discussion of artistic style and influence of the sort employed in the analysis of Lam Qua's paintings, in terms of available sources (and indeed of the degree of fetishlike fascination with which doctors viewed and collected images of and engaged with their subjects), it makes sense to allow the erotic as a kind of tributary stylistic source. As I noted earlier, such thematic slippage or intermingling of genres and types was typical of portrait photography created for the tourist trade of this period, as well as of medical photography, postcards, and the trade in images of so-called freaks. Along the same lines, James Ryan has demonstrated that photography was already "being utilized within a discourse of 'race' and 'types'" in the context of protoethnographic and "scientific" inquiry in British colonies by the late 1850s, and more important, that this protoethnographic photography at times overlapped with the erotic:

> The Western fascination with the "native" female body was also expressed in colonial photography where the figure of the beautiful, compliant woman posed and pictured in exotic surroundings with a view to erotic allure served overlapping categories of art, ethnography and pornography . . . such photographs were used in the depiction of the "Orient" of North Africa and the Middle East. Related to this, photographs of naked and seminaked African women — in the guise of the "Hottentot Venus" — were also

an important stereotype within the genre. . . . This "colonial Venus" also became an important element within the iconography of the South Pacific as an exotic paradise. Photographs of Samoa, for example — a popular destination for commercial photographers from Britain, Germany and America — are full of images of young women with titles such as "A Samoan Belle", often posed languishing among fruit and vegetation, or resting under palm groves, on beaches or in waterfalls. Such views rendered both bodies and landscape as available to a colonial gaze.[78]

Given all these things, it is, if anything, hard *not* to argue for a correlation between the erotic and the medical across painting, photography, and other media. This constitutes furthermore an intuitive connection if one considers how much erotic and medical photography have in common: both represent the body in a way not accountable to the limitations imposed by conventional portraiture; both occupy a liminal space vis-à-vis definitions of distinct genres or traditions; both involve the selective exposure of the body, the strategic use (or absence) of clothing, a manipulation of the gaze, and often a fixation or fetishization of one body part over another; and both may be subject to similar theoretical critiques, complicated by gender, race, and notions of alterity, exoticism, and abjection.

A particularly moving example is a pair of portraits of a young man with a large, dark-colored growth encircling his lower waist above and around the hip (figures 20A and 20B). In this set of images, rather than being presented with a before and an after, the viewer is faced instead with two present views, as if to accommodate the need for walking a full circle around the patient in order to get a sense of the whole. The "back view" presents us with what is essentially a familiar and almost lyrical appropriation of the model form of a nude from behind: posed three-quarters of full length, head in profile and eyes downcast, arm held across the chest so that the line of the length of the neck and back is uninterrupted and culminates not in the buttocks as we might expect, but in the large growth encircling the subject's waist. Against a plain background and lit from the side and above, what strikes the viewer in this first image is that the subject's sex may be said to remain ambiguous from a Western point of view —unclothed, long-haired, and depicted from behind, the subject manifests no visible markers recognizable to the late nineteenth- or early twentieth-century Western viewers to definitively assert whether they

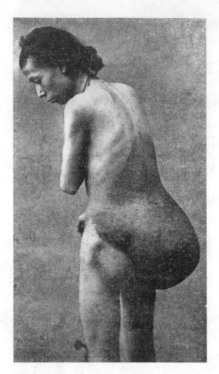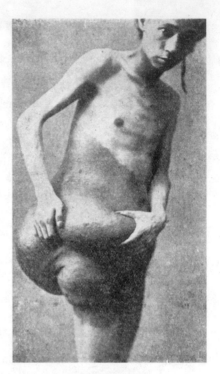

FIGURES 20A AND 20B: A. W. Tucker, "Lymphangioma. (Back view)" and "Lymphangioma. (Front view)," ca. 1906–26. Reproduced from Jefferys and Maxwell, *The Diseases of China* (1929), 466–67. COURTESY OF YALE MEDICAL COLLEGE LIBRARY.

are seeing a man or a woman; if anything the body is diminutive and its gestures—hands resting on the growth, shoulders slumped—suggest, perhaps, femininity, or at least resignation. The (emotional) complexity of the front view, however, is arresting: the subject looks back at us and meets the eye of the viewer directly, interrogative, plaintive, and possibly accusatory. Just as Newman remarks of a certain Civil War–era photo of a soldier with an amputated foot, "the abstracted nature of [the] amputated foot cannot compete with [the soldier's] determination to engage with the camera. . . . we are confronted with the erotic nature of this medical gaze [that] demands an *anti*-clinical consideration."[79] In the Chinese set of images the girdling growth can hardly compete with the subject's engagement with the camera, forcing us out of the clinic and into a dialogue with the erotic nature of the medical gaze. Furthermore the "a and b" format of the two pictures invokes an elementary yet insistent narrative according to which the gestures of the subject's hands resolve

from one mood in the first picture (demure, reticent?) to another mood in the second (jealous, protective?). While the subject's masculinity may be more obvious in the second picture, moreover, the strategic location of the growth now functions figuratively both to obscure *and to replace* the subject's missing sex. The result is that the subject's Chinese identity, his (uncertain) masculinity, and his sexuality are pathologized and eroticized all at once. A study in exposure, these photographs illuminate a chapter on "special tumours" in *The Diseases of China* and, as the authors write, "remind one of Pilgrim and his burden."[80] Though I do not disagree with this impression, still I wonder: what exactly did the Pilgrim's burden consist of? His disease, his nakedness, his femininity, or his Chineseness?

Decontextualizing and Recontextualizing Chinese Identity

What one gradually also starts to see in China at the turn of the century is the maturation of a dedicated subgenre of medical photography. Here again, this transition in style was in the broader sense consistent with the pattern of changes in clinical photography in Europe and the United States, which by the 1890s had started to develop fairly distinct conventions for representing pathological specimens.[81] In China, however, these changes took on the additional ideological burden of representing supposedly specifically Chinese pathologies to a global medical community increasingly attentive to the question of race in determining pathology (and, indeed, vice versa): with the expansion of global networks of doctors, colonial medicine, and the advancement of theories of race, phrenology, anthropometry, and the like, doctors were especially interested in generating a taxonomy of diseases that could be cross-referenced according to race and type. To accommodate this growing appetite, the inherently cluttered aspects of conventional portraiture, the documentation of war wounds, or erotics would no longer work; these forms had too much extraneous detail, too many distractions, too many opportunities for the photographic subject, like another of Newman's soldiers whose sad expression haunts the viewer, to "refuse . . . to be (reduced to) a sign."[82] This newer mode of representation instead idealized the objective, stripped the subject from its habitat—artificial and otherwise—and aimed to isolate and direct the gaze of the viewer by eliminating circumstantial detail. This mode, of course, was the precursor of contemporary clinical photography.[83]

Diseases of China

If John Thomson's four-volume anthology *Illustrations of China and Its People* (1874) defined "documentary" photographic views of China and its people for armchair tourists, the medical world's equivalent was the anthology *The Diseases of China, Including Formosa and Korea*, edited by the medical missionaries W. Hamilton Jefferys and James L. Maxwell. Jefferys and Maxwell, it should be noted, were uniquely positioned to edit such an anthology as their access to primary materials was unparalleled: both had been at various times editors of the *China Medical Missionary Journal*, and both served for a time on the board of the China Medical Missionary Society. Furthermore Maxwell had been appointed a "special commissioner for research" at the society, while Jefferys (the self-described "luny" for photography) was both a surgeon at St. Luke's Hospital and a professor in the St. John's University School of Medicine affiliated with it.[84] Although some significant differences exist between the two editions of the work—such as Maxwell's decision to leave out essays on hospital hygiene, obstetrics and gynecology, and the like in the second volume, and to reduce the number of illustrations for economic reasons—thematically the editions remain remarkably consistent (tumors have an especially long section in both, for instance, for as the authors remark, "Since the first physician who reported anything about medicine in China to the present day, the whole fraternity has been interested and fascinated by the subject").[85] Most striking is the preponderance of illustrations: the 1910 edition contains an astounding "5 Colored Plates, 11 Noso-Geographical Plates, and 360 Illustrations in the Text," while the 1929 edition contains the fewer but still impressive "176 Illustrations" (Thomson's volumes, by comparison, contained a total of 200 photographs).

In sketching the history of medical photography in China, what makes the illustrations in *The Diseases of China* especially interesting is the character of the collection that they take on, where the images as a group are characterized by what Susan Stewart might call the "metonymic displacement of part for whole, item for context" and where the "invention of a classification scheme which . . . define[s] space and time in such a way that the world is accounted for by the elements of the collection" when objects move from individual souvenir to cards in an imaginary castle.[86] In these volumes we see reproduced many of the same images and stories published or circulated independently

for decades in the *China Medical Missionary Journal* and elsewhere, but now they are framed or represented in an entirely new way, a way that to some degree "obliterates the object's context of origin": as a compendium or representative sampling of the diseases of China, the images here constitute a kind of catalogue of metonymic forms, explicitly intended to discipline an otherwise incoherent body of work.[87] Unsurprisingly, then, in these volumes what we also start to see are photographs in transition: not only older, more biographical illustrations alongside newer, more "clinical" formations but also stylistic reappropriations or recuperations of older photographs so that they more closely conform to the totalizing requirements of the type discourse and understandings of race.

This first set of illustrations, for example, was published originally in the *China Medical Missionary Journal* under the heading "A Pedunculated Fibroid" and was accompanied by a complete case history describing in no small detail the patient, "in his fifties and a copper smith by trade," who had "first noticed the growth sixteen years previously" and had at last come to the hospital where Jefferys worked "to have it taken off, though he believed it would kill him" (figure 21). The report also includes a brief anecdote describing the copper smith's delight on being searched by a "zealous policeman" who suspected him of "removing hospital property under his voluminous garments" only to find the tumor instead. The operation went smoothly ("of course the removal of the tumor was easy"), and the accompanying photographs, consistent with earlier modes, make prominent use of the before-and-after format, picturing the patient in portrait posture and in two views from behind, first leaning to the left and then standing upright. In the anthologized reproduction, however, a substantial reorganization of visual information has occurred: while the text remains almost identical, the photographs in the second set have been "doctored" so that the backdrops are blanked out or filled in and no extraneous detail is included (figure 22). While we learn the same biographical information about the patient that we did in the *China Medical Missionary Journal*, in the anthology the photographs that complement the story attempt to render the report more scientific—a fact reinforced by the authors' expression of concern, in the body of the text, that they be forgiven for "the unscientific presentation of this case."[88]

Such a decontextualization and recontextualization of the Chinese pathological figure occurs occasionally in the *China Medical Missionary Journal* and

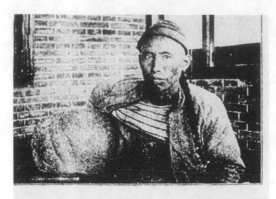

FIGURE 21: William Hamilton Jefferys, "A Pedunculated Fibroid," ca. 1900. Reproduced from *China Medical Missionary Journal* (1906): 157. COURTESY OF AUBREY R. WATZEK LIBRARY, LEWIS AND CLARK COLLEGE, OREGON.

increasingly throughout both editions of *The Diseases of China*: the human subject's contextual background is artificially manipulated or forced out of the picture, sometimes more obviously than at other times (see figure 23). In these decontextualizations and recontextualizations, one is reminded of the work of the late nineteenth-century documentary photographer Paul Martin, who, like Thomson, worked in London in the late 1800s taking pictures of the London working class and who was known to black out the backgrounds of some of his photographs, as Nancy Armstrong describes:

> Imitating the treatment that he had seen given to photographs of statuary, the story goes, Martin decided to set the working man apart from the welter of visual information with which the laboring body tended to merge. . . . Indeed, looking at their images removed from the visual space that presum-

FIGURE 22: William Hamilton Jefferys, "Sixty-Four Pound Fibroma (Resting)," ca. 1905. Reproduced from Jefferys and Maxwell, *The Diseases of China* (1910), 497. COURTESY OF HARLAN HATCHER GRADUATE LIBRARY, UNIVERSITY OF MICHIGAN, ANN ARBOR.

ably defined them, it is difficult to tell what such people were doing when Martin happened upon them with his camera . . . it detached [the] subjects from the symbolic economy in which they once had human purpose and labor value.[89]

In comparing such images with earlier works by Thomson, Armstrong concludes, one "can observe the progressive disappearance of the context for the human figure."[90] Similarly, in transitional photographs such as the ones included in the medical anthology, we can make the observation that, newly unburdened of their "welter of visual information," the decontextualized and recontextualized photographs nonetheless stand—at least for the moment—in conflict with the "symbolic economy" of the text "in which they [still have] human purpose and labor value." Though significant steps have been taken toward removing distracting biographical and contextual data from these transitional medical photographs, for the time being the human subject still coexists, however tenuously, with the pathology.

A final set of photographs illustrates this transition with particular poi-

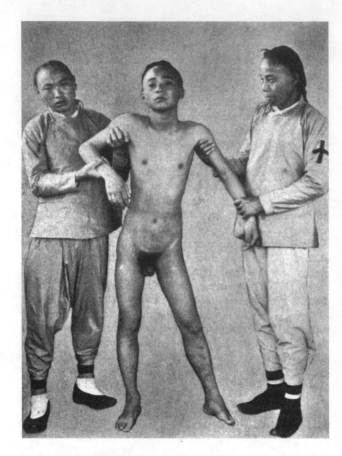

FIGURE 23: William Hamilton Jefferys, "Early Stage of Paralysis in Dry Beri-beri," date unknown. Reproduced from Jefferys and Maxwell, *The Diseases of China* (1910), 110. The authors write: "In regard to the lower extremities: The patient is paraplegic in greater or lesser degree. A numbness, seldom amounting to true anaesthesia, is complained of up the front of the legs, often as far or nearly as far as the waist, and there may be other patches of numbness in different parts of the body." COURTESY OF HARLAN HATCHER GRADUATE LIBRARY, UNIVERSITY OF MICHIGAN, ANN ARBOR.

gnancy, for in it we can see the unmistakable signs of the impending resolution to this lingering tension between cultural and racial iconographies of the Chinese pathological body in the late nineteenth and early twentieth centuries (see figure 24). Thinking back to Peter Parker's hope that Lam Qua's paintings could simultaneously provide ocular evidence of the effectiveness of Western surgery and spirituality, on the one hand, and illustrate the "shades of character" of the Chinese, on the other, we recall that Lam Qua made efficient use of the before-and-after format, of landscape and backdrop, and of clothing, color, and biographical information from Parker's case notes to emphasize notions of physical cure and natural (spiritual) restoration. By contrast, in this set of photographs we see a sort of double or embedded before and after: illustrations not only of the situation before and after Western-style surgical intervention but also, importantly, the implicit "after" of what happens when

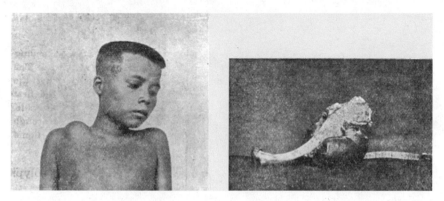

FIGURE 24: Dr. "Fraser," "Sarcoma of Clavicle" and "Clavicle and Tumour removed," date unknown. Reproduced from Jefferys and Maxwell, *The Diseases of China* (1929), 445. COURTESY OF YALE MEDICAL COLLEGE LIBRARY.

the concept of race is enforced in visual culture and ideologies of pathology, namely, the total disappearance or vanishing of the Chinese subject from the image to which it has become essentially superfluous.[91] Unlike in the portraits of Po Ashing (plates 4 and 5), in other words, in this illustration we see only a young boy with a "tumour of the clavicle," followed by a picture of the diseased clavicle "removed." There is no case study accompanying the image, no reference to it in the text. We do not know anything about the circumstances of the presentation, the identity of the patient, the surgery, its background, or its outcome. We know only that there was a pathology and that the pathology has been removed. The question is, which one?

4

"What's Hard for the Eye to See"

Anatomical Aesthetics from Benjamin Hobson to Lu Xun

> Doctors in China missed much of the detail observed by Greek dissectors and incorporated invisible features that dissection could never justify. This especially is what makes the acupuncture man seem a mystery—the blind indifference to the claims of anatomy. . . . Yet indifference to anatomy didn't mean a slighting of the eyes. Not at all: ancient Chinese doctors evinced great faith in visual knowledge. Like their Greek counterparts, they scrutinized the body intently. Only they somehow saw it differently.
>
> —*Shigehisa Kuriyama*, The Expressiveness of the Body and the Divergence of Greek and Chinese Medicine

Here is a true story: Sometime around 1782, King Louis XVI of France ordered his Jesuit representatives in Beijing to present a porcelain bust of Qianlong to the Chinese emperor as a gift. One of a variety of items to be offered, the bust had been specially crafted from the finest porcelain of Sèvres, and modeled after a portrait of Qianlong by the Italian Jesuit painter Giuseppe Panzi shipped to France in 1779.[1] In addition to flattering the emperor, the gift was probably also intended to show off the newfound French mastery of various techniques of Chinese porcelain manufacture that had until then been avidly studied but only poorly imitated.[2] Its intended presentation also occurred in an unusually rich period of exchange during which Qianlong con-

sulted with a number of French Jesuits at court on everything from cartography and navigation to art and architecture and even arranged for a large order of copper engravings of his war exploits to be executed in France.[3]

Remarkably, however, the man in charge of the transaction, a Jesuit called Father Bourgeois, refused to deliver the gift. In a 1784 letter to his superiors in France, Bourgeois explained his actions as follows:

> The white porcelain bust of the Emperor was not given to him for three reasons: first, because it is forbidden here to do the likeness of the Emperor. Second, because the statue doesn't look like the Emperor. And third, because it is not dressed according to the custom of this country; the bonnet, especially, which is layered like a Turkish turban, would seem ridiculous here. . . . They would have quite a laugh here if they knew that in France, as in the rest of Europe, we suspend the portraits of kings before liquor stores, exposing them to the dust, the rain, and the wind that makes them dance prettily, as well as to the praise and possibly ridicule of the people. . . . We withdrew some of the porcelain lockets as well for nearly the same reasons.

But that was not all. There was another reason, Bourgeois explained, "the power of which [was] difficult to grasp in other countries" (dont il est difficile de sentire [*sic*] la force dans d'autre pays): "In China, a head separated from the body causes such horror that when someone's head is cut off, his parents or his friends rush to sew it back on the body. And the lockets depicted a severed head; one might even say that you could see the place where the blow of the sword had been applied."[4]

Father Bourgeois knew well, it seems, what other missionaries would later struggle to grasp: that even when Western modes of representing the human body seemed innocent of any confrontational agenda, in a new cultural context they could nonetheless easily convey a host of unwelcome, even violent, collateral meanings. The perpetrator of such violence, Bourgeois cautioned, risked alienating his intended audience through *form* alone.

One could make the same point about Western medical understandings of the body when they were first systematically introduced to China: the form in which they were represented may have posed as great a challenge to conceptualization and cultural translation as the content itself. As Shigehisa Kuriyama

points out in his seminal study *The Expressiveness of the Body and the Divergence of Greek and Chinese Medicine*, for instance,

> When we speak today of the body in the context of medicine, we picture almost reflexively the muscles, nerves, blood vessels, and other organs revealed by the dissector's knife and dazzlingly displayed in atlases. . . . Historically, however, anatomy is an anomaly. Major medical traditions such as the Egyptian, Ayurvedic, and Chinese all flourished for thousands of years without privileging the inspection of corpses. For that matter even the treatises of Hippocrates, the reputed source of Western medical wisdom, manifest scarce interest in anatomical inquiry.[5]

Similarly, in his essay "Tales of *Shen* and *Xin*: Body-Person and Heart-Mind in China during the Last 150 Years," Mark Elvin remarks that "the human body in traditional China was not seen as having its own intrinsic physical glory. One will look in vain in the Chinese arts for anything remotely approaching classical Greek statues of young unclothed male athletes. . . . Chinese pictures of the human body, clothed or semi-clothed (in a furtive pornography), are—to Western eyes—meager, schematic and inadequate."[6] In his classic study entitled *Theoretical Foundations of Chinese Medicine*, Manfred Porkert emphasizes that Chinese medicine's attention to functional understandings of the medical body (as opposed to the causal, corporeal mode of Western anatomical thinking) "is not the close counterpart of Western anatomy but its antithesis." In what remains one of the most thorough and successful attempts to translate the theoretical foundations of Chinese medicine in a systematic way, Porkert goes to great pains to argue that the functional system of traditional Chinese anatomical practice is so divergent from Western counterparts as to be virtually untranslatable, or translatable only with a great caveat: that the translated terms used to describe Chinese "organs" and corporeal phenomena "be understood as definitions of effective relations or functions, not simply as expressions of crude anatomical insights."[7] For a study that aims to understand how ideas about pathology came to dominate literary and cultural descriptions of Chinese identity in the early modern period, it is therefore imperative to consider how ideas about the body itself were translated and transformed. The body, we must remember, constitutes the tabula rasa of pathology; to suffer from a peculiarly modern (or "Western") disease, one requires a peculiarly

modern ("Western") body. Thus just as the preceding chapters have demonstrated the cultural contingency of pathology and its definitions, so, too, must we consider the contingent definitions and transformations of the nearly modern body that enabled these modern pathologies at the conceptual level.

In this chapter I argue that not only the content but the form of dissection-based anatomy as it was introduced to China by Western medical missionaries beginning in the middle of the nineteenth century had a profound impact on subsequent reconceptualizations of the body and the self in the late Qing period and beyond. In the context of May Fourth literary innovation, for example, I will argue that the inherently "realist" conceptual vocabulary of Western-style dissection-based anatomy offered a solution to what Chinese writers and Western-trained doctors alike perceived as a troubling lack in Chinese descriptive traditions that failed to account for the (material, and eventually "modern") body with its layers of muscle and manifold definitions of flesh. Such anatomies, I also contend, represent not only the earliest introductions of Western-style anatomical learning but the earliest systematic articulations in Chinese of a new aesthetics or a new mode and practice of looking at the body, something one might call an "aesthetics of anatomical realism." The terms of this anatomical aesthetics included such features as a new focus on dimension and divisions between interior and exterior; a new understanding of the permeability and vulnerability of the human body; and most important, a radical new attention to the presumed transparency of what the eye can see. In these ways the introduction of anatomical aesthetics to China parallels what Barbara Stafford has called the exposure of the "geographical *terra incognita* of the subcutaneous" that occurred in Europe when "the problem of imaging what was 'out of sight' became critical in the fine arts and natural sciences" during the Enlightenment.[8] Thus in this chapter I outline the history of Western-style anatomy in China; discuss the particulars of an important early anatomical textbook, focusing especially on its aesthetics and visual priorities; and offer a detailed example (through literary realism) of one way in which this new aesthetics influenced Chinese self-perception and descriptions and conceptualizations of the body on the eve of modernity.

As the epigraph to this chapter states, however, it is imperative to emphasize that focusing a new attention on configuring what the eye can see in anatomy in China is not to suggest an earlier slighting of the eyes, or that Chinese doc-

tors did not "evince great faith in visual knowledge" before the introduction of Western-style anatomy. Rather, just as Michel Foucault described how the search for empirical evidence of disease through the positivistic practices of dissection came to replace the more superficial symptomatics of traditional diagnostic methods in Europe in the eighteenth century, a premise of my argument here is that a parallel process gathered speed in China with the introduction of dissection-based anatomical texts in the nineteenth century. The great art historian Erwin Panofsky has argued, for example, that "the rise of those particular branches of natural science which may be called observational or descriptive—zoology, botany, paleontology, several aspects of physics and, first and foremost, anatomy—was so directly predicated upon the rise of the representational techniques that we should think twice before admitting that the Renaissance achieved great things in art while contributing little to the progress of science."[9] Here I would like to transplant Panofsky's argument into a new context, focusing not on some Chinese "lack" of dissection practice, but instead on the question of the introduction of a specific science of looking— of "observational or descriptive . . . representational techniques"—to China alongside if not before the introduction of Western-style anatomical practice itself over the course of the nineteenth century. Since such a radically different mode of looking at and representing the human body essentially amounted to a realist metaphysics, its introduction proved nearly as momentous as that of dissection itself and had important consequences for how "reality" and realist aesthetics, literary and otherwise, were conceived of on the eve of Chinese modernity.

"What's Hard for the Eye to See" (目所難見): Hobson's *A New Treatise on Anatomy*

> Realistic genres do not mirror everyday life; they mirror its hierarchization of information. They are mimetic of values, not of the material world.
> —*Susan Stewart*, On Longing: Narratives of the Miniature, the Gigantic, the Souvenir, the Collection

Western ideas about anatomy were transmitted to China as early as the beginning of the seventeenth century with the Jesuits Giacomo Rho (羅雅谷; 1592–1638), Niccolo Longobardò (龍華民; 1565–1655), and Johann Terrenz Schreck

(鄭玉函; 1576–1630), whose collective translation into Chinese of Ambroise Paré's *Anatomie universelle du corps humain* was in turn based on the famous *De humani corporis* by Andreas Vesalius (1515–64).[10] Although this work, being limited to the closed circuit of the imperial archives, never achieved a wide audience in China, it nonetheless managed to leave a mark: scholars have shown that the *Pleasures of Ghosts* painting series by the Yangzhou Eccentric painter Luo Ping (羅聘; 1733–99) was based on this work (the ghosts bearing a conspicuous resemblance to Vesalius's skeletons), and the intellectual lineage of the nineteenth-century anatomist Wang Qingren (王清任; 1768–1831), whose influential and controversial 1830 treatise on anatomy emphasized the importance of the eyewitness observation of internal organs in order to describe location accurately, has also been convincingly (albeit indirectly) traced to Schreck.[11]

Nevertheless it was not until the second half of the nineteenth century that Western-style anatomy was introduced more systematically, not only through Japanese translations of Western anatomical works but through original works written in Chinese by men like Benjamin Hobson (合信; 全體新論 *Quanti xinlun* [*A New Treatise on Anatomy*], 1851), John Dudgeon (德貞; 全體通考 *Quanti tonkao* [*Anatomy*], Beijing: Tongwen guan, ca. 1886), and many others.[12] Alongside such other perceived lacunae as the failure to perform surgery, the failure to adopt vaccination quickly, a "singular lack of nerves," and a lack of "embarrassment about growths," at this time (as should start to be sounding familiar) Western medical missionaries began to construct, rhetorically and otherwise, still another "lack" in Chinese tradition: the lack of willingness or "ability" to perform autopsy because of what they saw as the cultural superstition that prevented it.[13] Starting as early as the mid-nineteenth century, in fact, the missionaries' journals and reports are peppered not only with reports of strange ailments encountered but with bitter lamentations about Chinese superstition and their stubborn refusal to allow dissections of any kind (therefore inhibiting the all-important goal of educating Chinese in Western medical-spiritual practice), as well as with the occasional faintly competitive reports of a purloined corpse or furtive dissection performed for willing medical students "on the fly." When Peter Parker convinced the relatives of one of his deceased patients to allow an autopsy in 1850, he remarked that the permission "may be regarded as a triumph," a statement that is particularly meaningful in light of Parker's earlier expressions of frustration as I described them in chapter two.[14] Echo-

ing Parker's frustration, John Kerr wrote in 1867, "The want of opportunities for dissection has been much felt, and the superstitious regard of the Chinese for the dead would seem to be an insurmountable obstacle to the prosecution of this important branch of study"; the doctor Joseph C. Thomson similarly remarked in 1890 of Chinese "anatomical diagrams" generally that they were "amazingly behind the times for a people who have had such a good *start*, and who now make such boast of superior knowledge"; and as late as 1929, in the introduction to the second edition of *The Diseases of China*, W. Hamilton Jefferys and James L. Maxwell reiterate that "the Chinese . . . have intelligent ideas as to the locality of organs and their mutual relationships, such as any observant people might gather in the course of time; and to some extent . . . an appreciation of the functions of the different organs of the body . . . [nonetheless] dissection of the human body is never attempted: the learning on these scores therefore has its strict and evident limitation."[15]

From a very early stage, missionary doctors thus developed inventive ways of working around what they perceived to be the greatest obstacle to anatomical learning, Chinese superstition, employing in their teaching imported models, skeletons, and even preserved specimens; demonstrating dissections on small animals like dogs; and producing numerous diagrams, charts, and other illustrations.[16] The remarkable photograph reproduced as figure 25, for example, shows a medical classroom (specifically a class "in minor surgery") at the St. John's medical school, established in Shanghai just before the turn of the century. Taken around 1905, the photograph depicts Chinese medical students with their instructor (probably Dr. E-li Day [譚以禮], himself a graduate of the class of 1903) in a classroom equipped with a skeleton, an anatomical diagram, and various charts. In classes like these medical missionaries quickly realized the potential of anatomical texts to advance their cause both within the classroom and without. In 1851, the first Western-style anatomy in Chinese, Benjamin Hobson's *A New Treatise on Anatomy*, was published in China, the first of a steady stream of illustrated texts in Chinese that in the following decades would find their way into the curricula of medical school classes like Day's, the academies affiliated with the arsenals established as part of the Qing "self-strengthening" movement, and the hands of practitioners of traditional Chinese medicine.[17] These texts were widely circulated, but what they proposed was far from universally accepted by the new readership. As

FIGURE 25: Photographer unknown, "Class in minor surgery," ca. 1903. Reproduced from Jefferys and Maxwell, *The Diseases of China* (1910), 11. COURTESY OF HARLAN HATCHER GRADUATE LIBRARY, UNIVERSITY OF MICHIGAN, ANN ARBOR.

Hobson wrote, his book was oriented as a corrective to those Chinese medical books "which are based on principles adopted two or three thousand years ago in which the important doctrine of the circulation of the blood is not only not understood, but preposterously confused and erroneous," and in which "there is no distinction between arteries and veins—no knowledge of the heart's proper function, nor of the necessary changes the blood undergoes in the lungs and capillary system," nor any knowledge "of the nervous system, its functions and diseases," and so on; *A New Treatise on Anatomy* set out to be comprehensive in its scope.[18] As the medical historians K. Chimin Wong and Wu Lien-teh conclude,

> The greatest compliment to the author lay perhaps in the fact that his books were several times republished by the Chinese—the Anatomy and Physiology first at the instance of the Viceroy of Canton. . . . Other editions followed. . . . The subsequent volumes were likewise reprinted as soon as they appeared. . . . Hobson's books remained for many years the standard works in Chinese, and their influence, not only upon the Chinese in touch with western medical men but upon scholars in general, cannot be overrated.[19]

However, *A New Treatise on Anatomy* was not a translation in the strictest sense. Rather, as the historian Yi-Li Wu has remarked, this and Hobson's other works "represented Hobson's distillation of what he considered to be the flower of British medical science, and he and his Chinese collaborators composed them directly in Chinese."[20] This has several important implications. First, it meant that Hobson did not rely on any single source text for his information, but rather drew from, and in that sense authored, all of the information presented. As Hobson himself wrote in the preface to *A New Treatise on Anatomy*, "Now with the assistance of my Chinese friend Chen Xiutang, I have assembled the medical texts of the Western countries and checked them against each other, making human forms on paper of the many joints and skeletons; cutting out the extraneous and selecting the most important points, and interpreting it all into a book."[21] Second, because it was the first book of its kind, it meant that the authors could not refer to earlier translations in search of appropriate vocabulary. Instead, Hobson and his Chinese collaborator Chen Xiutang (陳修堂) had to work together to create an entirely new vocabulary of anatomical terms in Chinese that would fit the illustrations and concepts that Hobson decided to include.[22] (As Ruth Rogaski has pointed out regarding the translations of scientific texts from the 1880s, "Chinese translators did not simply take a preformed set of dominant 'Western' knowledge and render it interestingly into an exotic indigenized Chinese idiom.")[23] Further, it meant that even the illustrations often had to be produced from scratch using figures created by Hobson's friend W. G. Dickson and converted into woodcuts by Chinese artists in Canton.[24] It also ultimately meant that what was presented—"the bones, and a comparison of the skeleton of various animals, the ligaments and muscles, followed by a description of the brain, the spinal cord, and the nervous system,"[25] among other things, was, though familiar, far from the standardized anatomical text that comes to mind when we think of anatomy today.

Differences between Chinese and Western-style anatomy have been outlined elsewhere as a subset of Sinological discussions about the conceptual bases of Chinese medicine, most notably by Kuriyama. For my purposes here I shall therefore concentrate instead on two significant consequences of the introduction of Western-style anatomy to China as exemplified by the publication of *A New Treatise on Anatomy*. The first of these concerns language.

As I mentioned, Hobson and Chen faced the quintessential "first encounter" dilemma when they set out to translate terms and concepts into Chinese for which there were no obvious equivalents or self-evident cognates. Such a project required intensive collaboration, whereby the Westerner communicated the new concepts to a Chinese collaborator (usually someone with some kind of background or interest in Western science and medicine) who would then try to assimilate all of this into the appropriate linguistic (literary, medical) Chinese register. In the course of this reproduction, the translators would choose either to invent new scientific terms without (if possible) playing on existing terminology, or to adapt existing vocabulary with some kind of cognate or seemingly equivalent value.[26] The latter case (Hobson's and Chen's general choice for the work) meant that sometimes the original meaning of a Chinese term might be borrowed to lend meaning to a new term.

Some of these etymological grafts were more successful than others. For example, since the concept of "muscle" was a foreign one to Chinese anatomy, Hobson and Chen decided to render the term in Chinese as *rou* 肉 (*jirou* 肌肉, a present-day translation of *muscle*, was introduced in headings at this time but *rou* alone was the common term throughout the book). Their choice may have had to do with the crossover concept of "sinew" and "tendon," as well as with the more familiar terms *flesh* or *meat*; but the resulting translations remain awkward and unclear, since *rou* alone does not communicate enough of the specificity of the concept of muscle. Translating round-trip the text in figure 26, for example, one reads that "a person's power is in the flesh (sinew); thus when power is exerted, the flesh (sinew) draws in and contracts" (人之力在肉/用力則肉縮而短). Though Hobson's model here is clearly the Galenic one, with its highly articulated Greek "braves" (in this case, Hercules and Antaeus) demonstrating their strength (and also of course their *Westernness*) through martial skill, the lack of appropriate vocabulary sent Hobson back to Hippocratic writers for inspiration.[27] As Kuriyama writes,

> Hippocratic writers do refer to muscles, but remarkably sparingly. Even in those treatises where we might expect the closest scrutiny of musculature, such as the *Surgery* and *Fractures*, the preferred terms are *neuroi* and *sarks*, tendons/sinews and flesh. In language quite similar to what we find in China, the author of *Fractures* thus speaks of "bones, tendons, and *flesh*," rather than "bones, tendons, and muscles"; and he cautions those treating

勇士用力圖

人之力在肉用力則肉聚而短

FIGURE 26: Illustration of "brave men fighting forcefully." Reproduced from Hobson, *A New Treatise on Anatomy*, n.p. COURTESY OF THE NATIONAL LIBRARY OF MEDICINE.

the arm that the "fleshy growth" (*sarkos epiphysis*) over the radius is thick, while the ulna is almost fleshless.[28]

A more successful lexical graft was the term that Hobson and Chen coined as a translation for *nerves*: *naoqijin* 腦氣筋. Bridie Andrews observes that Hobson's choice of *qi* here, because of contemporaneous associations with the translation for lightning as *dianqi* 電氣, reveals his indebtedness to "the Galvanic theory of animal electricity as the driving force for the nervous control of muscle contraction" that was popular in Europe in the early 1800s. She writes:

Since, for Hobson, galvanism (electricity) and the life force were related (if not identical), and since the Chinese used their term *qi* (literally, "air",

"breath", "vapor") in Chinese medicine in a very similar way to the early nineteenth-century western concepts of vital force and the "subtle fluid" through which both electricity and nervous transmissions were thought to flow, *qi* was for Hobson a natural candidate for use in the translations of both "nerve" and "electricity." In Chinese medicine, each organ of the body was conceived of as possessing its own *qi* as well as being influenced by the movement of "normal *qi*" 正氣 in the body, so the designation of nerves as "brain-*qi* tendons" had the added advantage of resonating with existing Chinese views of organ physiology.[29]

In their opportunistic adaptation of terms such as *nao* and *qi* and *jin*, Hobson and Chen were clearly attempting to bridge the conceptual divide between Chinese and Western medical systems, as well as to attract interest to their work. In this case, because of the increased specificity of the new term along with the specific appropriation of the Chinese terms, one could argue that the translation of *nerves* as *naoqijin* was perhaps more successful a transmittal than that of the term *muscles* as *rou*.

This dilemma of establishing an equivalence between Western and Chinese anatomical systems faced by Hobson and Chen was especially significant since what was at stake was the human body: the authors were not only struggling with how to represent the body and how to convey the internal relationships among its parts but also with how to represent and convey what was for the mid-nineteenth century a new universalism, that is, the suggestion that at base all humans are fundamentally the same (emergent theories of race notwithstanding) and that the common base for this universalism was none other than the human body. In other words, by creating *A New Treatise on Anatomy* out of borrowed words and suggestively parallel concepts, Hobson and Chen had to assume the idea of an invisible common referent (a universal human form), but a form for which there was not yet a Chinese equivalent. As Lydia Liu writes using the ideas of Jean Baudrillard, "Translation need not guarantee the reciprocity of meaning between languages. Rather, it represents a reciprocal wager, a desire for meaning as value and a desire to speak across, even under least favorable conditions. . . . The act of translation thus hypothesizes an exchange of equivalent signs and makes up that equivalence where there is none perceived as such."[30] Hobson and Chen had to arrive, in short, at "hypothetical equivalents" for the human body. Conceptually, this meant that to a

certain extent Hobson had to invent not only the language used to describe the anatomical body of the West but also the theoretical foundations of the body itself. On many occasions, this in turn meant conveniently introducing theological concepts into the text, as in the section on involuntary muscles (*bu neng zi zhu zhi rou* 不能自主之肉), in which Hobson (and Chen) write that if the various functions of these muscles had been voluntary, "one fears . . . they would certainly grow exhausted, hard to relax. Thus God in his infinite wisdom has made them function on their own, neither wearying nor resting, wearying nor resting, until death. The Lord has bestowed this great favor and virtue on man, and I trust in it, without hesitation; [one] can appreciate [this] without reflecting deeply."[31] Unsurprisingly, such religiously inflected passages were sometimes excised from Chinese and Japanese reprints of the text.[32]

But another important aspect of the introduction of Western-style anatomy to China as exemplified by the publication of *A New Treatise on Anatomy* was a shift in representational conventions and idioms that produced a new emphasis on observation. That is, in addition to the dramatic differences in the language and conceptualization of the body found in Hobson's work, the book also introduced new ways of representing and describing that body, new kinds of images with new relationships to text, that were grounded in specific ideas about what the eye could or could not see and that directed the eye to see in ways that differed from conventional Chinese techniques. In general, the emphasis in representations of the body in traditional Chinese medicine lay on schematics: the famous images frequently reproduced from the *Huangdi neijing* and other well-known Chinese medical texts are more maps *to* the body than pictures *of* the body (or at least make for pictures of a very different "body"), intended to illustrate relative location and approximate size and area, rather than to record the exact appearance of a particular organ or body structure, or to provide a healthy standard against which pathological anatomy could be compared (see figure 27, for example). As Porkert remarks, "Illustrations of orbisiconography were, as a rule, meant primarily as diagrams of functions, not as pictures of anatomical substrata."[33] The nineteenth-century anatomist Wang Qingren, for example—the anatomist famous for viewing corpses at executions and grave sites for his eyewitness illustrations—introduced his controversial illustrated book by remarking that the book "is not a complete volume on treating illnesses, but rather a book that *records the organs*."[34]

Recording accurately what the eye could see, in short, was less important in traditional Chinese medical illustrations than recording accurately the conceptual relationship among organs and body parts and their functions within the system as a whole. Furthermore, what we might take for granted as the depiction of plane, surface, and skin in Western-style anatomical texts was not a significant component of the Chinese counterparts; there was no skin in the Western sense, no graphic device reinforcing the division between interior and exterior. What John Hay notes regarding representations of the body in the contexts of Chinese art is relevant to anatomical illustrations as well: "Phenomena at all levels, not only the cosmic, tended to be understood as concentrations and conformations of *qi* rather than as geometric objects demarcated by solid planes and edges. . . . Surfaces were not impenetrable faces of geometric solids, but palpable interfaces through which the structural values of interiority interacted with the environment. Thus not only body organs, but bodies themselves were such phenomena."[35] Abstracted as road maps to the body, Chinese medical representations lent themselves readily to metaphor, both visual and conceptual: one famous Taoist anatomy, for instance, depicts the body as a microcosm of the world, complete with natural phenomena; another conceptual model equates the functions of the organs with the functions of government.[36] As Hay comments provocatively, "I might suggest that, in the Chinese sphere, when the entire ontology was metaphoric, then individual 'metaphors' were simply realistic."[37]

Representations of the body in *A New Treatise on Anatomy*, unlike Chinese representations and surpassing even Wang Qingren's bold experiments (which still did not allow him to actively dissect), emphasized first-hand and visual information on a new level through the practice of dissection. As Hobson and Chen write, "The organs are on the inside, [where] it's hard for the eye to see; thus whenever professional medical schools in the Western countries receive a dead body, they open up the chest and slice open the abdomen, investigate the organs and take out the intestines, researching and examining every little detail and recording it carefully in writing—not at all the same as the Chinese [method of] hearsay and guesswork."[38] In *A New Treatise on Anatomy*, images of the body are portrayed in such a way as to suggest a dimensionality and level of exposure that would be inconceivable (and indeed irrelevant) in their Chinese counterparts. An example of this difference can be seen in a

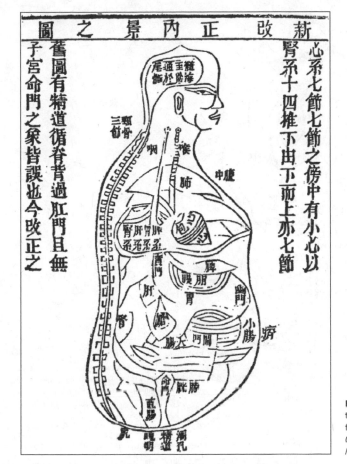

新改正內景之圖

舊圖有精道循脊背過肛門且無
子宮命門之象皆誤也今改正之

腎系十四椎下由下而上亦七節

心系七節之傍中有小心以

FIGURE 27: Diagram of
the body. Reproduced
from *The Yellow Emperor's
Classic of Internal
Medicine*, 41.

comparison of two images, one from a Chinese text (figure 28) and one from
A New Treatise on Anatomy (figure 29), although they may, at first glance, ap-
pear quite similar: both constitute representations of the abdomen, both are
anatomical/medical in function, and both accompany expository text. In the
Chinese example, however, there is no representation of skin or an encasing
boundary of any kind. Rather, the image is suspended north to south against
a plain field, with thick woodcut lines of uniform width defining not only the
outermost boundaries of the "five organs" but also the lines dividing the sym-
metrical leaves and lobes that make up the internal landscape (therefore sug-
gesting no depth). A stem leading upwards suggests the continuation of the
image beyond the visual field to include the other organs. Labels such as *wei*
胃, *xin* 心, or *dachang* 大腸 (stomach, heart, and large intestine, respectively)

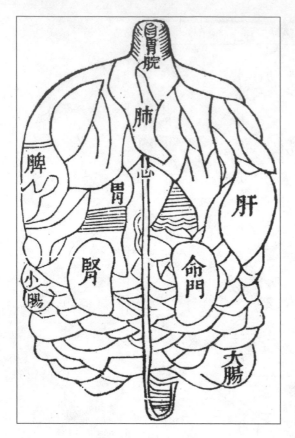

FIGURE 28: Classic illustration of "abdomen." Reproduced from *The Yellow Emperor's Classic of Internal Medicine*, 38.

appear vertically within the boundaries of their respective segments, in thick lines and in relatively sizeable fonts that occupy a large area of each individual field, suggesting that the lexical labels are representationally as important as the fields they occupy, if not more so. The image is typical of many Chinese anatomical illustrations that were diagrammatic rather than representational.

The image from *A New Treatise on Anatomy*, meanwhile, is intended to depict a much more substantial form, and in fact it goes to great lengths to enhance this impression of substantiality. The most immediately noticeable device used to create this effect is the representation of the layers of skin: in Hobson's image, layers of skin frame the internal organs, peeled back from the central axis (the spine? the groin?) in a mirror of the pages of the book in which they appear. Lest there be any confusion, the four corners of this synechdochal parchment are labeled clearly as "skin of the stomach" (*du pi* 肚皮) and "unfurled skin of the stomach" (*zhan chu du pi* 展出肚皮), the let-

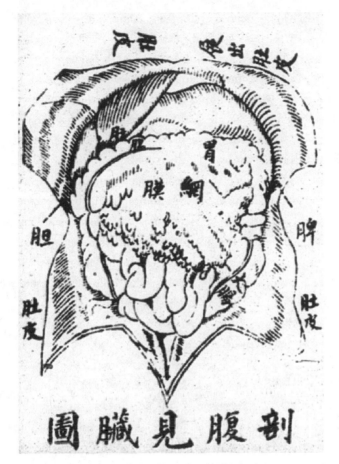

剖腹見臟圖

FIGURE 29: "Diagram of organs visible in the opened abdomen." Reproduced from Hobson, *A New Treatise on Anatomy*, n.p. COURTESY OF THE NATIONAL LIBRARY OF MEDICINE.

tering small and literally peripheral. Other devices suggest depth of field as well: a crude hatching grows denser near the edges of different organs, while thicker dividing lines near these edges are intended to create the impression of light and shadow; even the flaps of skin are given dimension by the addition of extra lines along the outside. Meanwhile labels presented within the organs are unobtrusive, in some cases slanted to follow the line of the image, for all intents and purposes subordinate to the graphic components. The overall effect of these devices is to signify exposure and dimension, to establish an interior and an exterior, and then to draw the viewer's eye inward. Graphically, these devices reflect the theoretical emphasis of Western anatomy on the visual field by approximating (or attempting to approximate) what the eye can see. The descriptive nature of the caption confirms this emphasis on visibility (*jian* 見):

"Diagram of organs visible in the opened abdomen" (*pou fu jian ʐang tu* 剖腹見臟圖). In this image, then, the body—like the illustration itself—is intended to be read literally, interpreted in terms of depth and texture through the active participation of the observer; the Chinese example, on the other hand, reflects more metaphorical priorities, with the emphasis placed on the relational and the conceptual. To borrow a term from translation studies, the two images are like visual "false cognates" for each other, suggesting shared meaning (and a shared referent) when in fact they have very little in common.

Another example of ways in which the anatomy represented by Hobson differed from that of conventional Chinese representations of the body can be seen in the idea of the cross-section. The cross-section was a device that may have seemed to have a cognate in certain Chinese representational conventions, but it was actually quite alien to these conventions. Although Chinese medical illustrations conventionally represented different "aspects" (*mian* 面) of a subject—front, rear, and side views, for instance—these were formal orientations more than windows inward, emphasizing relative area over planes, depth, or dimension. Cross-sections in *A New Treatise on Anatomy*, on the other hand, were premised on the idea of complex relationships among organic structures that could in turn be revealed by the anatomist's knife. In the picture of the "vertically cut eyeball" (figure 30), for instance, the portrayal of the different structures of the eyeball is predicated first and foremost on the ability of the viewer to conceptualize (and the image to communicate) a sense of *interiority*. But even more than in an image such as that of the opened abdomen above, the interiority of the cross-section pretends to go beyond what the eye can see, claiming to conceive of structures that would be difficult to reach even with the help of the anatomist's knife, and providing a very privileged, if nonexistent, vantage point. Thus the dimensionality of the cross-section expands laterally to include not only the sense of interiority but also, conceptually, a continuous series of abstract points at which a hypothetical incision will reveal consistent internal phenomena. In this case, a straight vertical cut down the center of this imaginary eyeball reveals an architecture of caverns, the largest appropriately called the "great chamber" (*dafang* 大房), while the plain white suggests an incongruous emptiness. A selection of textured lines, dashes, hooks, and dots meanwhile conveys a rich topography of optic muscles, sinewy optic nerve, cushioning fat, and forehead bone. The paradox of the cross-section is that

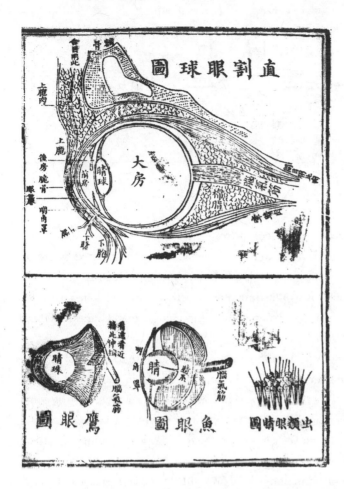

it claims to exploit the convenience of the printed page by reducing multiple dimensions to a single abstract plane, while at the same time suggesting that we must view the exposed surface itself as a representation of the "real," of the dimensional. In short, the cross-section at the time of Hobson's introduction is twice removed from the representational priorities of Chinese medical illustrations, first because it calls for the concept of interiority, and second because it asks the reader to on some level accept the reality of an unreal proposition, to accept that the view provided constitutes an actual and observable view.

A final example of an image in Hobson's book in which not only the content but also the representational conventions would have seemed alien to Chinese viewers is the figure of "brave men fighting forcefully," modeled as I mentioned earlier on Hercules and Antaeus (figure 26). This image differs from conven-

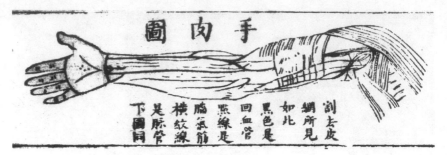

FIGURE 31: Illustration of the "flesh [肉, muscles] of the arm." Reproduced from Hobson, *A New Treatise on Anatomy*, n.p. COURTESY OF THE NATIONAL LIBRARY OF MEDICINE.

tional Chinese ones on many levels—from the curly-haired Greek models to the fact that they are wrestling to their dimensionality (emphasized by cross-hatching, shadow on the ground, etc.). Even more significantly, the whole purpose of this picture is to illustrate musculature and muscles in action—a structure and concept almost completely without cognate in Chinese medical literature.

The most striking aspect of this image however is the wrestlers' lack of skin. Where the illustrations of the abdomen in figure 29 used the skin as a visual device, here the *absence* of the skin constitutes the device: it is the complete lack of this organic boundary that presumes to give the viewer a kind of x-ray vision, the ability to see through to the muscles working underneath as the "brave men" test their strength (a view which is a technical impossibility even in the context of dissection, where presumably one is working with dead, rather than living, brave men). In figure 31, for example, the need for "cutting away" the skin is made explicit not only in the caption—"This is what is visible with the web of skin cut away" (割去皮網所見如此)—but also in a detailed key instructing the viewer in how to read this image: "Black are veins. Discontinuous lines are nerves. The horizontally sketched lines are blood vessels" (黑色是回血管／點線是腦氣筋／橫紋線是脉管／下圖同). In the picture of the men wrestling, on the other hand, the presence of skin is invoked by its own absence; no caption or key calls attention to the lack of skin. Instead we are intended to "read through" this implicit invisibility directly to the muscles working beneath.

In addition to denoting the enhanced visual capacity of the viewer, however, this lack of skin also distinguishes the image from conventional Chi-

nese counterparts at the level of representation. The skin's absence and our role as viewers—first to "create" the presence of the skin, and then to undo this presence by "seeing through" it to the substantial reality of the muscles underneath—becomes doubly complicated when faced with a visual tradition in which the skin is not necessarily the primary interface with the world, not the definitive boundary between interior and exterior that dissection assumes it to be in all of these pictures (pictures premised on the idea of the skin as an obstacle to be removed, as the primary barrier between scientific discovery and "what's hard for the eye to see"). As Hay notes of representations of clothing in his analysis of a passage from the novel *Golden Lotus*, "garments are not just transparent symbols. We are not expected to see straight through them to some somatic reality."[39] Thus the picture of the "brave men fighting forcefully" must have seemed foreign indeed to someone familiar only with conventional Chinese representations of the body: not only are the figures defined by striations that indicate (as Kuriyama points out) a structure with no equivalent in Chinese cosmology, that is, muscles, but they have also been twice flayed, not only of layers of skin but also of layers of clothing. Hay's speculation on what might have been the reception of the nude in China is relevant as well for the reception of an image like this one: "Since the idea of 'China' was fundamentally cultural rather than ethnic, one might suspect that the completely uncoded body would have been felt to be not human, and the naked body not, or not yet, Chinese."[40] Thus not only would the "brave men" have seemed foreign because of their physical characteristics portrayed in the image but also because the multiple layers of nakedness in a stylistic sense would have conveyed a body that was "not, or not yet, Chinese."

Taken together, Hobson's appropriation of familiar vocabulary to express new concepts, his introduction of religious and other ideological explanations of the body, and his use of new representational techniques represented a radical, almost violent refiguration of Chinese anatomical illustrations and, therefore, symbolic notions of the self and the human form. Where Chinese conventions prioritized a sort of metaphorical approach to the graphic representation of the body, Hobson's anatomy imposed a decidedly literal prerogative, emphasizing the visual over the conceptual, somatic "reality" over the schematic. Going into the half century following the Opium Wars, one reason *A New Treatise on Anatomy* proved so radical was that it involved not just a

new way of charting the body's structures and functions but the superimposition of a whole new way of *looking at* and *representing* the body.

Anatomical Aesthetics in the Writing of Lu Xun

> In realist metaphysics it is always the body that is accorded substantiality, and . . . it is above all those features of the natural world that invasively trespass the imagined autonomy of the body that achieve status as emblems of the Real.
> — *Marston Anderson*, The Limits of Realism

While some Chinese doctors and theorists found reasons to accept most or part of the premises of *A New Treatise on Anatomy*, a substantial number at least initially rejected it.[41] In trying to account for that rejection, many Sinological explanations, as with the discourses surrounding smallpox and vaccination practice, actually reproduce the predispositions of medical missionary ideology by attributing it to Chinese "superstition" or a sort of generic xenophobia, as when Frank Dikötter remarks that "the absence of common anatomical knowledge lent itself to speculation about barbarian physiology."[42] Somewhat more benignly, Ralph Croizier writes that suspicion on the part of Chinese about Western medicine in the early period "more often . . . was part of the pervasive anti-foreignism, taking the form of horror stories about diabolic practices behind the hospital walls."[43] Yet other scholars have gone to great pains to demonstrate that Chinese rejection of Western-style anatomy, as well as of other aspects of Western medicine, might also be construed as deriving from reasonable choices: arguments, for example, that morbid physiology would not prove illuminating for any understanding of the living; that the knowledge offered by dissection-based anatomy was redundant; that anatomical learning failed to focus on cures; or that it was less important to know the exact form of an organ than to understand its location and function.[44] Nonetheless, when Western-style autopsy and then the medical dissection of corpses were finally legalized by the provisional government in 1912 and 1913, respectively, it was considered by Western and Western-trained doctors to be a cultural and symbolic coup of great proportions; at the ceremonial occasion of the first "legal" dissection in Jiangsu in 1913, a crowd of Western and Chinese medical men and political figures posed together for a photograph with the corpse.[45]

After this, and with the emergence of neonationalistic impulses to "advance"

the cause of Chinese nationalism against the backdrop of a newly global stage, discourses of the acceptance and rejection of dissection-based anatomy began to be framed squarely in nationalistic and (as the potential of anatomy to act in the service of social Darwinism took hold) racial terms: Chinese doctors who accepted the practice framed their acceptance in terms of a nationalistic and scientific advancement, while criticizing those who did not on the basis of their superstition and backward cultural practice generally.[46] In the introduction of his periodical series on "Chinese reactions to Western medicine and pharmaceuticals," for example, Jiang Shaoyuan, a professor at Beijing University writing in the late 1920s, situated his advocacy of Western-style medicine and anatomy in racial terms. Allowing that Chinese medicine had been well received among the medicines of "colored peoples" (youse renzhong 有色人種), it was nonetheless eventually eclipsed, he claimed, by the introduction of superior Western medicine: "This relatively lofty discipline of Western medicine entered China gradually, alongside the power of white people." Those Chinese who rejected Western anatomy and all it represented, according to Jiang, showed evidence of "primitive thinking" (yeman sixiang 野蠻思想): "Please start from the attitude of primitive peoples toward Western medicine. You thought this was too degrading for Chinese people but actually it's not."[47] Another advocate of Western-style dissection practice argued that it could contribute to a more comprehensive understanding of human evolution, and consequently to a more idealistic picture of medical progress. He wrote, "I thought that the world's new medicine surely could trace human origins. So that between Chinese medicine, and also biology, and also theories of human evolution, it would round out our knowledge completely. One stage of that should be to learn Western-style dissection quickly, make our best effort to absorb it, exhaust our understanding of it." He added that "the final step would be to make Chinese medicine a basis for this exploration . . . to progress toward eventually eliminating illness and prolonging life."[48] Likewise in 1928 a doctor called Chong Jingzhou, frustrated that his attempts to perform a dissection were blocked by friends of the deceased in spite of the notarized authorization from the patient donating his body to the clinic, wrote in unambiguously nationalistic terms about the importance of practicing dissection. When the friends of the deceased patient "Zhang" objected to the dissection and volunteered to provide "a letter accepting responsibility" for the

decision to keep the body intact, the dissection was called off. The legal documents seemed to hold no sway, and Chong lamented, "If today someone on his deathbed allocated his legacy, and established a will, how could a letter of responsibility from a few friends nullify it?"[49] By contrast, Chong praised this patient Zhang for his selfless support of the nationalistic cause of improved, Western-style medicine, commenting that "although we couldn't realize his wishes, at least we must let people know that Mr. Zhang was an advocate of China, and that people in the scientific world can only venerate him."[50] Here Chong's rhetoric criticizing the absurdity of the friends' refusal to grant permission to dissect stands in sharp contrast to his description of the nationalistic impulse of the patient Zhang. Zhang, Chong concludes, should be appreciated as a sort of martyr to be venerated.

In this context, the great writer Lu Xun must also be seen, like Jiang or Chong, as one of those medically trained Chinese advocates of nationalism and scientific advancement who wholeheartedly embraced the new and controversial anatomical learning, not only at the level of practice but also at that of epistemology. It is a well-documented fact that Lu Xun studied anatomy himself—well ahead of his peers in China, and long before dissection was made legal—when he was a medical student at Sendai University in Japan between 1904 and 1906, a period he memorialized in the well-known autobiographical story "Fujino sensei"; he took three classes on anatomy at Sendai (osteology, practical anatomy, and topographical anatomy) and had the chance to cut open and dissect human bodies of all ages, both genders, and in different states of decay, observing their workings first-hand.[51] In the introduction to his 1922 collection of writings *A Call to Arms* (呐喊 *Nahan*), when Lu Xun recalls his early student years in Jiangnan, China's most famous writer even mentions Hobson's *A New Treatise on Anatomy* by title: "I went to N [Nanjing] and entered the K Academy [Jiangnan Arsenal school]; and it was there that I learned of the existence of physics, arithmetic, geography, history, drawing and physical training. They had no physiology course, but we saw woodblock editions of such works as *A New Course on the Human Body* [*New Treatise on Anatomy*, 全體新論] and *Essays on Chemistry and Hygiene* [化學衛生論]."[52] Lu Xun was also famously critical of his compatriots' superstitious beliefs and anxious about the placement of Chinese on a hierarchy of races beginning with the "primitive."[53]

More important, as Lydia Liu has crucially observed, dissection became a critical concept in the characterization of the writing process itself, particularly in its symbolic effectiveness for the "objectification of the inner world," not only by Lu Xun but also by other authors of the May Fourth period. She writes:

> One of the first fruits of Chinese literary cross-breeding with European and Japanese fiction is the objectification of the inner world through the act of storytelling. What could be more striking than the popular metaphor of dissection [. . .]? The surgical knife used to dissect the human body for scientific research translates in the hands of Lu Xun and his fellow writers into a powerful metaphor for the function of writing. Yu Dafu once remarked, citing examples from European autobiographical writing (particularly Henri Amiel's diary), that first-person narrative is best suited for the task of "dissecting the self". . . . The scientific trope of dissection thus renders the useful service of turning narrative inward in order to penetrate the psychological depths of the mind.[54]

Here the idea of dissection as a metaphor reflects the interest in psychological self-exploration characteristic of literature during this period. And indeed a predilection for metaphors of dissection can be noted elsewhere in Lu Xun's oeuvre, to the point of perhaps being identified as a unique characteristic of his narrative style. In 1926 Lu Xun made what would become a signature statement in response to criticism about his literary treatment of others: "Indeed I do dissect other people all the time," he wrote, "but I dissect myself even more often and even more ruthlessly."[55] And as Gao Xudong has remarked, in certain of Lu Xun's works one might notice "a kind of dissection-like coldness" (一種解剖式的冷靜). It certainly makes for an attractive approach to reading Lu Xun's complicated fictional narrators (such as those of "New Year's Sacrifice" or "In the Wineshop," for example, in which the narrator's guilt has been read as a reflection of the author's own feelings of ambivalence) to explain the narrators' relationships to other characters and events as diagnostic.[56] "Modern literature," Liu elaborates,

> was entrusted with the clinical task of "dissecting" (Lu Xun's favorite verb) the sick mind of the nation in order to restore life to its weakened body. . . . The medical and anatomical tropes that dominated the debate on literary

modernity effected a subtle homology between the literary and the clinical, and this "metaphorical" analogy helped arrogate the healing power of medical science to May Fourth literature while elevating the status of literature above that of science on the basis of a mind-body opposition.[57]

More than a source for metaphoric vocabulary, however, the terminology of dissection was also a source for the new descriptive language that Lu Xun and other writers employed to describe the human body in their experiments with transplanting literary realism to what Theodore Huters has referred to as "the stony soil of modern Chinese literature."[58] Like Hobson and Chen before them, writers who sought to create a new vocabulary for the body were faced with the formidable task of finding equivalents that could both accommodate the conceptual values of the host language and convey the neologistic values of the source. When it came to literature, these were dangerous waters: one misstep could have disastrous consequences for the quality of the results. Eva Hung gives the example of various approaches to translating Arthur Conan Doyle's Sherlock Holmes stories into Chinese at the turn of the century. In the original story "The Naval Treaty," Hung writes, "the protagonist's fiancée Ann Harrison is described in various ways as an exceptional woman: she writes a strong hand—like a man's [. . .]; she is not tall, has a beautiful olive complexion, large, dark Italian eyes and thick black hair." In a 1916 Chinese translation, however, the woman is described as "quite beautiful, with a *snow-white complexion, soft and dewy like congealed lard, and shiny* black eyes which look Italian. *Her gentle glance bespeaks charm* and her luxuriant black curly hair *which covers her forehead* is particularly appealing." Meanwhile an 1896 translation of the same story describes Ann Harrison as "short and stout, with a face like an olive, dark eyes like Italians, and jet black hair [. . . such that] the southern European kind of beauty found so often in English popular fiction becomes extremely unattractive in Chinese terms."[59] When May Fourth writers proposed to experiment with realism, they were thus also obliged to take on the task of describing a substantial, more "material" body than had ever been described before, even in pornography; a body with which the older, more evocative (rather than descriptive) language of set pieces and the like was ill equipped to cope.[60] For many of these writers—but for Lu Xun especially, given his unique background and training in medicine, anatomy, and science—the conceptual as well as the practical vocabulary for this transition came from science and

medicine; Lu Xun's hands-on knowledge of the human body, as well as his medical training and awareness of both Chinese and Western anatomical traditions, gave him the terminology to explore other literary descriptive modes, including intratextual questions about the mode of realism itself.

Two pieces from Lu Xun's collection of prose-poems *Wild Grass* (野草 *Ye cao*) provide particularly clear illustrations of how this first-hand knowledge of dissection informed his development of a literary descriptive mode. Written between 1924 and 1926, when the practice of dissection in China still remained quite circumscribed, the descriptive mode of these poems draws deeply on the intellectual and technical vocabulary of Western-style anatomy. Here, the description of the body is mediated through the clinical, literal capacity of a trained dissecting eye, and the blow-by-blow metaphor or set pieces of older literature are nowhere to be seen, except occasionally in shadowy irony intended, perhaps, to reveal them as empty. In "Revenge" (復讎 "Fuchou"), for instance, a meditation on the familiar Lu Xun theme of violent spectacle and apathetic crowd begins with an unmistakably anatomical description of the human body:

> Human skin is probably less than a millimeter thick, and below it, through a network of blood vessels denser than the densely packed *sophora japonica* caterpillars which crawl one over the other up the wall, courses hot red blood, radiating warmth. And with this warmth people arouse, provoke, and entice each other, desperate to cuddle, kiss, and embrace and thus achieve the deeply intoxicating, great ecstasy of life.
>
> But just one stab of a sharp knife through this thin, peach-colored skin and the hot red blood will spurt out like an arrow, flooding the killer directly with all its warmth; next, an icy exhalation of breath and the sight of pallid lips will cause him, his sense of common humanity bewildered [人性茫然], to achieve the transcendent, supreme ecstasy of life; while as for the body, it will forever remain saturated in the transcendent, supreme ecstasy of life.[61]

Here form matches content: the form is as radical as the idea it commemorates. In this passage, the indefinite metaphorical references one might find in traditional poetry are replaced with concrete, anatomically specific description. The skin that in earlier writing might have been abstract, existing only in its relationship to "congealed lard" or jade, here has a substance of its own: there

are blood vessels "below" it (皮膚 . . . 後面) and knives that may penetrate "through" it (穿透 . . . 皮膚); it is described as quantifiable, thin, and vulnerable ("less than a millimeter thick," "just one stab . . ."). Likewise the network of blood vessels beneath it, which one would not expect to see in traditional literature to begin with, are not compared to some fragile natural phenomenon but unpoetically to teeming clusters of insects ("the densely packed *sophora japonica* caterpillars which crawl one over the other up the wall"). Even the fact that skin is a finite surface in this poem distinguishes it from more permeable, holistic conceptions of skin in earlier art and literature. Reminiscent of the depiction of flaps of abdominal skin as a literal framing device for the internal organs in *A New Treatise on Anatomy*, skin in this poem serves simultaneously to introduce and to define concepts of the interior and the exterior. It is the delicate but material interface separating the depth of "hot red blood" from the surface's "icy exhalation of breath."

Given this pronounced materiality of skin, we might read the more metaphoric reference to its "peach-colored" quality in the second paragraph as ironic, since it signifies not only the vulnerability of the membrane but in a way the vulnerability of the descriptive mode itself employed to represent the body. By referring to the skin in this instance as "peach-colored," in other words, Lu Xun reminds us of the body that *was*. He then ironically deconstructs it (or demystifies it, as Marston Anderson might say) through the process of dissection—just one stab of the poet's pen, as it were, and the body is revealed to be material, nothing more than the organic matter of which it is composed. Perhaps the "revenge" of the title therefore refers not only to the cyclical interchange of violent spectacle and apathetic crowd in the rest of the poem but to the author's jab at the old representational system.

Here we are reminded that, as is often the case with Lu Xun, the mode itself is fair game in his literary dissections of culture, society, and the like. As Huters has pointed out in his analysis of the short story "My Old Home," a story in which the narrator returns to his old hometown only to find that his memories of an old acquaintance are inaccurate if not illusory, "If one construes the narrator's illusory memories in 'My Old Home' as emblems of the subjectivity that so obsessed Mao Dun in his critical writings from the early 1920s, one can see in Lu Xun's story a powerful metafiction concerning the representation of the individual imagination in modern Chinese literature. . . . In 'My Old Home,' fiction demonstrates itself to be a powerful instrument

of representation, but, paradoxically, only if it represents nothing beyond the problems of representation itself."[62] Keeping in mind Marston Anderson's description of the need for the presence of "the imagined autonomy of the body" to substantiate expressions of realism, we might expect therefore that when the body *lives* in fiction of this period it should be seen as the site of discussion about realism itself; and that when it *dies*, is dissected, mutilated, plagued by disease, or killed off, it should be seen as a comment on or discourse about the various modes of representing the body, thus making us interpret the way the body expires as a kind of indicator of the author's view on the success or failure of realism.[63] In this sense, "Revenge" is a kind of self-reflexive textual commentary on the vulnerability not of the body but of representation itself, describing its flimsiness when subjected to closer examination.

In another prose poem from the same collection entitled "Epitaph" ("Mu jie wen" 墓碣文), even more explicit parallels are drawn between the dissected body and the body of the text. "Epitaph" describes a dream encounter between the narrator, who is trying to decipher the inscription on a dilapidated tombstone, and a corpse lying in the open grave. The narrator first reads fragments of an inscription on the crumbling, moss-covered tablet that describe "'a wandering spirit, in the form of a snake with a poison tooth, that does not bite humans, biting instead its own body, and causing it to perish'" (有一游魂, 化為長蛇, 口有毒牙。不以嚙人, 自嚙其身, 終以殞顛). Proceeding to the back of the tablet, the narrator then notices an open grave. "No plants grew on it," he observes, "and it had fallen to ruin" (上無草木, 且已頹壞). Within this grave the narrator then notices a partially eviscerated corpse: "Peering through a large gap I saw a corpse, its chest and abdomen both opened, missing the heart and liver. Its face revealed neither joy nor sorrow, as inscrutable as smoke" (即從大闕口中, 窺見死屍, 胸腹俱破, 中無心肝。而臉上卻絕不顯哀樂之狀, 但濛濛如烟然). From the corner of his eye, the narrator then glimpses the remains of another inscription on the back face of the tablet:

> In fright I turned to leave, but I'd already caught a glimpse of the remains of an inscription on the other side of the tablet: ". . . I pulled out my heart to eat it in order to grasp its true flavor. But the pain was so excruciating, how could I grasp the true flavor? . . . When the pain had subsided, I savored the heart slowly. But it had already gone stale, now how could I grasp its true flavor? . . . Answer me, or get out! . . ."[64]

Finally as the narrator prepares to leave, frightened, the corpse sits up in its grave: "I was about to leave. But the corpse had sat up in its grave, and without moving its lips, said: 'When I turn to dust, you will see me smile!'" (我就要離開。而死屍已在坟中坐起，口唇不動，然而說：'待我成塵時，你將見我的微笑!'). The poem is not long, and ends on this macabre, eerie note.

It is the legibility of the body that appears most striking in this piece. Corpse and text, the fragmented human body and incomplete bodies of words, are made equivalent as the ominous text-within-a-text leads the narrator deeper into his discovery of the human viscera (or lack thereof). Imagistic parallels seal these equivalencies: the body with "its chest and abdomen both opened, missing the heart and liver" (胸腹俱破，中無心肝) is prefigured by the partially eroded inscription on the stone tablet (described as "very dilapidated . . . only limited text remained"; 剝落很多 . . . 僅存有限的文句) and then echoed again in the reference to "remains" of text on the obverse face of the tablet (殘存的文句). Meanwhile the contents of the enigmatic tombstone inscriptions describe the circumstances under which the corpse came to be eviscerated in the first place (i.e., by its own hand). Thus the narrator's job is as much to interpret the contents of the corpse's chest cavity as it is to decipher the text on the tombstone; and his gaze at both tombstone inscriptions and the opened cadaver is fundamentally diagnostic, reading actively both the inscription and the body itself. In this way the poem's overarching themes of cannibalization and self-destruction (as well as any metaphorical or self-reflexive significance they might have) are mediated for us by the narrator's dissecting eye.

Although it has been argued convincingly elsewhere that this poem "was in all likelihood inspired by Baudelaire's 'Une charogne' (Carrion)," I would claim that a primary source for Lu Xun's "Epitaph" came instead—or additionally—from anatomical learning, both from the author's training in Japan and from the life and work of the aforementioned anatomist Wang Qingren.[65] Wang was most famous in China for his 1830 text *Correcting the Errors of Physicians* (醫林改錯 *Yilin gaicuo*), a highly controversial work in which he claimed that the anatomy represented in the medical classics was wrong and that anatomical knowledge should come from direct observation. Wang's publication narrowly predated Hobson's *A New Treatise on Anatomy*, and these two works became associated with each other in emerging debates about "the moral implications of knowledge based on direct observation of internal organs," Wang becoming known in retrospect as "China's first anatomist."[66]

Given his training, Lu Xun was undoubtedly familiar with Wang's name and work, and he would have known that Wang was particularly concerned, among other things, with determining the correct location of the heart.[67] More important, Lu Xun also would have been aware of the famous circumstances under which Wang acquired his information about the locations of the organs and their correct appearance: unable to actually perform dissection himself, Wang was obliged to visit the shallow graves of plague victims, graves that had been disturbed by dogs, leaving their contents exposed to his view. In a passage from "Correcting the Errors of Physicians," Wang recounts:

> Daily I rode past on horseback. At first I could not help but hold my nose . . . but nonetheless I went to the burial site every morning. I examined closely the internal organs of those [bodies] that were exposed. The dogs had eaten the liver and heart mostly but left the stomach and intestines. Only about three out of ten bodies were complete. For ten consecutive days I examined over thirty perfect bodies. In this way I discovered that the ancient drawings as compared with actual human organs were entirely different, even the various parts did not agree.[68]

Conspicuous parallels exist between this autobiographical passage and Lu Xun's poem. Like Wang, for example, in "Epitaph" the narrator is also engaged in a form of anatomical/evidentiary research and comparison of texts in which he visits a cemetery and encounters an open grave. Like Wang, it is without touching or otherwise disturbing this open grave that the narrator is able to make his evaluation of the eviscerated corpse that lies within. And like Wang, the narrator of "Epitaph," looking closely at the corpse, discovers that it is missing the liver and the heart. For both Wang and the poem's narrator, the challenge is to interpret the body as a text given severely circumscribed physical and textual evidence (the textual fragments in the poem corresponding to the "three out of ten" complete bodies in Wang's account, for example), while the goal is to discover the exact nature of the relationship between old-style representation and actual fact (the lengths Wang had to go to in order to discover that "the ancient drawings as compared with actual human organs were entirely different" vis-à-vis the corpse's frustrated attempts to discern the "true flavor" of the heart). Both pieces make use of the same setting for this seminal discovery about representation: deep within the chest cavity of an eviscerated corpse.

In the course of Lu Xun's poem, the narrator's task thus appears to mirror that of the Chinese anatomist whose representational innovations, while closely associated with those introduced by Western doctors, nonetheless remained resolutely his own. Here both Chinese medicine and Western stylistics are borrowed to explore the theme of representation. The narrator, coded by these associations to be an educated Chinese informant, leads the reader on a visual tour from cavity to cavity, first in the text, then in the ground, and finally in the corpse, confirming that those things that are essential to it, namely, the heart and liver, are not only missing but have been cannibalized. In this sense the text is, of course, ironic, since it implicates the reader as well: like a found object, the text of the poem is itself an epitaph, fragmented and obscure (where does its author come from, and why is he in the cemetery? is the poem his own epitaph?), and we are forced to assume the same role as the narrator in interpreting it. Where irony in "Revenge" is stylistic, in "Epitaph" it is formal. Where the body in "Revenge" is vulnerable, the body in "Epitaph" quite literally gets the last laugh. Yet in both cases the bodies that the poems describe are neither figurative nor metaphorical, but literal in the anatomical sense.

Perhaps unsurprisingly, Lu Xun's self-consciousness about the relationship between anatomical illustration and representations of reality in shaping his own creative vision of the world also itself surfaces in his writing. In his commentary "On Photography" from 1925, for example, Lu Xun comments satirically on the persistence of representations of eyes in stylized ways in Chinese culture in spite of the introduction of what he perceived to be the more realistic modes offered by Western anatomical texts, remarking that in some temples pictures of "these hanging eyes are tapered to a point at either end just like carps; you will look in vain for a pair of round-shaped eyeballs like those sketched in foreign biology drawings."[69] In a passage from "Fujino sensei," Lu Xun's memoir about his anatomy professor at Sendai, Fujino sensei has summoned his young student into his office. Pointing to an anatomical diagram that Lu Xun has submitted with his class notes, Fujino offers his student some advice about the correct way to make anatomical illustrations: "Look, you have moved this blood vessel a little out of place. Of course it *does* look a bit nicer when moved this way; however dissection-based diagrams are not

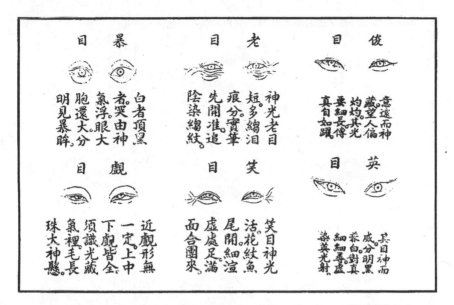

FIGURE 32: Illustrations of eyes with descriptions, from the well-known Qing dynasty 芥子園畫譜 *Jiezi yuan huapu* [*Mustard Seed Garden Manual of Painting*], here from a 1995 reprint (Beijing: Zhongguo heping chubanshe, 1995).

fine art, and the way real things are is something we have no way of changing. I have corrected it for you for now; in future you must render everything as it is on the blackboard." But the young Lu Xun (or the narrator) disagrees with his teacher's advice. While keeping it to himself, he nonetheless maintains that the aesthetic quality of the illustrations is more important than their accuracy in a technical sense: "But I remained unpersuaded. Though out loud I assented, inside I thought: 'But my renderings of the diagrams aren't bad. And as for the actual situation, I can remember that.'"[70]

I read this passage as a kind of mission statement regarding realism in literature, a sort of realist manifesto concerning what Huters has called "anxiety about writing's fidelity to the world": here, in no uncertain terms and in spite of explicit directions to the contrary from the symbolic voice of mediated Western-style authority (Fujino), Lu Xun has reserved the right to subordinate "the way real things are" in diagrams of the dissected body to subjective renderings that nonetheless "aren't bad." He has obstinately declared that artistic license—what he refers to elsewhere as *qubi* 曲筆, or "distortions"—is justified when "the actual situation" can still be remembered later.[71] He is, in effect, championing his right to a subjective reality in the face of Fujino's as-

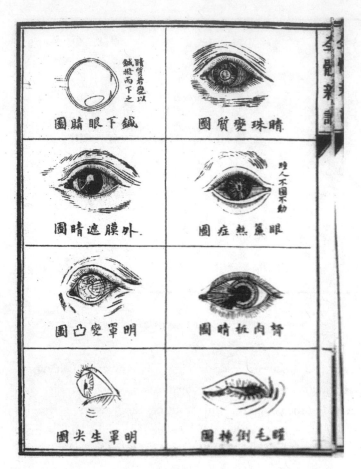

FIGURE 33: Various conditions of the eye. Reproduced from Hobson, *A New Treatise on Anatomy*, n.p. COURTESY OF SHANGHAI MUNICIPAL LIBRARY.

sertion of the hegemonic value of an objective reality to which the individual must always be subordinated.[72]

In this chapter I have suggested, using the examples of Hobson and Lu Xun, that the introduction of dissection-based anatomy to China led not only to literal but also to important figurative consequences. Dissection as introduced by medical missionaries like Hobson and others represented a dramatic conceptual departure both from conventional understandings of the body in China (its boundaries, its surfaces, its integrity in general) and from ways of seeing that body. In the case of medicine and visual culture, we have only to compare earlier Chinese anatomical drawings with images from Hobson's

translated anatomies to gather a sense of the profound nature of this transformation: what amount to charts, or maps, of relative positions of organs and points on the human body in conventional Chinese anatomical illustrations become exercises in exposure, obsessive visual records based on the principle of observation rather than that of relative function; concepts of surface, depth, and scale take on a newly finite flavor. If, therefore, the "imagined autonomy of the body" is a prerequisite for literary realism, then in late nineteenth- and early twentieth-century anatomies we see an almost paradigmatic transformation not only in the relationship of surface to interior but also in philosophical priorities and ways of seeing or imagining the body: perhaps it would not be going too far to call it (to borrow a phrase from Jonathan Crary) a "massive reorganization of knowledge and social practices" related to vision and the envisioning of the human body.[73] For Lu Xun this reorganization was reflected in, and indeed shaped by, a new and fundamentally diagnostic experimental literary realism, among other things. For other writers, artists, and scientists in early modern China, meanwhile, the impact of this reorganization has yet to be considered.

Through the Microscope

> What survived into the twentieth century, even after the en-
> vironment was no longer seen as a major cause of disease,
> was the notion that "natives" themselves produced disease
> through inherent deficiencies of body and behavior. The rise
> in the germ theory of disease accentuated this tendency to
> locate disease within the inherent "racial" habits of indige-
> nous populations.
>
> —*Ruth Rogaski*, Hygienic Modernity: Meanings of Health
> and Disease in Treaty-Port China

Inasmuch as myths of nationalism arise to account retroactively for the self-perception (and perception by others) of a whole people, or even for the imagination of a group to *be* a certain "people," this book has constituted an effort, at least in part, to account for the early roots of an enduring perception of modern Chinese identity as something originally and deep-structurally pathological. At the level of metaphor, perhaps the most familiar manifestation of this profoundly pathological identity is the stereotype of China as the "Sick Man of Asia," a new occupant for the discursive void left by the old Ottoman Empire. Like the idea that China was the cradle of smallpox, this formulation, while popular in the nineteenth century, has for the most part retreated into the historical unconscious of contemporary Western discourses, resurfacing only to nuance retrospective characterizations of masculinity in late imperial

China as effeminate or to bolster a popular understanding of SARS as a by-product of culture. Yet paradoxically, in Chinese nationalist discourse the idea that China is the Sick Man of Asia has remained alive and well over the past century: one observes with fascination the consistency of its expression in late Qing and early modern literature by Zeng Pu, Liang Qichao, Hu Shi, Lu Xun, and others; in midcentury Communist Party propaganda (witness reference to the idea in a motivational speech in Xie Jin's 1950s film *Girl Basketball Player No. 5*); in Bruce Lee's peculiar brand of muscular nationalism in the 1970s; and in contemporary characterizations of China in public discourse on the 2008 Olympics.[1] As Ruth Rogaski observes, "In the first decades of the twentieth century, Chinese elites accepted a medicalized view of their country's problems and embraced a medicalized solution for the deficiencies of both the Chinese state and the Chinese body."[2] The view endured.

If there is one thing that I hope to have conveyed, it is that when early modern Chinese intellectuals adopted these allegories of deficiency to describe their new national identity, developing a language to accommodate it and philosophies to match, they had many ideologically persuasive sources on which to draw. These sources consisted not only of detailed and striking clinical descriptions, both visual and textual, of the Chinese pathological body but also of aggressively promoted medical missionary discourses concerning what was perceived to be a Chinese cultural lack in all areas from hygiene to surgery to anatomical curiosity. With the increasing attribution of behavioral and cultural characteristics to racial distinctions as the nineteenth century wore on, ideas about lack and inability morphed into notions of the innate, thereby foreclosing the possibility of a cultural cure that existed in Peter Parker's and Lam Qua's day. It was this dilemma of supposed original deficiency that particularly troubled intellectuals like Liang Qichao and Lu Xun. If Chinese weakness was inherent at the most fundamental level—the racial, in the newly post-Lamarckian sense—what kind of remedy could there be?[3]

Beyond making a general statement about the adoption of deficiency metaphors and illness imagery in Chinese literature of the May Fourth period and after, to inquire how this particular mixture of scientific ideology and sovereign thinking influenced the development of self-perception and identity on the eve of Chinese modernity is, inevitably, beyond the scope of the present study. Nonetheless in closing, a brief reflection on still another passage from

the oeuvre of Lu Xun will offer a snapshot of one of the complex avenues by which allegories of deficiency and pathology entered the conceptual vocabulary of early modern Chinese literature and culture, while at the same time serving as a benchmark for future analyses of the relationship between scientific ideology and literary innovation in this period and beyond. The episode I am referring to, of course, is the oft-discussed sequence in which Lu Xun recounts his seminal awakening to the cause of literature while watching a slide show as a medical student in Japan, a story which he tells twice, first in the preface to his 1922 collection *A Call to Arms* (*Nahan*) and then in the 1926 biographical story "Fujino sensei."[4] Although this scene has been analyzed by scholars many times over (or, indeed, precisely because of this), I would like to suggest an alternative reading, one that takes into account the episode's all-important setting in a turn-of-the-century Japanese microbiology classroom, while foregrounding the inherent ideological resonances of the medium and its message. As Rey Chow has pointed out, "Lu Xun's story is not simply part of a famous writer's autobiography about his writing career but a story about the beginning of a new kind of discourse in the postcolonial 'third world.' This is the discourse of technologized visuality."[5] How does it complicate our understanding of the scene to consider that this "discourse of technologized visuality" was itself mediated through discourses of science, race, and imperium?

As some readers will recall, the scene in question takes place in a microbiology classroom, where Lu Xun finds himself the only Chinese among a cohort of Japanese students in post–turn-of-the-century Sendai. The day's lesson completed, the professor uses the remaining class time to project slides depicting recent news events, one of which shows the imminent execution of a Chinese spy by Japanese soldiers in the Russo-Japanese war of 1904–5. At the sight of the Chinese about to be beheaded, Lu Xun's Japanese classmates cheer, but instead of joining them, Lu Xun has an epiphany. It was at this moment, Lu Xun recalls, that he decided to give up a career in medicine in favor of literature. "As a rule," he wrote (in "Fujino sensei"), "the clapping of hands and cheering would follow each of the shows. But this time I found them particularly jarring to the ear. . . . It was there and then that my thinking underwent a transformation." In *Nahan* he adds, "After this [slide show] I felt that medical science was not so crucial after all."[6] It was the Chinese "spirit" that demanded his attention.

This scene has often been read as a plainly autobiographical description of a seminal event in the writer's creative evolution, an event that both signified and inspired Lu Xun's eventual "conversion" from medicine to literature.[7] As Lydia Liu notes, "This passage [the *Nahan* version] tends to be quoted and analyzed by critics who wish to establish a straightforward biographical reading of the author's fictional works." She gives the example that "for many years, scholars have labored to identify the slide in question, but with little success," and remarks crucially that even if the actual slide were identified, "the recovery of the slide and the factual ground for Lu Xun's narrative would not automatically account for the power of Lu Xun's narrative."[8] Liu's analysis of the "rhetoric of representation," on the other hand, highlights the dynamics of violence and spectacle underlying Lu Xun's representation of this seminal experience in his intellectual and creative development.[9]

In my view, another important subtext of the implicit intellectual violence in this famous scene is its foundation in the emerging rhetoric, values, and technologies of science and scientific visual culture. It is no accident, for instance, that Lu Xun's well-known realization takes place in a microbiology classroom. Like Western-style anatomy, microbiology and bacteriology were medical subfields of Western origin readily adopted in Japan, even as they were initially rejected in China at the turn of the century. Or as Ruth Rogaski remarks of the concept of "hygiene," "By the end of the nineteenth century, the extent to which new meanings of *eisei/weisheng* were constructed, embraced, and put into practice by national elites marked a distinct divergence between China and Japan."[10] Yet as Thomas Lamarre writes,

> In the second half of the nineteenth century, two directions emerged in the study of bacteria and the etiology of disease. In France, Louis Pasteur turned to experimental analysis to determine how infective disease is produced in the body and how recovery and immunity are brought about. In Germany, Robert Koch sought technical methods for the examination and cultivation of bacteria and developed rational principles of hygiene and prophylaxis. . . . In effect, these two directions suggested two interlocking strategies for the elimination of infectious disease: inoculation and sanitation. At the turn of the century, the study of hygiene in Japan gathered its momentum from studies done in Germany by scientists sent there by the Japanese government. Kitasato Shisasaburo, one of the most famous of

FIGURE 34: Photographer unknown, "Class in laboratory methods" (students at St. John's Medical College, Shanghai, looking through microscopes), ca. 1903. Reproduced from Jefferys and Maxwell, *The Diseases of China* (1910), 11. COURTESY OF HARLAN HATCHER GRADUATE LIBRARY, UNIVERSITY OF MICHIGAN, ANN ARBOR.

these scientists, studied under Robert Koch at the Hygienisches Institut in Berlin, as did Mori Rintaro. . . . Thus, the Japanese trajectory followed the hygienic, prophylactic, and sanitary practices associated with Koch.[11]

Bacteriology taught in missionary medical schools by Anglo-American doctors in China, on the other hand, generally followed the other trajectory: it was far less likely to include Koch's "new theories of microbial disease causation" than courses taught simultaneously in Japan (see figure 34).[12] Just as with the study of Western-style anatomy, Lu Xun therefore once again found himself among a privileged minority of Chinese medical students who had relatively unobstructed access to a new Western science at the turn of the twentieth century.

What this also meant, however, was that Lu Xun had unprecedented access and early exposure to the ideologies of race and hygiene introduced simultaneously with the new sciences. The rhetoric of this new bacteriology in particular, for example, was flush with martial metaphor, conceptualization, and imagery. Bruno Latour touches on this phenomenon in a Western context in his book *The Pasteurization of France*, which highlights the political implications and ideological circumstances behind the emergence of the romance of

Pasteur as the heroic sole "discoverer" of the microbe. The language of bacteriology—of alien bacteria invading healthy cells and causing illness, and increasingly as the first decade of the twentieth century wore on, the protective maneuvers of the newly discovered guardian phagocytes, or white blood cells—was none other than the language of war, employing the descriptive terminology of martial metaphor. In Japan, similarly, the introduction of bacteriology was closely linked to the introduction of ideas about hygiene; at precisely the time Lu Xun studied in the country, for example, Michael Bourdaghs notes that "in 1906 . . . [bacteriology and hygiene] were still considered to form a single discipline." The language used to describe this discipline drew heavily, meanwhile, from martial and nationalistic metaphors. As Bourdaghs writes,

> A number of idioms were invented or translated from other domains, all for use in describing the diseased body as one that had been invaded by foreign elements—germs—which were defined as the causes of illness. Karatani Kojin is a recent critic of germ theory, calling its view of illness a "theology" aimed at exorcising "evil." But, as Karatani argues, this chain of binary oppositions—health/unhealth, purity/impurity, presence/absence (of microbes)—won wide acceptance and became a fundamental precept in the thought of those who concerned themselves with the health of society as a whole.[13]

Even more important, Bourdaghs also notes that "a nationalistic conception of hygiene was reinforced by the militaristic imagery rampant in hygiene writings from this period. Moreover, especially in Japan, hygiene developed primarily as a form of military medicine designed to increase Japan's battle readiness in its wars of imperialist expansion."[14] Even in China, as germ theory was debated among Chinese medical practitioners, the appeal of martial metaphor in bacteriology was not lost on some nationalists: as Bridie Andrews notes, "In the early 20th century, there were many published instances of explicit comparisons between the body's fight against germs and the Chinese national and racial struggle to resist foreign encroachment and subordination. In this state-body analogy, the presence of imperialist forces (germs) on Chinese soil was in itself strong evidence that the Chinese nation was diseased and helpless to resist."[15] Lu Xun himself deployed this metaphor in his introduction to the *Re feng* (熱風) collection, in which he remarks that he always assumed

literature, like white blood cells, would die with the corrupt times it attacks since the presence of white cells indicates that the disease is still present as well.[16] In the context of Lu Xun's microbiology classroom, even the medium of the metaphor was fundamentally intertwined with the values and priorities of an imported imperialist propaganda: by 1902 lantern-slide presentations in Europe and the British colonies were used not only for projecting science but also for projecting "a robust and unifying vision of Empire on to the popular imagination" in entertainment and instruction.[17] In its conceptualization, then, the new bacteriology taught in Japan during the time of Lu Xun's studies was deeply infused with (if not fundamentally derived from) the phenomenological values of war and colonialism at the linguistic, conceptual, and technological levels.

There was therefore a certain unmistakable continuity between the medium and the message in the slides that Lu Xun and his Japanese classmates viewed that day in the bacteriology classroom. First, the slides of microbes and then the slides of war could be argued to be consistent at the level of metaphor, since both shared the language and imagery of war. As Latour quips, "In presenting a bacilli culture, a [late nineteenth-century] advertising headline ran: 'The new French colonies.' It was intended as a joke; it was also correct." In terms of visual imagery, the conflation of bacteriology with ideological content is also commented on by Latour when he describes the pictures accompanying an 1894 article about bubonic plague in Hong Kong:

> It is all there. We can see the centers on the map of China; we can see the poor classes in their hovels; we can see the tumors on the armpits of the sick; we can see the dead rats in the houses of the whites; but even better, we can see the curds along the wall of the tube. . . . The five photographic plates that accompany the article show *neither the Chinese nor the sores nor the dead nor the rats but the colonies under a microscope*.[18]

In the configuration of these images and their juxtaposition with the expository text in the new scientific format, the colonies of bacilli here overrun even their representational habitat, symbolizing the tenet of germ theory in this place and time that made every germ the agent of disease — essentially its single causal agent.[19] Further, as Bourdaghs notes in his important analysis of the 1906 Japanese novel *Broken Commandment*, "Just as disease is seen as the penetration of foreign elements into the body, so the carriers of those for-

eign elements—the novel's *burakumin* [a marginalized class, outsider] characters—are finally portrayed as the agents who introduce an unhealthy difference into the community. The diseased must be isolated, quarantined."[20] Therefore concerning a news slide like the one Lu Xun saw—following as it did immediately on the presentation of bacteria slides, their afterimage still burning, perhaps, in his retina—it is only a short leap to understanding the image contained therein as a continuation of the science lesson, as a picture of "foreign elements" like the *burakumin* that eclipse all other content: an equivalency established in the classroom between the bacteria and the Chinese prisoners of war. In the microbiology classroom we can assume that at the crucial moment of identification that has proven so important to studies of this scene, Lu Xun's identity collapses with that of the object under study—the microbe, the "foreign body"—by virtue of being the only Chinese person in the room; and he is transported to this identity via the powerful visual cultural medium of the lantern slide projector with its connotations of empire and colony.[21] As Leo Lee writes, "In watching this mirror image (the news slide) [Lu Xun] was transported to a more collective and pressing identity with his fellow countrymen"; Lu Xun came, in short, to identify with microbes.[22]

The seminal event depicted in this scene was therefore not Lu Xun's decision to give up medicine for literature, but rather the unexpected superimposition of the metaphysical body onto the scientific one, the cognitive merging of the represented scientific body, for the very first time, with an identifiably Chinese self or body. Combined with the various subtextual and overt reflections on human anatomy and racialized knowledge about it that permeate Lu Xun's other works, the visual epiphany depicted in this infamous slide scene represents the birth of the Chinese body at the metaphorical level and in the modern context—a prerequisite for literary modernism that is not to be mistaken for the birth of modern Chinese literature itself. If we are determined to find the "authentic" image that triggered Lu Xun's awakening, in other words, we should look not among those well-known pictures of a more literal war, but among the slides of microbes that the professor projected for his class that day, for these are what primed the young student's consciousness and prefigured in their most profound structure not only the scientifically pathological body but also the culturally and metaphorically pathological body, at once modern and yet distinctly Chinese, that would haunt literature for decades to come.

NOTES

Introduction

1. "Rendoujiezhenfa," 210.
2. To be clear, there are actually *two* sets of full-color smallpox images in the collection of the Bibliothèque Nationale. One of these copies has captions in Chinese; the other does not. It seems likely that the two sets arrived in France together. A curator of Oriental manuscripts at the Bibliothèque Nationale writes that it "appartient bien aux collections de la Bibliothèque Nationale de France. C'est l'une des soixante-et-une peintures figurant les diverses formes de la variole, regroupées en un album. . . . Une autre version [est] peinte sur soie. . . . Ces deux recueils ont été réalisés en Chine vers 1770 a l'initiative des jésuites français (probablement du Pere Amiot); envoyés en 1771, ils arrivèront à Paris en 1772 accompagnés d'une longue notice sur la 'petite verolle' par le Père Martial Cibot, publiée dans le Tôme IV des *Mémoires concernant les Chinois*." ([It] does indeed belong to the collections of the National Library of France. It's one of sixty-one paintings of the various forms of pox, assembled in an album . . . Another verison is painted on silk . . . These two collections were made in China around 1770 at the initiative of French Jesuits (likely Father Amiot); sent in 1771, they arrived in Paris in 1772 accompanied by a long essay on 'petite verolle' by Father Martial Cibot, published in volume 4 of the *Memoirs concerning the Chinese*.) Private correspondence with Monique Cohen, conservateur general (curator), Division Orientale du Département des Manuscrits, Bibliothèque Nationale de France, July 17, 1997. Cibot, "De la petite vérole."
3. See, for example, Huard and Wong, *Chinese Medicine*.
4. Soulié de Morant, "Chine et Japon," 1:545.
5. "[I]l me [sembloit] suivant tous les symptomes décrits dans le traité et depeints dans

les figures hÿdeuses qui l'accompagnent que la petite Vérole à la Chine est infiniment plus maligne qu'en Europe." Henri Bertin, unpublished letter signed "M. BERTIN à Mrs Ko et Yang, le 13 décembre 1772," letters of Henri Bertin, M.S. 1521, 158–61. I further discuss these letters in chapter 1 of this volume.

6. Wu Qian, *Yizong jinjian*.

7. See Wicks, *Children in Chinese Art*, especially Bartholomew, "One Hundred Children."

8. I discuss this matter further in chapter 2 of this volume.

9. Qtd. in Cadbury and Jones, *At the Point of a Lancet*, 132; emphasis added.

10. For a spirited debunking of this myth by one of the godfathers of contemporary Chinese as a second language (CSL) study, see DeFrancis, *The Chinese Language*, especially his chapter "The Ideographic Myth," 133–48.

11. See, for example, Lu Xun's short stories "Medicine" ("Yao") and "My Father's Illness" ("Fuqin de bing"), or his "Miscellaneous Talk Following an Illness" ("Binghou zatan") in *Lu Xun: Selected Works*.

12. See, for example, Zhang Zhen, "Phantom Theater, Disfigurement, and History in *Song at Midnight*."

13. See, for example, anything by Nathan Sivin, Manfred Porkert, and Paul Unschuld; Elman's comprehensive *On Their Own Terms* is also an excellent place to start. For examples of more specific histories, see Andrews, "Tuberculosis and the Assimilation of Germ Theory," and Rogaski, *Hygienic Modernity*.

14. Bruno Latour's *The Pasteurization of France* has been an important theoretical source for this book, especially in chapter 1; an example of an application of Michel Foucault to the history of medicine in Chinese scholarship is Yang, "The Establishment of 'Urban Health Demonstration Districts.'"

15. See, for example, Farquhar, *Appetites*, and Kuriyama, *The Expressiveness of the Body*. On various Chinese corporealities across disciplines, see Martin and Heinrich, *Embodied Modernities*.

16. Gilman writes: "The question I want to address . . . [concerns] images, pictures, visual representations of all kinds . . . in the writing of the history of medicine. . . . Certainly there seem to be enough 'illustrated histories' of medicine to acknowledge the importance of images in the written history of medicine. And yet their function as part of the materials of medical history has always been peripheral at best. What can explain the anxiety of historians of medicine about the use of visual images?" Gilman, "How and Why," 9.

17. Paul Unschuld echoes Gilman's complaint about the lack of studies of medical illustration in the introduction to his *Medicine in China*. This remains one of the only books specifically devoted to Chinese medical illustration, though it is mainly a catalogue. Yet as an outgrowth of an international conference held in Beiijing in Septem-

ber of 2005 and coorganized by the Wellcome Institute and the Zhongguo Zhongyi Yanjiuyuan [China Academy of Traditional Chinese Medicine], two volumes on Chinese medical illustration are being published: Wang Shumin and Vivienne Lo, eds., 中医历史图像史 *Zhongyi lishi tu xiang shi* ["A History of illustrations in Chinese medical history"] (Beijing: Renmin weisheng chubanshe, 2007); and Vivienne Lo and Wang Shumin, *Globalising Chinese Medicine: A Visual History* (Brill, forthcoming). An excellent online selection of pre-modern Chinese medical images "bought, catalogued, and translated" for "Project Chinese Medicine: A Visual History for Wellcome Institute's online medical iconographic collection" can be accessed at http://tinyurl.com/9jmwr.

1. The "Cradle of Smallpox"

1. Latour, *The Pasteurization of France*, 112.
2. On images of cholera, see Delaporte, *Disease and Civilization*; On China as the "original home of the plague," see Benedict, *Bubonic Plague in Nineteenth-Century China*.
3. See also Roger Hart's summary of relationships among discourses of science in the East and the West in his "Translating the Untranslatable"; see also Croizier, *Traditional Medicine in Modern China*.
4. Benedict, *Bubonic Plague in Nineteenth-Century China*, 166.
5. Moore, *The History of the Small Pox*, 8.
6. Downing, *The Fan qui in China*, 2:172–73.
7. Sirr, *China and the Chinese*, 81.
8. Cibot, "De la petite vérole," 4:392–420.
9. Wong and Wu, *History of Chinese Medicine*, 276.
10. Hopkins, *Princes and Peasants*. See also Hopkins, *The Greatest Killer*, a reprint under a new title of his 1983 *Princes and Peasants*, with a brief new introduction.
11. Cibot, "De la petite vérole," 4:397; for additional examples, see also 4:394–96.
12. Ibid., 4:413.
13. Ibid., 4:395.
14. Ibid., 4:394.
15. Han Qi, *Zhongguo kexuejishu de xizhuan ji qi yingxiang*, 117.
16. Rowbotham, "The 'Philosophes' and the Propaganda," 268–71.
17. See Catherine Jean Kudlick's description of "Paris malade," in her *Cholera in Post-revolutionary Paris*.
18. As recounted in Rowbotham, "The 'Philosophes' and the Propaganda," 268–87.
19. Voltaire's comment: "The time will come when inoculation will enter into the education of children and we will give them smallpox, just as we pull their baby-teeth in order to allow the remaining [teeth] the freedom to grow better." (Un temps vien-

dra ou l'inoculation entrera dans l'éducation des enfants et qu'on leur donnera la petite vérole comme on leur ôte leurs dents de lait pour laisser aux autres la liberté de mieux croître.) Qtd. in Rowbotham, "The 'Philosophes' and the Propaganda," 275–77.

20. Ibid., 268–71.

21. Ibid.

22. Voltaire, *Œuvre complètes*, 24:467. The term *emetics* refers to the substances used in a therapy practiced by inducing vomiting.

23. Dehergne, "Voyageurs chinois," 272.

24. On Gao and Yang (aka Etienne Ko and Alouis Yang), see Beurdeley, *Peintres jésuites en Chine*; Dehergne, "Voyageurs chinois," 372–97; Cordier, "Les Chinois de Turgot"; Benoist, Letters; and Waley-Cohen, *The Sextants of Beijing*, 123–24.

25. Cordier, "Les Chinois de Turgot."

26. See Chang Chia-feng, "Qing Kangxi Huang Di"; "Qing Dai De Cha Dou"; and "Strategies of Dealing with Smallpox," 199–205; also see Chang's excellent doctoral thesis, "Aspects of Smallpox," esp. 172, 182. See also Rawski, *The Last Emperors*. Chang translates *bidousuo* as "isolation centers"; Rawski refers to "Smallpox Avoidance Centers." Note that Chang does not describe a "universal" approach to smallpox prevention; in fact, she includes a comprehensive discussion of competing medical discourses that rejected the practice of inoculation on grounds that might have sounded familiar to a French contemporary. Nonetheless these were not the views anthologized in *The Golden Mirror of Medical Orthodoxy*, the only text cited by name in Cibot's essay. For what should be considered a standard reference on smallpox and inoculation practice in China historically, see also Needham, *Science and Civilisation in China*, vol. 6, esp. the chapter "The Origins of Immunology," 114–74.

27. Chang, "Aspects of Smallpox," 154.

28. Cibot, "De la petite vérole," 392. Pierre Huard and Ming Wong speculate that Father D'Entrecolles's work for the *Edifying and Curious Letters* was inspired by *The Golden Mirror*. Huard and Wong, "Les enquêtes françaises," 165. This seems unlikely, however, since *The Golden Mirror* was not yet published when D'Entrecolles wrote his letter to Duhalde in 1726. Cibot himself writes: "Le Livre *Teou-tchin-sin-fa*, ou *Traité du coeur sur la petite Vérole*, &c. fait partie d'une grande Collection imprimée au Palais. Il ne commence qu'au cinquante-sixième volume & en occupe quatre" (The book *Dou-zhen xinfa*, or "Heart's Treatise on Smallpox [*sic*]," was part of a great collection printed at the Palace. It doesn't begin until the fifty-sixth volume, and takes up four [volumes]). Cibot, "De la petite vérole," 397.

29. "La petite Vérole est une maladie epidémique en Chine, & connue par la Médecine il y a plus de trois mille ans. On raconte qu'elle n'etoit pas dangereuse dans la haute

antiquité, & qu'il etoit très rare qu'elle fût mortelle. A peine la regardoit-on comme
une maladie, parce que quelques tisanes & un peu de régime suffisoient pour la guérir.
Ce n'est, dit-on, qu'après la décadence de l'ancien gouvernement, qui renversa tout
dans les moeurs & dans la maniere de vivre, comme dans l'administration publique,
que cette maladie eut un venin & une force qui s'annoncèrent par les symptômes les
plus funestes, eteignirent en peu de jours les espérances des familles, & dépeuplerent
des Provinces entières en peu de semaines. Ces ravages si rapides allarmerent les
Empereurs, consternerent les peuples, & les firent tomber aux genoux de la Méde-
cine." Cibot, "De la petite vérole," 392.

30. Wu Qian, *Yizong jinjian*, ch. 60, 127: 上古無痘性淳樸，中古有痘情慾恣，痘稟胎元
出不再，毒之深淺重輕識。

31. "The idea of degeneration was not unusual during the Ming and Qing periods in
China; it was also applied to many other matters. The Chinese tended to think that
their sagely ancestors in the Three Dynasties (Xia, Shang, and Zhou Dynasties)
had established perfect models for all aspects of life, but these were not carefully
followed; smallpox was just one of the consequences. Through those assumptions,
we can see a strong moral connection between human beings and illness, involv-
ing parents and their children, and the implication that self-cultivation seemed a
possible means to avoid serious smallpox." Chang, "Aspects of Smallpox," 66–
67.

32. Chang writes: "One of the essential requirements for achieving a natural life span
in the *Huang Di Nei Jing* was to live a proper life style, and any unrestrained indul-
gence, such as insobriety, debauchery, or overstraining oneself, would harm one's
health. The inference drawn [in *The Golden Mirror of Medical Orthodoxy* and other
like books] was that one's wise ancestors knew how to maintain a balance, so they
were able to avoid smallpox. Their descendants, however, had not followed this wise
advice, and so more and more people fell victim to smallpox. . . . Such a comparison
with ancient people was seen as providing powerful proof of the effects of life style
on smallpox." Ibid.

33. Cibot, "De la petite vérole," 397. His mention of the "light diet" further suggests his
reliance on other texts besides the *Golden Mirror* for some of this information. Chang
mentions, for instance, that in addition to prescribing an improved lifestyle to pre-
vent smallpox, "many physicians also suggested that a light diet could alleviate the
severity of smallpox." Chang, "Aspects of Smallpox," 67.

34. Elisseeff-Poisle, "Chinese Influence in France," 151–65. See also Lundbaek, "Trans-
lations of Chinese Historical and Philosophical Works"; Lundbaek remarks of the
Memoirs that "the general articles discuss over many hundreds of pages the prob-
lems that still beset the minds of the Europeans, e.g., *the age of Chinese civilization in
relation to Biblical chronology*, the problem of whether the Chinese were the descen-

dants of Egyptian invaders who had traveled east millennia ago, etc." (35; emphasis added).

35. Dehergne, "Voyageurs chinois," 273: "Or ces observations vont permettre à Cibot, partisan du figurisme, de glisser dans l'*Essai* des opinions hasardeuses et meme outrancières" (However these observations would allow Cibot, a partisan of figurism, to slip into the essay some dangerous and even outrageous opinions).

36. As the Figurist Bouvet wrote of Siam, for him it was "a secret pleasure to recognize among all the fantastic stories of the religion of this country certain traces of our religion. . . . Can their god not be taken with some likelihood to be the person of Jesus Christ, and the knowledge of him [perhaps] obscured by the course of time due to the ignorance of these peoples?" Qtd. in Lackner, "Jesuit Figurism," 133.

37. Ibid., 130.

38. Ibid., 135–36.

39. After describing how early attempts at inoculation initially seemed promising but later failed to stand up to the "decisive facts" of epidemics, Cibot notes how the "evil" of these epidemics "tient beaucoup de la peste à certains egards" (are very similar to the plague in certain respects). Cibot, "De la petite vérole," 393.

40. "Avoit perdu presque tous ses anciens livres dans les guerres civiles; elle travailla sur ceux qui avoient echappé au naufrage général, & sur les observations nouvelles qui se multiploient de jour en jour. Ses premiers travaux la conduisirent, comme de raison, à des systêmes compliqués, obscurs, par lesquels on expliquoit tout. Le petit embarras de les concilier avec les faits de tous les jours, refroidit l'enthousiasme avec lequel on les avoit loués & défendus; & le bon sens qu'on n'avoit pas eu le loisir d'écouter, persuada peu-à-peu que la petite Vérole tenoit aux premieres sources de la vie, & dérivoit d'un levain inné qu'il falloit etudier dans ses effets." Ibid., 392.

41. Chang, "Aspects of Smallpox," 56–58: "The father's immoral behaviour was thought to be responsible for the production of *tai du*. For example, if the father enjoyed drinking, fighting, or taking aphrodisiacs . . . this would affect his *jing*. . . . [Likewise] the mother's emotions were particularly liable for the production of *tai du*. For instance, if she was impatient and jealous . . . she would consequently store much heat toxin and pass it on to her children. . . . Physicians also claimed that when a couple conceived a child, their sexual drive which was thought to contain abundant *yin huo* 淫火 (lubricious fire) or *huo du* 火毒 (fire toxin) would produce *tai du*, and this would be naturally passed on to their child. Furthermore, if the parents kept engaging in sexual activity during pregnancy, this would be considered to be contravening the model of the ancient sages; consequently, the *tai du* which was transmitted to the child would become more severe. These ideas not only indicate that everyone was thought to have received the *tai du* before birth, but also suggest that the theories about the origin of smallpox and moral beliefs were strongly connected." Signifi-

cantly, Chang also notes that "the concept that the origin of childhood disease resulted from parents before birth [was not restricted] to smallpox, but also [applied] to many other child disorders. . . . Smallpox was just thought to be the most serious disease caused by the *tai du*. In many paediatric accounts, there were *tai bing* 胎病 (fetal disorder) sections specifically discussing infants' disorders, including those which were thought to be related to the *tai du*."

42. 夫痘，胎毒也。伏於有形之胎，因感而發，為生人不能免。WuQian, *Yizongjinjian*, ch. 56, 1.

43. "Ce qui nous a le plus frappé dans toutes ces dissertations, c'est qu'en parlant de l'origine de la petite Vérole, nous avons trouvé bien des choses qui sont dites & enoncées de maniere qu'on y voit une tradition confuse du péché originel & des textes en particulier sur le *Tou-tai* ou *venin du sein maternel*, qui ne peuvent guère s'entendre autrement. Mais ce n'est pas ici le lieu d'appuyer sur cette observation; revenons à notre livre." Cibot, "De la petite vérole," 398.

44. "Je n'ay pu que le parcourir et j'ay vu avec beaucoup d'Etonnement (1) Que l'inoculation etoit deja connüe à la Chine dans le 10eme siècle, mais qu'elle n'y a duré qu'environ 50 ans—(2) Que cette maladie y paroit bien plus cruelle encore qu'elle ne l'est en Europe. L'abandon de l'inoculation a été causé en partie suivant l'énoncé du memoire, par une espece de fatalisme, qui neglige tout Remède, toute précaution quand il a pû se persuader que la mort etant inévitable, les précautions pour conserver la vie sont superflües . . . il me [sembloit] suivant tous les symptomes décrits dans le traité et depeints dans les figures hÿdeuses qui l'accompagnent que la petite Vérole à la Chine est infiniment plus maligne qu'en Europe." Bertin, unpublished letter, signed "M. BERTIN à Mrs Ko et Yang, le 13 décembre 1772," Letters of Henri Bertin, M.S. 1521, 158–61. See also Dehergne, "Voyageurs chinois," 267–98; and Huard and Wong, "Les enquêtes françaises," 137–213. On miasmic theory explanations of illness associated with the Orient (in particular India), see Arnold, *Colonizing the Body*.

45. 然種痘一科，多口傳心授，方書未載，恐後人視為虛誕之辭，相沿日久，無所考稽，使至理良法，竟置無用之地，神功湮沒，豈不大可惜哉！今將種痘一法，細加研究，審度精解，纂輯成書，永垂千古，庶為種痘之津梁，咸登赤子於壽域也。 Wu Qian, *Yizong jinjian*, ch.56, 1.

46. Chang describes this legend as "the most well-known legend concerning variolation." She elaborates that the legend "relates to the Wang family in the Northern Song Dynasty. Wang Dan (957–1017), a prime minister (*cheng xiang*), invited a ninety-year-old physician from the E-Mei Mountain in Sichuan to the capital to inoculate his son, Wang Su (1007–1073), who also became a prime minister in the first decade of the eleventh century. After being inoculated, Wang Su developed smallpox and later recovered. Many researchers have tended to believe this story [Chang indicates Joseph Needham specifically], and accordingly have assumed that

the Chinese had discovered variolation and had practised it in the eleventh century."
She also points out how the author of these chapters of *The Golden Mirror* takes the
legend "with a grain of salt." Chang, "Aspects of Smallpox," 125–27.

47. "La fatale nécessité d'avoir la petite Vérole ou dans l'enfance ou dans un âge plus
avancé, fit imaginer à un Médecin d'aller au-devant de ses coups, pour ainsi dire,
par l'inoculation, afin de vaincre sa malignité, en s'y préparant. Le premier succès
de cette tentative singuliere etonna la Médecine & enthousiasma le public. On crut
ici sur la fin du dixieme siecle que l'inoculation . . . alloit fermer pour jamais tous les
tombeaux que la petite Vérole faisoit ouvrir. Le secret s'en répandit rapidement dans
toutes les Provinces de l'Empire, & pénétra jusques dans les villages. Tout le monde
prétendoit que qui avoit eté inoculé ne pouvoit plus avoir la petite Vérole, & tout le
monde faisoit semblant de le croire. Mais cette opinion, si consolante pour les peres
& les meres, n'a pas pu se soutenir au-delà d'un demi-siecle." Cibot, "De la petite
vérole," 393.

48. Hopkins, *The Greatest Killer*, 18.

49. Wong and Wu, *History of Chinese Medicine*, 269–74.

50. Qtd. in ibid.: "Customs Medial Report for Half-year ending March 31, 1871, p. 7 &
foll.," 7.

51. Spence, *The Search for Modern China*, 132–36.

52. See Mackerras, *Western Images of China*.

53. Bertin, Friedrich Melchior Grimm wrote, wanted to "refondre entièrement l'esprit
de la nation . . . en . . . innoculant aux Français l'esprit chinois." Correspondance
littéraire de Grimm et de Diderot, XII (1780), 491. In his unpublished doctoral thesis,
Joseph Dehergne also notes that the word *inoculation* had in the early 1780s just "come
into fashion" (le mot venait d'être mis à la mode). See Dehergne, "Les deux Chinois
et Bertin." Bertin wrote to Cibot: "Vous ne connaissez pas à quel point l'Europe
est malade, et ce n'est pas l'émétique qu'il lui faut. Son état (surtout en France) va
jusqu'à une espèce de délire et son délire l'irrite surtout contre les remèdes." (You
don't know just how sick Europe is, and this is not due to a lack of emetics. Its state
(above all in France) is approaching a kind of delirium and its delirium is aggravated
above all by remedies.) Bertin, unpublished and undated letter, Letters of BERTIN,
M.S. 1522 fo. 129.

54. Qtd. in Hopkins, *The Greatest Killer*, xi; emphasis added.

55. Wong and Wu, *History of Chinese Medicine*, 27. Later it would be cataract surgery
and tumor removal that would be seen as devices for evangelizing the Chinese be-
cause of their dramatic effects, such as "bringing sight to the blind," and the like; see
chapter 2 of this volume.

56. See in particular Liu, "Robinson Crusoe's Earthenware Pot." Qianlong's famous re-
jection of British trade read as follows: "We have never valued ingenious articles,

nor do we have the slightest need of your country's manufactures. Therefore, O king, as regards your request to send someone to remain at the capital, while it is not in harmony with the regulations of the Celestial Empire we also feel very much that it is of no advantage to your country." See Macartney, *An Embassy to China*, 340. See also Hevia, *Cherishing Men from Afar*.

57. Written June 9, 1806; emphasis added. Barrow also included with his statement a copy of a pamphlet on vaccination that was written by a surgeon of the East India Company named Alexander Pearson and translated into Chinese by none other than Sir George Thomas Staunton (the son of the famous historian of the Macartney embassy in which he himself had taken part as a boy). On Staunton's smallpox translation, see Wong and Wu, *History of Chinese Medicine*, 277–83; and Huard and Wong, "Les enquêtes françaises," 170. Huard transcribes the inscription on the copy in the Bibliothèque Nationale de Paris, a gift of one "Langley." After its official recognition by the head of Chinese customs in 1811, the translated pamphlet (or parts of it) reappeared in various Chinese medical tracts, and it was eventually recycled yet again, with some changes, by the Medical Missionary Society in Shanghai as late as 1844. On Staunton's other well-known translation (of the penal code), see, among others, Mason, *Western Concepts of China and the Chinese*, 67.

58. Ibid., 289.

59. Ibid., 290, as "Customs Med. Rep. No. 15 (1877–78), p. 6."

60. Ibid., 299, 295. Chang, however, offers a different interpretation of this rejection of vaccination: "When those officials, local gentry and practitioners enthusiastically devoted themselves to vaccination, in the mean time, they faced rivalry with variolation practitioners, medicine dispensers and those who strongly objected to the Western ideas and methods. . . . Vaccination was institutionalized in many places by way of free vaccination, free education and free instruction books. These strategies obviously affected variolation practitioners, who secretly transmitted their skills from masters to students and made a living from it, and smallpox physicians, who gave medical treatment to natural smallpox victims, and medicine dispensers, who sold medicine to either natural or variolated smallpox sufferers." Chang, "Aspects of Smallpox," 163. See also Arnold, *Colonizing the Body*, 136, on the colonial doctors' view that vaccination was rejected in India due to fatalism: "Hopes of a ready and appreciative acceptance of vaccination were soon dashed. . . . Within ten years of the vaccine's introduction, medical officers were lamenting 'the prejudices and indolence of the natives' and 'the doctrines of fatalism, which inculcate resignation to the ravages of the small pox.'"

61. Dudgeon, *Diseases of China*, 43: "[Smallpox] prevails most generally in winter, and unfortunately this is just the season, from superstitious ignorant notions, when the Chinese will not vaccinate."

62. Hopkins, *Princes and Peasants*, 127.

63. Qtd. in Wong and Wu, *History of Chinese Medicine*, 289.

64. Ibid., 290.

65. "Here the Fu (府) official, dissatisfied with the evils resulting from old-style inoculation, selected 15 of the vaccinators to whom he agreed to issue certificates provided that they received proper instruction from the Missionary Dr. Mackenzie; only the holders of such certificates to be permitted to vaccinate hereafter." Ibid., 301.

66. Latour, *The Pasteurization of France*, 113.

2. Lam Qua's Medical Portraiture

1. For a general history of this period, see Waley-Cohen, *The Sextants of Beijing*.

2. Ibid., 99.

3. See Wakeman, "The Canton Trade and the Opium War"; see also Cohen, *China and Christianity*; and Spence, *God's Chinese Son*.

4. Fan, *British Naturalists in Qing China*, 27.

5. On this question specifically, see, for example, Choa, *"Heal the Sick" Was Their Motto*.

6. See, for example, Rubinstein, "The Wars They Wanted."

7. There are eighty-six paintings at Yale; twenty-three at Gordon's Museum of Guy's Hospital in London (twenty-two of which are duplicates); four at Cornell; and one at the Peabody Essex Museum in Salem, Massachusetts. The existence of the duplicates—the fact of the manufacture and deployment of reproductions of Lam Qua's paintings alone—suggests the intended exhibition value of the works, whether as pedagogical materials, curiosities, or both.

8. See, for example, Cadbury and Jones, *At the Point of a Lancet*; Gulick, *Peter Parker and the Opening of China*; and Spence, *To Change China*.

9. The best recent work on Lam Qua from outside Chinese studies is by Stephen Rachman. See Rachman, "Curiosity and Cure" and *"Memento Morbi."*

10. Xiong, *Xixue dongjian yu wanqing shehui*.

11. Fan, *British Naturalists in Qing China*, 57.

12. Parker, "Tenth Report"; and *Chinese Repository* 17 (1848): 133.

13. On the origins of nineteenth-century theories of Chinese character, see Liu, *Translingual Practice*, 53–60.

14. Parker, "Report of the Medical Missionary Society." See also Josyph, *From Yale to Canton*; and Cadbury and Jones, *At the Point of a Lancet*, 67–75. On displaying the paintings in New York, Parker notes: "[A meeting] at the Stuyvesant Institute . . . was numerously attended by the medical students of the different colleges, by merchants, and by many other distinguished citizens. On this occasion, paintings of the more remarkable surgical cases were exhibited; at the close of the meeting, a provi-

sional committee was appointed, to take measures for the organization of a Society" (Parker, "Report of the Medical Missionary Society," 199); on displaying the paintings in Boston, see Rachman's reference to the *Boston Medical and Surgical Journal* 24, no. 9 (1841): 177, in his "Curiosity and Cure," www.common-place.org/vol-04/no-02/rachman/.

15. See Downing, *The Fan-qui in China*, 2:178–81.

16. Lockhart, *The Medical Missionary in China*, 171.

17. "Thirteenth Report," 460–61. On the various edicts, see also Cohen, "The Missionary Enterprise." Liang Fa was, it should also be mentioned, the translator of the same illustrated biblical tracts that inspired the visions of the leader of the Taiping rebellion, Hong Xiuquan (Hung Hsiu-ch'uan). For more on Liang, see Cadbury and Jones, *At the Point of a Lancet*, 82–86; and Wagner, *Reenacting the Heavenly Vision* For more on Liang's biography and as a source for Hong, see Spence, *God's Chinese Son*, 16–18.

18. Rachman feels that Lockhart's 1861 generalization regarding the "before-and-after" mode of the paintings is "erroneous" because "there is only one instance in the collection of a before-and-after sequence, namely that of Po Ashing, which is in the collection at Guy's and doubtless inspired the comment." In my view, however, these eyewitness accounts by Downing and Lockhart, as well as Parker's own remarks about the "paintings and the illustrations of their cures," constitute compelling evidence that such "before-and-after" style displays did exist, even if they never made it into the collections at Guy's Hospital or at Yale. What would be fascinating indeed would be to know on what basis Parker selected the paintings for exhibition in the West versus for display in the Chinese hospital; at present one can only speculate, given available evidence, on the curious fact that the majority of paintings in Western collections are "befores." See Rachman, "*Memento Morbi*," 158n31. Parker's engagement of Lam Qua's services until as late as 1851 is evidenced by a note in Parker's ledgers that $25 were paid for "Lamqua paintings of tumors," in "Minutes of Two Annual Meetings of the Medical Missionary Society in China" (Canton, 1852), qtd. in Rachman, "*Memento Morbi*," 142, 143, 158n29.

19. See also Bartlett, "Peter Parker."

20. Parker, "Report of the Medical Missionary Society," 198–99; emphasis added.

21. Crossman, *The Decorative Arts of the China Trade*, 77.

22. Downing, *The Fan-qui in China*, 2:114.

23. Sirr, *China and the Chinese*, 1:113–14.

24. Tiffany, *The Canton Chinese*, 85. Also note Rachman's useful point that references to "likenesses" in this period should be distinguished from "representations" since "*likeness* in the old, conventional sense as a term of resemblance appropriate to portraiture (of persons)" contrasts with "*representation* as a term of resemblance appro-

priate to objects, a usage connoting graphic realism—likeness for people, representation for things." Commenting on both likeness and representation in Lam Qua's medical portraiture, Rachman observes that "the representation functions as a visual category in which one observes objects by type or classification, be it medical or some other system. It stands for some part of the body or some kind of growth, the pathological or non-normative. Lam Qua's images frequently invoke in the viewer a kind of gestalt where the eye of the beholder shuttles between these two ways of seeing." Rachman, "*Memento Morbi*," 145–46.

25. Crossman, *The Decorative Arts of the China Trade*, 81. Henry-Charles Sirr was moved to praise the artist's skill in depicting a series about the stages of opium addiction by commenting that "the opium smoker's progress would not disgrace Hogarth, either for conception or handling; this series is painfully correct in all its details" (Sirr, *China and the Chinese*, 113). Another observer notes that while Lam Qua's likenesses sometimes lacked "that extra dash and verve more characteristic of [George Chinnery]," a fine Lam Qua portrait of a Beekman of Philadelphia still "was long thought to have been a Sully" (qtd. in Crossman, *The Decorative Arts of the China Trade*, 72). See also Conner, "Lam Qua," esp. 61. Both Crossman and Conner reproduce good examples of Lam Qua's studio portraiture and more typical commercial work.

26. Conner, "Lam Qua," 58. On numbers of export painting studios in or near the hongs, see *Chinese Repository* 4 (1835–1836): 291; on materials, and the like, see Conner, "Lam Qua," 58.

27. Fan, *British Naturalists in Qing China*, 48.

28. For an evocative composite description of Lam Qua's studio in particular, see Conner, "Lam Qua," 56–62.

29. Crossman, *The Decorative Arts of the China Trade*, 96.

30. Conner, "Lam Qua," 49–50.

31. Fan, *British Naturalists in Qing China*, 48–49.

32. Parker, "Ophthalmic Hospital," 433–45.

33. See, for example, Crossman, *The Decorative Arts of the China Trade*, 87.

34. *China Medical Missionary Journal* 2, no. 4 (1889): 171.

35. Gulick, *Peter Parker and the Opening of China*, 133.

36. Cadbury and Jones, *At the Point of a Lancet*, 51–52; see also ibid., 50–59, regarding the early years of the Canton hospital and the funding for the Medical Missionary Society generally.

37. "Minutes of Two Annual Meetings of the Medical Missionary Society in China" (Canton, 1852), qtd. in Rachman, "*Memento Morbi*," 143.

38. On Kwan A-to's early wages, see Cadbury and Jones, *At the Point of a Lancet*, 50; and on his later wages, see John Kerr, *Report of the Medical Missionary Society in China for the Year 1861*, 16; *Report . . . for the Year 1863*, 27; and *Report . . . for the Year 1865*, 30.

39. Spence, *The China Helpers*, 43.

40. Fan, *British Naturalists in Qing China*, 49–51. On the availability of artists, Fan writes: "What we can be certain of is that Reeves, or any other British naturalist, could easily find competent artists to draw natural history illustrations in the streets nearby the foreign Factories" (49). On "coaching" the illustrators in Western visual cultural priorities, he claims: "To obtain the desired mode of representation, Reeves had to harness the Chinese artists' creative imagination in ways that were not incompatible with the established rules of natural history illustration. He had to keep it from transgressing the boundaries of 'scientific realism.' In addition, he also had to teach the Chinese artists what to pay attention to in depicting specimens. Evidence suggests that Reeves had the artists initially come to his house to execute botanical and zoological illustrations under his close supervision; and once the artists learned the principles, they worked at their studios" (51). On the early transportation of medical specimens, as early as 1829, a surgeon at Guy's Hospital in London recorded that "a specimen of a Chinese foot, the account of which I have the honor to lay before the Royal Society, was removed from the dead body of a female found floating in the river at Canton. On its arrival in England, it was presented to Sir Astley Cooper, to whose kindness I am indebted for the opportunity of making this curious dissection." A lengthy description follows; qtd. in *Chinese Repository* 3 (1834–1835): 539. On page 542 of the same volume, in the article "Small Feet of the Chinese Females," the author offers a detailed description of the anatomy of the bound foot, since he "thought it would be considered as curious, and calculated to interest scientific men." For an excellent theoretical contextualization of this case, see Zito, "Bound to Be Represented." In another case, a Chinese man called Hoo Loo was sent to London in 1830 for surgery to remove a large tumor and was the object of intense "medical" interest, but he died during the surgical removal of the growth in 1831. See *Chinese Repository* 3 (1834–1835): 489–93.

41. "Ophthalmic Hospital at Macao," *Chinese Repository* 2 (1833–1834): 270–71; emphasis added.

42. "Medical Missionary Society in China: Remarks Made at Its First Annual Meeting," *Chinese Repository* 7 (1838–1839): 459; emphasis added.

43. Qtd. in Cadbury and Jones, *At the Point of a Lancet*, 58.

44. Gilman speculates that Parker supplied Lam Qua with models from early nineteenth-century medical textbooks, although I have not found evidence to support this hypothesis. See Gilman, "Lam Qua and the Development of a Westernized Medical Iconography," 66.

45. *Chinese Repository* 5 (1836–1837): 458. For the case studies associated with Wang Keking, see *Chinese Repository* 5 (1836–1837): 457–58, and (reporting his death) *Chinese Repository* 7 (1838–1839): 105.

46. See *Chinese Repository* 7 (1838–1839): 438, case no. 3790.

47. "A painting . . . which is inscribed 'Lamqua' in both Chinese and Western script, indicates that Lamqua (or an able colleague) was prepared on occasion to make copies in oils of engravings. The picture . . . is a reversed copy of the Orientalist fantasy *La Grande Odalisque*, by Ingres, which caused such a sensation when it was exhibited at the Paris Salon in 1819; the Chinese artist would not have seen the original, but must have based this picture on an engraving, and relied for the colouring upon either the bringer of the print, or himself. In this case the strong blue of the drapery in the French original is replaced in the Chinese version by an inventive pink." Conner, "Lam Qua," 58–59.

48. This painting seems consistent with the description of case no. 5583 (*Chinese Repository* 7 [1838–1839]: 103), according to which a woman called Kwan Meiurh "had a preternatural development of the left mamma, which commenced two years ago. . . . She was much emaciated and the breast, one third as large as her head, came down as low as the umbilicus, when she stood up, *and layed upon her arm in the recumbent posture, presenting a large raw surface, exuding blood and the natural secretion of the gland as it was irritated by the clothes. At various points were seen the lacteal ducts greatly enlarged"*; emphasis added. However, this description would also fit several other paintings in the series.

49. For a fascinating discussion of Manet, *Olympia*, and the camellia blossom, see Floyd, "The Puzzle of *Olympia*."

50. See, for instance, Needham, "Manet, *Olympia*, and Pornographic Photography." See also Picquier, *Rêves de printemps*.

51. "In Lam Qua's paintings the patient becomes an extension of the pathology much as the English country gentlemen in Lawrence's paintings become representatives of a class or an attitude toward life." Gilman, *Disease and Representation*, 149.

52. On the compilation of *The Golden Mirror*, see Gao, "*Yizong jinjian*."

53. Gilman, *Disease and Representation*, 149.

54. Liu, *Translingual Practice*, 56.

55. Josyph, *From Yale to Canton*, 5. They might also be interpreted as "inscrutable"; see Purcell, *Special Cases*.

56. Gilman, "Lam Qua and the Development of a Westernized Medical Iconography," 63.

57. Stafford, *Body Criticism*, 302.

58. On the introduction of anesthesia, see Wong and Wu, *History of Chinese Medicine*, 339. On chloroform (introduced in 1848), see ibid., 340.

59. *Chinese Repository* 6 (1837–1838): 439, case no. 4016; emphasis added.

60. Ibid., 437–38; emphasis added.

61. *Chinese Repository* 5 (1836–1837): 475, case no. 2214.

62. Parker often recorded detailed accounts of patients' expressions of gratitude; for example, "[Leang A Shing] seems properly to appreciate the favor he has received, and was ready to tell others what has been done for him"; and "[Woo Pun] evinces *unbounded* gratitude. He seems to regard the favor received, as conferring on him full liberty to introduce any and all his diseased friends." See *Chinese Repository* 5 (1836–1837): 325–26; and *Chinese Repository* 6 (1837–1838): 436–37.

63. *Chinese Repository* 5 (1836–1837): 467–68, case no. 446.

64. See ibid., 467–68, case no. 446.

65. On Lam Qua's palette, see Crossman, *The Decorative Arts of the China Trade*, 87.

66. *Chinese Repository* 5 (1836–1837): 331.

67. *Chinese Repository* 5 (1836–1837): 475, case no. 2214.

68. Ibid., 475, case no. 2214.

69. See, for example, Jefferys and Maxwell, *The Diseases of China*, 451: "Combined with a lack of ability to remove even the simplest growth, the Chinese are as a race particularly unembarrassed by the mere presence of morbid growths which other races would find repellant indeed. To the Chinese a growth is painful or inconvenient, but seldom disfiguring."

70. *Chinese Repository* 5 (1836–1837): 457–58.

71. Josyph, *From Yale to Canton*, 8. "Plaister" refers to a kind of medicinal poultice applied to a wound.

72. *Chinese Repository* 5 (1836–1837): 457–58.

73. *Chinese Repository* 7 (1838–1839): 105.

74. I discuss some of the circumstances surrounding the introduction of dissection-based anatomical practice to China in chapter 4 of this volume.

75. This passage is taken from Parker's loose-leaf, typewritten journals in the archives of the Yale Medical Historical Library; emphasis added.

76. *Report of the Medical Missionary Society for the Year 1842*, qtd. in Cadbury, *At the Point of a Lancet*, 90.

77. On the emergence of a dialectic of Chinese versus Western medicine in the early modern period, see Andrews, "The Making of Modern Chinese Medicine"; on the "invention" of the idea of China itself, see Liu, *The Clash of Empires*.

3. Early Medical Photography in China

1. Perhaps the most comprehensive of Thomson's works on China is his *Illustrations of China and Its People* (1874; reprinted as *China and Its People in Early Photographs* in 1982). See also his *Thomson's China*, with an introduction by Judith Balmer.

2. On the relationship of "freak" photography and early medical and clinical photography, see the introduction to Fox and Lawrence, *Photographing Medicine*.

3. "Throughout the nineteenth century, doctors in Britain and America were key fig-

ures in the history of photography. . . . The standard histories of photography describe the important role of doctors in the creation of the new technology" (Fox and Lawrence, *Photographing Medicine*, 22). An early work on photography in Chinese by a missionary doctor is 脫影奇觀 *Tuoying qiguan* [*Extraordinary Sights of Photography*], published in 1873 by the doctor John Hepburn Dudgeon (德貞; 1837–1901); for more, including a reproduction of the cover and a set of illustrations, see Chen, Hu, and Ma, *Zhongguo sheying shi*. Another book, 照相略法 *Zhaoxiang luefa* [*The Art of Photography*] was published in 1887 by John Fryer (付蘭雅; 1839–1929), with the help of Xu Shou (徐壽, 字雪村; 1818–84); see also Wue, "Picturing Hong Kong," 35–36.

4. See Tagg, "Evidence, Truth, and Order," 257–60. Tagg discusses how in the closing decades of the nineteenth century, "the conditions were in play for a striking *rendezvous* — the consequences of which we are still living — between a novel form of the state and a new and developing technology of knowledge. A key to this technology from the 1870s on was photography" (257). Besides theorizations about the relationship of photography to ideology from Walter Benjamin to Pierre Bourdieu, a particularly useful volume for the present study has been Ryan, *Picturing Empire*.

5. Maxwell, *Colonial Photography*, 9.

6. Wue, "Picturing Hong Kong," 40. See also Wue, "Essentially Chinese."

7. Armstrong, *Fiction in the Age of Photography*, especially her chapter "The World as Image," to which I refer in greater detail later in this chapter. See also Ryan, *Picturing Empire*, 147–48.

8. Ryan, *Picturing Empire*, 147–48.

9. For a more general history, see Fox and Lawrence, *Photographing Medicine*.

10. Ryan, *Picturing Empire*, 145.

11. Jefferys and Maxwell, *The Diseases of China* (1910 and 1929).

12. Jefferys and Maxwell, *The Diseases of China* (1910), vii.

13. Didi-Huberman, *The Invention of Hysteria*, 30.

14. *Chinese Repository* 7 (1838–1839): 34. See also Wong and Wu, *History of Chinese Medicine*, 565: "Mention must be made of the foundation, in 1905, of the *Tsinanfu* [濟南府] *Institute* by the Rev. J. S. Whitewright of the English Baptist Mission. The history of this useful institution goes back to the year 1887 when, in connection with the foundation of a Theological Training School at Tsingchowfu under Whitewright, a small collection of interesting objects was made for the enlightenment of the students. Outsiders soon took much interest in this so that the collection was developed into a museum (1893). This was transferred to Tsinanfu and housed in fine premises erected with money provided by the trustees of the Arthington Fund (about $150,000). . . . The new buildings at Tsinanfu covered over three acres and contained exhibits on geography, architecture, chemistry, *pathology*, *hygiene*, and geology besides library,

reading room and lecture halls. The institute soon attained the fame it deserved, the number of yearly visitors amounting in 1920 to half a million" (emphasis added).

15. For a discussion of curiosity culture and the display of Lam Qua's paintings by Parker in 1840–41, see Rachman, "Curiosity and Cure." On the early "museumification" of China, see Fitzgerald, *Awakening China*, 50–55; quotes here are from pages 51 and 52.

16. Cadbury and Jones, *At the Point of a Lancet*, 132.

17. This is not to say that specimens of Chinese pathology, both living and dead, were not transported back and forth between China and Europe in the same way that plant specimens were in Fan's account; in fact, evidence of such commerce exists from early on (see, for example, chapter 2, n. 40). Some references to specimens of Chinese pathologies sent back to Europe during the latter part of the nineteenth century and earliest decade of the twentieth appear in Jefferys and Maxwell, *The Diseases of China* (1910), for example: "Endotheliomata are also seen clinically, and Maxwell (Formosa) has carefully studied and reported one as occurring in the upper jaw, in Tainan. Half of this tumor is in the museum of St. Bartholomew's Hospital, London" (451); or a reference to a testicular dermoid "from Central China . . . now in the museum of the Royal College of Surgeons, London" (460). There were many more.

18. Wong and Wu, *History of Chinese Medicine*, 374, emphasis added; Cadbury and Jones, *At the Point of a Lancet*, 119.

19. *Report of the Medical Missionary Society in China for the Year 1861*, 13.

20. "One of the earliest and presumably most successful of these early photographers . . . was the American Milton M. Miller (active 1850s–70s), of whom little is known. . . . Evidence suggests that after working in Japan he was in business in Hong Kong and Canton roughly between 1860 and 1864. The majority of Miller's surviving photographs are portraits of foreign and Chinese residents and travelers in Hong Kong and nearby Canton, executed in a style of unadorned and arresting directness. . . . Miller's focus on portraiture was atypical, for though the earlier daguerreotypists probably concentrated on portraits, by the 1860s Western photographers tended to be jacks-of-all-trades, and they may also have dabbled in other businesses." Wue, "Picturing Hong Kong," 31. See also Chen, Hu, and Ma, *Zhongguo sheying shi*, 51.

21. See *Report . . . for the Year 1861*, 16; *Report . . . for the Year 1863*, 27; and *Report . . . for the Year 1865*, 30.

22. Wue, "Picturing Hong Kong," 33. Didi-Huberman, *The Invention of Hysteria*, 62: "The fact that the photographic portrait required not only studios and make-up (as if to help the light come into its own) but also headrests, knee-braces, curtains, and scenery is a good indication of the terms of the paradox: an existence was authenticated, but through theatrical means."

23. Benjamin, *Illuminations*, 118. See also Albert Londe's *La photographie médicale*, qtd. in Didi-Huberman, *The Invention of Hysteria*: "In any case, 'when it is a question of reproducing illness . . . one indeed has an obvious interest in reducing exposure time as far as possible, either because one is dealing with subjects who can remain still only with great difficulty, or because one is working in hospital rooms that are, in general, poorly lit. The increase in the speed of photographic preparations has therefore been decisive from the perspective of its application to the medical sciences'" (107).

24. This is an example of a case in which Jefferys and Maxwell's *The Diseases of China* has proved most valuable: when I first read Kerr's description, I assumed a copy of the image in question no longer existed. But as reproduced in *The Diseases of China* (marked only as "Lent by St. Luke's Hospital, Shanghai"), it seems reasonable to hypothesize that this is, in fact, the first "medical photograph" in China. First, the description in Kerr's report matches this photograph precisely. Second, the outdoors location of the shot and the presence of other people supporting the patient as he stands indicate the need for the light and stillness that photography of this period required. Finally, other images anthologized in these volumes that are labeled as deriving from the St. Luke's archive are uniformly the same as those collected by Kerr during his many years of practice and later archived in, or donated to, the medical museum. My attribution to the photographer Milton Miller is explained below. The image is here reproduced from Jefferys and Maxwell, *The Diseases of China* (1929), 449. Note that in this volume, the negative of the image appears to have been reversed; I reverted it here.

25. Qtd. in Cadbury and Jones, *At the Point of a Lancet*, 112; emphasis added.

26. Kerr, *Report . . . for the Year 1865*, 42–45; Cadbury and Jones, *At the Point of a Lancet*, 177–78.

27. Cadbury and Jones, *At the Point of a Lancet*, 189.

28. *China Medical Missionary Journal* 1, no. 2 (1887): 70. The first president of the Medical Missionary Society was Thomas R. Colledge (1838–79); he was followed by Parker (1880–88); and then Kerr (1889–99). See Cadbury and Jones, *At the Point of a Lancet*, appendix D.

29. *China Medical Missionary Journal* 2, no. 3 (1891): 228–29.

30. Ibid., 224.

31. Wong and Wu, *History of Chinese Medicine*, 469.

32. I discuss this in greater detail in chapter 4 of the present volume. On Western practices from the same period, see Richardson, *Death, Dissection, and the Destitute*. Consider the following folk ditty, cited as originating in a collection called 大家想想歌 *Dajia xiangxiang ge* [*Songs of Popular Imagination*]: "Their telegraph wires, they say, have been / Concocted of eyeballs, and medicine / And Western medicines

distilled / They claim with hearts and eyes are filled. / If death's a lantern snuffed out at night / How can the eyes still give off light? . . . / In the West a criminal is cut / The doctor examines his opened gut / Stomach, liver, lungs, and heart / What average man lets you tear him apart? / When a Westerner meets, by strange illness, his end / He bequeaths his bowels to doctors to rend / But on discovering the cause they let everyone know / What the ancient Chinese knew long ago . . . / Whoever said we must dissect / Each and every corpse, was incorrect." (有說他的電線報／是取眼球和藥造／又說洋人水藥靈／用的人心人眼睛／人死如同燈滅樣／那裡眼球還有亮.... 西洋犯法人剮了／醫生破肚來查考／查他肚肺與心肝／那有平民准你剝／又有洋人怪病死／遺囑醫生破肚子／查明症候告人知／中國古時常有之.... 不知誰把話說錯／說是死人都要破。) Recorded in Jiang Shaoyuan, 中國人對於西洋醫藥和醫藥學的反應 "Zhongguoren duiyu xiyang yiyao he yiyaoxue de fanying" ["Chinese reactions to Western medicine and pharmacology"], 貢獻雜誌 *Gongxian Zazhi* [*Contributions Magazine*] 1, point 25, p. 2; from the personal collection of Professor Yuezhi Xiong, Shanghai Academy of Social Sciences. Jiang has been described as a "liberal professor" at Beijing University writing in the late 1920s. This series of essays and commentaries, published between 1928 and 1929, gathers together quotes and reflections on Western and Chinese medicine from many different contemporary writers and intellectuals. It is divided into various short pieces or "points," from which I quote more extensively in chapter 4.

33. For a detailed account of how St. Luke's Hospital was run in the earliest years of the twentieth century, see Jefferys and Maxwell, *The Diseases of China* (1910), 336–54.

34. See Ye, *The Dianshizhai Pictorial*.

35. Ibid., 137–38. The article about the removal of a tumor also mentions that the doctor who performed the surgery was a woman; one may speculate that this woman is Elizabeth Reifsnyder, who operated around this time on a woman with a tumor that weighed 180 pounds; see Jefferys and Maxwell, *The Diseases of China* (1910), 611.

36. For more on Reifsnyder, see Jefferys and Maxwell, *The Diseases of China* (1929), 436; and Wong and Wu, *History of Chinese Medicine*, 453–54.

37. Craig Clunas and others make the point that early photography of the China trade was "heavily influenced by export painting in its choice of subjects." Clunas, *Chinese Export Watercolours*, 102.

38. For an excellent illustrated discussion of such photographs and postcards, see Sakamoto, *Chugoku*, 149–93. See also Zito, "Bound to Be Represented," on foot binding and discursive practice in both the East and the West; and Ko, *Cinderella's Sisters*.

39. Wue, "Picturing Hong Kong," 43–44.

40. Ibid., 303; boldface original.

41. Ibid. "A contributing factor to the presence of Chinese 'curios' in foreign shows is the well-known delight which the Chinese themselves take in their freaks, and the

fact that they get them together in travelling exhibits for their own edification and amusement" (303).

42. Maxwell, *Colonial Photography*, 10. Wue, "Picturing Hong Kong," 43: "The strong desire to typecast a racially different subject is particularly evident in the occasional slippage from Chinese portrait to Chinese type, when copies of a photograph originally commissioned as a portrait were later sold [in studios] to the tourist trade as a generic type. . . . The predetermined nature of such views is reinforced by the fact that many of these genre images produced for commercial sale were artificially posed and recreated in the studio." On the Japanese use of strikingly similar photos of Chinese with the endemic goiter for scientific campaigns in the 1930s, see Low, "The Japanese Colonial Eye," 110–13.

43. Jefferys and Maxwell, *The Diseases of China* (1910), 466–67.

44. Selections from this scrapbook were generously supplied to me by Karen Swan Naftzger, John Swan's great-granddaughter.

45. "'The usual number of obstetrical calls have been responded to, some of them requiring journeys of fifteen or twenty miles into the interior. The hospital is well-known for the certain relief, usually involving the saving of life, which it brings in these cases. The foreign physician [Swan] has had to respond to calls to attend the more distant and difficult cases, but there have been no objections raised on account of a male physician being in attendance.' This was in 1901 and it marked a decided change in the attitude of the Chinese women." Cadbury and Jones, *At the Point of a Lancet*, 207–8.

46. Fan, *British Naturalists*, 141–43.

47. Ibid., 141.

48. Ibid., 225n106, 226n107. The internal quote comes from Wood, *Fankwei*, 365–71.

49. Earlier representations of doctors and their Chinese assistants provide a revealing point of contrast. In an 1840s Lam Qua portrait of Peter Parker, his assistant Kwan A-to, and a Chinese patient, for example, Parker is seated in the foreground at a desk, his gaze directed at the viewer, while his student stands behind him, his gaze directed at the head of the patient who is seated with his back to us and on whom Kwan, scalpel poised, is about to operate. Rather than simply superiority, this complex portrait conveys among other things a sense of transmission and the passage of knowledge from (American) doctor to (Chinese) medical student. Rather than the forward motion symbolized by the sedan chair as a vehicle in Swan's portrait, this painting suggests more the establishment and prospering of the institution that constitutes its backdrop. For a reproduction of the image and a brief discussion, see Rachman, "*Memento Morbi*," 143–44.

50. For an example of a lithograph reproduction, see McCartney, "James H. McCartney's Report," 5; and for a beautiful example of a lithograph plate, see "Medical Report

no. 52," *China Imperial Maritime Customs Medical Reports* (April–September 1896): between pages 24 and 25. The customs medical reports began in 1870; the inspector general Robert Hart wrote in a general request for information from doctors around China: "It has been suggested to me that it would be well to take advantage of the circumstances in which the Customs Establishment is placed, to procure information with regard to disease amongst foreigners and natives in China; and I have, in consequence, come to the resolution of publishing half-yearly in collected form all that may be obtainable. If carried out to the extent hoped for, the scheme may prove highly useful to the medical profession both in China and at home, and to the public generally" ("Inspector General's Circular No. 19 of 1870," published at the front of every issue as a general call). (Note: The *China Imperial Maritime Customs Medical Reports* was published at irregular intervals and with inconsistent issue notation. The website of the Chinese Maritime Customs Project is an excellent source for locating these and related materials: http://www.bristol.ac.uk/history/customs.)

51. See, for example, *China Imperial Maritime Customs Medical Reports*, no. 47 (April–September 1894): 5; *China Imperial Maritime Customs Medical Reports*, no. 48 (April–September 1894): 24; and *China Imperial Maritime Customs Medical Reports* (October–March 1904): between pages 28 and 29. For the color illustration mentioned above, see "Tchan Kin-Pao," *China Imperial Maritime Customs Medical Reports*, no. 62 (April–September 1900): between 48–49.

52. Wong and Wu, *History of Chinese Medicine*, 464: "'The first medical missionary journal in heathen land,' was first issued—printed by Kelly & Walsh—in quarterly instalments [*sic*] under the name of the *China Medical Missionary Journal*. From January 1, 1905, it was published every two months until in 1923 when, with the help of the China Medical Board, it appeared monthly. In May, 1907, its title was changed to the *China Medical Journal*, which amalgamated in January 1932 with the *National Medical Journal* to form the *Chinese Medical Journal*." Its first issue came out in March of 1887.

53. *China Medical Missionary Journal* 1, no. 1 (1887): 2.

54. Wong and Wu, *History of Chinese Medicine*, 465; *China Medical Missionary Journal* 2, no. 3 (1890): 228–29.

55. Wong and Wu, *History of Chinese Medicine*, 485. Article 11 of the constitution of the new association stipulated: "First. The Promotion of the Science of Medicine amongst the Chinese and Mutual Assistance derived from the varied experiences of Medical Missionaries in this country. Second. The Cultivation and Advancement of Mission Work and of the Science of Medicine in General. Third. The preservation of the character, interest, and honour of the fraternity by maintaining a union and harmony of the regular profession in this country." Qtd. in Wong and Wu, *History of Chinese Medicine*, 465.

56. It should be remembered that Parker published two kinds of reports on his medical activities: one set that appeared in the *Chinese Repository* and one set of fourteen individual reports on the activities of the hospital. These latter are the ones that Kerr continued and began to illustrate.

57. Cadbury and Jones, *At the Point of a Lancet*, 80.

58. Kerr, *Report of the . . . Hospital in Canton for the Year 1863*, 23–24. See also *Report . . . for the Year 1859*: "A report of the operations of the hospital has been prepared in Chinese and is now in the hands of the printer. It was supposed that this would be the best way to present to the more intelligent classes the benevolent objects of the hospital and to give them correct information as to what is to be expected from foreign practice. It is also hoped that some of the wealthy Chinese may be induced to subscribe to the support of the hospital" (3). And again in the *Report of the . . . Hospital in Canton for the Year 1865*: "A Report of the hospital in Chinese of 40 pages has just been issued. It is illustrated by 12 cuts, some of which appear in this report. The cost is $1.40 per 100 copies" (25).

59. "By 1899 photography was a mass-leisure activity and available to a vast number of amateur enthusiasts." Ryan, *Picturing Empire*, 122.

60. See Thiriez, *Barbarian Lens*, 28; and Wue, "Picturing Hong Kong," 29–30.

61. Jefferys and Maxwell, *The Diseases of China* (1929), 432.

62. *China Medical Missionary Journal* 21, no. 5 (1907): 80.

63. William Hamilton Jefferys, "Kodaking for Small Game," *China Medical Missionary Journal* 21, no. 5 (1907): 96.

64. *China Medical Missionary Journal* 21, no. 5 (1907): 96. See also James Ryan's excellent discussion of "camera hunting" culture in colonial Africa in his *Picturing Empire*, 99–139. He remarks, for instance, that "the fact that camera hunting was common within the work of both European and American naturalists shows that photographic technology and the language of hunting were not merely part of British colonial discourse, but were implicated in broader movements to create and preserve a vision of nature as a timeless domain for white Euro-American men" (137). Jefferys was clearly participating actively in the same discourse.

65. Wong and Wu, *History of Chinese Medicine*, 605.

66. Fox and Lawrence, *Photographing Medicine*, 9.

67. "Douthwaite," *China Medical Missionary Journal* 4, no. 3 (1890): 177.

68. Jefferys and Maxwell, *The Diseases of China* (1910), 437.

69. Many missionaries seemed to feel strongly that the queue was a superstitious relic better to be removed. For example, in a discussion titled "Acquired Deformities," Jefferys and Maxwell cite the various means by which "brigands and those who seek revenge on their fellow human beings not infrequently resort to the practice of **maiming their victims**" (boldface original). They continue: "Cutting out the tongue,

ear-slitting and the cutting off of ears is a form of revenge rather than a brigand's practice, and of course the cutting of the cue is a deadly insult — though a blessing in disguise" (ibid., 307).

70. See Thiriez, *Barbarian Lens*, 9, on Felice (Felix) Beato (1830–1906), in particular his war photography in China and India and his notoriety for "views showing dead soldiers in the foreground," which he was accused of staging. Ruth Rogaski describes an 1895 volume, *The Surgical and Medical History of the Naval War between Japan and China, 1894–1895*, "written by the director of the medical department of the Imperial Japanese Navy, Baron Yasuzumi Saneyoshi" and translated into English five years later. She describes it as "a tour de force of medical observation. . . . Every wound received by every Japanese casualty in the Yellow Sea battles is catalogued, beginning with 'Mutilation of Whole Body,' followed by wounds to the skull, and proceeding down the body following a meticulous anatomical route. injuries of the eyes, injuries of the ear, upper extremity, upper limbs, lower extremity, and so on. The course and outcome of treatment for each of the 371 cases is recorded in elegant English prose, augmented by lavish photographs and color illustrations." Rogaski, *Hygienic Modernity*, 157.

71. Newman, "Wounds and Wounding," 65–66. Of the 1,865 photographs that constitute the subject of her essay Newman writes that "it is possible that they were originally bound in albums and circulated in field hospitals for 'on-the-job' training during the war. . . . Some of these photographs, or at least their duplicate prints, were then submitted for inclusion in the Army Medical Museum and the six-volume *Medical and Surgical History of the War of Rebellion*, which was compiled and published after the war. . . . Duplicates of these photographs were also attached to each soldier's military papers and used to verify the nature and extent of the soldier's injury at the time his pension was disbursed. While it is staggering to consider the pedagogical, scientific, and economic function these photographs served, there remains one more startling detail: the surgeon who operated on these men was the same man who photographed them. . . . Civil War surgeon Reed B. Bontecou is credited with being 'the originator and first to practice the application of photography to the history of military surgery.'" (64). See also Connor and Rhode, "Shooting Soldiers."

72. See Newman, "Wounds and Wounding," 69 (in images), 78 (in text).

73. It was perhaps connected to the Japanese documentary project *The Surgical and Medical History of the Naval War between Japan and China, 1894–1895*, described in Rogaski, *Hygienic Modernity*, 157.

74. For more on Dugald Christie, see Wong and Wu, *History of Chinese Medicine*, 444–45.

75. *China Medical Missionary Journal* 10, no. 3 (1896): 95.

76. Ibid., 102.

77. Ibid., 99.

78. Ryan, *Picturing Empire*, 145–46.

79. Newman, "Wounds and Wounding," 83–84.

80. Jefferys and Maxwell, *The Diseases of China* (1929), 467.

81. "By the 1890s, because of the establishment of laboratory science and experimental and clinical pathology as the source of medical perceptions, relatively distinctive conventions had been established for producing photographs of the sick. They were made anonymous, often by blacking out the area over and around their eyes. Photographers less frequently recorded clues about social class except when depicting the results of therapy. Subjects were increasingly photographed naked and against plain backgrounds. . . . Often the parts of the body which were not diseased were eliminated from the print." Fox and Lawrence, *Photographing Medicine*, 26.

82. Newman, "Wounds and Wounding," 69.

83. "Because many of the basic conventions used in current clinical photography were produced at the turn of the century, clinical photographs from that time resemble much more those taken today than they do those produced in the 1850s and 1860s." Fox and Lawrence, *Photographing Medicine*, 9.

84. For more on Maxwell, see Wong and Wu, *History of Chinese Medicine*, 563; see also the second preface (unnumbered) in Cadbury and Jones, *At the Point of a Lancet*. On Jefferys, see Wong and Wu, *History of Chinese Medicine*, 549.

85. Jefferys and Maxwell, *The Diseases of China* (1910), 451.

86. Stewart, *On Longing*, 162.

87. Ibid., 158.

88. Jefferys and Maxwell, *The Diseases of China* (1910), 497–98.

89. Armstrong, *Fiction in the Age of Photography*, 98–102.

90. Ibid., 103.

91. Sander Gilman's analysis, applied originally in his examination of Lam Qua's work, obtains even better here: "The audience, whether of physicians or of Christian missionaries, has its belief system concerning the nature of the Chinese reified in the establishment of its sense of superiority to the patient. The patient bears a double stigma—first, the sign of the pathology, and second, the sign of barbarism, his or her Chinese identity." Gilman, *Disease and Representation*, 149. See also chapter 2 of the present volume, n56.

4. "What's Hard for the Eye to See"

1. No. 2 Memoire 1er Février 1779, Fonds Brequigny, manuscrits occidentaux, Bibliothèque Nationale de France: "Le F. PANZI, jésuite italien, était le peintre que la maison française entretenait auprès de l'empereur de Chine. Il avait envoyé en France le portrait de K'ien Long et on le lui renvoyait, peint sur porcelaine (de Sèvres) afin qu'il

put en faire présent à l'empereur." (Father Panzi, an Italian Jesuit, was the painter that the French maintained near the Chinese emperor. He had sent a portrait of K'ien Long [Qianlong] to France, and they sent it back to him, painted on porcelain (from Sèvres) so that he could present it to the emperor.)

2. The presentation of the bust was probably also intended as a means of showing off and demonstrating Western prowess at the newly acquired art of porcelain manufacture. See Liu, "Robinson Crusoe's Earthenware Pot," for more on this question.

3. See, for example, the chapter "Foreign Goods and Foreign Knowledge in the Eighteenth Century," in Waley-Cohen, *The Sextants of Beijing*, esp. 114–17.

4. "La statue de l'Empereur en porcelaine blanche ne luy a point été offerte pour trois raisons: la première, parce qu'il est deffendu icy de faire le portrait de l'Empereur. La seconde, parce que la statue ne ressemble pas à l'Empereur. La troisième parce qu'elle n'est pas habillée selon la coûtume de ce pays-cy; le bonnet, surtout, qui est boursouflé comme le Turban des turcs paroitroit icy ridicule. . . . On riroit bien icy si l'on sçavoit qu'en France et dans le reste de l'Europe on suspend devant une boutique de vin le portrait des Roys exposé à la poussière, à la pluye et a vent qui les fit danser joliment, aux bons mots et peut-etre aux sarcasmes de la populace. . . . On n'a point tiré parti des médaillons en porcellaine à peu près pour les mêmes raisons. Il y a une autre, dont il est difficile de sentir la force dans d'autre pays. En Chine, une tête séparée du corps fait horreur en sorte que quand on couppe la tête à quelqu'un, ses parents ou ses amis la font aussitot recoudre sur le corps. Or les médaillons représentent une tête coupée; on diroit même qu'on voit l'endroit ou le coup de sabre a été appliqué." Lettre de Bourgeois, Pékin 19 nov. 1784, Fonds Brequigny.

5 Kuriyama, *The Expressiveness of the Body*, 117–18.

6. Elvin, "Tales of *Shen* and *Xin*," 213. The art historian John Hay goes even further, suggesting that what is remarkable in such depictions is the very absence of a physical body. Citing the example of the seventeenth-century novel *Golden Lotus*, Hay remarks on the way literary descriptions in this novel tend to contain a "plethora of similes" that indicate less the presence of an actual physical referent than the "absence of a visible body" as such. Quoting a passage in which Pan Jinlian's body is described systematically in extensively metaphoric terms—her hair, eyebrows, face, body, fingers, waist, and bosom are all compared in a very short passage to a raven's plumage, willow leaves, almonds, cherries, a silver bowl, a flower, shoots of a young onion, a willow, and jade, respectively—Hay remarks that "the absence of a visible body, either female or male, characterizes the innumerable and exceedingly varied conjugations throughout this very long novel. Descriptions frequently specify functions of the body and specific details of sexual anatomy, but there is no body of the sort that Western readers might expect, especially where the pornographic drive is so overwhelming. There is no image of a body as a whole object,

least of all as a solid and well-shaped entity whose shapeliness is supported by the structure of a skeleton and defined in the exteriority of swelling muscle and enclosing flesh" (Hay, "The Body Invisible," 50–51). Such a diffuseness in the description of the body's characteristics through clothes, environment, and generalized metaphor in *Golden Lotus* contrasts sharply, Hay emphasizes, with those Western stylings of the body in which representation is geared toward creating the illusion of the body's "shapeliness . . . supported by the structure of a skeleton," along with its "exteriority of swelling muscle and enclosing flesh," a comparative phenomenon the outlines of which Hay traces in art as well (61). See also François Jullien, *Le nu impossible*.

7. Porkert, *The Theoretical Foundations of Chinese Medicine*, 107–8.

8. Stafford, *Body Criticism*, 8, xvii.

9. Panofsky, "Artist, Scientist, Genius." For a discussion of the relationship between Renaissance art and scientific illustration generally, see Topper, "Towards an Epistemology."

10. On Dominique Parennin's translation of an anatomy into Chinese for Kangxi (1661–1772), see Saunders and Lee, *The Manchu Anatomy*.

11. See Standaert, "A Chinese Translation"; Hay, "Culture, Ethnicity, and Empire"; Chu, "Shenti, linghun yu tianzhu"; Xiong, *Xixue dongjian*; and Kuriyama, *The Expressiveness of the Body*. On Wang Qingren's intellectual roots, see Andrews, "The Making of Modern Chinese Medicine," as well as her "Wang Qingren"; Xiong, *Xixue dongjian*, 74–76; and Wang, "Yilin gaicuo."

12. See Wu, "God's Uterus"; and Xiong, *Xixue dongjian*, 155. The title of Hobson's book is also rendered as *Outline of Anatomy and Physiology* in Wong and Wu, *History of Chinese Medicine*, 364n308 and in the catalogue of the National Library of Medicine and the Wellcome Library in London. On *A New Treatise on Anatomy* in Japan, see Wong and Wu, *History of Chinese Medicine*, 157; both Chinese and Japanese editions are available at the Shanghai Municipal Library, as is the Dudgeon text.

13. See chapter 2, note 69 of the present volume for a quote about the Chinese "lack of embarrassment about growths."

14. See, for instance, Cadbury and Jones, *At the Point of a Lancet*, 81–82: "By 1850 two autopsies, as far as known, the first to be permitted, were done in the [Canton] hospital. The first was a patient who had died on May 18th from stone; he had entered the hospital in such a weakened condition that nothing could be done for him. His relatives at last gave consent after his death, and the permission, Parker said, 'may be regarded as a **triumph**.' The second one took place in November . . . the autopsy was allowed without any difficulty" (boldface original). The case of the introduction of dissection-based anatomy in Egypt in the first half of the nineteenth century provides an instructive parallel to the situation in China: French doctors there decried

the "superstitions" of Islam and the cultural prohibitions they encountered toward the teaching of dissection in newly established medical schools, but in fact there was also considerable advocacy by practitioners who did not find an inherent conflict between the values of Islam and the practice of dissection. I am very grateful to Khaled Fahmy for providing me with a copy of a paper on this topic; see his excellent "Islam and Dissection in Nineteenth-Century Egypt," paper presented at the "Science and Religion in the Age of Capital and Empire" conference, University of Michigan, Ann Arbor, November 2–3, 2001.

15. See Kerr, *Report of the Medical Missionary Society in China for the Year 1866*; and Wong and Wu, *History of Chinese Medicine*, 194–201, 392; Joseph C. Thomson, "Native Practice and Practitioners," *China Medical Missionary Journal* 4, no. 3 (1890): n.p.; and Jefferys and Maxwell, *The Diseases of China* (1929), 8.

16. As early as 1845, a "Dr. Macgowan" "collected 2,000 rupees" from "the generosity of the European community of Bengal" which "enabled him to furnish the hospital with instruments as well as books, plates and anatomical models (the latter from Paris)." He then used these tools to attempt lectures on anatomy "before the Ningpo practitioners and their students." Wong and Wu, *History of Chinese Medicine*, 347–48. The report by Kerr adds, for instance, that "an endeavor has been made to prepare the way for this by holding post-mortem examinations in cases where patients without friends die in the hospital. Opportunity is taken also to dissect an arm or a leg in a hasty way and thus some of the most important regions of the body have been shown to the pupils. . . . The fact that the Chinese have little or no regard for the corpse of a child has been taken advantage of, and in one instance the body of a child which was given to me was dissected in the hospital yard" (qtd. in Cadbury and Jones, *At the Point of a Lancet*, 176). Cadbury and Jones also mention the note that "in 1874, Dr. Scott, evidently a private practitioner in Canton, assisted the medical class [at the Canton hospital] by giving lessons in anatomy by the dissection of dogs. 'While it is impracticable to study anatomy from dissections of the human subject, the aid which the student obtains from dissecting the lower animals is very great'" (170–78). In 1861, James Henderson of the London Missionary Society "not only performed a number of *autopsies* at the [Shantung Road] hospital but gave to Chinese practitioners a series of demonstrations of surgical operations performed upon the dead body." Wong and Wu, *History of Chinese Medicine*, 380; emphasis added. H. W. Boone (who we will remember as the advocate for a medical museum at St. Luke's in Shanghai), according to Wong and Wu, *History of Chinese Medicine*, "advocated the use of animals and pointed out that 'for actual knowledge of human anatomy we can get wonderful fresh preparations from England. . . . This would obviate the objection that has been made to the teaching from plates and models'" (466).

17. The doctor Wong Fun (1828–78), reported to be the "first Chinese to have gradu-

ated in medicine abroad (see Wong and Wu, *History of Chinese Medicine*, 371), for instance, gave "instruction in Anatomy, Physiology and Surgery" as early as 1866. See Kerr, *Report . . . for the Year 1866*. In 1880, "instruction in Anatomy and practical Medicine is given by [the American-educated] Dr. So To Ming [1847–1919], using Dr. Hobson's text-books" (qtd. in Cadbury and Jones, *At the Point of a Lancet*, 179). For a wealth of information in English on the texts and translations associated with the Jiangnan Arsenal (including an informative outline of the context of these texts' flow to Japan), see Elman, "Naval Warfare"; see also Meng, "Hybrid Science versus Modernity."

18. Wong and Wu, *History of Chinese Medicine*, 366.

19. See ibid. One author commented, "'New Treatise' was completely new knowledge as far as the Chinese medical world was concerned, because at the time the 'Explanation of the Human Body' had long since been forgotten." ('全体新论' 对中国医界来说完全是新知识。因这时 '人体说概' 早已被人民忘记了。) Xiong, *Xixue dongjian*, 155.

20. Wu, "God's Uterus," 4.

21. 近得華友陳修堂相助，乃集西國醫譜，參互考訂，復將鉸連骨格及紙塑人形，與之商確定論，刪煩撮要，譯述成書 (from the preface to the 全體新論 [*A New Treatise on Anatomy*]).

22. On medical translation collaboration between missionaries and Chinese assistants, see Xiong, *Xixue dongjian*, 281; he includes a lengthy discussion of the community of Chinese scholars doing translation work related to Western medicine and technology and theorizes that at this time they were still for the most part iconoclasts — frustrated scholars or independents. See also Andrews, "The Making of Modern Chinese Medicine," 33; Rogaski, *Hygienic Modernity*; and Wu, "God's Uterus," for more on this question.

23. Rogaski, *Hygienic Modernity*, 111.

24. Qtd. in Wong and Wu, *History of Chinese Medicine*, 365n314: "The engravings illustrating the books, many from original drawings made by Hobson's friend and voluntary helper Dr. [W. G.] Dickson, were executed by Chinese artists in Canton." See also Lockhart, *The Medical Missionary in China*, 185: "In his report, Dr. Hobson warmly expresses his thanks to his friend Dr. Walter Dickson, who was in practice in Canton, for his very valuable assistance in the hospital; not only in the performance of operations, but by the numerous and beautiful drawings for the illustrations of the works alluded to above."

25. Wong and Wu, *History of Chinese Medicine*, 366.

26. Much has been written on the problems specific to medical translation. For translation issues in general and the problems related to translating Chinese medical terminology in particular, with helpful bibliographic references, see the excellent Sivin,

"Translating Chinese Medicine"; see also Zhang, "Demystifying Qi," on the translation etymology of *qi*.

27. Kuriyama notes on the writings of Herodotus: "Comparatively speaking, the Hippocratic author [Herodotus] asserted, the opposition of the articulated and the inarticulate, of the brave and pusillanimous, corresponded to the divide between Europe and Asia. . . . The Asian physique and character largely replicates the Scythian. Shaped like the Scythians by a climate with little seasonal variation, Asians resemble each other, their bodies lack articulation and their spirits want endurance. Europeans, by contrast, 'are more courageous than Asiatics. For uniformity engenders slackness, while variation fosters endurance in both body and soul. Rest and slackness are food for cowardice, endurance and exertion for bravery. Wherefore the Europeans are more warlike. . . .' The taut, lean bodies of Europe were the bodies of hardy conquerors. The individualized, articulated physique embodied European identity." Kuriyama, *The Expressiveness of the Body*, 141–42.

28. Ibid., 129–30.

29. Andrews, "The Making of Modern Chinese Medicine," 31.

30. Liu, *Tokens of Exchange*, 34.

31. 何謂不能自主之肉，乃人身內之心，膈，肺，胃，腸 . . . 倘果惟人自主勢必疲弊難安，故上帝以其神智全能，使之自行其用，不困不息，困息即死。上主之鴻庥大德，賦於人者，吾人賴之，不容少間，可不深思而敬佩也哉。In Hobson, *A New Treatise on Anatomy*, conclusion to section "On Muscle Function," n.p.

32. For related discussion, see Wu, "God's Uterus," 21–31 For reference to the Japanese excisions, see Lockhart, *The Medical Missionary in China*, 160.

33 Porkert, *The Theoretical Foundations of Chinese Medicine*, 108.

34. Wang Qingren, preface, *Yilin Gaicuo*; emphasis added. Yi-Li Wu notes that one of the factors contributing to the rejection of Hobson's work by the literatus Wang Tao, for instance, was that the work did not pay enough attention to the pragmatics of providing actual cures. She writes: "Wang's comments highlight one reason why Western anatomical studies did not challenge traditional Chinese views of the bodily function, even among those who saw Western medicine as interesting and valuable: the normative, anatomical body of discrete structures was simply subordinated to the Chinese body of mutually-influencing and mutually-transformative vitalities. Another contributing factor was that the therapeutic value of Western anatomical science was simply not self-evident to Chinese readers. For example . . . Wang Tao (1823–1897), an associate of Hobson, noted that 'it was truly regrettable that [*Outline of Anatomy*] did not record any medical prescriptions for treating illness.'" Wu, "God's Uterus," 33.

35. Hay, "The Body Invisible," 66.

36. The following is John Hay on the metaphor of government with respect to the body:

"Once we observe the mediating concept of 'function' between the organs of government and those of the body, we may realize that this is more than a metaphor. It is an extremely adaptable and powerful model." Ibid., 65. See also Despeux, *Taoisme*; and Schipper, *The Taoist Body*.

37. Hay, "The Body Invisible," 61.

38. 臟腑居內，目所難見，故西國業醫之院，每領死人，剖胸刳腹，搜臟淪腸，細小考究，詳載於書，比中土耳聞臆斷者，實不相侔。 In Hobson, *A New Treatise on Anatomy*, subsection on "discussion of the organs" (*zangfu gongyong lun* 臟腑功用論).

39. Hay, "The Body Invisible," 61.

40. "Early Confucian texts . . . seem to draw a basic distinction between simple ornament and dress-and-ornament, referring to the wearing of clothes in opposition to the tattooing of skin as a marker between the civilization of the Chinese and the noncivilization of barbarians. The very notion of civilization, which lay at the core of the self-image of China itself, was understood partly as the process of ornamentation in a semiotic sense, the articulating of pattern in the substance of humanity." Ibid., 63.

41. For examples of positive responses, see Jiang Shaoyuan, 中國人對於西洋醫藥和醫藥學的反應 "Zhongguoren duiyu xiyang yiyao he yiyaoxue de fanying" ["Chinese reactions to Western medicine and pharmacology"], 貢獻雜誌 *Gongxian Zazhi* [*Contributions Magazine*], Beijing, 1928–29. In this serial publication from the late 1920's, Jiang gathers itemized "points" (項目) of interest, and describes how advocating the adoption of Western-style anatomy and dissection practice, for instance, were those who believed that Western medicine could provide a deeper understanding of the body's internal structures. Responding to a critic who blamed Western medicine for treating the human body like a machine, one man defended it by commenting: "Wang Yiren objected to Western medicine, complaining that they [practitioners of Western medicine] shouldn't treat humans like machines. I don't understand this statement. All I know is that in a person's belly are some 'organs.' Westerners seem to have a much better understanding than we do of how many bones there are in the human body and what they look like, as well as the nature and function of each part of the human body." (王一仁反對西醫，責備他們不該把人當做機器看。這句話我不懂，我所知道者，人的肚子裡有些什麼'臟腑'，人體有多少根和什麼形狀的骨頭，以及人身各部分的性質功能等等，西洋人似乎比我們明白的多。) Jiang, *Zhongguoren* I, point 254, p. 9. In a similar vein, another writer argued that without Western-style anatomy texts, Chinese would never be able to have more than a superficial grasp of the "true shape" of the organs, and without dissection of the true form (*shixing jiepou* 實形解剖) would be unable to see transformations in internal diseases, and so on. "If not for the entry of the Western anatomy texts into China, though 'drinking water from the higher pool,' one could

never have seen through [to the true form of the organs]. . . . Without dissection of the true form, how can one understand fully the details of transformations in internal disease? This is beyond [just] the diseases of external medicine and the symptoms of the whole body." (余雲岫. 若非泰西之書入中國，則臟府真形，雖飲上池水者亦未會洞見 . . . 內病之變化，非實形解剖，能洞見臟結乎。彼外科之病，全身證候之外。) Ibid., point 278, p. 20–21. Still another writer argued that in order to discover the "true relationship" of the flesh (*routi* 肉體) to the spirit (*jingshen* 精神), Chinese doctors must put aside the *Lingshu suwen* [a traditional Chinese medical text] and take up "modern" (*jindai* 進代) science from the West and learn about physiology and psychology. Jiang, *Zhongguoren* 3, point 298, p. 28. A more moderate form of advocacy proposed a merger of Chinese and Western medicine to take the best of both worlds. One doctor argued that at the core the two medicines were fundamentally the same, the only difference being that Western medicine treated not only "function" (*yong* 用) but also "form" (*xing* 形): "The Yellow Canon only talks about its function, but Western medicine also discusses its form. The names may differ but the facts match." (是內經只言其用，而西醫兼論其形。名雖異而實則同也。) Jiang, *Zhongguoren* 9, point 306, p. 23.

42. Dikötter, *The Discourse of Race in Modern China*, 43.

43. Croizier, *Traditional Medicine in Modern China*, 41.

44. For an excellent discussion of the reasons behind the Chinese rejection of Hobson's anatomy, see Wu, "God's Uterus"; see also Andrews, "The Making of Modern Chinese Medicine." Andrews specifically frames her work in the context of Paul Cohen's *Discovering History in China*. As part of her project of rehistoricizing the introduction of Western medicine in general to China, for example, Andrews notes that "many [Chinese historians] are clearly embarrassed and apologetic at their predecessors' 'inability' to recognize the superiority of western science. One of my aims is therefore to explain why it was a reasonable choice for many Chinese to prefer Chinese medicine over western medicine, and — in a symmetrical way — to explore some of the social implications when people did actually decide to accept the authority of western science and medicine" (3–4).

Jiang Shaoyuan provides an array of quotes from Chinese doctors rejecting Western-style anatomy in his *Zhongguoren* 5, point 279, p. 21–22. One legend, for example, suggested that ancient sages had possessed a sort of x-ray vision (*tong-shi* 洞視) that allowed them to see through to the organs, rendering dissection unnecessary: "Some people believed the ancient Chinese sages could see through to the organs, so there was no need to dissect" (有人以為中國古聖能夠洞視臟腑，所以無須乎剖割), a notable feature of this belief being that it does not suggest that dissection itself is useless, merely that it has nothing new to offer. Jiang, *Zhongguoren* 4, point 273, p. 4–15. Another argument suggested that the dissection of corpses

was of little medical use since the dead body differed too greatly from the living one: "One reason offered by those who didn't believe in Western dissection and anatomy studies was that the bodies of the living and the dead were different, so all those who made the effort to perform dissection on corpses would not necessarily be able to gain any clarity on the physiology of the living." (不信西洋解剖學者所持理由之一，是說生死之體既殊，則專在屍體上作剖視工夫者，不見得就能夠明白活人的生理。) Jiang, *Zhongguoren* 15, point 338, p. 28–29. And still another nonsuperstitious, theoretically based argument against dissection claimed that the bodies represented in works like Hobson's were not, after all, Chinese—and therefore would be of little use to Chinese physicians who would be working with a different anatomy. See Jiang, *Zhongguoren* 5, point 280, p. 22–23. Of course, superstition also occasionally constituted the foundation for the rejection of Western anatomical practice. In some cases this may have reflected a sort of cultural misinterpretation, as in the case of the belief that Christians used preserved hearts and eyes for worship, which might have sprung partly from rumors about the Catholic practice of keeping relics. A certain novel apparently even suggested that Westerners made opium by cooking decaying corpses. On fears about Catholic missionaries using eyes and hearts for worship, see Jiang, *Zhongguoren* 1, point 255, p. 8; on opium and corpses, see ibid., 6.

Lu Xun commented critically on such suspicions in his essay "On Photography," in which he writes how "one often heard in S City men and women discussing how the foreign devils would pluck out people's eyes. . . . It is the custom of S City that by winter's arrival families of means pickle in large jars enough cabbage to provide for the coming year's needs. Whether the cabbage is meant to be used in the same way as Sichuan pickled vegetables I know not. The use foreign devils had for pickled eyes, of course, lay elsewhere, only the preparation was influenced by S City's pickling of cabbage, which is sure proof of the saying that China has great power of assimilation over the West." Lu Xun, "On Photography," 200.

45. See Wong and Wu, *History of Chinese Medicine*, 598–99: "In November, 1913, a Presidential Mandate was issued legalizing and regulating *dissection of dead bodies* and on the 22nd of the same month detailed regulations were promulgated as follows: Order of the Board of interior No. 51 . . . [following is the text of four regulations, one of which stipulates that 'the bodies of all those meeting death by punishment or dying in prison from disease, without relatives or friends to claim their bodies, may be given by the local magistrate to a physician for dissection, to be used for the purpose of experimentation in medical science, but after dissection the body must be sewed up and buried.'] As soon as a copy of the 1913 regulations was given to the Peking Union Medical College, Dr. J. G. Cormack, its principal, sent a petition to the Board of Interior, asking for a body from the prisons . . . two more corpses soon followed and—no arrangements having been made for the preservation of such—further

offers by the prison authorities had to be refused" (emphasis added). Wong and Wu further note that an early legal dissection (in 1913) attended by "the representative of the Governor [of Jiangsu], judges, many other officials and Chinese as well as foreign medical men . . . was considered so memorable, that the guests" — together with the corpse — "were photographed and a descriptive pamphlet was published in which it was stated that this was the first dissection in China for four thousand years!" (599). Even half a century earlier, it must be remembered, Hobson himself commented that he had written the texts "both for the instruction of native practitioners and to diffuse general information on these subjects, with the hope that, ere long, the Chinese government will do something to encourage the study of the medical art," adding that "anatomy is totally interdicted both by law and public opinion." Qtd. in Lockhart, *The Medical Missionary in China*, 154. On the first public dissection, see also Wang, "Mingguo chunian."

46. On the reform movement's relationship to medicine, see Croizier, *Traditional Medicine in Modern China*, 230–31: "At the beginning, concern for national strength in a Social-Darwinist world prompted the first reformers to point out traditional medicine's inadequacies in public health. Then, in the May 4th period, the new radicals' bitter repudiation of everything associated with traditional medicine was an integral part of their complete rejection of traditional culture in favor of science and modernity. Similarly, the 'national essence' defenders of Chinese medicine were defending it as part of the general struggle to save Chinese culture from total submergence in the flood of Western cultural importations. Their attempts to incorporate modern science into a reformed medicine, still recognizably Chinese, were typical of the modern dilemma over modernization and cultural continuity."

47. 這較高的泰西醫學，隨著白種人的勢力，慢慢輸入中土 (Jiang, *Zhongguoren* 1, points 251–60, pp. 1–2); 請從野蠻人對於西洋醫藥的態度講起。你以為這未免太唐突中國人嗎，其實並不 (Ibid., point 298, p. 32). Such fears about the threat of degenerating into "barbarians" can actually be traced to late Ming writers such as Wang Yangming, who linked degeneration to the status of animals with a failure to cultivate moral virtue; an early transformation of this idea into racial terms — and the strain in which Jiang Shaoyuan and Lu Xun were participating — began in the late Qing period with Zhang Binglin. See, for example, Fitzgerald, *Awakening China*, 121–22.

48. Jiang, *Zhongguoren* 3, point 268, p. 29.

49. 假如今有人臨終支配其遺產。立有遺囑。亦可經三數朋友一紙負責書取消之乎。 Jiang, *Zhongguoren* 8, point 300, p. 31–33.

50. 余等既不能貫澈其主張。則至少亦須為其發表。使人知張君為中國之提倡者。科學界人必能崇拜之也。 Ibid.

51. See Xu, *Wangyou Lu Xun yinxiang ji*, 9. See also page 16: "In medical school, he [Lu

Xun] dissected many corpses, male, female, old and young. He told me: 'When I began, I was quite ill at ease, especially with the corpses of young women, children, and infants, and often felt as if I couldn't stand to ruin them, and couldn't apply the scalpel without specially gathering my courage.' He also told me: 'How amazing was the fetus in the mother's womb, how black were the lungs of the coal miner, how cruel was the harm to the child of syphilitic parents.'" (［鲁迅］在医学校，曾经解剖过许多男女老幼的尸体。他告诉我：最初动手时，颇有不安之感，尤其对于年轻女子和婴孩幼孩的尸体，常起一种不忍破坏的情绪，非特别鼓起勇气，不敢下刀。他又告诉我：胎儿在母体中的如何巧妙，矿工的炭肺如何墨黑，两亲花柳病的贻害于小儿如何残酷。) Leo Ou-fan Lee, *Voices from the Iron House*, 178, also cites Yamada Norio, *Ro Jin den sono shiso to henreki* (*Biography of Lu Xun: His Thought and Experience*) (Tokyo, 1964), 17.

52. Lu Xun, *Lu Xun*, 1:34. The other title Lu Xun mentions, *Huaxue weisheng lun* (*On Chemistry and Hygiene*), refers to a serialized work in eighty-eight installments, beginning in 1878 and translated by John Fryer (1839–1928) and Chinese collaborators in the *Chinese Science Magazine* (*Gezhi huibian*), also published by Fryer. For more on this work, see Rogaski, *Hygienic Modernity*, the chapter titled "Translating *Weisheng* in Treaty-Port China," esp. 109–18. For more on texts used in teaching at the Jiangnan Arsenal, also see Rogaski's chapter; Elman, "Naval Warfare"; and Meng, "Hybrid Science versus Modernity."

53. A comment by Lu Xun takes note of the increasing centrality of racial hierarchy to Chinese self-perception by looking at the socio-etymological origins of the term *native*: "I heard a friend say that an English doctor at a church in Hangzhou wrote a preface to a medical text, [in which he] calls Chinese people 'natives' [土]; at the time I was quite uncomfortable with this, but now that I've thought it over carefully, I might as well accept it. The word 'native' originally just meant someone born on this soil; it had no negative connotations. Later, because what it indicated was mainly 'primitives,' a new kind of meaning was added; it was as if it became a substitute term for 'primitive.' In using this word to describe Chinese people, there is inevitably a derogatory meaning—only now we have no choice but to accept this moniker." (聽得朋友說，杭州英國教會里的一個醫生，在一本醫書上做一篇序，稱中國人為土；我當初頗不舒服，子細再想，現在也只好忍受了。土人一字，本來只說生在本地的人，沒有什麼惡意。後來因其所指，多系野蠻民族，所以加添了一種新意義，仿佛成了野蠻人的代名詞。他們以此稱中國人，原不免有侮辱的意思；但我們現在，除承受這個名以外，實是別無方法。) Lu Xun, *Refeng*, 33. He goes on to talk ironically about the aspects of Chinese "character" and culture of which he was famously critical, like cannibalism, polygamy, and so on. It is crucial to note that implicit to Jiang's and Lu Xun's (and many other authors' as well) contrast of barbaric versus Western thinking is the important subtext of evolutionary

determinism. At this particular moment in history—the earliest part of the twentieth century, as the idea of eugenics began to gain momentum among certain Chinese nationalists—the question of race was becoming increasingly crucial to Chinese self-definition. See, for example, Pusey, *China and Charles Darwin*, on the evolution of evolutionism in China and Lu Xun's appropriation of it. An implication of Jiang's argument (and implicitly of Lu Xun's on another level), is the idea that to adopt Western medicine itself was to make a bid toward advancing on the scale of racial hierarchies; the whole discussion was framed in racial and evolutionary terms, where "barbarian" represented the lowest (least desirable) stage and equivalency with white people (*baizhongren* 白種人) represented the goal.

54. Liu, *Translingual Practice*, 128.

55. 我的确时时解剖别人，然而更多的是更无情地解剖自己。 *Lu Xun quanji*, 1:283.

56. See Gao, "Lu Xun," 159–69. On the poem "Revenge," published in Lu Xun's collection *Wild Grass*, Gao remarks that "from this section of the text one can also see a kind of dissection-like coldness. Thus, all of Lu Xun's literary works are shot through with a doctorly coolness" (163). (从这段文字中也可以看到一种医生解剖式的冷静。因此，医生式的冷峻是贯穿于鲁迅所有文体之中的。)

57. Liu, *Translingual Practice*, 50.

58. Huters, "Ideologies of Realism," 160: "The very ease and plasticity of fictionality as introduced into China in the twentieth century carried with it the seeds of a powerful anxiety that even demonizing traditional literature could not wholly suppress. . . . If anxiety about writing's fidelity to the world is a feature of all notions of representation, the form this anxiety took in May Fourth China was of a special kind . . . it becomes a perpetual concern as to whether a literary ideal can be transplanted onto stony Chinese soil. As such, it would seldom lead in the direction of questioning the means of representation themselves, but rather would be displaced into constant apprehension as to whether or not the individual writer could transcend his or her own tradition sufficiently to be faithful to the terms of the new norm."

59. Hung, "Giving Texts a Context," 165.

60. See Hanan, *The Chinese Vernacular Story*, 20–21: "Coordinate description usually appears as a piece of parallel prose, less often as a poem. It is description from a general viewpoint, a tableau presented to the reader usually at the same time the character sees it but not necessarily through his psychology. Its diction tends toward an elevated Classical, full of well-worn imagery and allusion. For this reason, and also because passages of description are often borrowed from other works as part of the common currency of the novelist's art, they are known as set pieces, at least in their parallel prose form. A suitable general term to apply to both prose and verse would be *descriptio*, as it is used in medieval European literature. Like reflexive comment, *descriptio* is a common feature in many kinds of oral narrative."

61. The original Chinese corresponding to this section (about the first third of the poem) reads: 人的皮膚之厚，大概不到半分，鮮紅的熱血，就循著那面，在比密密層層地爬在牆壁上的槐蠶更其密的血管裡奔流，散出溫熱。于是各以這溫熱互相蠱惑，煽動，牽引，拼命地希求偎倚，接吻，擁抱，以得生命的沉酣的大歡喜。　但倘若用一柄尖銳的利刃，只一擊，穿透這桃紅色的，菲薄的皮膚，將見那鮮紅的熱血激箭似的以所有溫熱直接灌溉殺戮者；其次，則給以冰冷的呼吸，示以淡白的嘴唇，使之人性茫然，得到生命的飛揚的極致的大歡喜；而其自身，則永遠沉浸於生命的飛揚的極致的大歡喜中。　Original text in Lu Xun, *Ye cao*, 15. See also Yip, "Hesitation Between."

62. Huters, "Ideologies of Realism," 147–73. On Lu Xun's "Regret for the Past," see also Liu, "Narratives of Modern Selfhood."

63. By this reasoning, Shen Congwen's short story "New and Old" ("Xin yu jiu" 新與舊) is not just about an executioner in transition from the old regime to the new one; it is also a story about the role of the author in negotiating new modes of representation. Similarly in the case of Mao Dun's "Searching," when the only character who seems to be successful in love holds up a picture of his perfect bride alongside a telegram alerting him that she has just been disfigured. This may be read as a comment on the authorial dilemma of realism, that is, the appropriateness and success or failure of realism as a mode.

64. 我在疑惧中不及回身，然而已看見墓碣陰面的殘存的文局———／'. . . 抉心自食，欲知本味。創痛酷烈，本味何能知?' . . . ／'. . . 痛定之後，徐徐食之。然其心已陳舊，本味又何由知' . . . ／'. . . 答我。否則，離開！ . . .' (ellipses original).

65. Sun, "The Presence of the Fin-de-Siècle," 205: "Lu Xun's writings contain other indirect allusions to syphilis. The putrid corpse in his poem 'Tombstone Inscriptions' (1925) was in all likelihood inspired by Baudelaire's "Une charogne" (Carrion), a poem about a corpse in a state of syphilitic decay, with its open legs pointing blasphemously heavenward." For sensitive readings of the entire collection, see Leo Ou-fan Lee, *Voices from the Iron House*. See also Lee, "Solace for the Corpse"; and Wang, *The Sublime Figure of History*. On his poetry generally, see Kowallis, *The Lyrical Lu Xun*.

66. Andrews, "The Making of Modern Chinese Medicine," 38–39.

67. See Unschuld, *Medicine in China*, 212–15. In examining the bodies of child plague victims, Wang found that "the diaphragm was always torn, so that Wang was unable to determine if the heart was located above or below it. Despite such unfavorable conditions, he felt he detected considerable differences between the reality of what he saw here and the statements of medical literature. After his curiosity had been aroused, Wang devoted the rest of his life to this question" (212–13). Another means of investigation for Wang was to interview executioners. Once, for instance, "he had an opportunity to witness the execution of a woman sentenced to dismemberment,

but since he was a man, he was not permitted to approach closely, and had to have the executioner show him the heart, liver, and lungs after the sentence had been carried out. Two decades later, in 1820, he was finally able to attend the execution of a man sentenced for matricide, but once again, the diaphragm tore before he was able to examine it closely. Only after forty years did he find an official who had seen numerous executions and consequently was able to describe the structure of the diaphragm" (213–15).

68. Qtd. in Wong and Wu, *History of Chinese Medicine*, 199–200. I have adapted their translation.

69. Lu Xun, "On Photography," 201. See also Lu Xun's essays 病后杂谈 "Binghou zatan" ["Miscellaneous talk after an illness"], *Lu Xun quanji*, 6:182–85; and 病后杂谈之余 "Binghou zatan zhi yu" ["More miscellaneous talk after an illness"], *Lu Xun quanji*, 6:187–88. In both essays Lu Xun discusses the skills of traditional executioners, and contrasts them with the lack of anatomical knowledge evidenced by traditional Chinese drawings of the body.

70. '你看，你將這條血管移了一點位置了。 － － － 自然，這樣一移，的確比較的好看些，然而解剖圖不是美術，實物是那麼樣的，我們沒法改換牠。現我給你改好了，以後你要全照著黑板上那樣的畫。' / 但是我還不服氣，口頭答應著，心裡卻想道－ － － '圖還是我畫得不錯，至于實在的情形，我心裡自然記得的。' Lu Xun, *Zhaohua xishe*, 123. See also the translation by Xianyi Yang and Gladys Yang, in Lu Xun, *Lu Xun*, 1:104.

71. Huters, "Ideologies of Realism," 160 (see quote in note 58). *Qubi* (曲筆) literally translates into "crooked brushstrokes." I follow Marston Anderson's translation of Lu Xun's use of the term *qubi* here as "distortions," based on his argument about the etymology of the term. Lu Xun mentions *qubi* in his preface to *Nahan*, or *Call to Arms*. See Anderson, *The Limits of Realism*, 86–87. Interestingly, Lu Xun closes "Fujino sensei" with the reflection that he had long since lost the class notes he took under Fujino. "I had the lecture notes he corrected bound into three thick volumes and kept them as a permanent souvenir," he writes, but "unfortunately seven years ago when I was moving house, a case of books broke open on the road and half the contents were lost, including these notes" (see "Mr. Fujino," in Lu Xun, *Lu Xun*, 410). In fact the notes survived: they are now archived in the Lu Xun Museum in Beijing—more than nine hundred pages. For more information on the notes, see *Lu Xun yu Xiantai*. My thanks to Lydia Liu and Jon Kowallis for bringing this information to my attention.

72. My thanks to Yi-Li Wu for helping me articulate this observation and for pointing out its similarity to "the divergence between subjective interpretation and standardization" that characterized the difference between "the knowledge claims made by classical Chinese medicine and biomedicine" generally; she points out that "the starting

assumption in Chinese diagnosis and therapy is that individual bodies vary, whereas biomedicine starts with the claim that bodies are interchangeable and capable of being normalized." Thus Lu Xun's resistance to this hegemonic thinking can be seen as consistent with certain themes in Chinese medical critiques of Western/biomedical practice, including anatomy. Wu, personal correspondence, September 2004.

73. Jonathan Crary is describing the context of a "European rupture with *Renaissance*, or *classical*, models of vision and of the observer." He writes: "How and where one situates such a break has an enormous bearing on the intelligibility of visuality within nineteenth- and twentieth-century modernity. Most existing answers to this question suffer from an exclusive preoccupation with problems of visual *representation*; the break with classical models of vision in the early nineteenth century was far more than simply a shift in the appearance of images and art works, or in systems of representational conventions. Instead, it was inseparable from a massive reorganization of knowledge and social practices that modified in myriad ways the productive, cognitive, and desiring capacities of the human subject." Crary, *Techniques of the Observer*, 3.

Epilogue: Through the Microscope

1. On Bruce Lee's muscularity, see, for example Berry, "Stellar Transit"; on Chinese media representations of SARS, see Wang, "Body Politics."

2. Rogaski, *Hygienic Modernity*, 2–3.

3. For a general treatment of theories of evolution in Lu Xun's day, see Pusey, *Lu Xun and Evolution*.

4. See Liu, *Translingual Practice*, 45–76, for a discussion of these two versions.

5. Chow, *Primitive Passions*, 5.

6. Translations by Lydia Liu in *Translingual Practice*, 61–63.

7. In Lee, "Genesis of a Writer," the climactic news-slide incident is described independently from other parts of the story as something that "decisively changed the course of Lu Xun's life." Lee reads the scene psychoanalytically as "focused on [a] confrontation between himself as an 'observer' in a foreign classroom and a larger, symbolic image of self as a 'participant,'" and speculates that a psychological interpretation might be that it signified Lu Xun's need "to surpass his father and find another 'right medium' on a sufficiently wider scale than the practice of medicine" (178).

8. Liu, *Translingual Practice*, 62–63.

9. One might also consider that in certain late-imperial legal discourses concerning the treatment of criminals, beheading was one of a variety of punishments being critically evaluated for excessive cruelty that would soon be formally abolished in China; the drafters of an important 1905 memorial for "suppressing harsh laws in the

Qing code" quoted ancient legal precedent when they remarked, for instance, that "the way to improve the people lies certainly in government and education, not in the inspiration of awe by punishments." See Bourgon, "Abolishing 'Cruel Punishments,'" 858. Bourgon remarks, moreover, that "the shift from cruelty openly legitimized and practiced by the state to its official prohibition and ashamed toleration is an epochal change, which stems from the April 24th 1905 memorials" (851), and notes that, far from being a minority view or a view influenced exclusively by Western models of legal reform, the impulse to revise these harsher aspects of the Qing penal code was espoused not by "dissidents or clandestine authors" but by "posted officials, or writers whose works were reprinted and circulated among generations of scholars" (861). Lu Xun's reactions to the slide of the beheading are consistent with such views.

10. Rogaski, *Hygienic Modernity*, 62–63.

11. Lamarre, "Bacterial Cultures," 619.

12. See Andrews, "Tuberculosis." See also Andrews, "The Making of Modern Chinese Medicine," 238–40: "The Japanese had committed themselves to acquiring expertise in modern science and medicine from the beginning of the Meiji reign period, in 1868. This was initially accomplished by sending students to study abroad, usually in Germany or the Netherlands. As the numbers of returning students rose, an institutional infrastructure for the pursuit of modern science was gradually constructed around them. . . . Chinese students of medicine in Japan were thus far more likely to be instructed in the new theories of microbial disease causation than their compatriots on the mainland studying under missionary physicians."

13. Bourdaghs, "The Disease of Nationalism," 644.

14. Ibid., 646.

15. Andrews, "The Making of Modern Chinese Medicine," 225. That the metaphorical promise of bacteriology in particular to describe the dilemma of China in the international and post-Darwinian world was recognized is demonstrated clearly by this quote by a Chinese supplied by Andrews and originally published in the *Sino-Western Medical Journal* (*Zhong-xi yixue bao*) in 1911: "The twentieth century is the autumn of the competition for existence among races. It is also the extreme of the violent war between man and microbes. If man is victorious in war, then his race is strong and the nation is prosperous. If man is defeated in war then his race is weak and the nation is wiped out" (225).

16. Lu Xun, 1925 introduction to *Re Feng*. Note Hu Shi's earlier comment (in 1918): "The health of a society and of the nation depends on the few tenacious, persevering white blood cells that battle the evil and degenerate elements of society; only through them is there hope for reform and progress." Hu, "Yibusheng zhuyi" ["Ibsenism"], 188–89.

17. Ryan, *Photographing Empire*, 190–93: "Lantern-slides had been used since at least the mid-1860s, along with diagrams, maps and live experiments, in the popular dissemination of science." He also writes: "By 1902 lantern-slide shows were used extensively for both instruction and entertainment throughout Britain. . . . Lantern-slides of distant colonial lands and peoples were shown for a range of purposes in a variety of venues, including schools, church and mission halls, popular theatres and scientific societies. . . . At a time of widespread anxiety about the fitness of Britain's imperial spirit a variety of imperial propaganda societies found lantern-slides and other visual technologies a particularly effective means of projecting a robust and unifying vision of Empire on to the popular imagination. . . . Similar use of visual instruction was made by colonial governments themselves, many of whose representatives in Britain loaned out their own sets of lantern-slides for promotional and educational purposes" (193).

18. Latour, *The Pasteurization of France*, 98; emphasis added.

19. See Andrews, "The Making of Modern Chinese Medicine," esp. the chapter titled "Germ Theory in Chinese Medicine."

20. Bourdaghs, "The Disease of Nationalism," 656.

21. The following is a translation by Lydia Liu (*Translingual Practice*): "I do not know what advanced methods are now used to teach microbiology, but at that time lantern slides were used to show the microbes" (from *Nahan*; 61); and "During my second year, bacteriology was added to the curriculum and the configuration of bacteria was taught exclusively through film slides" (from "Fujino sensei"; 63).

22. Lee, "Genesis of a Writer," 178. Marston Anderson, on the other hand, writes, "Besides the content of the slide, the unique circumstances of its viewing—in a microbiology class after the day's lessons are concluded—disturb Lu Xun. The classroom setting, as well as the coldly reproductive nature of the photographic medium, would seem to encourage Lu Xun to view the projected scene with the distancing, objectifying perspective of scientific observation—as a self-delimited fact, unavailable to the interference of its viewers. But unlike the microbes that are the class's usual viewing matter and which are indeed oblivious of their observers, the execution assumes the observers' presence and is enacted for their sake." Anderson, *Limits of Realism*, 78.

SELECTED BIBLIOGRAPHY

Anagnost, Ann. *National Past-Times: Narrative, Representation, and Power in Modern China*. Durham, N.C.: Duke University Press, 1997.

Anderson, Marston. *The Limits of Realism: Chinese Fiction in the Revolutionary Period*. Berkeley: University of California Press, 1990.

Andrews, Bridie Jane. "The Making of Modern Chinese Medicine, 1895–1937." PhD diss., University of Cambridge, 1996.

———. "Tuberculosis and the Assimilation of Germ Theory in China, 1895–1937." *Journal of the History of Medicine and Allied Sciences* 52, no. 1 (1997): 114–57.

——— "Wang Qingren and the History of Chinese Anatomy." *Journal of Chinese Medicine*, no. 36 (1991): 30–36.

Armstrong, Nancy. *Fiction in the Age of Photography: The Legacy of British Realism*. Cambridge: Harvard University Press, 1999.

Arnold, David. *Colonizing the Body: State Medicine and Epidemic Disease in Nineteenth-Century India*. Berkeley: University of California Press, 1993.

———, ed. *Imperial Medicine and Indigenous Societies*. Manchester: Manchester University Press, 1988.

Baigrie, Brian S., ed. *Picturing Knowledge: Historical and Philosophical Problems Concerning the Use of Art in Science*. Toronto: University of Toronto Press, 1996.

Bartholomew, Terese Tse. "One Hundred Children: From Boys at Play to Icons of Good Fortune." In *Children in Chinese Art*, ed. Ann Barrott Wicks, 57–83. Honolulu: University of Hawai'i Press, 2002.

Bartlett, C. J. "Peter Parker, the Founder of the Modern Medical Missions: A Unique Collection of Paintings." *Journal of the American Medical Association*, no. 67 (1916): 407–11.

Benedict, Carol. *Bubonic Plague in Nineteenth-Century China*. Stanford, Calif.: Stanford University Press, 1996.

Benjamin, Walter. *Illuminations: Essays and Reflections*. Ed. Hannah Arendt. Trans. Harry Zohn. New York: Schocken, 1968.

Benoist, Michel. Letters. In "Les correspondants de Bertin: Secrétaire d'état au XVIII siècle," by Henri Cordier. *T'oung Pao*, no. 18 (1917–1919): 295–379.

Bernheimer, Charles. *Figures of Ill Repute: Representing Prostitution in Nineteenth-Century France*. Cambridge: Harvard University Press, 1989.

Berry, Chris. "Stellar Transit: Bruce Lee's Body; or, Chinese Masculinity in a Transnational Frame." In *Embodied Modernities: Corporeality, Representation, and Chinese Cultures*, ed. Fran Martin and Larissa Heinrich, 327–52. Honolulu: University of Hawai'i Press, 2006.

Berry-Hill, Henry, and Sidney Berry-Hill. *George Chinnery, 1774–1852: An Artist of the China Coast*. Leigh-on-Sea, UK: F. Lewis, 1963.

Beurdeley, Michel. *Peintres jésuites en Chine au XVIIIe siècle*. Arcueil, France: Anthèse, 1997.

Bourdaghs, Michael. "The Disease of Nationalism, the Empire of Hygiene." *positions: east asia cultures critique* 6, no. 3 (1998): 637–73.

Bourgon, Jérôme. "Abolishing 'Cruel Punishments': A Reappraisal of the Chinese Roots and Long-Term Efficiency of the *Xinzheng* Legal Reforms." *Modern Asian Studies* 37, no. 4 (2003): 851–62.

Brieger, Gert. "Sense and Sensibility in Late Nineteenth-Century Surgery in America." In *Medicine and the Five Senses*, ed. W. F. Bynum and Roy Porter, 225–43. Cambridge: Cambridge University Press, 1993.

Bynum, W. F., and Roy Porter, eds. *Medicine and the Five Senses*. Cambridge: Cambridge University Press, 1993.

Cadbury, William Warder, and Mary Hoxie Jones. *At the Point of a Lancet: One Hundred Years of the Canton Hospital, 1835–1935*. Shanghai: Kelly and Walsh, 1935.

Chang Chia-feng. "Aspects of Smallpox and Its Significance in Chinese History." PhD diss., London University, 1996.

———. 清代的察痘与避痘制度 "Qing Dai De Cha Dou Yu Bi Dour Zhi Du" ["The Quarantine and Investigation Systems for Smallpox in the Early Qing Dynasty"]. 漢學研究 *Han Xue Yan Jiu* [*Chinese Studies*] 14, no. 1 (1996): 135–56.

———. 清康熙皇帝採用人痘法的時間与原因試探 "Qing Kangxi Huang Di Cai Yong Ren Dou Fa De Shi Jian Yu Yuan Yin Shi Tan" ["On the Time Frame and Reasons for the Kangxi Emperor's Adoption of Variolation"]. 中華醫史雜誌 *Zhong Hua Yi Shi Za Zhi* [*Chinese Journal of Medical History*] 26, no. 1 (1996): 30–32.

———. "Strategies of Dealing with Smallpox in the Early Qing Imperial Family (1633–1799)." In *East Asian Science: Tradition and Beyond*, ed. Keizo Hashimoto, Catherine Jami, and Lowell Skar, 199–205. Osaka: Kansai University Press, 1995.

Chang, James. "Short Subjects: A Reconstructive Surgeon's Taste in Art; Dr. Peter Parker and the Lam Qua Oil Paintings." *Annals of Plastic Surgery* 30, no. 5 (1993): 468–74.

Charcot, Jean-Martin, and Paul Richer. *Difformes et les malades dans l'art*. Amsterdam: B. M. Israel, 1972.

Chen Shen, Hu Zhichan, and Ma Yunzeng, eds. 中國攝影史 *Zhongguo sheying shi, 1840–1937* [*History of Photography in China, 1840–1937*]. Rev. ed. Taipei: Sheyingjia chubanshe, 1990.

Choa, G. H. *"Heal the Sick" Was Their Motto: The Protestant Medical Missionaries in China*. Hong Kong: Hong Kong University Press, 1990.

Chow, Rey. *Primitive Passions: Visuality, Sexuality, Ethnography, and Contemporary Chinese Cinema*. New York: Columbia University Press, 1995.

Chu P'ing-yi. 身體，靈魂與天主：明末清初西學中的人體生理知識 "Shenti, linghun yu tianzhu: Mingmo qingchu xixuezhong de renti shengli zhishi" ["The Flesh, the Soul, and the Lord: Jesuit Discourse of the Body in Seventeenth-Century China"]. 新史學 *Xinshixue* [*New History*] 7, no. 2 (1996): 47–98.

Cibot, Martial. "De la petite vérole." In *Mémoires concernant l'histoire, les sciences, les arts, les moeurs, les usages, etc. des Chinois, par les missionnaires de Pékin*, by Joseph Marie Amiot et al., 4: 392–420. Paris: Chez Nyon Libraire, 1779.

Clarke, J. J. *Oriental Enlightenment: The Encounter between Asian and Western Thought*. New York: Routledge, 1997.

Clunas, Craig. *Chinese Export Watercolours*. London: Victoria and Albert Museum, 1984.

————. *Pictures and Visuality in Early Modern China*. Princeton: Princeton University Press, 1997.

Cohen, Paul. *China and Christianity: The Missionary Movement and the Growth of Chinese Antiforeignism, 1839–1939*. Cambridge: Harvard University Press, 1963.

————. "Christian Missions and Their Impact to 1900." In *The Cambridge History of China*, ed. John K. Fairbank and Denis Twitchett, 10:543–72. Cambridge: Cambridge University Press, 1978.

————. *Discovering History in China: American Historical Writing on the Recent Chinese Past*. New York: Columbia University Press, 1984.

Comaroff, John, and Jean Comaroff. *Ethnography and the Historical Imagination*. Boulder, Colo.: Westview, 1992.

Conner, Patrick. "Lam Qua: Western and Chinese Painter." *Arts of Asia* 29, no. 2 (1999): 46–64.

Connor, J. T. H., and Michael G. Rhode. "Shooting Soldiers: Civil War Medical Images, Memory, and Identity in America." *Invisible Culture: An Electronic Journal for Visual Culture*, no. 5 (2003): n.p., www.rochester.edu/in_visible_culture/Issue_5/Connor Rhode/ConnorRhode.html.

Cordier, Henri. "Les Chinois de Turgot." In *Mélanges d'histoire et de géographie orientales*. Vol. 1. Paris: J. Maisonneuve, 1914.

Crary, Jonathan. *Techniques of the Observer: On Vision and Modernity in the Nineteenth Century*. Cambridge: MIT Press, 1990.

Croizier, Ralph. *Traditional Medicine in Modern China: Science, Nationalism, and the Tensions of Cultural Change*. Cambridge: Harvard University Press, 1968.

Crossman, Carl L. *The Decorative Arts of the China Trade: Paintings, Furnishings, and Exotic Curiosities*. Woodbridge, UK: Antique Collectors' Club, 1991.

DeFrancis, John. *The Chinese Language: Fact and Fantasy*. Honolulu: University of Hawai'i Press, 1984.

Dehergne, Joseph. "Les deux Chinois et Bertin: L'enquête industrielle de 1764 et les débuts de la collaboration technique franco-chinoise." PhD diss., Sorbonne, 1965.

——. "Une grande collection: Mémoires concernant les Chinois (1776–1814)." *Bulletin de l'École Française d'Extrême-Orient*, no. 70 (1983): 267–98.

——. "Voyageurs chinois venus à Paris au temps de la marine à voiles et l'influence de la Chine sur la littérature française du XVIIIe siècle." *Monumenta Serica*, no. 23 (1964): 372–97.

Delaporte, François. *Disease and Civilization: The Cholera in Paris, 1832*. Trans. Arthur Goldhammer. Cambridge: MIT Press, 1986.

Denton, Kirk A., ed. *Modern Chinese Literary Thought: Writings on Literature, 1893–1945*. Stanford, Calif.: Stanford University Press, 1996.

Despeux, Catherine. *Taoisme et le corps humain: Le Xiuzhen tu*. Paris: Guy Tredaniel Éditeur, 1994.

Didi-Huberman, Georges. *The Invention of Hysteria: Charcot and the Photographic Iconography of Salpêtrière*. Trans. Alisa Hartz. Cambridge: MIT Press, 2003.

Dikötter, Frank. *The Discourse of Race in Modern China*. Stanford, Calif.: Stanford University Press, 1994.

——. *Sex, Culture and Modernity in China: Medical Science and the Construction of Sexual Identities in the Early Republican Period*. London: Hurst, 1995.

Downing, C. Toogood. *The Fan-qui in China, in 1836–37*. 3 vols. London: H. Colburn, 1838.

Dudgeon, John. *Diseases of China: Their Causes, Conditions, and Prevalence, Contrasted with Those of Europe*. Glasgow: Dunn and Wright, 1877.

Elisseeff-Poisle, Danielle. "Chinese Influence in France, Sixteenth to Eighteenth Centuries." In *China and Europe: Images and Influences in Sixteenth to Eighteenth Centuries*, ed. Thomas H. C. Lee, 151–65. Hong Kong: Chinese University Press, 1991.

Elman, Benjamin. "Naval Warfare and the Refraction of China's Self-Strengthening Reforms into Scientific and Technological Failure, 1865–1895." *Modern Asian Studies* 38, no. 2 (2004): 283–326.

————. *On Their Own Terms: Science in China, 1550–1900.* Cambridge: Harvard University Press, 2005.

Elvin, Mark. "Tales of *Shen* and *Xin*: Body-Person and Heart-Mind in China during the Last 150 Years." In *Self as Body in Asian Theory and Practice*, ed. Thomas P. Kasulis, with Roger Ames and Wimal Dissanayake, 213–94. Albany: State University of New York Press, 1993.

Fahmy, Khaled. "Islam and Dissection in Nineteenth-Century Egypt." Paper presented at the conference "Science and Religion in the Age of Capital and Empire," University of Michigan, Ann Arbor, November 2–3, 2001.

Fairbank, John K., and Denis Twitchett, eds. *The Cambridge History of China.* Vol. 10. Cambridge: Cambridge University Press, 1978.

Fan, Fa-ti. *British Naturalists in Qing China: Science, Empire, and Cultural Encounter.* Cambridge: Harvard University Press, 2004.

Farquhar, Judith. *Appetites: Food and Sex in Postsocialist China.* Durham, N.C.: Duke University Press, 2002.

Fitzgerald, John. *Awakening China: Politics, Culture, and Class in the Nationalist Revolution.* Stanford, Calif.: Stanford University Press, 1996.

Floyd, Phylis A. "The Puzzle of *Olympia*." *Nineteenth-Century Art Worldwide: A Journal of Nineteenth-Century Visual Culture* 3, no. 1 (2004): n.p., 19thc-artworldwide.org/spring_04/articles/floy.html.

Foucault, Michel. *The Birth of the Clinic: An Archeology of Medical Perception.* Trans. A. M. Sheridan Smith. New York: Pantheon, 1973.

Fox, Daniel M., and Christopher Lawrence. *Photographing Medicine: Images and Power in Britain and America since 1840.* New York: Greenwood, 1988.

Gao, Mingming. '医宗金鉴' 的编纂及其成就 "*Yizong jinjian* de bianji ji qi chengjiu" ["*Golden Mirror of Orthodoxy of Medicine*: Its Compilation and Achievements"]. 中华医史杂志 *Zhonghua yi shi za zhi* [*Chinese Journal of Medicine*] 22, no. 32 (1992): 80–83.

Gao Xudong. 鲁迅：在医生与患者之间 "Lu Xun: Zai yisheng yu huanzhe zhijian" ["Lu Xun: Between Doctor and Patient"]. In 文学与治疗 *Wenxue yu zhiliao* [*Literature and Healing*], ed. Ye Shuxian, 159–69. Beijing: *Shehui kexue wenjian chubanshe*, 1999.

Gilman, Sander L. *Disease and Representation: Images of Illness from Madness to AIDS.* Ithaca: Cornell University Press, 1988.

————. "How and Why Do Historians of Medicine Use or Ignore Images in Writing Their Histories?" In *Picturing Health and Illness: Images of Identity and Difference*, 9–32. Baltimore: Johns Hopkins University Press, 1995.

————. "Lam Qua and the Development of a Westernized Medical Iconography in China." *Medical History* 30, no. 1 (1986): 50–69.

————. *Picturing Health and Illness: Images of Identity and Difference.* Baltimore: Johns Hopkins University Press, 1995.

Goldman, Merle, ed. *Modern Chinese Literature in the May Fourth Era*. Cambridge: Harvard University Press, 1977.

Gombrich, E. H. *The Uses of Images: Studies in the Social Function of Art and Visual Communication*. London: Phaidon, 1999.

Goodrich, L. Carrington, and Nigel Cameron. *The Face of China as Seen by Photographers and Travelers, 1860–1912*. New York: Aperture, 1978.

Grimm, Friedrich Melchior. *Correspondance littéraire, philosophique et critique de Grimm et de Diderot, 1753–1790*. Vol. 12. Paris: Furne, 1830.

Gulick, Edward V. *Peter Parker and the Opening of China*. Cambridge: Harvard University Press, 1973.

Guo Moruo. 沫若文集 *Guo Moruo wenji* [*The Collected Works of Guo Moruo*]. Beijing: Renmin wenxue chubanshe, 1959.

Han Qi. 中國科學技術的西傳及其影響 *Zhongguo kexuejishu de xizhuan ji qi yingxiang* [*The Transmission Westward and Influence of Chinese Scientific Skills*]. Yishi Jiazhuang, China: Renmin chubanshe, 1999.

Hanan, Patrick. *The Chinese Vernacular Story*. Cambridge: Harvard University Press, 1981.

Hart, Roger. "Translating the Untranslatable: From Copula to Incommensurable Worlds." In *Tokens of Exchange: The Problem of Translation in Global Circulations*, ed. Lydia H. Liu, 45–73. Durham, N.C.: Duke University Press, 1999.

Hashimoto, Keizo, Catherine Jami, and Lowell Skar, eds. *East Asian Science: Tradition and Beyond*, Osaka: Kansai University Press, 1995.

Hay, John. "The Body Invisible in Chinese Art?" In *Body, Subject, and Power in China*, ed. Angela Zito and Tani E. Barlow, 42–77. Chicago: University of Chicago Press, 1994.

Hay, Jonathan. "Culture, Ethnicity, and Empire in the Work of Two Eighteenth-Century 'Eccentric' Artists." *Res*, no. 35 (1999): 201–24.

Heinrich, Larissa. "Handmaids to the Gospel: Lam Qua's Medical Portraiture." In *Tokens of Exchange: The Problem of Translation in Global Circulations*, ed. Lydia H. Liu, 239–75. Durham, N.C.: Duke University Press, 1999.

———. "How China Became the 'Cradle of Smallpox': Transformations in Discourse, 1726–2002," in *positions: east asia cultures critique* 15, no. 1 (2007): 7–37.

———. "The Pathological Empire." In *History of Photography* 30, no. 1 (2006): 25–37.

Hershatter, Gail, ed. *Remapping China: Fissures in Historical Terrain*. Stanford, Calif.: Stanford University Press, 1996.

Hess, Thomas B., and Linda Nochlin. *Woman as Sex Object: Studies in Erotic Art, 1730–1970*. New York: Art News Annual, 1972.

Hevia, James Louis. *Cherishing Men from Afar: Qing Guest Ritual and the Macartney Embassy of 1793*. Durham, N.C.: Duke University Press, 1995.

Hobson, Benjamin. 全體新論 *Quanti xinlun* [*A New Treatise on Anatomy*, also translated as *Outline of Anatomy and Physiology*]. Shanghai: Mohai Books, 1851.

Hopkins, Donald. *The Greatest Killer: Smallpox in History*. Chicago: University of Chicago Press, 2002.

————. *Princes and Peasants: Smallpox in History*. Chicago: University of Chicago Press, 1983.

Hu Shi. 易卜生主義 "Yibusheng zhuyi" ["Ibsenism"]. In 中國新文學大系 *Zhongguo xinwenxue daxi* [*New Compendium of Chinese Literature*], ed. Zhao Jiabi, 179–92. Shanghai: Liangyou Tushu, 1935.

Huard, Pierre, and Ming Wong. *Chinese Medicine*. Trans. Bernard Fielding. New York: McGraw-Hill, 1968.

————. "Les enquêtes françaises sur la science et la technologie chinoises au xviiie siècle." *Bulletin de l'École Française d'Extrême-Orient*, no. 53 (1967): 137–213.

Hung, Eva. "Giving Texts a Context: Chinese Translations of Classical English Detective Stories, 1896–1916." In *Translation and Creation: Readings of Western Literature in Early Modern China, 1840–1918*, ed. David Pollard, 151–76. Amsterdam: J. Benjamins, 1988.

Hutcheon, Robin. *Chinnery: The Man and the Legend, with a Chapter on Chinnery's Shorthand by Geoffrey W. Bonsall*. Hong Kong: South China Morning Post, 1975.

Huters, Theodore. "Ideologies of Realism in Modern China: The Hard Imperatives of Imported Theory." In *Politics, Ideology, and Literary Discourse in Modern China: Theoretical Interventions and Cultural Critique*, ed. Liu Kang and Xiaobing Tang, 147–73. Durham, N.C.: Duke University Press, 1993.

Jefferys, W. Hamilton. "Kodaking for Small Game." *China Medical Missionary Journal* 21, no. 5 (1907): 96.

Jefferys, W. Hamilton, and James L. Maxwell. *The Diseases of China, Including Formosa and Korea*. Philadelphia: P. Blakiston's Son and Company, 1910.

————. *The Diseases of China, Including Formosa and Korea*. 2nd ed. Shanghai: A.B.C. Press, 1929.

Josyph, Peter. *From Yale to Canton: The Transcultural Challenge of Lam Qua and Peter Parker*. Exhibition brochure. Smithtown, N.Y.: Smithtown Township Arts Council, 1992.

————. "The Missionary Doctor and the Chinese Painter." *MD* 36, no. 8 (1992): 45–48, 51–52, 55–58.

Jullien, François. *Le nu impossible*. Paris: Seuil, 2005.

Kaldis, Nicholas. "The Prose Poem as Aesthetic Cognition: Lu Xun's *Yecao*." *Journal of Modern Literature in Chinese* 3, no. 2 (2000): 43–82.

Kasulis, Thomas P., with Roger Ames and Wimal Dissanayake, eds. *Self as Body in Asian Theory and Practice*. Albany: State University of New York Press, 1993.

Kerr, John G. *Report of the Medical Missionary Society in China for the Year 1859.* Macao: Medical Missionary Society, 1860.

———. *Report of the Medical Missionary Society in China for the Year 1861.* Canton: Medical Missionary Society, 1862.

———. *Report of the Medical Missionary Society in China for the Year 1863.* Hong Kong: A. Shortreve and Co., 1864.

———. *Report of the Medical Missionary Society in China for the Year 1865.* Canton: Medical Missionary Society, 1866.

———. *Report of the Medical Missionary Society in China for the Year 1866.* Canton: Medical Missionary Society, 1867.

———. *Report of the Medical Missionary Society's Hospital in Canton for the Year 1863.* Hong Kong: A. Shortreve and Co., 1864.

———. *Report of the Medical Missionary Society's Hospital in Canton for the Year 1865.* Hong Kong: A. Shortreve and Co., 1866.

Kleinman, Arthur, and Tsung-yi Lin, eds. *Normal and Abnormal Behavior in Chinese Culture.* Boston: D. Reidel, 1980.

Knight, David. "Scientific Theory and Visual Language." In *The Natural Sciences and the Arts: Aspects of Interaction from the Renaissance to the Twentieth Century; An International Symposium, Uppsala 1985.* Stockholm: Almqvist and Wiksell International, 1985.

Ko, Dorothy. *Cinderella's Sisters: A Revisionist History of Footbinding.* Los Angeles: University of California Press, 2005.

Kowallis, Jon. *The Lyrical Lu Xun: A Study of His Classical-Style Verse.* Honolulu: University of Hawai'i Press, 1996.

Kudlick, Catherine Jean. *Cholera in Post-revolutionary Paris: A Cultural History.* Berkeley: University of California Press, 1996.

Kuriyama, Shigehisa. *The Expressiveness of the Body and the Divergence of Greek and Chinese Medicine.* New York: Zone, 1999.

Lackner, Michael. "Jesuit Figurism." In *China and Europe: Images and Influences in Sixteenth to Eighteenth Centuries*, ed. Thomas H. C. Lee, 129–49. Hong Kong: Chinese University Press, 1991.

Lackner, Michael, Iwo Amelung, and Joachim Kurtz, eds. *New Terms for New Ideas: Western Knowledge and Lexical Change in Late Imperial China.* Leiden, Netherlands: Brill, 2001.

Laignel-Lavastine, Maxime, ed. *Histoire de la médecine, de la pharmacie, de l'art dentaire, et de l'art vétérinaire.* 3 vols. Paris: Albin Michel, 1936–1949.

Lamarre, Thomas. "Bacterial Cultures and Linguistic Colonies: Mori Rintaro's Experiments with History, Science, and Language." *positions: east asia cultures critique* 6, no. 3 (1998): 597–635.

Latour, Bruno. *The Pasteurization of France.* Trans. Alan Sheridan and John Law. Cambridge: Harvard University Press, 1988.

Lee, Leo Ou-fan. "Genesis of a Writer: Notes on Lu Xun's Educational Experience, 1881–1909." In *Modern Chinese Literature in the May Fourth Era*, ed. Merle Goldman, 161–88. Cambridge: Harvard University Press, 1977.

———. *Voices from the Iron House: A Study of Lu Xun.* Bloomington: Indiana University Press, 1987.

Lee, Mabel. "Solace for the Corpse with Its Eyes Gouged Out: Lu Xun's Use of the Poetic Form." *Papers on Far Eastern History*, no. 26 (1982): 145–73.

Lee, Thomas H. C., ed. *China and Europe: Images and Influences in Sixteenth to Eighteenth Centuries.* Hong Kong: Chinese University Press, 1991.

Le Gobien, Charles, and Yves Mathurin Marie Tréaudet de Querbeuf, eds. *Lettres édifiantes et curieuses écrits des missions étrangères par quelques missionaires de la Compagnie de Jésus.* Vol. 27. Paris: N. Le Clerc, 1726.

Leung, Angela Ki-che. "Organized Medicine in Ming-Qing China: State and Private Medical Institutions in the Lower Yangtze Region." *Late Imperial China* 8, no. 1 (1987): 134–66.

Lin, Keh-ming. "Traditional Chinese Medical Beliefs and Their Relevance for Mental Illness and Psychiatry." In *Normal and Abnormal Behavior in Chinese Culture*, ed. Arthur Kleinman and Tsung-yi Lin, 95–111. Boston: D. Reidel, 1980.

Liu, Kang and Xiaobing Tang, eds. *Politics, Ideology, and Literary Discourse in Modern China: Theoretical Interventions and Cultural Critique.* Durham, N.C.: Duke University Press, 1993.

Liu, Lydia H. *The Clash of Empires: The Invention of China in Modern World Making.* Cambridge: Harvard University Press, 2004.

———. "Narratives of Modern Selfhood: First-Person Fiction in May Fourth Literature." In *Politics, Ideology, and Literary Discourse in Modern China: Theoretical Interventions and Cultural Critique*, ed. Kang Liu and Xiaobing Tang, 12–23. Durham, N.C.: Duke University Press, 1993.

———. "Robinson Crusoe's Earthenware Pot." *Critical Inquiry* 25, no. 4 (1999): 728–45.

———. *Translingual Practice: Literature, National Culture, and Translated Modernity in China, 1900–1937.* Stanford, Calif.: Stanford University Press, 1995.

———, ed. *Tokens of Exchange: The Problem of Translation in Global Circulations.* Durham, N.C.: Duke University Press, 1999.

Lockhart, William. *The Medical Missionary in China: A Narrative of Twenty Years' Experience.* London: Hearst and Blackett, 1861.

Low, Morris. "The Japanese Colonial Eye: Science, Exploration, and Empire." In *Photography's Other Histories*, ed. Christopher Pinney and Nicolas Peterson. Durham, N.C.: Duke University Press, 2003.

Lundbaek, Knud. "Translations of Chinese Historical and Philosophical Works." In *China and Europe: Images and Influences in Sixteenth to Eighteenth Centuries*, ed. Thomas H. C. Lee, 151–65. Hong Kong: Chinese University Press, 1991.

Lu Xun. *Lu Xun: Selected Works*. Trans. Xianyi Yang and Gladys Yang. 4 vols. Beijing: Foreign Languages Press, 1985.

———. 鲁迅全集 *Lu Xun quanji* [*The Complete Works of Lu Xun*]. Beijing: Beijing renmin chubanshe, 1981.

———. 呐喊 *Nahan* [*Call to Arms*]. Shanghai: Shanghai wenyi chubanshe, 1999.

———. "On Photography." Trans. Kirk A. Denton. In *Modern Chinese Literary Thought: Writings on Literature, 1893–1945*, ed. Denton, 196–203. Stanford, Calif.: Stanford University Press, 1996.

———. 热风 *Re feng* [*Heat Gusts*]. Beijing: Renmin Wenxue Chubanshe, 1995.

———. *Wild Grass*. Trans. Xianyi Yang and Gladys Yang. Beijing: Foreign Languages Press, 1974.

———. 野草 *Ye cao* [*Wild Grass*]. Shanghai: Shanghai wenyi chubanshe, 1999.

———. 朝花夕拾 *Zhaohua xishe* [*Dawn Blossoms Plucked at Dusk*]. Shanghai: Shanghai wenyi chubanshe, 1999.

鲁迅与仙台: 东北大学留学百年 *Lu Xun yu Xiantai: Dongbei daxue liuxue bainian* [*Lu Xun and Sendai: A Hundred Years of Overseas Study at Tohoku University*]. Trans. Jie Zechun. Beijing: Zhongguo dabaike quanshu chubanshe, 2005.

Macartney, George. *An Embassy to China: Being the Journal Kept by Lord Macartney during His Embassy to the Emperor Ch'ien-lung, 1793–1794*. Ed. J. L. Cranmer-Byng. Hamden, Conn.: Archon Books, 1963.

Mackerras, Colin. *Western Images of China*. Oxford: Oxford University Press, 1989.

MacLeod, Roy, and Milton Lewis, eds. *Disease, Medicine, and Empire: Perspectives on Western Medicine and the Experience of European Expansion*. London: Routledge, 1988.

Malcolm, Elizabeth L. "The *Chinese Repository* and Western Literature on China, 1800–1850." *Modern Asian Studies* 7, no. 2 (1973): 165–78.

Martin, Fran, and Larissa Heinrich, eds. *Embodied Modernities: Corporeality, Representation, and Chinese Cultures*. Honolulu: University of Hawai'i Press, 2006.

Mason, Mary Gertrude. *Western Concepts of China and the Chinese, 1840–1876*. New York: Seeman Printery, 1939.

Maulitz, Russell Charles. *Morbid Appearances: The Anatomy of Pathology in the Early Nineteenth Century*. Cambridge: Cambridge University Press, 1987.

Maxwell, Anne. *Colonial Photography and Exhibitions: Representations of the "Native" and the Making of European Identities*. London: Leicester University Press, 1999.

McCartney, James H. "James H. McCartney's Report on the Health of Chungking." In *China Imperial Maritime Customs Medical Reports* (October–March 1893–94): 3–6.

Meng, Yue. "Hybrid Science versus Modernity: The Practice of the Jiangnan Arsenal." *East Asian Science, Technology, and Medicine*, no. 16 (1999): 13–52.

Moore, James. *The History of the Small Pox*. London: Longman, Hurst, Rees, Orme, and Brown, 1815.

Mungello, D. E. "Confucianism in the Enlightenment: Antagonism and Collaboration between the Jesuits and the Philosophes." In *China and Europe: Images and Influences in Sixteenth to Eighteenth Centuries*, ed. Thomas H. C. Lee, 99–127. Hong Kong: Chinese University Press, 1991.

Needham, Gerald. "Manet, *Olympia*, and Pornographic Photography." In *Woman as Sex Object: Studies in Erotic Art, 1730–1970*, ed. Thomas B. Hess and Linda Nochlin, 81–89. New York: Newsweek, 1972.

Needham, Joseph. *China and the Origins of Immunology*. Hong Kong: Centre of Asian Studies, University of Hong Kong, 1980.

———. *Science and Civilisation in China*. Vol. 6, *Biology and Biological Technology, Part VI: Medicine*. Ed. Nathan Sivin. Cambridge: Cambridge University Press, 2000.

Newman, Kathy. "Wounds and Wounding in the American Civil War: A (Visual) History." *Yale Journal of Criticism* 6 (1993): 63–86.

Ng, Vivienne. *Madness in Late Imperial China: From Illness to Deviance*. Norman: University of Oklahoma Press, 1990.

Panofsky, Erwin. "Artist, Scientist, Genius: Notes on the 'Renaissance Dämmerung.'" In *The Renaissance: Six Essays*, by Wallace K. Ferguson et al., 121–82. New York: Harper and Row, 1962.

Parker, Peter. "Opthalmic Hospital in Canton: Seventh Report, Being That for the Term Ending on the 31st of December, 1837." *Chinese Repository* 6 (1837–1838): 433–45.

———. "Report of the Medical Missionary Society, Containing an Abstract of Its History and Prospects, and the Report of the Hospital at Macao, for 1841–2; Together with Dr. Parker's Statement of His Proceedings in England and the United States in Behalf of the Society." *Chinese Repository* 12 (1843): 189–211.

———. "Tenth Report of the Ophthalmic Hospital, Canton, Being for the Year 1839." *Chinese Repository* 8 (1839–1840): 631.

———. "Thirteenth Report of the Ophthalmic Hospital, Canton, Including the Period from the 1st January, 1844, to the 1st July, 1845." *Chinese Repository* 14 (1845): 460–61.

Petherbridge, Deanna, and L. J. Jordanova. *The Quick and the Dead: Artists and Anatomy*. Berkeley: University of California Press, 1997.

Picquier, Phillippe, ed. *Rêves de printemps: L'art érotique en Chine*. Paris: Collections Bartholet, 1998.

Pinney, Christopher. *Camera Indica: The Social Life of Indian Photographs*. London: Reaktion, 1997.

Pinney, Christopher, and Nicolas Peterson, eds. *Photography's Other Histories*. Durham, N.C.: Duke University Press, 2003.

Pollard, David, ed. *Translation and Creation: Readings of Western Literature in Early Modern China, 1840–1918*. Amsterdam: J. Benjamins, 1998.

Pomeranz, Kenneth. *The Great Divergence: China, Europe, and the Making of the Modern World Economy*. Princeton: Princeton University Press, 2000.

Porkert, Manfred. *The Theoretical Foundations of Chinese Medicine: Systems of Correspondence*. Cambridge: MIT Press, 1974.

Purcell, Rosamond Wolff. *Special Cases: Natural Anomalies and Historical Monsters*. San Francisco: Chronicle, 1988.

Pusey, James Reeve. *China and Charles Darwin*. Cambridge: Council on East Asian Studies, Harvard University, 1983.

———. *Lu Xun and Evolution*. Albany: State University Press of New York, 1998.

Rachman, Stephen. "Curiosity and Cure: Peter Parker's Patients, Lam Qua's Portraits." In *Common-Place* 4, no. 2 (2004): n.p. www.common-place.org/vol-04/no-02/rachman/.

———. "*Memento Morbi*: Lam Qua's Paintings, Peter Parker's Patients." In "Difference and Identity," ed. Jonathan M. Metzl and Suzanne Poirier, special issue, *Literature and Medicine* 23, no. 1 (2004): 134–59.

Rawski, Evelyn Sakakida. *The Last Emperors: A Social History of Qing Imperial Institutions*. Berkeley: University of California Press, 1998.

人痘接抽法 "Rendoujiezhenfa" ["Methods for Treating Smallpox"]. In 中國全集 *Zhongguo quanji* [*China Anthology*]. Vol. 4, 科技中國 *Keji zhongguo* [*Technological China*]. Taipei: Jinmao Press, 1983.

Report of the Medical Missionary Society in China for the Year 1868. Hong Kong: DeSouza and Co., 1869. *See also* Kerr, John G.

Richardson, Ruth. *Death, Dissection, and the Destitute*. 2nd ed. Chicago: University of Chicago Press, 2000.

Rogaski, Ruth. *Hygienic Modernity: Meanings of Health and Disease in Treaty-Port China*. Berkeley: University of California Press, 2004.

Rowbotham, Arnold H. "The 'Philosophes' and the Propaganda for Inoculation of Smallpox in Eighteenth-Century France." *University of California Publications in Modern Philology* 18, no. 4 (1935): 268–87.

Rubinstein, Murray A. "The Wars They Wanted: American Missionaries' Use of *The Chinese Repository* before the Opium War." *American Neptune* 48, no. 4 (1988): 271–82.

Ryan, James R. *Picturing Empire: Photography and the Visualization of the British Empire*. London: Reaktion, 1997.

Sakamoto, Hiroko. 中国民族主義の神話: 人種. 身体. ジェンダー *Chugoku minzoku shugi no shinwa: jinshu, shintai, jenda* [*The Myth of Nationalism in Modern China: Race, Body, Gender*]. Tokyo: Iwanami Shoten, 2004.

Saunders, John B. de C. M., and Francis R. Lee. *The Manchu Anatomy and Its Historical Origin, with Annotations and Translations.* Taipei: Li Ming Cultural Enterprise, 1981.

Schipper, Kristofer. *The Taoist Body.* Berkeley: University of California Press, 1993.

Shih, Shu-mei. *The Lure of the Modern: Writing Modernism in Semicolonial China, 1917–1937.* Berkeley: University of California Press, 2001.

Silvestre de Sacy, Jacques. *Henri Bertin, dans le sillage de la Chine (1720–1792).* Paris: Éditions Cathasia, Les Belles Lettres, 1970.

Sirr, Henry Charles. *China and the Chinese: Their Religion, Character, Customs, and Manufactures; The Evils Arising from the Opium Trade; With a Glance at Our Religious, Moral, Political, and Commercial Intercourse with the Country.* 2 vols. London: Orr, 1849.

Sivin, Nathan. "Science and Medicine in Imperial China: The State of the Field." *Journal of Asian Studies* 47, no. 1 (1988): 41–90.

———. "Translating Chinese Medicine: Not Just Philology." Paper presented at the conference "New Directions in the History of Chinese Science," University of California, Los Angeles, May 24, 1997.

Soulié de Morant, Georges. "Chine et Japon." In *Histoire de la médecine, de la pharmacie, de l'art dentaire, et de l'art vétérinaire,* ed. Maxime Laignel-Lavastine. Vol. 1. Paris: Albin Michel, 1936.

Spence, Jonathan D. *The China Helpers: Western Advisors in China, 1620–1960.* London: Bodley Head, 1999.

———. *God's Chinese Son: The Taiping Heavenly Kingdom of Hong Xiuquan.* New York: Norton, 1996.

———. *The Search for Modern China.* New York: Norton, 1990.

———. *To Change China: Western Advisors in China, 1620–1960.* Harmondsworth, UK: Penguin, 1980.

Stafford, Barbara. *Body Criticism: Imaging the Unseen in Enlightenment Art and Medicine.* Cambridge: MIT Press, 1993.

Standaert, Nicolas. "A Chinese Translation of Ambroise Paré's *Anatomy.*" *Sino-Western Cultural Relations Journal* 21 (1999): 9–33.

Stewart, Susan. *On Longing: Narratives of the Miniature, the Gigantic, the Souvenir, the Collection.* Baltimore: Johns Hopkins University Press, 1984.

Sun, Lung-kee. "The Presence of the Fin-de-Siècle in the May Fourth Era." In *Remapping China: Fissures in Historical Terrain,* ed. Gail Hershatter, 194–209. Stanford, Calif.: Stanford University Press, 1996.

Tagg, John. "Evidence, Truth, and Order: Photographic Records and the Growth of the State." In *The Photography Reader,* ed. Liz Wells, 257–60. London: Routledge, 2003.

Thiriez, Régine. *Barbarian Lens: Western Photographers of the Qianlong Emperor's European Palaces.* Amsterdam: Gordon and Breach, 1998.

Thomson, John. *China and Its People in Early Photographs: An Unabridged Reprint of the Classic 1873/4 Work*. New York: Dover, 1982.

———. *Illustrations of China and Its People: A Series of Two Hundred Photographs with Letterpress Descriptive of the Places and People Represented*. London: Samson, Low, Marston, Low, and Searle, 1874.

———. *Thomson's China: Travels and Adventures of a Nineteenth-Century Photographer*. Hong Kong: Oxford University Press, 1993.

Thomson, John D. "Dr. John D. Thomson's Report on the Health of Hankow." *China Imperial Maritime Customs Medical Reports*, no. 52 (April–September 1896): 25–34.

Tiffany, Osmond, Jr. *The Canton Chinese; or The American's Sojourn in the Celestial Empire*. Boston: J. Munroe, 1849.

Ting, Joseph S. P., ed. *Gateways to China: Trading Ports of the Eighteenth and Nineteenth Centuries*. Hong Kong: Hong Kong Museum of Art, 1987.

———. *Late Qing China Trade Paintings*. Hong Kong: Urban Council, 1982.

Topper, David. "Towards an Epistemology of Scientific Illustration." In *Picturing Knowledge: Historical and Philosophical Problems Concerning the Use of Art in Science*, ed. Brian S. Baigrie, 215–49. Toronto: University of Toronto Press.

Unschuld, Paul. *Medicine in China: A History of Ideas*. Berkeley: University of California Press, 1985.

The Yellow Emperor's Classic of Internal Medicine: Chapters 1–34. Trans. Ilza Veith. New ed. Berkeley: University of California Press, 1966.

Vinograd, Richard. *Boundaries of the Self: Chinese Portraits, 1600–1900*. Cambridge: Cambridge University Press, 1992.

Voltaire, *Œuvre complètes*. Vol. 24. Paris: A. A. Renouard, 1819–25.

Wagner, Rudolf G. *Reenacting the Heavenly Vision: The Role of Religion in the Taiping Rebellion*. Berkeley: Institute of East Asian Studies, University of California, 1982.

Wakeman, Frederic. "The Canton Trade and the Opium War." In *The Cambridge History of China*, ed. John K. Fairbank and Denis Twitchett, 10:163–212. Cambridge: Cambridge University Press, 1978.

Waley-Cohen, Joanna. *The Sextants of Beijing: Global Currents in Chinese History*. New York: Norton, 1999.

Wang, Ban. *The Sublime Figure of History: Aesthetics and Politics in Twentieth-Century China*. Stanford, Calif.: Stanford University Press, 1997.

Wang Daohuan (Wang Daw-hwan). '醫林改錯' 的解剖學 "'Yilin gaicuo' de jiepouxue" ["Wang Ch'ing-jen on Human Anatomy"]. 新史學 *Xinshi xue* [*New History*] 4, no. 1 (1995): 95–112.

Wang, David Der-wei. "Crime or Punishment? On the Forensic Discourse of Modern Chinese Literature." In *Becoming Chinese: Passages to Modernity and Beyond*, ed. Wen-hsin Yeh, 260–97. Berkeley: University of California Press, 2000.

———. "Lu Xun, Shen Congwen, and Decapitation." In *Politics, Ideology, and Literary Discourse in Modern China*, ed. Kang Liu and Xiaobing Tang, 174–87. Durham, N.C.: Duke University Press, 1993.

Wang, David Der-wei, and Jeanne Tai, eds. *Running Wild: New Chinese Writers*. New York: Columbia University Press, 1994.

Wang, Min'an. "Body Politics in the SARS Crisis." Trans. Judith Farquhar and Lili Lai. *positions: east asia cultures critique* 12, no. 2 (2004): 587–96.

Wang Qingren. 醫林改錯 *Yilin gaicuo* [*Correcting the Errors of Physicians*]. Taipei: Newton, 1990.

Wang Yangzong. 民國初年一次 '破天荒' 的公開屍體解剖 "Mingguo chunian yici 'potianhuang' de gongkai shiti jiepou" ["A 'groundbreaking' demonstration of dissection in early Republican China"]. 中國科技史料 *Zhongguo keji shi liao* [*China Historical Materials of Science and Technology*] 22, no. 2 (2001): 109–12.

Wells, Liz, ed. *The Photography Reader*. London: Routledge, 2003.

Wicks, Ann Barrott, ed. *Children in Chinese Art*. Honolulu: University of Hawai'i Press, 2002.

Wong, K. Chimin, and Wu Lien-teh. *History of Chinese Medicine: Being a Chronicle of Medical Happenings in China from Ancient Times to the Present Period*. 2nd. ed. Shanghai: National Quarantine Service, 1936.

Wood, William Maxwell. *Fankwei; or, The San Jacinto in the Seas of India, China, and Japan*. New York: Harper, 1859.

Wu, Hung. "Emperor's Masquerade—'Costume Portraits' of Yongzheng and Qianlong." *Orientations* 26, no. 7 (1995): 25–41.

———. "Photographing Deformity: Liu Zheng and His Photo Series 'My Countrymen.'" *Public Culture* 13, no. 3 (2001): 399–427.

———. *Transience: Chinese Experimental Art at the End of the Twentieth Century*. Chicago: David and Alfred Smart Museum of Art, University of Chicago, 1999.

Wu, Hung, and Katherine R. Tsiang, eds. *Body and Face in Chinese Visual Culture*. Cambridge: Harvard University Asia Center, 2005.

Wu Qian, ed. 醫宗金鑒 *Yizong jinjian* [*The Golden Mirror of Medical Orthodoxy*]. 1742. Taipei: Xin Wen Feng Chu Ban Gongsi, 1985.

Wu, Yi-Li. "God's Uterus: Benjamin Hobson and Missionary 'Midwifery' in Nineteenth-Century China." Paper presented at the conference "The Disunity of Chinese Science," University of Chicago, May 10–11, 2002.

Wue, Roberta. "Essentially Chinese: The Chinese Portrait Subject in Nineteenth-Century Photography." In *Body and Face in Chinese Visual Culture*, ed. Hung Wu and Katherine R. Tsiang, 257–82. Cambridge: Harvard University Asia Center, 2005.

———. *Picturing Hong Kong: Photography, 1855–1910*. New York: Asia Society Galleries, 1997.

———. "Picturing Hong Kong: Photography through Practice and Function." In *Picturing Hong Kong: Photography 1855–1910*. New York: Asia Society Galleries, 1997.

Xiong Yuezhi. 西学东渐与晚清社会 *Xixue dongjian yu wanqing shehui* [*The Eastward Transmission of Western Learning and Late Qing Society*]. Shanghai: Shanghai renmin chubanshe, 1994.

Xu Shoushang. 亡友鲁迅印象记 *Wangyou Lu Xun yinxiang ji* [*Impressions of My Late Friend Lu Xun*]. Beijing: Renminwenxue chubanshe, 1977.

Yang, Nianqun. "The Establishment of 'Urban Health Demonstration Districts' and the Supervision of Life and Death in Early Republican Beijing." *East Asian Science, Technology, and Medicine* 22 (2004): 68–95.

Ye, Xiaoqing. *The Dianshizhai Pictorial: Shanghai Urban Life, 1884–1898*. Ann Arbor, Mich.: Center for Chinese Studies Press, 2003.

Yeh, Wen-hsin, ed. *Becoming Chinese: Passages to Modernity and Beyond*. Berkeley: University of California Press, 2000.

Yip, Wai-Lim. 兩間餘一卒、荷戟獨彷徨：論魯迅兼談《野草》的語言藝術 "Liangjian yu yi zu, he ji du pang huang: lun Lu Xun jian tan 'Yecao' de yuyan yishu" ["Hesitation Between: Lu Xun and the Art of Language in *Wild Grass*"]. 當代 *Dangdai* [*Contemporary Monthly*] 18, no. 69 (1992): 1–36.

Zhang, Qiong. "Demystifying Qi: The Politics of Cultural Translation and Interpretation in the Early Jesuit Mission to China." In *Tokens of Exchange: The Problem of Translation in Global Circulations*, ed. Lydia H. Liu, 74–106. Durham, N.C.: Duke University Press, 1999.

Zhang, Zhen. "Phantom Theater, Disfigurement, and History in *Song at Midnight*." In *Body and Face in Chinese Visual Culture*, ed. Hung Wu and Katherine R. Tsiang, 335–62. Cambridge: Harvard University Asia Center, 2005.

Zito, Angela. "Bound to Be Represented: Theorizing/Fetishizing Footbinding." In *Embodied Modernities: Corporeality, Representation, and Chinese Cultures*, ed. Fran Martin and Larissa Heinrich, 21–41. Honolulu: University of Hawai'i Press, 2006.

Zito, Angela, and Tani E. Barlow, eds. *Body, Subject, and Power in China*. Chicago: University of Chicago Press, 1994.

INDEX

Akae, 62–65

Akin, Lew, 49–50, 55–56

Alibert, Jean-Louis, 59

anatomical aesthetics: comparative concepts of, 113–47, 186n.41; in Hobson's *New Treatise*, 13–14, 117–34; in Lu Xun's work, 134–47; translation of terms into Chinese and, 121–34, 184n.26, 185n.27; in Western medicine/s, 117–34

anatomical texts, 13–14

Anatomie universelle du corps humain (Paré), 118

Anatomy (Dudgeon), 118

Anderson, Marston, 141, 193n.71, 196n.22

Andrews, Bridie, 43, 123–24, 154, 187n.44, 195n.12, 195n.15

Apollo Club, 47

archival sources, of medical photography, 77–84

Armstrong, Nancy, 75, 108–9

art history, 9–10

autopsy: anatomical findings from executions, 192–93n.67; Chinese cultural proscription against, 67, 171n.74; legalization in China of, 134–36, 188n.45; Western medicine's promotion of, 118–19, 182n.14, 183n.16. *See also* dissection-based anatomy

bacteriology, emergence in China of, 152–56

Baizi tu ("Hundred children pictures"), 3

Barrow, John, 35, 165n.57

Baudelaire, Charles, 142, 192n.65

Baudrillard, Jean, 124

Beato, Felice (Felix), 99–100, 179n.70

beheadings, 194n.9

Benedict, Carol, 16

Benjamin, Walter, 80, 174n.23

Bertin, Henri, 2–3, 22–25, 29–32, 33–34, 163n.44

Bibliothèque Nationale de Paris, 2

Bibliothèque Royale, 2

bidousuo (smallpox avoidance centers), 23–25

bioterrorism, smallpox and, 15

Blake, John, 51

body: Chinese literary representations of, 7–8, 137–47, 191n.58; European re-ordering of models of, 147, 194 n.73; Hobson's treatise on anatomy and images of, 13–14, 117–34; Western vs. Chinese concepts of, 113–47, 181n.6

Bontecou, Reed B., 179n.71

Boone, H. W., 82, 90–91, 95, 183n.16

Boston Athenaeum, 47

botanical paintings, by Chinese export painters, 51

Bourdaghs, Michael, 154

Bourdieu, Pierre, 95–96

Bourgeois (Jesuit father), 114

Bourgon, Jérôme, 194n.9

breast cancer, 56–57, 170n.48

Broken Commandment, 155–56

Call to Arms, A (Lu Xun), 136, 151–56

cataract surgery, 164n.55

Catholic Church, 21–22

Chang, Chia-feng, 160n.26, 161nn.31–32, 162n.41, 163n.45, 165n.60

Chen Xiutang, 121–34, 138

China: as "cradle of smallpox," 11–12, 16, 25–37, 149–50; export art of, 11; inoculation practices in, 2, 27–37; medical photography in, 12–13, 73–111; medical texts in, 3–4; national iden-tity in, 11–12, 149–56; "pathological" image of, 11–12, 42, 68–71, 78, 149–56, 173n.17; technological and scientific advancements in, 1–2, 151–56; Western notions of medical practices in, 2–7, 18–25; Western-style medicine in, 13–14, 152–56

China and the Origins of Immunology (Needham), 25

China Imperial Maritime Customs Medical Reports, 74, 90, 96–97, 176n.50

China Medical Journal. See *China Medical Missionary Journal*

China Medical Missionary Association, 81–82, 90–91, 177n.55

China Medical Missionary Journal, 74; Jef-fereys and Maxwell as editors of, 106–8; medical photography in, 76–77, 82, 90–91, 93–95, 97–99, 177n.52; title change of, 95, 177n.52; war wounds photography in, 99–104

China Medical Missionary Society, 44–46, 50–53, 174n.28; museums estab-lished by, 77–84, 172n.14

Chinese culture: anatomical aesthetics in, 144–47; Lam Qua's paintings as repre-sentation of, 42–46; modernity and in-terpretations of, 5–6; pathologization of, 68–70, 149–56; visual orientation in, 41–46, 77–78; Western consump-tion of items from, 87–90; Western stereotype of pain insensibility in, 59–65

Chinese identity: body aesthetic and, 116–47; in Lam Qua's paintings, 43–46, 58–70; Lu Xun's discussion of, 135–36, 190n.53; in medical photography, 75–76, 104–5; modern Chinese intellectual discussion of, 150–56; nationalist poli-tics and, 134–47, 149–56; origins of smallpox and concepts of, 16; patholo-gization of, 68–70, 149–56; smallpox images and, 39

Chinese Medical Journal. See *China Medi-cal Missionary Journal*

Chinese medicine: anatomical aesthetics in, 118–47; contemporary commentary

on, 174n.32; reform of, 135, 150–56, 189n.46; translation issues in discussion of, 121–34, 184n.26; Western stereotypes of, 40–41, 65–71

Chinese Repository, 43, 177n.56

Chinese Science, 190n.52

Chinnery, George, 48

Chi Ying, 48

cholera, 16

Chong Jingzhou, 135–36

Chow, Rey, 151

Christianity: Chinese resistance to, 65–70; mythology of Chinese receptiveness to, 60–65, 171n.62; origins of smallpox and theories of, 27–28. *See also* medical missionaries

Christie, Dugald, 100

Chu P'ing-yi, 43

Cibot, Martial, 2, 11, 17–29, 173n.2; Bertin's critique of, 29–32; on evolution of smallpox in China, 25–29, 32–37; Figurism and, 27–28, 162n.35; source texts for, 33–34

"circuit community," of Western medical practitioners in China, 74

Civil War (U.S.), war wound photography in, 99–100, 179n.71

class structure, 75

clothing, Chinese and Western concepts of, 133–34, 186n.40

Cohen, Paul, 187n.44

colonial ideology, origins of smallpox and, 16–37

commercial transactions, 40

Communist Party of China, nationalist discourse and, 150

"Comparison of Chinese and World Cultures" (exhibit), 1

Conner, Patrick, 48, 56

contextuality, in medical photography, 104–11

Correcting the Errors of Physicians (Wang Qingren), 142–43

Crary, Jonathan, 147, 194n.73

Crossman, Carl, 46

cross-section, in anatomical illustration, 130

cultural practices: history of medicine and, 8–9; medical photography and, 109–11; Western stereotypes of Chinese practices, 40–71

Cumming, William Henry, 66

Day, E-li, 119

deficiency metaphor, Chinese national identity and, 150–56

degeneration, origins of smallpox linked to, 26–29, 161n.32

Dehergne, Joseph, 22, 164n.53

De humani corporis (Vesalius), 118

"De la petite vérole" (Cibot): critical reception of, 29–37; origins of, 17–37; source texts for, 33–34

D'Entrecolles, François Xavier, 19–20, 24–25

descriptio features in Chinese literature, 191n.60

Dianshizhai Pictorial, 83–84

Dickens, Charles, 6

Dickson, W. G., 121, 184n.24

Diderot, Denis, 34

Didi-Huberman, Georges, 77

diet, 27, 161n.33

Ding Ling, 6

disease: Chinese ideologies of, 11; cultural representations of, 6–7

Guy's Hospital: Chinese specimens at, 169n.40; Lam Qua's paintings at, 45, 167n.18

Han Qi, 20
Hart, Roger, 43, 176n.50
Hay, John, 126, 133, 181n.6, 185n.36
Henderson, James, 183n.16
Herodotus, 185n.27
historiography: Chinese medical history and, 11; on smallpox, 15–37
History of Chinese Medicine (Wong and Wu), 33, 188n.45
Hobson, Benjamin, 185n.34, 188n.45; Chinese rejection of, 134–47, 187n.44; *New Treatise* of, 13–14, 117–34, 136, 140, 142, 184nn.19–20
Hogarth, William, 47
Hong Xiuquan, 167n.17
Hopkins, Donald, 19, 32–33, 36
Howqua, 50
Huangdi neijing, 125
Hung, Eva, 138
Hu Shi, 150
Huters, Theodore, 138, 140–41, 191n.58
hygiene, 152–36

Ideologues' philosophy, 59
ideology, photography and, 74–75, 172n.4
illness: Chinese illustrations of, 6–7, 11–12; literary depictions of, 7–8
Illustrations of China and Its People (Thomson), 106
India: anatomical research in, 183n.16; smallpox vaccination in, 35; war wounds photography in, 179n.70
Ingres, Jean-Auguste-Dominique, 56, 170n.47

inoculation: Chinese practice of, 2, 25–37, 165n.61; Cibot's dismissal of Chinese methods of, 17–25, 28, 162n.39; Enlightenment arguments concerning, 20–25; French controversy concerning, 17–25; legends concerning origins of, 30–32, 163n.45; Western development of, 34–37
interiority, anatomical aesthetics and concepts of, 130–34
Islam, 182n.14

Jamieson, R. A., 35
Japan: intermediary role of, 43, 118; war wounds photography in, 99, 101, 179n.70, 179n.73; Western science and medicine in, 118, 152, 195n.12
Jefferson, Thomas, 34
Jefferys, W. Hamilton, 13, 85–87, 93–94, 106–11, 119
Jenner, Edward, 34–37
Jesuit missionaries in China, 113–14, 180n.1, 181n.2; anatomical aesthetic of, 117–18; theories of smallpox origins and, 27
Jiangnan Arsenal, 119–20, 184n.17
Jiang Shaoyuan, 135–36, 186n.41, 187n.44, 190n.53
Josyph, Peter, 58–59

Kafka, Franz, 80
Kerr, John, 96–97, 174n.24, 178n.56, 178n.58; on anatomical research, 183n.16; medical photography and, 78–81, 90–92
Kerr, William, 51
Koch, Robert, 152–53
Kuhne, John, 94

Kuriyama, Shigehisa, 113–15, 121–23, 133, 185n.27

Kwan A-to, 49–53, 80, 176n.49

laboratory science, 104–5, 180n.81

Lackner, Michael, 27

La Grande Odalisque (Ingres), 56, 170n.47

Lamarre, Thomas, 152–53

Lam Qua, 11–13; Chinese identity in paintings of, 65–70, 150; facial expressions in portraits by, 58–65; influence of Western art on, 47–49, 56–58; landscape images in paintings of, 62–65; locations for paintings of, 166n.7; medical photography influenced by, 95–104; medical portraiture of, 39–40, 53–71; Parker's collaboration with, 42–46, 48–53, 59–65, 110; queue as symbol in portraiture of, 63, 66–69; representation theory and work of, 47, 77–78, 167n.24; studio and productivity of, 46–49; Western exhibitions of paintings by, 44–49, 166n.14, 168n.25

Lam Qua, subjects in paintings by: Akae, 62–65; Lew Akin, 49–50, 55–56; Lo Wanshun, 64–65; Lu Akwang, 68–69; Parker and Kwan A-to, 176n.49; Po Ashing, 63–65, 111; Wang Ke-king, 54, 66–71, 98; Yang She, 54–55

lantern-slides, medical presentations using, 155, 195n.17

Latour, Bruno, 16–17, 37, 153–55, 158n.14

Lee, Bruce, 150

Lee, Leo Ou-fan, 156, 194n.7

Leroux, Gaston, 6

Leung Kin Choh, 81

Liang Fa, 45, 167n.17

Liang Qichao, 150

Lin Chong, 48

literature in China: deficiency and pathology metaphors in, 150–56; dissection-based metaphor in, 135–47, 190n.53, 191n.58, 191n.60

Liu, Lydia, 43, 124, 137, 152, 196n.21

Lockhart, William, 36, 45, 167n.18

Londe, Albert, 174n.23

Longobardo, Niccolò, 117

Lo Wanshun, 64–65

Lu Akwang, 68–69

Lundbaek, 161n.34

Luo Ping, 118

Lu Xun, 6, 14, 188n.44, 189n.51, 190n.53; anatomical aesthetics of, 134–47; conversion from medicine to literature by, 152, 194n.7, 194n.9; deficiency and pathology metaphors in work of, 151–56; fictional narratives of, 137–47; microbiology and work of, 154–55; nationalist discourse in work of, 150; race and hygiene theories and work of, 153–56; realism in work of, 144–47, 193nn.71–72

Lu Xun, works of: *A Call to Arms*, 136, 151–56; "Epitaph," 141–44; "Fujino sensei," 136, 144–46, 151, 193n.71; "Medicine," 6; "Miscellaneous talk after an illness," 193n.69; "My Father's Illness," 6; "My Old Home," 140–41; "On Photography," 144, 188n.44, 193n.69; *Re feng* collection, 154–55, 195n.16; "Revenge," 139–41, 191n.56; *Wild Grass*, 139, 191n.56

Manet, Éduard, 56

Mao Dun, 6, 192n.63

Martin, Paul, 108

masculinity, 149–50

Maxwell, Anne, 74–75, 87, 102, 176n.42

Maxwell, James L., 13, 87, 93, 106–11, 119

May Fourth period, 137–38, 150–51, 191n.58

Medical and Surgical History of the War of Rebellion, 100, 179n.71

medical anthologies, 77, 90–95

medical history: in China, 8–9, 73–111; visual culture studies and, 9–10

medical illustrations: facial expressions in, 58–65; medical missionaries' promotion of, 41–42

medical missionaries: anatomical aesthetic among, 118–34, 146–47, 183n.16; Chinese collaboration with, 42–46, 121, 184n.22; communication problems of, 4–5; frustration with Chinese resistance to, 65–70; funding difficulties of, 41; medical photography by, 12–13; origins of smallpox and views of, 16–17; preoccupation with visual of, 4–5; stereotypes of Chinese medicine by, 40–71; treatment of external ailments in China by, 41

medical museums, 77–84

medical photography: archival sources of, 77–84; before-and-after pictures, 95–104; Chinese identity and, 75–76, 104–5; circulation in China of, 76–95; contextuality in, 104–11; in *Diseases of China*, 106–11; early technological requirements for, 80, 173n.22; establishment of laboratory science and, 104–5, 180n.81; in Europe and United States, 104–5; history of, 12–13; print reproductions of, 93; private collections of, 84–90; in publications, 90–95; stylis-

tics of, 95–104; theatrical aspects of, 80–81, 173n.21; war wounds depicted in, 99–104

"Medicine" (Lu Xun), 6

Medicine in China (Unschuld), 158n.17

Memoirs on the History...of the Chinese, 19, 22, 161n.34

Miller, Milton M., 79–80, 173n.20

missionary doctors. *See* medical missionaries

Moore, James Carrick, 17–18

moral philosophy, origins of smallpox linked to, 26–29, 162n.41

"My Father's Illness" (Lu Xun), 6

"My Old Home" (Lu Xun), 140–41

nationalism: Chinese identity and, 134–47, 150; Chinese pathology and, 11–12, 68–70, 149–56; scientific and hygienic development linked to, 154–56; self-perception and, 149

National Medical Journal, 177n.52

National Palace Museum, 1–2, 4

"Naval Treaty, The" (Doyle), 138

Needham, Joseph, 25

nerves, 123–24

neurofibromatosis, 78

"New and Old" (Shen Congwen), 192n.63

Newman, Kathy, 99–100, 179n.71

New Treatise on Anatomy (Hobson), 13–14, 117–34, 136, 140, 142, 184nn.19–20

Olympia (Manet), 56

Olympic Games of 2008, 150

On Chemistry and Hygiene, 190n.52

"On Photography" (Lu Xun), 144–47, 188n.44, 193n.69

"On Smallpox." *See* "De la petite vérole"

Opium Wars: medical missionaries and, 46; pathology and identity in, 11–12, 42, 71

pain, myth of Chinese insensibility to, 59–65
Panofsky, Erwin, 117
Paré, Ambrose, 118
parents, Parker's stereotypes of, 68–70
Parker, Peter, 11–12; autopsies performed by, 118–19, 182n.14; belief in visual demonstration of, 77–78; frustration with Chinese resistance by, 65–70; Lam Qua's collaboration with, 42–46, 48–53, 59–65, 110; Lam Qua's portrait of, 176n.49; medical missionary activities of, 41; medical reports on activities of, 178n.56; models for Lam Qua supplied by, 53, 169n.44; stereotypes of Chinese identity in work of, 60–65, 150, 171n.62; on Western exhibitions of Lam Qua's work, 166n.14, 167n.18
Pasteurization of France, The (Latour), 153–54, 158n.14
pathology: body aesthetic and, 116–17; Chinese artistic representations of, 11–12; Chinese identity and, 11–12, 42, 68–71, 78, 149–56, 173n.17; in medical photography, 75–76, 104–11, 180n.81
Pearce, T. W., 5, 78
Pearson, Alexander, 165n.57
Pennsylvania Academy of Fine Arts, 47
Phantom of the Opera (Leroux), 6
Picturing Empire (Ryan), 178n.64
Pinney, Christopher, 1
Pleasures of Ghosts painting series (Luo Ping), 118
Po Ashing, 63–65, 111

Porkert, Manfred, 115
postcards, medical photography on, 86–90, 175n.41, 176n.42
Pottinger, Henry, 48
"primitive thinking," Republican-era Chinese appraisals of, 135–36, 189n.47
Princes and Peasants (Hopkins), 19, 32–33
private medical photography collections, 84–90
protolinguistic theory, 5

Qianlong, 113, 180n.1, 181n.2; imperial archive of, 3–4; rejection of British trade by, 35, 164n.56
Qing dynasty: literature from, 150; medical research under, 119–20; penal code during, 194n.9; relaxation of proscriptions against Christianity by, 45; restrictions on foreign commercial activity by, 40
quarantine, 23–25, 160n.26
queue: as cultural symbol, 98, 178n.69; in Lam Qua's portraiture, 63, 66–69

race: Chinese and hierarchy of, 136, 190n.53; in medical photography, 75–76, 109–11; origins of smallpox and concepts of, 16
Rachman, Stephen, 167n.18, 167n.24
realism, in Chinese literature, 145–47, 193nn.71–72
Reeves, John, 51, 169n.40
Re feng collection (Lu Xun), 154–55, 195n.16
Reifsnyder, Elizabeth, 84, 175n.35
Reports of the Medical Missionary Society, 91–93, 178n.58
representation: Lam Qua's illustrations

vaccination: history in China of, 18–19, 34–37, 165n.57, 166n.60; Jenner's development of, 34–37

Vesalius, Andreas, 118

visual culture studies: history of medicine and, 9–10; impact of science on, 152–56

visual images: medical missionaries' preoccupation with, 4–5, 41–46, 52–70; in medical museums, 77–78; Western anatomical aesthetics and, 126–34

Voltaire, 21–22, 159n.19, 160n.22

Von Recklinghausen's disease, 78

Wang Daw-hwan, 43

Wang Ke-king: Lam Qua's portrait of, 54, 66–71, 98; resistance to Western medicine by, 66–67

Wang Qingren, 125–26, 142–43, 185n.34, 192–93n.67

Wang Tao, 185n.34

Wang Yangming, 189n.47

war wounds, medical photographs of, 99–104, 179n.70–71, 179n.73

Western art, influence on Lam Qua's work of, 47–49, 56–58

Western medicine: anatomical aesthetics in, 114–47, 186n.41; archival practices in, 83; Chinese commentary on, 174n.32; Chinese images of, 6, 11–12; Chinese resistance to, 65–70, 146–47, 171n.69, 193n.72; cultural impact in China of, 13–14, 41–46, 52–70, 152–56; eroticism in Chinese medical photography and, 102–4; fraternity in China

of practitioners of, 73–74; history of smallpox in, 15–37; impact of photography on, 74–75, 171n.3; medical photography as promotion of, 12–13, 95–104; technological developments in, 70–71; translation issues in China with, 121–22, 184n.26; vaccination as symbol of, 35–37, 165n.60; visual evidence of superiority of, 4–5, 87–90, 176n.49

Whitwright, J. S., 172n.14

Wild Grass (Lu Xun), 139, 191n.56

Wong, K. Chimin, 19, 33–35, 78, 120–21, 188n.45

Wong Fun, 183n.17

World Health Assembly, on smallpox, 15

Wu, Yi-Li, 43, 121, 185n.34, 193n.72

Wue, Roberta, 75, 85–87

Wu Lien-teh, 19, 33–35, 78, 120–21, 188n.45

Wu Qian, 24

Xie Jin, 150

Xiong Yuezhi, 42–43

Yang, Étienne, 22

Yang She, 54–55

Yilin gaicuo (Wang Qingren), 142–43

Yizong jinjian (Quian), 3, 24–33, 56–57, 160n.26, 161n.32

Young, Charles W., 94

Yu Dafu, 6

Zeng Pu, 150

Larissa N. Heinrich is an associate professor of modern Chinese literature, comparative literature, and cultural studies at the University of California, San Diego.

Library of Congress Cataloging-in-Publication Data
Heinrich, Larissa.
The afterlife of images : translating the pathological body between China and the West / Larissa N. Heinrich.
p. ; cm. — (Body, commodity, text)
Includes bibliographical references and index.
ISBN 978-0-8223-4093-5 (cloth : alk. paper) — ISBN 978-0-8223-4113-0 (pbk. : alk. paper)
1. Medical illustration—China—History. 2. Medicine in art—China—History. 3. Missions, Medical—China—History. 4. Medicine—China—History. I. Title. II. Series.
[DNLM: 1. Medicine in Art—China. 2. Medicine in Art—Europe. 3. Medicine in Art—United States. 4. Attitude to Health—China. 5. Attitude to Health—Europe. 6. Attitude to Health—United States. 7. Cross-Cultural Comparison—China. 8. Cross-Cultural Comparison—Europe. 9. Cross-Cultural Comparison—United States. 10. History, 18th Century—China. 11. History, 18th Century—Europe. 12. History, 18th Century—United States. 13. History, 19th Century—China. 14. History, 19th Century—Europe. 15. History, 19th Century—United States. 16. History, 20th Century—China. 17. History, 20th Century—Europe. 18. History, 20th Century—United States. 19. Medical Illustration—history—China. 20. Medical Illustration—history—Europe. 21. Medical Illustration—history—United States. 22. Missions and Missionaries—history—China. 23. Missions and Missionaries—history—Europe. 24. Missions and Missionaries—history—United States. 25. Stereotyping—China. 26. Stereotyping—Europe. 27. Stereotyping—United States. WZ 330 H469a 2008]
R836.H46 2008
610.951—dc22 2007032555